ABSTRACT PAINTING AND SCULPTURE IN AMERICA 1927–1944

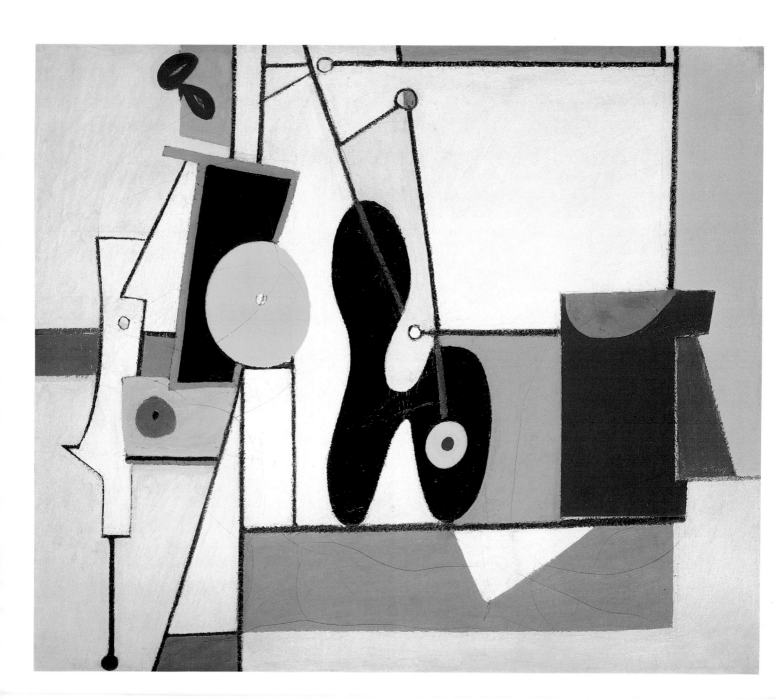

ABSTRACT PAINTING AND SCULPTURE IN AMERICA 1927–1944

EDITED BY JOHN R. LANE

AND SUSAN C. LARSEN

MUSEUM OF ART, CARNEGIE INSTITUTE
PITTSBURGH

IN ASSOCIATION WITH

HARRY N. ABRAMS, INC.
PUBLISHERS, NEW YORK

This book was published on the occasion of the exhibition "Abstract Painting and Sculpture in America 1927–1944."

Museum of Art, Carnegie Institute, Pittsburgh
 November 5–December 31, 1983
San Francisco Museum of Modern Art
 January 26–March 25, 1984
The Minneapolis Institute of Arts
 April 15–June 3, 1984
Whitney Museum of American Art, New York
 June 28–September 9, 1984

The exhibition was made possible by grants from The Hillman Foundation, Inc., and the National Endowment for the Arts.

Editor: Janet Wilson
Production Editor: Margaret Donovan
Designer: Judith Michael

Frontispiece: Arshile Gorky. *Organization*, 1933–36. Oil on canvas, 50¼ × 60¼ in. (127.6 × 153 cm.). National Gallery of Art, Washington; Ailsa Mellon Bruce Fund

LIBRARY OF CONGRESS CATALOGING IN PUBLICATION DATA

Main entry under title:

Abstract painting and sculpture in America.

 Accompanies the exhibition: Abstract painting and sculpture in America, 1927–1944.
 Bibliography: p.
 Includes index.
 1. Art, Abstract—United States—Exhibitions.
I. Lane, John R.; 1944– . II. Larsen, Susan C.
III. Carnegie Institute. Museum of Art.
N6494.A2A24 1984 759.13'074'013 83–3850
ISBN 0–88039–006–9 (pbk)
ISBN 0–8109–1805–6

Printed and bound in Japan

CONTENTS

6 Lenders to the Exhibition
6 Contributing Authors
7 Foreword
 John R. Lane

ABSTRACT PAINTING AND SCULPTURE IN AMERICA 1927–1944

10 The Meanings of Abstraction
 John R. Lane
15 The Quest for an American Abstract Tradition, 1927–1944
 Susan C. Larsen

ART AND ARTISTS

46 Josef Albers
 Nicholas Fox Weber
48 Charles Biederman
 Jan van der Marck
51 Ilya Bolotowsky
 Deborah M. Rosenthal
56 Byron Browne
 April J. Paul
59 Alexander Calder
 Joan Marter
63 Stuart Davis
 John R. Lane
68 Willem de Kooning
 Harry Rand
70 Burgoyne Diller
 Nancy J. Troy
74 Werner Drewes
 Susan C. Larsen
76 John Ferren
 Craig Ruffin Bailey
79 Suzy Frelinghuysen
 John R. Lane
144 A. E. Gallatin
 Susan C. Larsen
147 Fritz Glarner
 Nancy J. Troy
150 Arshile Gorky
 Harry Rand
157 John Graham
 Harry Rand
161 Balcomb Greene
 Linda Hyman
164 Gertrude Greene
 Jacqueline Moss
167 Jean Hélion
 Merle Schipper

170 Hans Hofmann
 Cynthia Goodman
172 Carl Holty
 John R. Lane
175 Harry Holtzman
 John R. Lane
178 Raymond Jonson
 Susan C. Larsen
180 Paul Kelpe
 Susan C. Larsen
182 Ibram Lassaw
 Joan Marter
184 Fernand Léger
 Vivian Endicott Barnett
187 Alice Trumbull Mason
 Susan C. Larsen
189 Jan Matulka
 Patterson Sims
192 László Moholy-Nagy
 Joan M. Lukach
194 Piet Mondrian
 Nancy J. Troy
198 George L. K. Morris
 Melinda A: Lorenz
202 Isamu Noguchi
 Joan Marter
205 Irene Rice Pereira
 Susan C. Larsen
208 Ad Reinhardt
 Patterson Sims
211 Theodore Roszak
 Joan Marter
214 Rolph Scarlett
 Joan M. Lukach
216 John Sennhauser
 Susan C. Larsen
218 Charles Shaw
 Susan C. Larsen
221 Esphyr Slobodkina
 Susan C. Larsen
223 David Smith
 Karen Wilkin
227 John Storrs
 Noel Frackman
229 Albert Swinden
 Susan C. Larsen
231 Vaclav Vytlacil
 Susan C. Larsen
233 Jean Xceron
 Daniel Robbins

CATALOGUE
237
245 Selected Bibliography
252 Index
256 Photograph Credits

LENDERS TO THE EXHIBITION

ACA Galleries, New York
Edward Albee
Aluminum Company of America, Pittsburgh
Mr. and Mrs. John P. Anderson
The Art Institute of Chicago
The Berkshire Museum, Pittsfield, Massachusetts
Louis Hélion Blair
The Brooklyn Museum, New York
The Chrysler Museum, Norfolk
Edward R. Downe, Jr.
Barney A. Ebsworth
Joseph Erdelac
Ertegun Collection Group
Dr. Peter B. Fischer
Mr. and Mrs. James A. Fisher
Robert Hull Fleming Museum, University of Vermont, Burlington
Dr. and Mrs. Phillip Frost
Mrs. Robert C. Graham, Sr.
The Grey Art Gallery and Study Center, New York University Art Collection
The Solomon R. Guggenheim Museum, New York
Mrs. Raymond F. Hedin
Estate of Joseph Hirshhorn
Hirshhorn Museum and Sculpture Garden, Smithsonian Institution, Washington
Olga Hirshhorn
Estate of Hans Hofmann
Harry Holtzman
Honolulu Academy of Arts
The Archer M. Huntington Art Gallery, University of Texas, Austin
Sidney Janis Gallery, New York
Dr. and Mrs. Arthur E. Kahn
Kunsthaus Zürich, Switzerland
Ibram Lassaw
Mr. and Mrs. Raymond Learsy
Cornelia and Meredith Long
Meredith Long & Co., Houston
Los Angeles County Museum of Art
Lowe Art Museum, University of Miami, Coral Gables
Edith and Milton Lowenthal
The Metropolitan Museum of Art, New York
The Minneapolis Institute of Arts
Musée National d'Art Moderne, Paris
Museum of Art, Carnegie Institute, Pittsburgh

The Museum of Fine Arts, Houston
The Museum of Modern Art, New York
National Museum of American Art, Smithsonian Institution, Washington
The Newark Museum
New Jersey State Museum, Trenton
Isamu Noguchi
Pennsylvania Academy of the Fine Arts, Philadelphia
Philadelphia Museum of Art
The Phillips Collection, Washington
Private Collection (5)
Mr. and Mrs. Harvey W. Rambach
Mr. and Mrs. Orin Raphael
Mr. and Mrs. Milton Rose
San Francisco Museum of Modern Art
Mr. and Mrs. Fayez Sarofim
Sheldon Memorial Art Gallery, University of Nebraska, Lincoln
Dr. and Mrs. Milton Shiffman
Estate of David Smith
Allan Stone Gallery, New York
Robert L. B. Tobin
Mr. and Mrs. Burton Tremaine
University of Arizona Museum of Art, Tucson
Suzanne Vanderwoude
Washburn Gallery, New York
Mr. and Mrs. Rolf Weinberg
Thomas Weisel
Mr. and Mrs. John T. Whatley
Whitney Museum of American Art, New York
Louise and Joe Wissert
Zabriskie Gallery, New York

CONTRIBUTING AUTHORS

Craig Ruffin Bailey
Vivian Endicott Barnett
Noel Frackman
Cynthia Goodman
Linda Hyman
John R. Lane
Susan C. Larsen
Melinda A. Lorenz
Joan M. Lukach
Joan Marter
Jacqueline Moss

April J. Paul
Harry Rand
Daniel Robbins
Deborah M. Rosenthal
Merle Schipper
Patterson Sims
Nancy J. Troy
Jan van der Marck
Nicholas Fox Weber
Karen Wilkin

FOREWORD

The years between 1927 and 1944 were a remarkably fertile period in the history of American art, giving rise to a complex and lively abstract movement that produced some of the finest painters and sculptors of the time and nurtured many younger talents who would become leaders of the Abstract Expressionist movement. Yet much of the attention —popular, critical, historical, both during those years and since—has been given to the manifestations of "American Scene" painting and Social Realism, to which most artists of the period were committed. The purpose of "Abstract Painting and Sculpture in America 1927–1944" is to present the first full-scale study of this important aspect of art in the United States during a period that begins with the revitalization of the abstract tradition in 1927—a year marked by Stuart Davis painting his "Eggbeater" series and A. E. Gallatin establishing the Gallery of Living Art, the first permanent, public collection of abstract art—and ends in 1944 with the death of Piet Mondrian in New York and the emergence of that city as the center of the new, international modernist style, Abstract Expressionism. It may, in fact, be argued that when Mondrian—in retrospect, then the greatest of abstract painters—arrived in America in 1940, it was an event of more symbolic than historic importance; by the late thirties, with the coming of age of a second generation of American modernists, New York had already become the most vital world center for the development of abstract art.

In the organization of this project I have been exceptionally fortunate to have as a colleague and co-curator Susan C. Larsen, Associate Professor of Art History at the University of Southern California, Los Angeles, whose scholarly work for more than a decade has been focused on American abstract art of the thirties. We agreed from the beginning that there were three especially pressing needs that ought to be addressed by "Abstract Painting and Sculpture in America 1927–1944": the first was for a comprehensive history of the subject that would bring together the best of the extensive new research, much of which has been either unpublished or disseminated only to a limited, specialized audience; the second was for a hierarchy based on artistic accomplishment within the community of abstract artists active at the time; and the third was to select a body of exceptional objects, meant to serve as a standard of quality against which to measure other work of the period.

In any survey, and particularly one of a relatively unexplored and undefined period, it seems appropriate to comment on the thinking that has informed the organizers' selection. The artists and the paintings and sculpture included in "Abstract Painting and Sculpture in America 1927–1944" are, to a very large measure, within the Cubist and geometric abstractionist tradition. These were the styles employed by most of the best American modernists who matured in the thirties, as well as by a number of the younger artists who first engaged modernism during those years. While good work was also accomplished by American abstractionists working in more expressionist or organic Surrealist manners, those contributions did not, in general, seem to us to be as important. Expressionist and Surrealist abstraction would certainly come of age in New York during the forties under new influences, but in the thirties it was the late Cubism of Pablo Picasso and Fernand Léger, the biomorphic forms of Joan Miró and Jean Arp, and the reductive geometric tendencies of Constructivism, De Stijl, the Bauhaus, and Abstraction-Création that dominated the minds of most of the best American abstractionists.

One of the most important figures of the entire decade of the thirties was Arshile Gorky. He was also the artist who convincingly broke the pattern of American dependency on European leadership when, in 1943–44, he abandoned late Cubism and biomorphic abstraction in favor of a freer and looser expressionist style that carried American painting beyond its provincial and dependent state, setting the stage for the ascendancy of Abstract Expressionism. Because this aspect of his career is so clearly part of the ensuing Abstract Expressionist chapter in the history of modernism in America, Gorky's work after the very early forties is not included in this exhibition. Neither is the work of the first generation of American abstractionists, whose achievements are more closely associated with the period immediately preceding and following the 1913 Armory Show and who, for the most part, had diverged from abstraction during the twenties in favor of Precisionism or personal varieties of expressionist figuration—paths they continued to follow in the thirties. John Storrs is an artist who does not fit in neatly. Only his paintings have been included because in the thirties they were a new and significant departure from his abstract sculpture of the previous decade.

Our judgment regarding the relative significance of the forty-three artists represented in this exhibition is indicated first by the number of their objects selected and, second, by the length of the individual essays commissioned to discuss them. (In the case of each European abstractionist represented, because the major focus of the exhibition is the achievement of American artists, we arbitrarily imposed a limit of two works known to have been made in this country.) While we have

sought to show the development of a few of the most important artists through the entire period surveyed, in the case of many artists we intentionally did not attempt to be comprehensive but made a limited selection of what were, in our judgment, examples of their very best work. Because of the exceptional generosity and interest of the museums, private collectors, and galleries from whom we sought loans, the exhibition does represent our view of what was the best abstract work of the period. (In those few instances where works of critical importance were unavailable for the exhibition, we have illustrated them in this publication in order to round out the presentation, at least in print.)

"Abstract Painting and Sculpture in America 1927–1944" has enjoyed the interest, goodwill, and support of an extraordinary number of individuals and institutions. We first gratefully acknowledge the lenders to the exhibition. We thank our colleagues who have shared their special knowledge in the essays of this publication. We make particular note of Joan M. Lukach, who generously gave us access to her research on Hilla Rebay, and Nancy J. Troy, who made such an important contribution to the essay on Harry Holtzman. Many people were helpful in our survey of collections, and we especially thank Patterson Sims, Whitney Museum of American Art; Vivian Endicott Barnett, Solomon R. Guggenheim Museum; Thomas Hudspeth, Ertegun Collection Group; Martin Diamond, Martin Diamond Fine Arts; Virginia Zabriskie and Beth Urdang, Zabriskie Gallery; Joan Washburn, Washburn Gallery; and Meredith Long, Meredith Long & Company.

At the Museum of Art, Carnegie Institute, Gloria Gilmore-House coordinated the organization of the exhibition with skill, determination, and a great deal of goodwill. Helen J. Goodman and Barbara L. Phillips both made significant and highly appreciated contributions. With intelligence, patience, and facility, Janet Wilson undertook an especially challenging editing assignment that included dealing with submissions from twenty-one different authors.

It has been a pleasure to work with our co-publisher, Harry N. Abrams, Inc., where our collaboration on this book has been with Margaret Kaplan and Margaret Donovan.

William C. Agee and Barbara Rose were importantly involved in conceptualizing "Abstract Painting and Sculpture in America 1927–1944." The project has also benefited from the encouragement and advice of Thomas N. Armstrong III, Grace Borgenicht, Michael Botwinick, Catherine Grimshaw, Anne d'Harnoncourt, Norman Hirschl, Abram Lerner, Lauri Martin, Mark B. McCormick, Marilyn Pearl, Dorothy and Leo Rabkin, Marian G. Ruggles, Brian Rushton, Lowry Simms, James M. Walton, James Yohe, and many others.

We are very pleased that the exhibition will be shared with three distinguished American museums, and I thank my colleague directors for their interest and the participation of their institutions: Henry Hopkins, San Francisco Museum of Modern Art; Samuel Sachs II, The Minneapolis Institute of Arts; and Thomas N. Armstrong III, Whitney Museum of American Art.

"Abstract Painting and Sculpture in America 1927–1944" has been made possible by generous grants from the National Endowment for the Arts and The Hillman Foundation, Inc. We are grateful to both and especially thank Henry L. Hillman, president of The Hillman Foundation and a trustee of Carnegie Institute, and Ronald Wertz, executive director of The Hillman Foundation, for their belief in the importance of this undertaking. It is also a pleasure to note that the exhibition program of the Museum of Art, Carnegie Institute enjoys general support from the Howard Heinz Endowment and the Pennsylvania Council on the Arts.

With the ambition of having its own collection represented in a significant way in this exhibition, the Museum of Art, Carnegie Institute has acquired during the past three years a number of important examples of abstract painting and sculpture of the period. We are very grateful to the generous donors who made these purchases possible, including Edith H. Fisher, the Robert S. Waters Charitable Trust, The A. W. Mellon Educational and Charitable Trust, Kaufmann's, the Women's Committee of the Museum of Art, and the friends of Mary Oliver Robinson.

John R. Lane
Director, Museum of Art, Carnegie Institute

ABSTRACT PAINTING AND SCULPTURE IN AMERICA 1927–1944

THE MEANINGS OF ABSTRACTION

by John R. Lane

ABSTRACTION AND REALISM

It is one of the paradoxes of twentieth-century art that the more it has distanced itself from the imitation of natural appearances—that is, the more abstract it has become—the more vehemently insistent have been its creators that their work is realistic. This claim is founded on the modernist aesthetic principle that each art form should seek to reduce itself to its essential ingredients. In the case of painters and sculptors, this has meant, first and foremost, concentrating on organizing and manipulating the means of expression—line, color, light and shade, form, and space—to create art that merits appreciation without needing to justify its existence by making imitative references to subjects in the natural world (although in modernist art those references to recognizable imagery *may* still be there). During the period 1927 to 1944 individual abstract artists in America may have differed on the secondary meanings of their paintings and sculpture, but they agreed that the primary subject was the created object itself and that the main reason for looking at a work of art was to appreciate its formal quality.

Hardly new concepts, these ideas could have been articulated by any number of avant-garde artists working in European centers during the teens and twenties, but in the late twenties in America there were very few artists who understood the tenets of modernism and fewer still who actually knew how to translate them into artworks of quality. One of the few, Stuart Davis, wrote in 1927:

In the first place my purpose is to make Realistic pictures. I insist upon this definition in spite of the fact that the type of work I am now doing is generally spoken of as Abstraction. . . . People must be made to realize that in looking at abstractions they are looking at pictures as objective and as realistic in intent as those commonly accepted as such.[1]

It was during the thirties that a sophisticated understanding of formalist principles was achieved by a somewhat wider circle of American artists. This process enjoyed the reinforcement of influential Europeans visiting or working in the United States. In a 1935 lecture at The Museum of Modern Art, subsequently published in the journal *Art Front*, Fernand Léger addressed the subject of "The New Realism." Beginning with the Impressionists, he stated, artists have struggled to rid themselves of the constraints imposed on composition by subject matter. Color and form, according to Léger, have been freed from their traditional representational duties:

. . . color has a reality in itself, a life of its own; that a geometric form has also a reality in itself, independent and plastic.

Hence composed works of art are known as "abstract," with these two values reunited.

They are not "abstract," since they are composed of real values: colors and geometric forms. There is no abstraction.[2]

In another lecture, also well known to abstract artists in New York, Mondrian said in 1941:

. . . it can be stated that all art is more or less realism. Men are conscious of life by the manifestation of reality. Reality is here understood to be the plastic manifestation of forms and not of the events of life.[3]

László Moholy-Nagy, the Bauhaus teacher and artist whose career had an important American phase beginning in the late thirties, wrote that Cubism brought a neutrality to subject matter and that

. . . in constructivism even the neutral object disappeared. The aim was no longer the reproduction of objects in the search for resemblance to life, not the representation of the object, or even of sentiment, but the establishing of relations of volume, material, mass, shape, direction, position and light, symbolizing the meaning of a new reality, based on all-embracing relationships.[4]

While some American abstractionists sought to move beyond the prerequisite of creating works that conformed to the modernist notion of realism, only a few were articulate enough, visually or verbally, to enrich their art with unique meaning. Most notable is Stuart Davis, a painter who sought a new synthesis between European modernist style and the "American Scene" subject matter that was the inspiration for some of the best traditional realist art of the thirties. His invention of a vernacular Cubism was the highest stylistic contribution to the period made by an American and served as a powerful vehicle for carrying ideas and images that were singularly American.

An interesting aspect of abstract art in the United States during the thirties was the extent to which it eschewed the spiritual values associated with Mondrian's European work and with French idealists like Jean Hélion. In fact, both artists, partly because of their experiences in the United States, retreated from quite extreme positions to embrace the materialism of American culture. Of the important American art-world figures, only Hilla Rebay (curator of the Solomon R. Guggenheim Collection and, after 1939, first director of Guggenheim's Museum of Non-objective Painting) was

steadfast in adhering to the idea that abstract art carried profound religious values. In a letter written to Rebay in 1937 in response to her views, seven members of the American Abstract Artists group jointly stated:

We cannot accept with approbation the opinions which Baroness Rebay seems to have that abstract art has "no meaning and represents nothing," that it is the "prophet of spiritual life," something "unearthly": that abstractions are "worlds of their own achieved as their creators turned away from contemplation of earth." The meaning implied in these phrases is that abstract artists preclude from their works, and lives too (for after all, an artist must live some super-worldly experience in order to create super-worldly works of art), worldly realities, and devote themselves to making spiritual squares, and "triangles perhaps, less spiritual," which will exalt a few souls who have managed, or can afford, to put aside materialism.

The writers of the letter to Rebay acknowledged that "any good work of art has its own justification, that it has the effect of bringing joyful ecstasy to a sensitive spectator, that there is such a thing as esthetic emotion, which is a particular emotion, caused by a particular created harmony of lines, colors and forms," but they could not accept Rebay's "sublime non-intellectuality."

It is our very definite belief that abstract art forms are not separated from life, but on the contrary are great realities, manifestations of a search into the world about one's self....
 The modern esthetic has accompanied modern science in a quest for knowledge and recognition of materials in search of a logical combination of art and life.[5]

If there is an identifying characteristic of abstract artists working in America during the period, it is a greater willingness to accept the materialistic implications of modernist art theory.

"ABSTRACT" AND "NONOBJECTIVE"

The logic of modernist reductivism led it toward abstraction and, as abstraction became more extreme, its practitioners utilized an ever more complex vocabulary to explain its nuances. Some of the terms proposed during the period 1927 to 1944 were "abstract," "concrete," "direct," "near," "pure," "absolute," "presentational," "nonobjective," "nonrepresentational," and "nonfigurative," and the ensuing semantic battles were sometimes taken very seriously. A

less subtle and more substantive debate of the American avant-garde, however, centered on differences between those who based their art on observation of the natural world and then abstracted from those perceptions, and those who maintained that true abstract art could not be referential but must be the exclusive product of invented forms. (This essay uses the term "abstraction from nature" for the former—primarily Cubist in its visual manifestations—and "nonobjective" for the latter—which most commonly drew upon the various schools of geometric abstraction.) During the late twenties and early thirties in New York those artists who were both articulate and committed to abstracting from nature—most notably Davis, Arshile Gorky, John Graham, and George L. K. Morris—had a nearly exclusive command of the dialogue on avant-garde ideas. It was not until the late thirties that other voices were effective in pleading the virtues of nonobjective art. By the early forties, however, the nonobjective point of view had come to dominate, and even artists like Davis and Morris were pulled into practicing as well as advocating more extreme forms of abstraction. The difference between Davis' statement in the introduction to the catalogue of the 1935 Whitney Museum of American Art exhibition, "Abstract Painting in America," and his comments on his recently finished painting *Ultramarine* in 1943 is revealing. In 1935 he wrote about the relationship between art and nature:

What is abstract art? ... Art is not and never was a mirror reflection of nature.... Art is an understanding and interpretation of nature in various media. Therefore in our efforts to express our understanding of nature we will always bear in mind the limitations of our medium of expression. Our pictures will be expressions which are parallel to nature and parallel lines never meet. We will never try to copy the uncopiable but will seek to establish a material tangibility in our medium which will be a permanent record of an idea or emotion inspired by nature.[6]

And in 1943 he remarked about purity of form in his art:

So let's be done with all this mid-Victorian nonsense of looking for familiar images and visual effects in painting. Even Picasso is guilty of it and his painting falls short of purity because of his lapses into imitation. From now on the painting must stand on its own legs as pure color-position solidity symbols and textures.[7]

While the differences between artists who abstracted from nature and those who adhered to nonobjective principles provided lively controversy, it was not in general a very original dialogue, having already been debated in Europe. And,

since these discussions took place within the fraternity of abstract modernists—a relatively small and rarefied segment of the American artistic community—they did not address the broader questions that faced painting and sculpture in America during a time of profound political, social, and economic dislocation.

ABSTRACT ART AND SOCIAL UTILITY

It is to their very considerable credit that members of the American avant-garde did choose to grapple seriously with the major issue of the time—the social utility of art, and particularly the difficult question of how to reconcile socialist humanism and modernist aesthetics. This is the core of the most fascinating aspect of the intellectual history of the abstract movement in America in the thirties and early forties.

Meyer Schapiro, the leading art historian-critic of the American left, addressed the first American Artists' Congress in 1936, rebuking the modernists for the personal character of their work and their preoccupation with formal problems. He deplored what he perceived to be the artists' isolation from society, which in his view was reflected in work stripped of all meaning except the aesthetic. Describing the art made by modernists as "private instruments of idle sensation," he equated the function of abstractionists with that of a woman of the leisure class who "constantly rearrang[es] herself as an aesthetic object." He called on artists to recognize their dependence on an unhealthy social order and to develop the courage to take on society's concerns.[8]

The assessment of Alfred H. Barr, Jr., director of The Museum of Modern Art and organizer of the highly influential exhibition "Cubism and Abstract Art," was objective, not political, but he remarked that abstract art "is not yet a kind of art which people like without some study and some sacrifice of prejudice," and he further commented that the loss of subject matter "involves a great impoverishment of painting." Suggesting that "the abstract artist prefers impoverishment to adulteration," he observed that this "suggests a concern with the world of art instead of the world of life and may consequently be taken as a symbol of the modern artist's social maladjustment."[9]

It was in the context of Schapiro's kind of criticism that Davis, in the May 1935 edition of *Art Front*, had urged his fellow artists to enter the "arena of life problems."[10] He was convinced that if modernists could be leaders in aesthetic matters, they could also be in the vanguard for social progress, which he defined in Marxist terms. He was not willing to compromise the formal values in his art. Rather, in his search for greater objectivity in the use of the materials of expression, Davis frequently described the role of the modernist artist pursuing the advance of painting in terms similar to that of a researcher seeking the conquest of nature through science.[11] The positive results of his quest, he believed, would be a reflection of progressive modern technology and a contribution to the knowledge of materialistic reality. This allusion to the scientist's role was common among artists and no doubt relates to the claim of dialectical materialism that it was a social philosophy based on the process of scientific analysis.

George L. K. Morris saw art and social change as independent, but he viewed art, through its achievement of harmonious structure, as pointing the way for society.[12] For John Graham, avant-garde art was a vehicle for demonstrating that change, including progressive social change, was possible and desirable. He wrote that "abstraction as a figure of speech opens the unconscious mind and *allows the truth to emerge*; it opens new vistas of speculation; it teaches that the old habitual moorings can be safely abandoned and new, saner and more general bases sought after."[13] "Abstract painting," he said, "is the most realistic, materialistic, and idealistic in the end."[14] Asking himself, "For whom does the artist create?", he replied:

Artist creates for society. He does not cater down to the public's taste, he does not pacify it with platitudes. He leads humanity by whatever methods of pain to higher levels of knowledge and to heroic deeds. If his efforts are not understood, he does not trade his ideals for success.[15]

Inquiring, "What is the relationship of art to society?", he wrote:

Give the masses good art and do not worry about the masses understanding it. . . . Masses want and desire to be educated up to the highest standards and not catered down to. . . .
. . . art is essentially a social manifestation. Being a subject matter art has no other direct objective except the aesthetic. . . . Ideology plus the aesthetic ingredients produce good art. . . . [16]

In an article published in *Art Front* in 1937, Léger railed against those who believed the masses could not understand the new art, claiming that it was only necessary to give workers leisure time and access since modernist art re-

flected their times and the products they manufactured.[17] Davis, in a similar vein, wrote about the Williamsburg Housing Project murals and Gorky's Newark Airport murals, saying, "A vast education in art is being made available to the American people."[18]

In 1938, Balcomb Greene, lamenting the state of a world in which fascism, totalitarianism, capitalism, and nationalism were such powerful forces, saw abstract art as a way to reach people on a deeper level than that addressed by Social Realism:

It is in this world of shaded pragmatism that the artist must work out his values.... The stimulus of the revolutionist is uniquely his.... For arrogance or for independence one must seek, as at all chaotic moments, in the individual....

... It is actually the artist, and only he, who is equipped for approaching the individual directly. The abstract artist can approach man through the most immediate of aesthetic experiences.... There is nothing in his amorphous and geometric forms, and nothing within his unconscious or within the memory from which he improvises which is deceptive. The experience is under its own auspices. To whatever extent it helps reconstruct the individual by enabling him to relive important experiences in his past—to that extent it prevents any outward retrogression.[19]

To be objective, these statements defending the social utility of abstract art seem tortuous and sometimes precious. While some members of the intelligentsia actively seeking social change may have been sympathetic to modernist art, there is no reason to believe that in America, any more than in the Soviet Union, abstract art with high ideals had a significant impact on the opinion leaders and decision makers of the time, not to mention on a broad popular audience.

The thirties, a decade that demanded a social role of the artist, must have drawn to a close for many with a combination of disappointment and relief. A series of events—the Moscow show trials, the Nazi-Soviet nonaggression pact, the Soviet invasion of Finland, and the increasing intransigence and militancy of those American leftist artists and intellectuals who adhered to Stalinist Marxism—conspired to drive reasonable artists to question the viability of their involvement with social issues. Faith in peace and social progress was shattered, and even Hélion, a spokesman from the left and the most influential European advocate of abstract art with a social conscience in America before Mondrian's arrival in 1940, could be heard to say that abstract art had not contributed anything to social progress.[20] In 1938 he wrote, "The more beautiful the painting, the less convincing does

its subject become rendered for the masses; it is dominated by the plastic activity,"[21] and the same year he admitted that his faith in the working class had failed. In a letter to Meyer Schapiro in 1938, he wrote, "I have positively no more hopes in what the proletariat would do for artists of my kind if it came to power."[22]

Davis, who had so ardently advocated the social role of the American artist in the thirties, stated in 1940, "For great art to exist there must be a great audience, consisting of at least one person,"[23] and he further remarked, "There's nothing like a good solid ivory tower for the production of art."[24]

"OBJECTIVITY" AND "SUBJECTIVITY"

The significant change in attitude evidenced by Hélion's and Davis' statements pervaded the American avant-garde community as artists and critics alike turned their attention from social issues to formal concerns. Those still intellectually bound to leftist social ideals but aesthetically committed to modernist abstraction embraced the more liberal Marxist theories of Leon Trotsky which seemed to encourage formalist art. Influential proponents of these theories were Morris and Clement Greenberg, whose important critical contributions were published in the *Partisan Review*. With the renewed formalist emphasis adding strength to the cause of the nonobjective abstractionists, a significant number of leading artists who had advocated abstraction from nature were pulled, to one degree or another, in the direction of nonobjectivity. Mondrian's arrival in New York in the fall of 1940 both reinforced and contributed additional momentum to this trend. It was his influential presence during the early forties that, in large part, explains why the work of such artists as Davis and Morris, leaders of the tradition of abstraction from nature, evidenced a greater interest in nonobjective principles. Mondrian's example also certainly increased the confidence of nonobjective artists and provided for him a lively circle of American practitioners of Neo-Plasticism.

The post-Cubist, "all-over" formal innovations found in the work of Kandinsky, Miró, and—beginning in the late thirties—Mondrian were assimilated by many of the Cubist and geometric abstractionists and also influenced the development of the young Abstract Expressionists. Surrealism was the ingredient that made the difference between the

"new" abstraction of Gorky, Pollock, and Rothko, among others, and the "old" abstraction. During the thirties a running battle was waged in Paris, pitting the Cubists and geometric abstractionists against the abstract Surrealists, whose innovation and energy prevailed as the decade wore on. In the United States in the late thirties the absence of Surrealism as a serious competing force was a major reason why Cubist and geometric abstraction flourished during that period. Surrealism began to make a significant impact on American abstract art only after André Breton, Matta (Roberto Sebastian Antonio Matta Echaurren), and other Surrealist émigrés arrived in New York in the early forties. The personal, subjective approach to content that the Abstract Expressionists took from Surrealism was in marked contrast to the objective point of view of the Cubist and geometric abstractionists (the word "nonobjective" notwithstanding) who were seeking in their art a higher reality, whether it be the universal of Mondrian or the more particular of Davis.

Beginning in the thirties, a central problem facing the American avant-garde was how to marry abstract form with meaningful content. In a decade characterized by political activism, artists had sought to infuse their formal researches with social meaning, but although they addressed this challenge with determination and high intentions, they cannot, in general, be said to have fulfilled their ambition. If aesthetic strength depends on both formal innovation and meaningful content, then it may be observed that the "old" objective abstractionists did not bring to their exploration of the possibilities of a post-Cubist "all-over" style a content that was sympathetic to and reflective of the radically altered state of the world and the mind of the forties. These artists were surprised and dismayed (and eventually some were disillusioned and embittered) when the Abstract Expressionists, with their subjective approach to art, ascended to leadership of the international avant-garde—an achievement grounded in their thoroughly successful integration of form and content. While it is certainly understandable that the "old" abstractionists would have felt entitled to recognition in a new decade more sympathetic to abstract formalism, it is suggestive of the level of sophistication in the narrow world of the New York avant-garde that distinctions were made early on between the true innovations of the emerging Abstract Expressionists and the European-derived styles and theories of the "old" abstractionists. What seems in retrospect genuinely ungenerous is that the "old" abstractionists were never properly recognized for having kept vital the tradition of twentieth-century modernist painting and sculpture in America during an era that was overwhelmingly antimodernist in its bias, an accomplishment of distinction by any measure.

[1] Stuart Davis to Edith Halpert, 11 August 1927, Edith Halpert Papers, Archives of American Art, Smithsonian Institution, Washington.

[2] Fernand Léger, "The New Realism," *Art Front* (December 1935), pp. 10–11, translated by Harold Rosenberg; reprinted in Fernand Léger, *The Functions of Painting* (New York: Viking Press, 1973), pp. 109–13.

[3] Piet Mondrian, "A New Realism," *American Abstract Artists Annual 1946*; reprinted in *American Abstract Artists, Three Yearbooks (1938, 1939, 1946)* (New York: Arno Press, 1969), pp. 225–35. The article is dated April 1943, but it was based on the lecture given by Mondrian in 1941 at the Nierendorf Gallery for the American Abstract Artists group.

[4] László Moholy-Nagy, *The New Vision*, 1928; fourth revised edition (New York: George Wittenborn, 1947), p. 52.

[5] Quoted in Rosalind Bengelsdorf Browne, "American Abstract Artists and the WPA Federal Art Project," Francis V. O'Connor, ed., *The New Deal Art Projects: An Anthology of Memoirs* (Washington: Smithsonian Institution Press, 1972), pp. 230–32. The letter was signed by Hananiah Harari, Jan Matulka, Herzl Emanuel, Byron Browne, Rosalind Bengelsdorf Browne, Leo Lances, and George McNeil.

[6] Stuart Davis, "Introduction," *Abstract Painting in America* (New York: Whitney Museum of American Art, 1935).

[7] Stuart Davis Papers, Fogg Art Museum, Harvard University, Cambridge, Massachusetts, Index, 31 Dec 42a.

[8] Meyer Schapiro, "The Social Bases of Art," *First American Artists' Congress* (New York: 1936), pp. 31–37; reprinted in David Schapiro, ed., *Social Realism: Art as a Weapon* (New York: Ungar, 1983).

[9] Alfred H. Barr, Jr., *Cubism and Abstract Art* (New York: Museum of Modern Art, 1936), pp. 13, 15.

[10] Stuart Davis, "A Medium of Two Dimensions," *Art Front* (May 1935), p. 6.

[11] Stuart Davis Papers, Fogg Art Museum, Harvard University, Cambridge, Massachusetts, Index, 21 Jul 37a.

[12] Melinda A. Lorenz, *George L. K. Morris, Artist and Critic* (Ann Arbor: UMI Research Press, 1982), p. 44.

[13] John Graham, *System and Dialectics of Art* (Paris and New York: 1937); reprinted as *John D. Graham's System and Dialectics of Art*, with introduction by Marcia Epstein Allentuck (Baltimore: Johns Hopkins Press, 1971), pp. 94–95.

[14] Ibid., p. 106.

[15] Ibid., p. 97.

[16] Ibid., pp. 137–38.

[17] Fernand Léger, "The New Realism Goes On," *Art Front*, translated by Samuel Putman (February 1937); reprinted in Fernand Léger, *The Functions of Painting* (New York: Viking Press, 1973), pp. 115–16.

[18] Stuart Davis, "Federal Art Project and the Social Education of the Artist (ca. 1938)," printed in Diane Kelder, ed., *Stuart Davis: A Documentary Monograph* (New York: Praeger, 1971), p. 165.

[19] Balcomb Greene, "Expression as Production," *American Abstract Artists Annual 1938*; reprinted in *American Abstract Artists, Three Yearbooks (1938, 1939, 1946)*, pp. 30–31.

[20] Merle Solway Schipper, "Jean Hélion: The Abstract Years, 1929–1939," Ph.D. dissertation, University of California, Los Angeles, 1974, pp. 123–24.

[21] Jean Hélion, "The Abstract Artist in Society," reply to a questionnaire by George L. K. Morris in "Art Chronicle," *Partisan Review* (April 1938), pp. 33–39, quoted in Schipper, p. 139.

[22] Jean Hélion to Meyer Schapiro, 22 November 1938, quoted in Schipper, p. 138.

[23] Stuart Davis Papers, Fogg Art Museum, Harvard University, Cambridge, Massachusetts, Index, 27 May 40.

[24] Ibid., 2 Jun 40.

THE QUEST FOR AN AMERICAN ABSTRACT TRADITION, 1927–1944

by Susan C. Larsen

The history of abstract painting and sculpture in America follows a complex and variable course from its beginnings at the turn of the twentieth century through the Armory Show and the exploratory years of the thirties to the end of World War II. Its fortunes are linked to European modernism: this period in American art is characterized by a restless spirit of exploration and analysis and a desire to learn from the abstract art of Europe but to consider it as a basic language capable of expressing the content and style of modern,American life.

Opportunities to study European modernism were affected by two world wars, economic uncertainties, and the growth of public and private collections in the United States. Other factors such as European immigration to the United States and the efforts of a few visionary American artists, dealers, collectors, and curators sustained an awareness of European art throughout the early twentieth century, encouraging re-newed consideration by several generations rather than the pursuit of a narrower, entirely American evolution out of the first developments in abstract art in the United States just after 1910.

Early exhibitions at Alfred Stieglitz' Gallery 291, founded in 1905 in New York, had introduced a small circle of Ameri-can artists and a limited audience to a wide range of mod-ern European art during the first decade of the century. The historic Armory Show of 1913 further dramatized the vast differences between the expressionistic urban-scene paint-ing of the Ashcan School and radical new movements in Europe, principally Fauvism, Cubism, and abstract and figu-rative expressionism. During the teens of the century, there came to maturity a generation of American artists, including Charles Demuth, Stanton MacDonald-Wright, John Marin, Georgia O'Keeffe, Charles Sheeler, Joseph Stella, and Max Weber, who embraced the fragmentation of Cubism, the biomorphic forms of expressionist abstraction, abstract color theory, or even the playful anarchies of Dada, only to enter a period of re-evaluation and retrenchment during the twenties. One by one, for personal reasons and while pro-ducing works of great beauty and quality, they returned to the solid meanings and pleasures of concrete imagery and to the enduring historic themes of American art: landscape, tangible objects, and a romantic identification with nature.

American involvement with the European avant-garde in the early twentieth century tended to be episodic, with peri-ods of intense interest followed by years of reconsideration and consolidation. Thus the artists of the Stieglitz circle, so deeply touched by the dynamic of Cubism during the teens,

endeavored to bring it home in the twenties, to reconcile it with the native tendency toward realism and with their own emphasis upon individual perceptions and experiences. Out of this effort evolved the Cubist-realist style called Precision-ism, closely related to the advent of art photography, which forged even closer links between the specific, the tangible, and the abstract.

In 1921, in his "Dissertation on Modern Painting," Marsden Hartley expressed the desire "...to arrive at a species of purism native to ourselves in our own concentrated period, to produce the newness or the 'nowness' of individual experience."[1] This statement is characteristic of Hartley and his generation in its emphasis upon a native expression rooted in time and place and its belief in the absolute value of direct observation and experience. Thus the twenties bore witness to Sheeler's devotion to the imagery of rural Pennsylvania and his classically rendered vision of an urban New York, Marin's evocative marine scenes of Maine and New Hamp-shire, and O'Keeffe's dramatic, compressed images of the American Southwest. By the mid-twenties, the art of Thomas Hart Benton, John Steuart Curry, Reginald Marsh, Raphael Soyer, and Grant Wood proposed a naturalistic style that would depict the "American Scene."

American artists of the twenties evidenced little desire to pursue to their ultimate conclusion the theoretical and stylis-tic implications of early modernist concepts, nor to address themselves to the purely structural elements of Cubist form in order to push these toward a true nonobjective art. In Europe, however, such developments and experiments were taking place during that period, as Piet Mondrian's Neo-Plasticism evolved in Holland and was further developed in Paris, and the later phases of Suprematism and Constructiv-ism matured in Russia before also being transported to Paris. Wassily Kandinsky and Paul Klee taught at the Bauhaus in Germany, and the second generation of Cubist painters, sculptors, and architects in France, including Fernand Léger, Jean Hélion, and Charles Jeanneret (Le Corbusier), strug-gled to place modernism at the center of a newly industrial-ized society. Also, by 1924, the Surrealists in Paris were launching a new chapter in the life of modern painting and poetry, one that would have a profound impact on the next generation of Americans.

During the twenties Paris once more assumed its tradi-tional role as a haven for the international avant-garde. The founders of Cubism, Pablo Picasso and Georges Braque, were of course in residence, as were Léger, Jean Arp, Constantin Brancusi, the important Dutch founders of De Stijl,

Mondrian and Georges Vantongerloo, and their countryman, César Niewenhuis-Domela. Constructivists Antoine Pevsner and Ivan Puni fled the deteriorating avant-garde in Russia and arrived in Paris in 1923. Naum Gabo was also frequently seen in Paris during this decade. Patrick Henry Bruce, an American who had been living in Paris off and on since 1903, considered himself part of the international community of artists in residence.

As this polyglot community of abstract painters and sculptors sustained themselves in the French capital between two world wars, they brought together numerous theoretical and stylistic points of view. Artists who—separated by language and geography—had founded and participated in the important movements of the early twentieth century now came to know one another as individuals. Pursuing their own work, they nonetheless began to acknowledge common ideals and principles, which led them to seek one another out and form long-lasting friendships. Thus was born the spirit of an international avant-garde, uniting artists pursuing a variety of styles but all committed to the future of nonobjective art and to furthering public acceptance of their work and its place in society.

Cahiers d'Art began publication in Paris in 1926 and soon became the international journal that effected a broader sharing of ideas and images. While focusing primarily on the international community in Paris, the journal was widely read in Europe and in the United States by artists concerned with the art of their own time. In 1929 a group of abstract and nonobjective artists working in Paris formed the important but short-lived alliance, Cercle et Carré, to affirm their common interests and to introduce their art to a Parisian audience. The group held one exhibition in 1930 and published several issues of a magazine of the same name.

Cercle et Carré lasted only one year, but was immediately followed in 1931 by the similar but much larger organization, Abstraction-Création Non-Figuratif (commonly referred to as Abstraction-Création). This alliance lasted five years, until 1936, attracting a vast membership of some four hundred abstract artists, many of whom lived outside of Paris, in other parts of Europe, in England, and in the United States. These international members frequently took part in the organization's annual exhibitions and kept in touch through its highly successful publication, *Abstraction-Création Non-Figuratif*. Within its pages, the Cubism of Jacques Villon and Albert Gleizes collided with the animated style of Hélion and the artistic and social theories of Léger. Mondrian's Neo-Plasticism emerged as a potent, uncompromising vision, highly

admired and emulated in varying degrees by artists working abroad, including England's Marlow Moss and Ben Nicholson and America's Charles Biederman, Burgoyne Diller, and Harry Holtzman. Abstraction-Création became a forum in which the complex evolution of abstract art in Europe could be clearly seen. The individuals who had gathered in Paris during the twenties represented various points of view, but slowly their diverse styles contributed to a broader conception of abstract art, much of which was described in the press and elsewhere as geometric, rational, the plastic expression of a new state of order in society at large.

Even while the work of well-known American artists of the twenties indicated a return to representational imagery and to American themes, many younger Americans were attracted to the multifaceted international community of modern artists in the French capital. One of the first of his generation to embark for Paris was Jan Matulka, who made his initial trip during the winter of 1919–20 and throughout the twenties divided his time between Paris and New York. Some of the younger American artists were attracted to Hans Hofmann's school in Munich, which was gaining an international reputation. Among the first foreign students to enroll, from 1922 to 1926, was the American-born Vaclav Vytlacil. There he met his countryman Carl Holty, who arrived in 1926 and later moved to Paris, where he became an active member of Abstraction-Création.

The early Parisian years of Alexander Calder from 1926 to 1933 were extremely important for his development, even as his innovative exhibitions there helped him to gain an international reputation. As a member of Abstraction-Création and a popular young man, he had access to the studios of many well-known artists and was exposed to numerous points of view. Calder drew from a wide range of sources: the biomorphic forms of Arp and Joan Miró, the structural geometry and primary color of Mondrian, and the machine imagery of the Constructivists. It was precisely this incredible range of ideas and personalities that encouraged younger artists like Calder to create a rich and complex synthesis of modernist form and imagery.

Other Americans spent shorter periods of time in Paris. Sculptor Theodore Roszak stayed several months in 1929 before traveling eastward to Czechoslovakia and Germany, where he learned about Constructivism and the artistic and industrial theories of the Bauhaus. Isamu Noguchi went to Paris on a Guggenheim Fellowship in 1927 and worked as a studio assistant to Brancusi. Noguchi met Calder and also Stuart Davis, whose 1928–29 stay deepened his understand-

ing of Cubism and later phases of abstract art. However, Davis rejected, at least for himself, the possibilities of a totally nonobjective art in favor of an art that would embrace the forms and events of the natural world.

Many Americans living in Paris were especially attracted to the art of Hélion, a young Frenchman who began his career as an abstract painter in the late twenties and was deeply affected by the nonobjective art and theory of Theo van Doesburg, one of the Dutch founders of De Stijl. Hélion's command of the English language put him in touch with the community of American artists, as did his role as first editor of the journal *Abstraction-Création Non-Figuratif*. Hélion's style broadened in the early thirties as the art of Arp, Léger, and Mondrian persuaded him to loosen his tightly bound shapes of the twenties and to deal with the overall dimensions of his canvases, spreading out his subtly rounded images in open space. Among the Americans in Hélion's circle was John Ferren, whose ten-year residence in Paris began in 1929. Ferren's curved and mobile forms glowing with vivid light and color bear a strong formal resemblance to Hélion's sharply curved planes, although they reject the French artist's structural armature in favor of a new dynamic thrust and a radiant, atmospheric space.

The social and artistic circle of Ferren and Hélion intersected that of the wealthy New Yorkers A. E. Gallatin and George L. K. Morris. As both collector and artist, Gallatin was a familiar figure in Paris during the twenties, and he assembled a substantial and important personal collection purchased for the most part directly from the artists during his regular visits to their studios. He enjoyed long-standing relationships with Picasso, Braque, Léger, Brancusi, Mondrian, and especially Hélion, who served as adviser to Gallatin for several years during the early thirties.

Morris, who first knew Gallatin as an older friend of the family, was introduced by him to the studios of Arp, Brancusi, Picasso, and others. Morris was particularly impressed by the art of Léger and elected to study with him and Amédée Ozenfant at the Académie Moderne during the spring sessions of 1929 and 1930.

Thus a deep and continuous dialogue had opened between the European avant-garde, centered primarily in Paris, and the generation of American artists born between 1900 and 1910. Too young to have seen the Armory Show, they were not, by and large, persuaded by American versions of Cubist form and were eager to seek out the artistic and social milieu of their contemporaries in Europe. In doing so, they also came into direct contact with the first generation of Eu-

ropean modernists headquartered in Paris, forming ties of friendship with Hofmann, Léger, Mondrian, and László Moholy-Nagy, all of whom would ultimately seek refuge in the United States. Most of these young American artists returned to New York during the early thirties, bringing with them the vision of an international community that would transform the city into the next important center for the avant-garde.

Even while Americans were studying abroad, immigration figured prominently in the growth of the artistic community in New York during the twenties. Among the young immigrants of exceptional ability were Arshile Gorky, John Graham, Ibram Lassaw, Ilya Bolotowsky, Paul Kelpe, Willem de Kooning, and Esphyr Slobodkina. Still in their formative years as artists, they would become assimilated with others of their own generation in America.

Also significant were the growing collections of modern art, which provided day-to-day contact with major twentieth-century works and offered a ground of shared experience for painters and sculptors in New York. The Société Anonyme: Museum of Modern Art, founded in 1920 under the leadership of Katherine Dreier and Marcel Duchamp, played a crucial role in the cultural life of New York during the twenties and early thirties. The Société Anonyme was a lively organization that presented exhibitions, radio programs, and public lectures. During its early years one lecture series featured Marsden Hartley, Joseph Stella, Walter Pach, and Louis Lozowick, and there was a notorious evening in 1921 with Gertrude Stein.

The Société Anonyme's programs encompassed a broad range of modern art with an orthodox but basically ecumenical spirit—a splendid irony in view of the fact that its first exhibition committee of 1920, composed of chief sponsor Dreier, Duchamp, Man Ray, and Joseph Stella, included some of the world's major practitioners of Dada. As Dreier observed in her foreword to the catalogue of the collection, "... the Société Anonyme started and has continued its educational approach without the interference of personal taste, which is the basis of most collections."[2] It was certainly true that the international avant-garde was exhibited almost in its entirety by the Société Anonyme. Its evenhanded program and scholarly catalogues recall Duchamp's often-stated belief that art is not a matter of good or bad taste but a matter of ideas, the encounter between man's creativity and the world as it exists or may exist in the imagination.

Central to the life of the Société Anonyme was its educational mission. According to Dreier, "... we always tried to

discover the pioneers so that their work would stimulate the imaginative and inventive attitude in America."[3] Its programs were directed toward the growing American audience for modern art, not merely to document the achievements of European modernism but to insure the future of contemporary art and artists in the United States. The organization's motto, borrowed from Franz Marc, summarized its thrust and spirit: "Traditions are beautiful—but to create them—not to follow."[4]

Within its exhibition rooms at 19 East Forty-seventh Street in New York, the Société Anonyme operated more like a gallery than a museum, changing its entire installation several times a year. During its early years the organization presented major exhibitions of Cubism, Futurism, Dada, Precisionism, German Expressionism, Surrealism, the art of Picasso, Brancusi, Kandinsky, Tatlin, Mondrian, and many others. Particularly strong were the selections of abstract art from France, Germany, Holland, and Russia. Dreier was responsible for most of the major purchases, but artists from all over the world donated works, and in its early years the Société frequently borrowed from the fine modern collections of John Quinn and Arthur B. Davies.

Among the Société Anonyme's major events was the "International Exhibition of Modern Art" held at The Brooklyn Museum from November 10, 1926, to January 1, 1927. As its title suggests, the exhibition surveyed the worldwide panorama of modern art, country by country, beginning with Cubism in Paris, introducing developments in Germany, including the work of Kandinsky, Marc, and Gabriele Münter, then going on to survey Eastern Europe, including Russia, Czechoslovakia, and Hungary. The two mature Neo-Plastic paintings shown in this exhibition marked the debut of Mondrian's work in America. Kazimir Malevich's Suprematism, as well as Constructivist works by Lissitzky, Gabo, and Pevsner, were also represented, as were influential works by Arp, Brancusi, Miró, Moholy-Nagy, and Max Ernst.[5]

In contrast to the broadly based exhibition program of the Société Anonyme was the highly focused, quite personal collection of A. E. Gallatin, which he christened the Gallery of Living Art (renamed the Museum of Living Art after 1933). When Gallatin opened the doors of his gallery at New York University on December 12, 1927, he offered a small but carefully constructed survey of European and American modernism, assembled to reflect chronological and stylistic relationships between major artists and movements of the early twentieth century. Gallatin's historical construct, which considered abstraction as the central impulse in modernism,

had an impact upon those who frequented the South Study Hall of the university overlooking Washington Square, where the collection was installed. As early as 1933, the Gallery of Living Art offered a virtually complete and well-documented survey of Cubism, as well as excellent works by Arp, Hélion, Klee, Miró, and Mondrian. Visitors were able to trace the evolution of modern European art from Cézanne through Cubism to the De Stijl group, Constructivism, and the latest phases of nonobjective art.

The informal atmosphere of the Gallery of Living Art, and its proximity to the studios of young painters and sculptors, made it a popular meeting place in Greenwich Village during the thirties. Gallatin insisted that the study room remain open at least until nine o'clock in the evening, frequently until ten, for the convenience of working people and students. Many artists described it as the "neighborhood museum," and others acknowledged its impact upon their early development.

Gallatin was forty-six years old when he opened the Gallery of Living Art, quite a bit older than the artists who frequented his museum. His was a rich offering at a time when many New York artists were eager to study the work of the School of Paris. As up-to-date as the latest issue of *Cahiers d'Art*, the Gallery of Living Art exhibited the work of European modernists acquired by Gallatin on his annual trips to Paris. Among the major works entering the collection during the late twenties and thirties were Miró's *Dog Barking at the Moon* (1926), acquired in 1929; Picasso's *Three Musicians* (1921), acquired in 1936; and Léger's *La ville* (The City; 1919), acquired in 1937. During the thirties Gallatin purchased four works by Mondrian; the first, in 1933, was the Dutch master's *Composition with Blue and Yellow*, painted the previous year. Perhaps most important of all was the stability of the Gallery of Living Art. Throughout the important years of the thirties, well-known and favorite works were available to be seen again and again, shared and studied like the well-thumbed volumes of a local library.

The Gallery of Living Art was so much a part of the life of Greenwich Village from 1927 to 1943 that it is impossible to list the names of all the artists who visited it regularly, but it is known to have had an impact upon the early development of Charles Biederman, Ilya Bolotowsky, Byron Browne, Burgoyne Diller, Arshile Gorky, John Graham, Balcomb Greene, Gertrude Greene, Philip Guston, Carl Holty, Harry Holtzman, Alice Mason, George L. K. Morris, Ad Reinhardt, Charles Shaw, and David Smith. Hans Hofmann took classes to the Gallery of Living Art to see individual works. Willem de

Kooning recalled, "I went so many times. I remember a Mondrian, and also the French artist Hélion. When I met Gorky he used to go there often. It was so easy to walk in and walk out again, no charge, it was so nice."[6]

As both artist and collector, Gallatin played an active role in the community of painters and sculptors in Paris as well as in New York. He was especially close to Hélion, whose work provided a persuasive bridge from Cubism to the nonobjective art of the second quarter of the century. Gallatin and Hélion often made the rounds of the Paris studios together. In the early thirties they became, in effect, collaborators, as Hélion's advice guided many of the later purchases of the Gallery of Living Art. The French artist wrote a provocative preface to Gallatin's revised handbook and catalogue of the collection as of 1933 in an effort to respond to some of the critics and the public who had been baffled by such acquisitions as Miró's *Dog Barking at the Moon* and Mondrian's *Composition with Blue and Yellow*. Hélion addressed his readers in an adamant tone, pointing out the difference between seriousness and entertainment value in art. "From the public's side, it has often been said that a recognizable subject is indispensable to establish contact between the artist and the spectator. If it were true, the crowd at the museums where all the works are figurative would stop in front of the good pictures instead of stagnating, as it does in front of the mediocre. The image of nature helps the public very little. . . ."[7]

Even while American artists abroad were forging relationships between themselves and two generations of European modernists, public and critical attention was focused upon the return of realism and literary and social themes in art —factors that contributed to the rise of the school of American art known as Regionalism. The Société Anonyme and the Gallery of Living Art were based upon the premise of continuity between early twentieth-century European modernism and the future of abstract art in the United States. Dreier and Gallatin, the founders and primary financial supporters of these institutions, were themselves painters and collectors whose sympathies were focused on the future. They did not view their efforts as static or fixed in time, but as an ongoing process whose outcome could be substantially affected by their activities.

In 1929, almost ten years after the debut of the Société Anonyme and just two years after the opening of the Gallery of Living Art, several prominent collectors created the first major institution of its kind in the United States, New York's Museum of Modern Art. The museum's first home was on the upper floors of a Manhattan residence owned by Abby Aldrich Rockefeller at 10 West Fifty-fourth Street. Mrs. Rockefeller's personal collection, together with that of Lillie B. Bliss, formed the nucleus of the museum's impressive holdings. The Museum of Modern Art's policy, under its first director, Alfred H. Barr, Jr., was to create a comprehensive survey of the significant modern European movements by means of an ambitious program of exhibitions and acquisitions. With a serious emphasis on scholarship and a superb collection that grew rapidly during its early years of existence, the museum offered a historical overview of early twentieth-century movements which significantly affected the direction of art, of collecting, and of art-historical studies in the United States. Barr's carefully documented, chronological, movement-by-movement installation of the permanent collection served as a living text for generations of Americans who knew the collection better than that of any other museum. The Vincent van Gogh retrospective staged in 1935 occasioned public interest and controversy, doing much to promote a greater awareness of late nineteenth-century European art and to stimulate a greater appreciation of twentieth-century painting and sculpture.

In early 1936 the museum's "Cubism and Abstract Art" exhibition presented the abstract art of the early twentieth century as the continuous development of several major themes. Barr traced the step-by-step structural evolution of Cubism in Paris, noting the connections between Cubist form and the highly innovative art of the Russian Suprematists and Constructivists, as well as Mondrian's disciplined Neo-Plasticism. As indicated by Barr's title for the exhibition, the central focus of his inquiry was Cubism, which he presented as the generative movement from which much of the abstract art of the twentieth century had evolved. However, this massive survey exhibition also documented the work of Kandinsky and the expressionist art of Germany and noted the presence of abstract form in much Surrealist art, particularly that of Alberto Giacometti, André Masson, and Miró.

Barr's catalogue—the most lucid, historically accurate, and comprehensive of its day—continued to influence American artists, collectors, and scholars long after the exhibition itself had closed. Artists in New York welcomed "Cubism and Abstract Art," even though contemporary American abstract painters and sculptors were not included in Barr's summary of current developments—with the exception of Alexander Calder, whose recent work was presented alongside that of European artists. The exhibition, in fact, seemed to indicate that The Museum of Modern Art and its director—unlike Dreier and Gallatin—did not look toward a continuing evolution of

nonobjective art in America coming out of early twentieth-century developments in Europe. Instead, the policies of the museum supported a view held by many at the time that the strong realist bias in American culture had once again come to the fore, as expressed in Precisionist art of the twenties and Regionalist art of the thirties. Thus the path of contemporary American art would be separate and unique, one that would not coincide with those developments taking place in Paris during the late twenties and thirties. The role of The Museum of Modern Art as the most authoritative and prestigious institution of its type in the United States would become a problematic one with regard to the work of American abstractionists of the thirties. The museum, its collections and exhibitions, and the international focus of its programs were held in high esteem by younger American artists, who, perhaps incorrectly, assumed that it would be supportive of Americans who considered themselves part of the international community of abstract artists. This was especially true of those who had been members of Abstraction-Création in Paris. However, their overtures were politely turned aside, and the museum frequently exhibited recent European modernist art alongside that of the American Regionalists of the thirties.

The Whitney Museum of American Art was a pioneering institution founded in 1930 by Gertrude Vanderbilt Whitney, herself a sculptor who had maintained a studio in Greenwich Village since 1907. An early supporter of the work of Robert Henri, George Luks, John Sloan, and other artists who exhibited as The Eight at the Macbeth Gallery in 1908, Mrs. Whitney held informal exhibitions in her own studio and supported the antiacademic community of American artists by acquiring important examples of their work throughout the early years of the century. Her private program of philanthropy expanded to become the Whitney Studio Club, founded in 1918, which sponsored exhibitions of work by promising young artists, including Edward Hopper, Charles Sheeler, Andrew Dasburg, Oscar Bluemner, Reginald Marsh, John Steuart Curry, and Stuart Davis. During the twenties the Whitney Studio Club also served a social function, offering financial support, emergency funds, and a meeting place for artists working downtown.

By 1930, it was virtually inevitable that these related but separate endeavors would be brought together under the aegis of one institution. A building at 12 West Eighth Street was remodeled to house Mrs. Whitney's ever-expanding collection of more than five hundred works of art, and in November 1931 The Whitney Museum of American Art opened its doors to the public.

Defining itself as a museum of American art, the Whitney Collection offered a substantially different view of twentieth-century developments than did the Société Anonyme, the Gallery of Living Art, or The Museum of Modern Art. Mrs. Whitney had been one of the financial benefactors of the Armory Show in 1913 and had also supported the Society of Independent Artists, which held exhibitions in New York during the late teens. However, her museum's collection, dedicated to the growth and development of American art, focused upon modernism only insofar as it appeared in the work of twentieth-century American painters and sculptors such as Bruce, Hartley, MacDonald-Wright, Russell, Sheeler, and Weber. By the late twenties, however, it seemed to many that the impact of the Armory Show and modernist movements such as Synchromy, American variants of Cubism, and even Precisionism were giving way to a reawakening of realism and a desire to record the geographical and social diversity of American life.

Focusing upon the work of The Eight (several of its members were also known as the Ashcan School), the Whitney Collection documented the expressionist realism of Henri, Sloan, and their generation, who portrayed an energetic, diverse American population, its characteristic moods, ethnic origins, and the imprint of modern society upon individual experience. Thus a continuity was suggested from The Eight throughout the twenties to the work of Charles Burchfield, Hopper, and Marsh, on into the emerging school of Regionalism, as exemplified by the art of Benton, Curry, and Wood, which was fast becoming a dominant influence in American art of the thirties.

In 1935 the Whitney Museum presented "Abstract Painting in America," a comprehensive exhibition of 134 works. Its purpose was to trace the evolution of abstract form in American painting from the Armory Show to the mid-thirties, with special emphasis on major figures such as Davis, Demuth, Dove, Marin, Maurer, O'Keeffe, Sheeler, Stella, and Weber. Although several younger American artists were included—and pleased to show their work—they considered much of the painting in the exhibition to be merely stylized, not truly abstract. They did not acknowledge any strong American influence in their own development, which they believed was based on the European modernist art they had seen in New York and on their trips abroad.[8] Although the exhibition did affirm the existence of abstract art in America, like The Museum of Modern Art's "Cubism and Abstract Art," the Whitney show was something of a summary despite the inclusion of younger artists such as Byron Browne, Werner Drewes, Arshile Gorky, John Graham,

Balcomb Greene, Jan Matulka, Irene Rice Pereira, Theodore Roszak, and Louis Schanker.

Stuart Davis, the most respected and prominent abstract painter of his generation, wrote the catalogue introduction to "Abstract Painting in America." Discussing the period covered by the exhibition, he observed, "The American artists who from various angles have orientated themselves about the abstract idea have not in all cases been as wholeheartedly scientific as the above considerations would seem to call for." Then, remarkably, Davis concluded, "The period of greatest activity in abstract art in America was probably about 1915 to 1927."[9] It is difficult to comprehend how Davis, who in 1927 was in the midst of his historic "Eggbeater" series, could have made such a statement from the viewpoint of 1935. However, on all sides could be heard the call for a return to realism, to social relevance, to an art that would survey and record the "American Scene." This impulse ran headlong into the internationalism set forth by Dreier, Gallatin, and Barr and stood in direct contrast to the art of many young Americans who sought to extend the modernist idiom, modeling their careers after their contemporaries in Europe.

By the early thirties, the stage was set for a conflict in ideology and style, as American art moved in at least two directions at once: a highly visible return to realism and the "American Scene," paralleled by the advent of a new generation of abstract artists whose outlook was international. During the early thirties these opposing views caused heated controversy at the Art Students League in New York. In 1928 Vaclav Vytlacil, newly returned from Hofmann's school in Munich, found a teaching position at the League. Bringing with him his own, but essentially faithful, version of the Hofmann curriculum, Vytlacil pointed out the abstract structure in the art of Cézanne and introduced his students to the rigors of Cubism. He soon heard objections from fellow faculty members Kenneth Hayes Miller and Reginald Marsh, who accused him of misleading the students. Back in 1920–21, the American Cubist Max Weber had unsuccessfully introduced similar ideas at the League, ideas that virtually languished until the arrival of Vytlacil and Matulka. Also on the faculty from 1926 to 1935 was the popular and vigorous teacher Thomas Hart Benton, who had worked his way through modernism to become the most successful exponent of Regionalism. Among Benton's closest associates was his young studio monitor, Jackson Pollock.

The controversial appointment of Hofmann in the autumn of 1932 was suggested by his former students such as Vytlacil and by others such as Byron Browne who knew of him by reputation. Hofmann's appointment took place over the ob-

jections of Benton, Miller, and Sloan, but he proved to be a superb teacher who was supportive of a group of students, including Burgoyne Diller, Harry Holtzman, Albert Swinden, and Albert Wilkinson. The rudiments of abstract form were learned in Matulka's classroom by another group of young Americans, including Dorothy Dehner, George McNeil, Irene Rice Pereira, David Smith, and Diller. During the early thirties the Art Students League was a virtual art world in microcosm, where the strongest practitioners and theorists of abstract art and "American Scene" realism engaged in a spirited confrontation that introduced their students to the broader world they were soon to enter.

Following the stock market crash of 1929, and the even more terrible years of the early thirties, America's cultural and economic life experienced a great turning inward. Searching for the stability that might support a broader recovery of society, American art and literature paid increasing attention to the great cultural myths that helped form the national character in the eighteenth and nineteenth centuries—the work ethic, the existence of an agrarian heartland, the ideal of rugged individualism, and the democratic vision of an open, egalitarian society predicated upon equality of opportunity. Regionalism and the art of the "American Scene" actually began in the mid-twenties, before the advent of the Great Depression, but this return to "domestic naturalism," as Davis called it, uniquely served the needs of the American public in the thirties and became the dominant, most popular style.

The most vocal exponent of Regionalist art, critic Thomas Craven, expressed this isolationist vision of America in 1934: "In the present economic crisis, America, more conspicuously than ever before stands out as a separate part of the world."[10] Standing apart from a world in turmoil, the nation was experiencing one of the most difficult tests of the democratic ideal. Many urged the American artist to become a healer of society's wounds, to forsake his ivory tower and speak plainly to a public in need of heroic images and optimistic visions. In Craven's words, ". . . it is the artist's business to see the world clearly and to allow no convention of ideology or technique to obscure his vision or stand in the way of representational truth."[11]

In this atmosphere of competing ideologies and economic crisis, the various New Deal federal art projects initiated by the administration of President Franklin D. Roosevelt were the great support and social leveler for American artists in the thirties. These programs brought together people who might not otherwise have known one another and contributed to the sharpening and articulation of major social and aesthetic issues of the time. The initial program was the Pub-

lic Works of Art Project (PWAP), which was active from December 1933 to April 1934. Then the Department of the Treasury established the Treasury Section of Painting and Sculpture in October 1934, which was followed by the largest and most important public-assistance art program, the Federal Art Project of the Works Progress Administration (WPA), officially in existence from August 1935 to January 1943, but most active from 1935 to 1939.

The history of the WPA Federal Art Project—which offered employment to visual artists, musicians, writers, and playwrights—is an important and fascinating one, already well documented and extensively studied in recent years.[12] What mattered most in the lives of individual artists was that the project succeeded admirably in fulfilling several major aspects of its mission during the thirties. It provided employment, sustenance, and a measure of dignity within a culture based upon the work ethic. Careers that might otherwise have been lost were kept alive during the Depression, and the role of the artist gained a measure of respectability as artists joined workers from other walks of life while earning the "plumber's wages" that artist George Biddle had originally mentioned when he first proposed the project to President Roosevelt.

Administrators of the WPA Federal Art Project sought to effect a rapprochement between the artist and society, and the program was launched at a time when many artists were turning away from abstraction and other forms of modernism in order to cultivate a vigorous naturalism based on subjects and themes taken from their immediate environments. Thus as artists sought to render the great geographic and cultural diversity of America in murals, sculpture, and easel paintings, the Regionalist outlook came to dominate the program. Holger Cahill, national director of the Federal Art Project, could say in 1939: "It brought the artist closer to the interests of a public which needs him, and which is now learning to understand him. And it has made the artist more responsive to the inspiration of the country, and through this the artist is bringing every aspect of American life into the currency of art."[13] Quoting the philosopher John Dewey, whose book *Art as Experience* was published in 1934, Cahill viewed the artist as an active agent in the renewal of society: "The direct response of the artist to his environment is a thing to be encouraged, it seems to me, for it is the artist, as John Dewey says, who keeps alive our ability to experience the common world in its fullness."[14]

Participation in the project put young artists into the thick of things with astonishing rapidity. As workers within a mammoth bureaucracy, they had to find a common voice with which to address administrators and the American public. The collective spirit, so intimately linked to the radical politics of the time, made virtually inevitable the creation of the Artists' Union in 1934. By November of that year, the organization had its own publication, *Art Front*, a forum for internal debate and a platform for launching artists' programs and policies directed toward the bureaucratic structure of the WPA. Among the frequent contributors to *Art Front* were Stuart Davis, Jacob Kainen, Ben Shahn, Louis Lozowick, Clarence Weinstock, and Charmion von Wiegand. It was an exciting magazine, irreverent and at times highly personal in its criticism of contemporary artists and politics. Within its pages, critical debates took place over the merits of Regionalism, abstract art, Marxism, the "American Scene," and the WPA itself.

Most of the artists within the supportive structure of the WPA Federal Art Project did not tread a smooth path, particularly those with aspirations toward abstraction. All participants in the various projects were routinely required to submit sketches for the approval of WPA committees, who then evaluated the aesthetic merit of a composition and its suitability for a proposed site. Abstract artists were especially vulnerable to criticism and were frequently accused of being insensitive to the overwhelming social and economic problems of their time. For the abstract artist, there were no national goals, no iconographical program, no socially approved form of service that might be quickly understood and appreciated by the general public.

Charged with a mandate to record the "American Scene," supervisors were often reluctant to approve abstract or even severely stylized works of art. A notable exception was the Mural Division in New York City, which supported a number of abstract painters and sculptors and allowed a much greater range of style and content. Other divisions of the New York WPA, the easel project, and several teaching programs, evidenced a great deal of stylistic diversity, which made it possible for artists to participate fully without severely compromising their personal ideals. Among the abstract artists who were involved for varying lengths of time in the PWAP, then the WPA, during its nine-year tenure in New York City, were Rosalind Bengelsdorf, Ilya Bolotowsky, Byron Browne, Giorgio Cavallon, Martin Craig, Francis Criss, Stuart Davis, Burgoyne Diller, Werner Drewes, Arshile Gorky, Balcomb Greene, Harry Holtzman, Paul Kelpe, Willem de Kooning, Lee Krasner, Ibram Lassaw, George McNeil, Jan Matulka, Irene Rice Pereira, Ad Reinhardt, Louis Schanker, David Smith, Albert Swinden, and John von Wicht.

In one of the most fortuitous and farsighted moves of the

period, Audrey McMahon, director of the WPA Federal Art Project for the New York region, appointed a serious young painter, Burgoyne Diller, to supervise the Mural Division in New York City. An independent and mature person, Diller was already well along in his career when he assumed the highly controversial position in 1935. As early as 1928, while studying with Matulka at the Art Students League, Diller had made his way from the style of Cézanne through the intricacies of Synthetic Cubism. When Hofmann arrived at the League in 1932, Diller became one of his most serious and respected students. Perhaps the first painter of his generation in New York to grasp the essentials of nonobjective art, Diller began, about 1934, to base his work upon principles derived from his study of Constructivism and Neo-Plasticism.

As supervisor of one of the most highly visible and active sections of the WPA Federal Art Project, Diller lost no time in recruiting the ablest of his contemporaries then working in New York, including a good many who were developing in the direction of abstraction. Diller and others involved in the Federal Art Project believed that the American public would benefit most from viewing authentic works of art created by artists who had freely chosen the assignments. In 1936–37 the Federal Art Project was invited to do an extensive group of indoor and outdoor murals for a lower-middle-income housing project in Brooklyn, the Williamsburg Houses, being designed in a modernist idiom by the architect William Lescaze. Diller reasoned that aesthetically pleasing forms and colors might be more appealing after a hard day's work than images of factories, city streets, and allegories of class struggle. Of the artist's role in the Williamsburg Project, Diller observed, "These murals, as well as many others, symbolize the effort that is being made ... to stimulate rather than to restrict the direction of painting, which, in the last analysis, should be the artists' prerogative."[15] The Williamsburg Houses contained a generous number of murals, reliefs, and free-standing works of sculpture by Ilya Bolotowsky, Harry Bowden, Byron Browne, Martin Craig, Francis Criss, Stuart Davis, Balcomb Greene, Paul Kelpe, Willem de Kooning, George McNeil, Jan Matulka, Eugene Morley, and Albert Swinden.

As both artist and administrator, Diller served as an effective mediator between his artists and the bureaucratic hierarchy. Arshile Gorky's massive ten-panel mural, *Aviation: Evolution of Forms under Aerodynamic Limitations*, created under the auspices of the WPA for the Newark Airport in New Jersey between 1935 and 1937, was a highly visible, controversial work. A synthesis of many influences, among them the art of Léger and Davis seen through a Surrealist concept of metamorphosis, the work revealed Gorky's ability to effect a powerful compression of machine-age form and transform it into a fluid group of shapes evoking the experience of flight. When the work was completed, a panel of WPA officials and politicians voiced their disapproval, but both Gorky and Diller stood their ground, finding unexpected support from the ranks of airport employees.

The classic and historically significant contributions of the WPA Federal Art Project in the realm of abstract art were produced by Diller's Mural Division. One group, still extant, is the ensemble of abstract murals at Radio Station WNYC in the Municipal Building, painted in 1939 by Byron Browne, Stuart Davis, Louis Schanker, and John von Wicht. Commissioned to complement the musical programs of the station, each mural treats the theme in a different style and spirit. Browne's is rectilinear and cool, a horizontal and vertical structure in tonal grays based upon carefully calculated intervals of space and color. Schanker's mural has a free-flowing, open structure inhabited by musical instruments hovering in a colored space. Davis, whose work frequently had musical references, constructed a waterfront fragment with boat rigging and masts, then overlaid it with a colorful saxophone and musical notations. Bauhaus veteran von Wicht's mural in the broadcasting booth is all geometry, but his sharply delineated concentric circles repeat the shapes of record discs and the curvilinear forms of microphones.

The enormously popular 1939–40 New York World's Fair afforded WPA artists the opportunity to create murals for the large exposition halls. Diller recruited Bolotowsky, Browne, Greene, and Schanker, who produced abstract murals for the Medicine and Public Health Building. Gorky's mural for the Aviation Building continued the theme he had developed at the Newark Airport. The Hall of Communications featured a mural by Davis, and the Hall of Pharmacy was the site of murals by Willem de Kooning, Michael Loew, and Stuyvesant Van Veen. José de Rivera and Eric Mose worked on the Hall of Industrial Science. These were all highly visible buildings at the fair, featuring the work of abstract painters and sculptors.

The artist's freedom of choice was of paramount importance to many working on the WPA and often conflicted with popular taste and the administrators' desires for communication and accessibility. National director Cahill's appeal for a bond of understanding between the artist and the public was frequently repeated by both artists and administrators. However, others questioned whether this was possible or even desirable. In "Society and the Modern Artist," an essay

written for the WPA Federal Art Project in 1938, Balcomb Greene observed, "A mousetrap can conceivably be made which pleases every man, and a house designed which pleases most, but the painting which finds this easy acceptance is probably turned out the way mousetraps are."[16]

WPA artists were acutely aware of the economic and political climate in which they lived. Suffering under the physical hardships of the Depression, finding themselves employed as trade-union workers by a government bureaucracy, many were attracted to leftist political groups and became Trotskyites or Stalinists, or attended the American-based John Reed Club. The connection between art and politics was, however, complex and changed dramatically throughout the thirties. At the most basic level, the populist attitudes expressed by WPA administrator Cahill placed the artist within the American mainstream and charged him with a mandate to reflect and record society's characteristic activities, its achievements, and some of its larger social aspirations. Yet a significant number of WPA artists, particularly urban ethnic and racial minorities, often chose to depict society's ills as well as its aspirations. Their powerful model was the art of the Mexican muralists José Orozco, Diego Rivera, and David Alfaro Siqueiros, who used their work as a tool of social reform and direct political expression. Efforts to suppress their art, as in 1933, when Rivera's commissioned mural—including a portrait of Lenin—was removed from Rockefeller Center in New York, only served to heighten their prestige and dramatize their cause in America.

By the late thirties, the issues were not so clearly drawn. The Soviet government had established Social Realism as its official style in 1932. American artists, writers, and other intellectuals learned of the purge trials of 1936–38, the Nazi-Soviet nonaggression pact of 1939, and the Russian invasion of Finland that same year. In place of freedom of expression and the flowering of modernist art and literature, they witnessed in the Soviet Union the installation of a bureaucratically sanctioned and controlled form of populist propaganda. Many American artists with leftist leanings, who had been sympathetic to the Marxist view that the artist had a responsibility to produce work that would help bring about social change, found themselves increasingly disenchanted with doctrinaire Soviet Marxism. American artists of the thirties might identify themselves as workers and take comfort in their struggle alongside their contemporaries in all walks of life, but the most thoughtful among them separated economic means and artistic ends. The freedom to develop a personal style and to solve the formal problems of their work was not to be abandoned for an orthodoxy that could not see beyond the social content of art.

Within the community of artists working in New York, Stuart Davis and Balcomb Greene were among the most politically radical, but also among the most articulate and thoughtful concerning the artist's need to participate fully in society while preserving his intellectual freedom. In "Society and the Modern Artist," Greene reflects his growing disillusionment with orthodox Marxism and his contempt for Regionalism as an aesthetic formula:

Because of his development and traditions the modern artist is placed on the defensive in our period of political uncertainty, but least of all on the defensive against the orthodox Marxist critic. Like most formal criticism, Marxism has only aborted a reactionary art, mouthing the fine phrases of revolution for an instant, then taking a quick dive into the much publicized midwestern grave which Benton and Curry have dug for it—in a word, into nationalism without benefit of music.[17]

Davis, a founding member of the Artists' Union and editor of *Art Front*, also linked artistic freedom to political freedom in an essay of 1939: "Abstract art is here to stay because the progressive spirit it represents is here to stay. A free art cannot be destroyed without destroying the social freedoms it expresses.... I have tried to point out that art values are social values, not by reflection of other social values but by direct social 'participation.'"[18]

Confronted with economic and political issues which many found too overwhelming to deal with on a personal level, abstract artists of the thirties also faced the grim realities of an art market gone broke and a harsh reception from the major New York critics. Artists fortunate enough to have exhibitions of their work in the mid-thirties and hoping for an impartial hearing from the critics would have been well advised to pay attention to the cool reception given their famous European predecessors. Critics writing for the major newspapers and art publications in New York and elsewhere during the thirties welcomed the return of realism to American art. They saw it not only as the revival of a more indigenous, manageable tradition but as the beginning of a new productive period during which America would be able to deal with Europe on terms more particularly her own.

The "critical brotherhood," as *New York Times* senior art critic Edward Alden Jewell called it, had good reason to be relieved when Regionalist and Social Realist art grew to dominate American museums and galleries during the thirties. Many critics had not come to terms with modern European abstraction and had failed to achieve a thorough under-

standing of the basic concepts involved. Many who had closed their eyes to it were relieved when it seemed to be going away and were unaware of the developments taking place in Europe as well as on their own doorstep.

One event that led to an outpouring of critical debate was the opening in March 1936 of "Cubism and Abstract Art" at The Museum of Modern Art. Jewell's coverage of the show in the March 8, 1936, edition of the *New York Times* focused on the reviewer's sense of frustration when confronted by the work of Picasso, Arp, Mondrian, and other European modernists:

But we, the anxious, the harassed spectators—we who go about trying so hard to understand abstraction as presented to us in terms of color and line and plastic form—are we uniquely at fault when failure crowns our efforts? No, I am inclined to think that the artists themselves should be asked to shoulder their just share of the blame. Too often they who ought to be bearers of light, have walked in darkness or flown in such a fog as would keep any sensible aviator on the ground.[19]

Jewell continued along similar lines when addressing himself specifically to the exhibition: "With few exceptions [such as] the experimental futurist 'Dog on a Leash' by Balla, everything in this exhibition at the Museum of Modern Art may be classified as decorative...."[20]

The term "decorative" was used with regularity by Jewell and also by Emily Genauer, who wrote for the *New York World-Telegram*. Their use of the term usually implied that an artist's work should be placed in a lower category, along with everyday decorative objects such as floor tiles and wallpaper. Genauer's review of "Cubism and Abstract Art," published on March 7, 1936, is a typical example of her use of this analogy:

... or Piet Mondrian's and Moholy-Nagy's assorted compositions, which appear to be so many simple commonplace patterns for bathroom tiles. Or, most amazing of all, Malevich's "White on White" which is the *reductio ad absurdum* into which all such preciosity must lead, or which may be just a grand joke on the part of the painter. It is a big sheet of canvas painted white, with a square of ivory-white painted on top of this. That's all there is. There isn't any more. And that's all, there doubtless will be many to say, that there is to abstraction and Cubism in art, too.[21]

With the "critical brotherhood" and much of the general public uncomprehending and dismayed when presented with an exhibition of abstract art by major European masters, it is easy to understand why galleries might have hesitated to support young unknown Americans and their efforts in the direction of abstract and nonobjective art. Furthermore, in the minds of many critics, curators, and dealers, there was no link between European modernist art and the major thrust of American art. The latter was and always had been predominantly realist, whereas European art, particularly that of France and Russia, was concerned with formal values and philosophical issues. Thus the two traditions existed in virtual isolation.

Throughout the thirties the Museum of Living Art, with its impressive collection of Cubist and post-Cubist abstract art, became a symbol of resistance to the prevailing winds of realism. When Picasso's *Three Musicians* made its New York debut at the museum in the autumn of 1936, the painting became something of a *succès de scandale*. In the November 30, 1936, edition of the *New York American*, Thomas Craven issued his spirited denunciation:

The hosts of French modernism in America, now a minority of dejected hero-worshippers, have been diligently on the job of late. Rallying around a fallen idol, the vested interests, collectors, nuts and professional esthetes have joined hands in a last desperate campaign to restore the tarnished majesty of Picasso, a king without a kingdom, a ruler with a few loyal sycophants and courtiers but with few subjects in the ranks of genuine artists....

Ranging from the subject of Picasso and the School of Paris, Craven then focused on the circle of American artists and collectors who were the early supporters of modern art:

His pictures were endorsed by kindred exponents of Bohemian infantilism like Gertrude Stein; by his literary friends who wrote volumes of pseudo-philosophic drivel on the spiritual advantages of cubes and cones ... the Museum of Living Art, of New York University, acquired the other day an old piece of mangled trumpery by Picasso....[22]

Always one to take up a challenge, Gallatin was not content to confine his activities to the collection of the Museum of Living Art. He also embarked upon some smaller exhibitions featuring the work of younger artists, many of whom he had met in Europe. In March 1936 he organized "Five Contemporary American Concretionists: Biederman, Calder, Ferren, Morris and Shaw." George L. K. Morris and Charles Shaw were close friends who had participated in the growth of the Museum of Living Art. Charles Biederman, Alexander Calder, and John Ferren, all of whom Gallatin had met in Paris and New York, had already achieved some measure of critical attention at home and abroad. Each was committed to developing his art in the direction of abstraction.

"Five Contemporary American Concretionists" opened at

the Paul Reinhardt Galleries in New York on March 19, 1936. The term "concrète" had originated with Arp, and as Morris observed, "Gallatin probably used the term to imply that abstract art is concrete. It had a more positive connotation than a term like non-objective."[23] Gallatin never revealed whether it was coincidence or careful planning that synchronized the opening of his "Concretionist" exhibition with The Museum of Modern Art's "Cubism and Abstract Art." But for Gallatin and Morris, their exhibition proved an effective way to showcase the work of younger modernist artists, in contrast to Barr's essentially historical presentation of abstract art at The Museum of Modern Art and his virtual omission of any significant American work. Gallatin and Morris were both lenders to Barr's exhibition and had advance notice of its contents and emphasis, to which both objected.

In his "Art Chronicle" column in *Partisan Review*, Morris commented on "Cubism and Abstract Art": "The historical approach can be highly dangerous, especially when it is a living tradition which is being retrospectively conceived; in this case the exhibition went far back into the nineteenth century, the principal weight was thrown around the years 1905–23, and most of the more recent aspects were tucked away on the top floor."[24] Barr did note the "Concretionist" exhibition in the closing footnote of the catalogue of his show: "As this volume goes to press, an exhibition of five young American abstract painters opens in New York. . . . " However, his two-page consideration of "The Younger Generation" touched upon the work of only one American, Alexander Calder, and noted the international decline of geometrically based abstract art. Barr concluded, "The formal tradition of Gauguin, Fauvism and Expressionism will probably dominate for some time to come the tradition of Cézanne and Cubism."[25] Barr's analysis, which was certainly accurate concerning the European if not the American scene of the thirties, stood in direct opposition to Gallatin's vision of a continuity of development from the art of Picasso, Léger, and Mondrian to the work of the next generation of American modernists. In essence, both men were right, except in their claims for dominance or exclusivity; the two traditions continued to evolve in the United States, side by side, throughout the thirties and early forties.

The work exhibited by Gallatin's "Five Contemporary American Concretionists" could not have been further removed from the "domestic naturalism" of the "American Scene." Biederman's work of the early thirties was a personal but somewhat orthodox variant of Synthetic Cubism. By 1934, it had become more freely biomorphic. During the years 1935–36 the influence of Léger placed Biederman's

innate feeling for three-dimensional space within a more disciplined geometric context. His *New York, July 1936* (cat. no. 3, ill. p. 49) is a beautifully resolved work typical of this moment, poised as was its creator between New York and Paris. Biederman returned to Paris in October 1936, whereupon his abstract reliefs acquired a Constructivist and Neo-Plastic emphasis—the happy outcome of his meetings with Mondrian, Vantongerloo, Niewenhuis-Domela, Pevsner, Gabo, and other pioneer European modernists. These colored reliefs in wood, metal, and plastic are remarkable for their elegant clarity of form and their fusion of painterly and sculptural concerns, shown principally by the action of light moving through transparent planes. The work Biederman had chosen to send to the "Concretionist" exhibition in early 1936 was a sampling of various Cubist and Surrealist influences, full of ideas partially understood. The artist who returned from Paris in 1937 had acquired polish and discipline, and his work had become lean, articulate, and beautifully integrated.

Gallatin had recently acquired Calder's *Construction* of 1932 (cat. no. 21, ill. p. 61), which was shown in the "Concretionist" exhibition. Their exchange of letters regarding this transaction reveals Calder's self-confidence and his concern about the correct placement of the work in the exhibition space and later at the Museum of Living Art. A wall-based stabile with two floating black discs set at oblique angles to the wall surface, it is among his most rigorous works of this period, with links to Constructivist form and few, if any, allusions to the natural world. It is also more completely abstract than many of Calder's other works based on the biomorphic imagery he adapted from the work of Arp, Miró, and the Surrealists.

At the time of the "Concretionist" exhibition, Calder had already made a place for himself within the European avant-garde in Paris and was treated as a major international figure both in America and abroad. Upon his return to New York from Paris in 1933, his art found an audience among those collectors and curators who knew the recent history of modernism in Europe. Calder's brilliant career unfolded as it did because he was effectively able to grasp, synthesize, and go beyond his immediate sources. He saw a great deal of European modernist art firsthand and built upon his own personal inclinations as a young sculptor. Calder seemed to understand that within his own generation the broad variations in modern art would best be expressed through the work of individual artists who borrowed freely from many styles and movements without feeling compelled to follow a single movement to its conclusion.

The third "Concretionist" was John Ferren, whose career,

like that of Calder, had begun in Europe, where he became a member of Abstraction-Création. During the late thirties Ferren was experimenting with a highly innovative process for making relief compositions in plaster. His untitled plaster relief of about 1937 (cat. no. 47, ill. p. 101) is a fine example of this work, imprinted from etched plates and then carved to enhance and deepen some areas. Ferren added touches of color to these intricate, even delicate, reliefs. Some are extremely subtle, while others on a larger scale have a strong dramatic presence.

Ferren's curved, hovering forms bear a strong resemblance to the dynamic curved planes used by Léger and more specifically by Hélion. However, Hélion's forms are more self-contained and crisply outlined, while Ferren's have a strongly atmospheric sense of color, radiating a phosphorescent, otherworldly glow. His plaster reliefs of the type exhibited in the "Concretionist" show reveal an area of Ferren's range as an artist in which intimacy, precision, and subtlety replace the dynamism and high color of his larger paintings and pastels.

Closest to Gallatin were Morris and Shaw, whose wealth and social position matched his own. Restless and inquisitive, Morris traveled frequently between New York and Paris during the late twenties and early thirties. Of the painters he met in Paris during this period, Morris felt the greatest personal enthusiasm for Léger as an artist who addressed himself to the aesthetic and social issues of modern life. In his essay for *The Museum of Modern Art Bulletin* in 1935, which documented the Léger retrospective, Morris wrote of the French artist's ability to fuse abstract form with direct observations of the urban, industrial landscape. "His forms are clear and sharp, and the conception of the object has remained as mental as a Coptic fresco. It is the object that removes him farthest from the Cubists and it is the object for its own sake that has become the *grande passion* of Léger's artistic consciousness...."[26]

That any manifestation of the "American Scene" should spring from Morris' brush may be surprising, but he was an avid student of American history, having been raised in the historically conscious regions of New England. Morris' Americana is full of folklore, humor, and Yankee ingenuity. The example of Léger was so important to him because Morris aspired to a synthesis of American subject matter and abstract, essentially Cubist form. During his student days at the Art Students League, he shared his teacher John Sloan's enthusiasm for American Indian themes, which reappear in Morris' spontaneous and playful *Pocahontas*, 1932 (cat. no. 101, ill. p. 200), which contrasts with the more formal, som-

ber beauty of a work such as *Stockbridge Church*, 1935 (cat. no. 102, ill. p. 126).

A classic of this period is Morris' *Nautical Composition*, 1937–42 (cat. no. 104, ill. p. 201), a curvaceous tangle of forms and signs supported by layers of interwoven planes. It recalls the traffic signs, staircases, and industrial hardware of Léger's *La ville* (fig. 4, ill. p. 65), which entered the Gallatin Collection in 1937. Nevertheless, Morris' vision of this nautical landscape had the idiosyncratic compression and repeated, rhyming shapes typical of his work, as well as the antistatic tendency to unbalanced composition which marks this painting as truly his own.

Gallatin and Morris were active as collectors of abstract and nonobjective art, but in their own work as artists they remained essentially faithful to Synthetic Cubist structures developed in Paris during the late twenties. Shaw shared Morris' desire for an American abstraction that would reveal characteristic features of the contemporary landscape in an original and sophisticated style. He had studied with Benton at the Art Students League during the late twenties, but soon found himself working through the essential features of Synthetic Cubism to arrive by the early thirties at a geometric, compressed style with muted colors.

By 1936, Shaw's art had matured, notably in the series of paintings entitled the "Plastic Polygon." These shaped and constructed canvases exploring the theme of the Manhattan skyline take their inspiration from the stepped-back profile of thirties-style architecture. Slits of sky appear between buildings, and textured planes are enhanced by dense brush strokes. Clean outlines suggest spatial recession as buildings shade and overlap one another.

Shaw's desire to incorporate three-dimensional elements into a two-dimensional composition links him to the other artists in the "Concretionist" exhibition. He recounted the genesis of this series: "In the main these experiments were founded upon the New York scene—rather than a form composing varying planes, it had taken on the rigid tranquility of a sidewalk pattern viewed from above.... That in its growth and development it no longer embraces those somewhat realistic features found in its progenitor is of no comment. Structurally and functionally it is solely of America."[27]

The "Concretionist" exhibition was one of several attempts by abstract painters and sculptors in New York to make their work more visible during the late thirties. Gallatin's show did not have a major impact, but is noteworthy because it offers a cross section of one segment of the art community—the already somewhat successful, small privileged circle of artists surrounding the founder of the Gallery of Living Art. This

group would soon join the broader community involved in the WPA Federal Art Project, studying with Hofmann, and working on their own to sustain careers during a difficult period in American history.

When Hofmann arrived at the Art Students League in the fall of 1932, his reputation as a stimulating teacher had preceded him. His students, past and present, met one another at the League and at his Fifty-seventh Street school, which opened in 1933. During his first season in New York, Hofmann encountered a handful of young painters at the League who were seriously involved in nonobjective art. Burgoyne Diller, Harry Holtzman, and Albert Swinden were frequent companions at this time, united by their mutual interest in abstract act. With Albert Wilkinson and Charles Trumbo Henry, they staged an exhibition of abstract painting at the League in 1932.

Diller began an important friendship with Hofmann based on respect for each other's ideas and work. He, Swinden, and Holtzman studied informally with Hofmann at the League and later at Hofmann's school. Most intimately involved with the Hofmann classroom at the League was Holtzman, then only twenty years old, who became for a time his teaching assistant.

The work of these three artists is characterized by rigorous, hard-edged, completely nonobjective form. Unlike so many of his contemporaries, Diller was too impatient and clearsighted to spend his early career, as he stated, "sweating out Cubism." He passed through and beyond a Synthetic Cubist phase by 1930 and began a serious investigation of Russian Suprematism and Constructivism, which he was able to study at several exhibitions of the Société Anonyme and in contemporary European journals. His grasp of the basic fundamentals of Russian modernism was unique among American painters of his era. Diller's small untitled composition of about 1933 (cat. no. 36, ill. p. 72), in which a bold, centrally placed image—four interconnecting shapes of red, yellow, blue, and black—is set on a generous white background, is a free and personal variation on the basic forms of Suprematism.

In addition to his active interest in Suprematism and Constructivism in the early thirties, Diller investigated Neo-Plasticism as it developed in the art of Mondrian and van Doesburg. Their work was familiar to him through his association with Katherine Dreier and his study of recent acquisitions in the collection of the Museum of Living Art. Diller was the first American painter to look for his own idiom within the disciplines of Neo-Plasticism. From 1933 to the early forties, he worked toward an understanding of its dimensions and

limitations, accepting a horizontal and vertical orientation and restricting himself to the three primary colors, plus black and white, while at the same time freely manipulating spatial relationships of line and plane. Here Hofmann's teaching program appears to have had an impact, for Diller overlapped the major horizontal and vertical lines of the Neo-Plastic grid and reintroduced the spatial recession and figure-ground relationships that Mondrian had systematically eliminated from his work. In a painting such as *Second Theme*, 1937–38 (cat. no. 38, ill. p. 73), the three-dimensional pull created by overlapping linear elements becomes the most potent force, moving in counterpoint to the two-dimensional tensions that are the dynamic substance of Mondrian's structural language.

Diller's emphasis on a dynamic, reciprocal relationship between two- and three-dimensional elements recalls Hofmann's often-stated thesis on the importance of spatial tension in a work of art. Writing for an Art Students League publication of 1932–33, Hofmann stated, "The mystery of plastic creation is based upon the dualism of the two dimensional and the three dimensional. . . . Reality is different than it appears to be. Reality is three dimensional. Appearance is two dimensional." Thus, in Hofmann's program the three-dimensional must be retained, even within a nonobjective composition. Or, as Hofmann maintained in the same essay, "Space sways and resounds. Space is filled with movement, with forces, counterforces, with tensions and functions."[28]

Diller's art, however, is much more than a synthesis of Neo-Plastic form and spatial dynamics derived from Hofmann. *Construction No. 16* of 1938 (cat. no. 39, ill. p. 96) introduces a mood of focused intensity, as established by a stark, dramatic black plane traversed beautifully and cleanly by slender members of red, yellow, and white. Such a work is able to present itself as a unified image in the viewer's mind and eye. Diller's art is not based upon surfaces, style, or sheer formal inventiveness, but upon a fusion of ideated form and emotional presence. He was not merely fascinated by the beauty of nonobjective form, but understood that the material structure of his work could transcend itself and become a living presence. There is little otherworldly impetus in the art of Diller, who did not share Hofmann's interest in self-expressive brushwork. Diller's emotions are firmly controlled. Reticent yet eloquent, this work is capable of presenting his deepest feelings with great dignity and clarity of purpose.

Diller's vision of an uncompromised, nonobjective art was shared by Holtzman. During the early thirties, like many others at the League, Holtzman was studying the structures of Cubism, but he also experimented freely with rhythmic, lin-

ear stylization of the figure and occasionally ventured into an expressionist form of nonobjective art. In 1934, at Diller's suggestion, he visited the Museum of Living Art to see two paintings by Mondrian. These had an immediate and intense impact on Holtzman, who within the year sailed for Paris on a pilgrimage to meet the Dutch master. Holtzman arrived at Mondrian's apartment late at night and engaged him in a through-the-door conversation.[29] Eventually the door was opened, and the two men embarked upon a friendship that would lead Holtzman to sponsor Mondrian's immigration to America in 1940.

Upon Holtzman's return to New York in 1935, he assumed an important post working with Diller as assistant supervisor in charge of the abstract painters in the Mural Division of the WPA Federal Art Project. For a short time he also resumed his activities as Hofmann's classroom assistant. Of all the American Neo-Plastic painters and sculptors, Holtzman had the most orthodox and carefully considered approach. His best-known and most personal works are his freestanding Neo-Plastic painted sculptures of 1940 (cat. no. 83, ill. p. 117). Holtzman's highly personal solution was to incorporate actual three-dimensional space rather than to work out reciprocal compositional relationships between two-dimensional and implied three-dimensional elements. He also introduced the factor of time into his freestanding sculptural works, with individual planar compositions revealing themselves one at a time as the viewer moves through space. No more than two planes can be seen at any one moment. The viewer perceives not a total, unchanging image revealed in an instant, but a complex polygon incorporating the elements of time and memory.

Holtzman worked slowly during the late thirties and early forties, producing a small number of works, but those extant are challenging and original. Each appears to be the result of long consideration and deliberate innovation. Perhaps most surprising of all is his Neo-Plastic composition of 1936, *Square Volume with Green* (cat. no. 80, ill. p. 116), which relies on a single heretical wide rectangle of green. It is a surprising discovery, and one that offers a refreshing look at Holtzman's approach, which allowed him to do the forbidden and to expand the language he had studied so diligently.

Swinden was a serious, sensitive painter whose work has a clear, logical structure more completely geometric than that of Diller and Holtzman. He was also more involved with the intricacies of complex tonal color, which becomes an expressive as well as a structural element in his work. Abstract painting of the thirties is frequently described as geometric. The term is inappropriate, especially when used to characterize Neo-Plasticism—a style conceived as a unified system of relationships and not a mere fitting together of various geometric parts. Swinden's work, however, may be quite correctly described as geometric, as he invented rectangular and elegantly curved shapes, which he then placed in counterpoint so that the entire composition achieved a dynamic but controlled modulation of advancing and receding, moving and static forms. The clearly articulated colored shapes of *Abstraction*, 1939 (cat. no. 138, ill. p. 230), with its precise integration of parts to the whole, recalls Hofmann's conceptual model. "It is the relation between things that gives meaning to them and that formulates a thought. A thought functions only as a fragmentary part in the formulation of an idea."[30]

The art of Diller, Holtzman, and Swinden, with its lean, nonobjective form and emphasis upon purely plastic means, put these painters at odds with the larger community of artists working in New York during the thirties. Their work was seen as austere, tied to the most extreme late phases of European modernism, out of step with the spirit of social involvement and direct expression of personal feeling. Compared to the Cubist-derived form and spirit of the Gallatin circle, the work of these three had abandoned any possibility of recording American life within a modernist vocabulary and had entered the realm of pure form. Indeed, Hofmann himself was not persuaded to take such a step, nor were the vast majority of his American students. There were other attractive avenues open to American modernists, chief among them the transformative language of Surrealism, with its biomorphic rather than geometric emphasis, its possibilities for metaphor and allusion to mental and physical states of feeling.

Arshile Gorky's work of the thirties borrowed freely from a wide variety of sources, and in this respect he was typical of his generation. What was not so typical was his instinctive grasp of the basic principles underlying style, as well as his ability to extract the important lessons from various movements without subscribing to any of them. His early enthusiasm was for the art of Cézanne and Picasso. Gorky had no intention of eliminating imagery from his work, but sought to understand the dynamics of abstract form, then to fuse it with a richly suggestive personal iconography derived from immediate or remembered experience. The growth of geometric nonobjective art within his own generation disturbed Gorky, who felt it was too austere, lacking in emotional warmth and breadth. Vaclav Vytlacil characterized the mood of his friend Gorky during this period:

He wanted to enrich it. He felt that pressure was narrowing the act of painting down towards geometric form . . . he liked the painterly.

He loved sensuality, and sensuality in the treatment of his calligraphy as he painted. Flat things irritated him if they were supposed to be the primitive of the new painting, leaving the other behind.[31]

Gorky studied the major artists of his time, adapting to his own use an entire lexicon of formal and compositional structures derived from Picasso, Léger, Miró, and many others. Like Manet or Picasso, Gorky generally succeeded in transforming this imagery and making it so completely his own that it became a spirited allusion to another's work rather than imitation or dependency. Such is the case in Gorky's group of related images entitled "Nighttime, Enigma and Nostalgia" (cat. no. 56, fig. 11; ill. pp. 153 and 151), which evolved during the years 1931 to 1934. He took sections from a small work by Giorgio de Chirico then in the Museum of Living Art, found compositional support from a work by Picasso in the collection of The Museum of Modern Art, and expanded upon this imagery over several years to express his own elegiac, moody lyricism.

Gorky's embrace of Surrealist concepts and forms caused a sharp separation between his circle and many other artists of the thirties who considered Surrealism a literary genre antithetical to the abstract structural language of modern art. This issue would in time cause an important and fundamental rift between abstract artists of the thirties. Gorky, Graham, and de Kooning were among those who borrowed freely from both abstract art and Surrealism, while others like Diller and Holtzman sought to uphold the conceptual clarity of nonobjective art, resisting the intrusion of any literary or expressionist tendencies.

Although these basic differences would establish at least two major lines of development in American art, synthesis was the order of the day during the thirties. Gorky's art of this period contains a remarkable combination of elements. The very title, *Organization* (ill. as frontispiece), suggests his structured, clearly articulated composition, whose horizontal and vertical axes cause an otherwise unruly assemblage of forms to behave in an almost classical manner. There are numerous quotations from Picasso, Léger, Miró, and perhaps also Stuart Davis, who alone among American painters of his day was able to manage such a rich scale of tonal values as Gorky has attempted here. The geometric armature of *Organization* links Gorky's art briefly to that of the very artists with whom he frequently quarreled, and yet it is one of the last of this type in his oeuvre as he slowly but surely dropped the synthetic language of the thirties and found his own unique expressive voice.

It was Gorky's wide-ranging curiosity and willful pursuit of his own best interests that enabled him to choose what he liked in various styles and movements, wisely leaving the rest behind. His knowledge of earlier art enabled him to understand that artists themselves create styles and movements, not the reverse. Cognizant of so many options, he chose none of them entirely, and in so doing gained the measure of self-confidence that allowed him to play such an emphatic and important role during the period.

By 1936, Gorky had overturned any prearranged sense of order in his work, allowing forms to flow freely through space and colors to vibrate against one another in strident, unexpected combinations. Comparing *Organization*, which was painted between 1933 and 1936, to *Enigmatic Combat* of 1936–38, one sees that remnants of the geometric order found in the earlier work have been engulfed by tumbling biomorphic forms finding their locations within the dynamic flow of the later painting. Pigment has been dragged across the canvas and built up in heavy layers, as the theme of the painting is borne out by its physical structure.

With Gorky's masterful series of paintings,"Garden in Sochi," which he worked on from 1940 to 1943, those special qualities of line and tone half-revealed in earlier work were able to manifest themselves beautifully and completely (see *Garden in Sochi*, 1941, fig. 13, ill. p. 156). By placing his own individual stamp on the lessons learned from Miró and Surrealism, he succeeded in opening up a broad avenue of form and feeling in abstract art that would serve as a source of inspiration and strength for other artists.

The Armenian-born Gorky, with his charismatic personality, attracted numerous friends, but few offered him as much emotional and intellectual support as did fellow immigrants Willem de Kooning, from Holland, and John Graham, from Russia. Among the best-informed students of both historical and modern art in New York, the three nonetheless shared a vision of time and history different from that of many of their contemporaries. Together they pored through the vast collections of the New York museums of art and natural history, paying special attention to the work of Ingres, Picasso, and Uccello, as well as African, Oceanic, and American Indian art. They distrusted the concept of "progress" in art, focusing upon the expressive language of individual artists rather than upon movements or styles. Gorky and Graham frequently commented upon stylistic and conceptual links between the art of the past and present, using terms that parallel Carl Jung's concept of the collective unconscious. In Graham's important essay of 1937, "Primitive Art and Picasso," he outlined the parallels between tribal art and

that of Picasso, emphasizing those expressive and non-rational powers of the mind which were so valued by the Surrealists:

Primitive races and primitive genius have readier access to their unconscious mind than so-called civilized people. It should be understood that the unconscious mind is the creative storehouse of power and of all knowledge past and present. The conscious mind is but a critical factor and a clearing house.... Therefore, the art of primitive races has a highly evocative quality which allows it to bring to our consciousness the clarities of the unconscious mind, stored with all the individual and collective wisdom of past generations and forms.... [32]

Focusing specifically upon Picasso's work of the late twenties and early thirties, Graham continued, "Picasso alone graphically penetrated and brought out the real meaning of this art. He delved into the deepest recesses of the Unconscious, where lies a full record of all past racial wisdom."[33]

Graham had extensive knowledge of African art, specifically sculpture, and largely supported his family by dealing in African art and serving as a consultant to private collectors, among them Duncan Phillips, whose holdings in modern art would later evolve into The Phillips Collection in Washington. On his frequent trips to Europe, most often on business, Graham assembled a fine personal collection of African sculpture, which was much studied and admired by his friends, especially the sculptor David Smith.[34]

During the late twenties and early thirties, Graham's own work bore the imprint of Synthetic Cubism, combined with an idiosyncratic handling of pigment that involved a heavy impasto alternating with smooth, sharply defined planes. In *Still Life with Pipe*, 1929 (cat. no. 61, ill. p. 108), the viewer is immediately aware of the heavily painted form; at the center of the composition, supported and encircled by a finely wrought substructure of massed horizontals and verticals. The unusual counterpoint of rough and smooth is a somewhat disjointed aspect of the composition, but a dramatic one that links Graham's art to the late work of Braque and Picasso. In terms reminiscent of those used by the art historian Bernard Berenson, Graham described the role of "tactile value" in his painting. "Tactile value concerns the tissue (matière) and the surface (patine) of matter accessible to a highly developed sense of perception by touch as related to sight. Rare ability!"[35] More stark and somber is *Lunchroom Coffee Cup*, 1930 (cat. no. 62, ill. p. 158), another work in which Graham employed his architectural layering of the painted surface.

Perhaps more noteworthy than the strong interest in abstract Surrealism, which had gained ascendancy by the early forties, was the continuing loyalty to Cubist form during the thirties. Virtually every abstract artist of that period passed through some personal variant of Cubist style. It was the core of Hofmann's teaching program and the historical genesis of abstract art for curator-historians such as Barr and Gallatin. Picasso's work of the thirties provided many younger Americans with an example of Cubist form put to the service of Surrealist preoccupations. During the Spanish Civil War, popular sympathy for the people of that beleaguered country was heightened when Picasso's *Guernica* was shown in New York at the Valentine Gallery in 1939. Moreover, the Picasso retrospective at The Museum of Modern Art in 1939 left a strong impression on New York artists. Earlier in the decade, Gorky and Graham engaged in periods of direct imitation, placing the Spanish master on a pedestal, although Graham was later to recant. In Picasso's work of the thirties, they both saw a vital continuation of Cubist abstraction as his work broadened to include political and mythological themes.

The central and most influential American painter of the period was Stuart Davis, unique among the abstract painters of the thirties because he had become a mature artistic personality during the previous decade. Davis had already considered the formal structures of Cubism and adapted certain features to his own style and use. Most important of all, he did so with convincing fluidity and great verve, transforming the static structures of Cubism into quick-moving, highly evocative images of modern life. Davis' circle of friends included Gorky, Graham, de Kooning, Ad Reinhardt, and David Smith, younger artists with whom he shared the commitment to seek a broader view of art than that offered by the purely nonobjective. Style was important to all of them, but there was also the desire for content, emotion, and the free play of personality in their work.

The maturity and complexity of Davis' views on life and art gave his young friends a great deal to think about in an era rife with simplistic ideologies. President of the Artists' Union, editor of *Art Front*, and national chairman of the American Artists' Congress, Davis was a tireless spokesman for the economic and political rights of artists and other workers. At the same time, he was also a modernist and equally assertive when the artist's freedom of choice and expression was threatened in the name of social and political necessity.

At least a decade older than many of his peers, Davis alone was able to connect the art of the twenties to the emerg-

ing forms of abstract art in the thirties. By the mid-twenties, he had become master of his own modernist vocabulary. *Eggbeater No. 1*, 1927–28 (cat. no. 26, ill. p. 91), was a major achievement for a young painter, exhibiting his exciting use of sharp, abstracted planes of light and dark, a linear form of architectonic space definition, and a racy but modulated palette never before seen on either side of the Atlantic. Dark navy blues, tonal browns, bright areas of red, and pale planes of pastel animate Davis' "Eggbeater" paintings. These searching and dynamic works anticipate and generally surpass those explorations of Cubist form that would occupy the generation of artists slightly younger than Davis, whose mature work would emerge in the mid-thirties.

Although largely unacknowledged as an influence by artists outside his circle, Davis was a central figure and pioneer modernist whose work undoubtedly had an impact on the tonal palette developed by younger painters such as Bolotowsky, Greene, Holty, and Morris. Quite unlike the classic tonalities of European Synthetic Cubism, Davis' paintings employed a greater range and variety of color, including both vivid pastels and bright, hot primaries. The jazzy counterpoint of this color and the horizontal architecture of many of his compositions, not to mention his habit of cutting away and making irregular the outer boundaries of his work, precede similar developments in the work of the aforementioned younger artists.

Just when many of his peers were moving toward abstract and nonobjective art, Davis proceeded to reaffirm subject matter in his own work. *Sail Loft*, 1933 (cat. no. 29, ill. p. 67), exhibits those compositional and coloristic qualities just noted, but also focuses on specific objects, their function and integration with one another. In his masterful *House and Street* of 1931 (cat. no. 27, ill. p. 66), Davis is able to render an experience of urban sunlight and shadow in flat colored planes satisfying in their formal architecture but also full of familiar visual reminiscences of streets and warehouse districts.

Davis' work addressed itself to the immediacy and irregularity of the urban landscape, never aspiring to that transcendental state of pure detachment advocated by some younger contemporaries of the thirties and also by many European modernists. The exuberant, raucous rhythms of *Hot Still-scape for 6 Colors—7th Ave. Style*, 1940 (cat. no. 31, ill. p. 67), or the overwhelming profusion of color, shape, and line in *Report from Rockport*, 1940 (cat. no. 32, ill. p. 93), with their all-over compositions and calligraphic imagery, ally Davis with that emerging group of painters—Gorky, Graham, de Kooning,

and Pollock—who would define the style known as Abstract Expressionism. However, as a pivotal figure, Davis embraces both the architectonic geometry of the thirties and those expressionist, imagist tendencies that were developing during the period and gained ascendancy during the forties.

The role of Cubism in the art of de Kooning appears to have been less overtly acknowledged but just as enduring. With his close friends of the period, Gorky and Graham, de Kooning developed the painterly and coloristic aspects of his art while focusing his sights on the human figure. However, he retained remnants of the geometry of Cubism, incorporating its deeper spatial structures into the matrix of his compositions. He proceeded to enrich it with his own adaptations of the biomorphism of Miró and the abstract Surrealists and the broad planes of saturated color established in the mature paintings of Matisse. Throughout the thirties and early forties, de Kooning combined rectilinear and biomorphic forms in a group of intriguing, beautiful, and sometimes awkward works. Softly delineated rectangles stand side by side with voluptuous biomorphs. Areas of relative stability contrast with fluid zones full of torsion and movement. An untitled painting of about 1942 (cat. no. 34, ill. p. 95), typical of de Kooning's work of the early forties, is packed with movement and incident, yet also carefully structured, as his soft, painterly touch and incisive line work together to establish the warmth and definition of his imagery.

A more completely lyrical painting with direct reference to the human figure is *The Wave*, ca. 1942–44 (cat. no. 35, ill. p. 69). Tumbling gray and black curves suggest a figure in motion, while a red-orange oval hovers in a vast, light-filled space. A pink rectangle pushes forward, all by itself, on a vivid green field—an abstract shape or an open window in an otherwise biomorphic world. De Kooning's conception of beauty is full of rich contrasts and contradictions, most compelling when it is combined with unabashed ugliness. Like Graham or Gorky, he dwelt upon the darker as well as the warmer aspects of human experience. Uniquely capable of inventing beautiful forms and even more seductive color, de Kooning revealed in his paintings of this period a powerful expressionist sensibility that was too impatient to concern itself with formal values for their own sake. Lush, compelling, but also strained and unsettling, de Kooning's work of the late thirties and early forties began to reveal his vision of a world where the contradictions and painful ambiguities of the late modern era are explored in a spirited engagement of form and imagery.

During the thirties Byron Browne was also drawn to the

circle of Graham and de Kooning, with whom he shared a commitment to the rendering of the human figure and an interest in Surrealism. Browne worked from nature, deriving abstract shapes from plant and animal forms which grew into entire biomorphic compositions. His palette—a range of browns, muted blues, and textured passages of orange and black—reflected the earthy, sensuous basis of his art. Browne rarely worked in a geometric manner, preferring to invent his own buoyant, irregular curves, tilted planes and lines cutting into flat zones of color. *Non-Objective Composition*, 1935–36 (cat. no. 17, ill. p. 57), is among the most austere of his works. Clearly defined planes inhabit a darkened field, moving in curved paths across and around one another.

Numerous references to Surrealism are evident in Browne's work of this period. He produced a series of hauntingly beautiful, strongly classical portrait heads that owe much to the portraits of Ingres. Browne's figural work reveals direct ties to the art of Graham, who is known for his fantastic heads of this type; to de Kooning, who reinterpreted the human images of classical antiquity through Surrealism; and of course to Gorky, who did not follow this format as closely as the others, but made references to it in such works as *Nighttime, Enigma and Nostalgia*. All four of these painters admired the sensuous abstraction of Ingres.

As one of the youngest abstract painters in New York during the late thirties, Ad Reinhardt was befriended by Davis, the senior figure within that community of artists. The two lived next door to each other, visited each other's studios, and met frequently at the neighborhood cafés. Possessing a sophistication beyond his years, Reinhardt quickly worked his way through a wide range of modernist styles, with Davis serving as an important catalyst in the younger man's early work. Reinhardt was eager, however, to move beyond the sphere of recognizable objects in order to focus on the pure architecture of the canvas. His *Number 30*, 1938 (cat. no. 113, ill. p. 130), is charged with hot reds and electric blues moving throughout tilted planes of space, recalling Davis' brash energy but refraining from overt references to specific subject matter. As was also true of Reinhardt's teacher, Carl Holty, the geometric and the biomorphic existed simultaneously within their art. Reinhardt's untitled work of 1940 (cat. no. 116, ill. p. 210) is filled with animated curves and fluid forms; yet they appear to define a flattened field of energy, thus dispersing the viewer's attention throughout the work from edge to edge.

Reinhardt synthesized elements from many kinds of abstrac-tion—Cubism, Neo-Plasticism, the American Cubism of Davis, the biomorphic art of Miró—but unlike many of the older artists in his circle, he had not proceeded from figuration to abstraction. Essentially Reinhardt began his career as an abstract painter—a highly unusual circumstance for an American artist of the late thirties, but one that would become commonplace in the United States after 1950.

Reinhardt's work often appears systematic in its structure, perhaps reflecting its conceptual rather than perceptual origins. *Red and Blue Composition*, 1939–41 (cat. no. 114, ill. p. 209), involves a great deal of systematic movement, juxtaposition, and repetition as individual elements appear here and there, turned, reversed, and repeated. Its horizontal breadth and lively rhythms again recall the spirited art of Davis, but Reinhardt's painting is cooler, standing apart from the forms and emotions of the natural world.

Reinhardt's preference for a pure, nonreferential abstract art corresponded to the ideals of Ilya Bolotowsky and Balcomb Greene, whom he came to know in the thirties. A Russian immigrant, Bolotowsky began his career as a figurative expressionist and exhibited as one of "The Ten" who held their first show at the Montross Gallery in 1936.[36] Even as this group was gaining notoriety, Bolotowsky changed his direction to a deep involvement with abstraction, moving swiftly and confidently toward a completely nonobjective art.

White Abstraction, 1934–35 (cat. no. 9, ill. p. 52), is dominated by strong diagonal lines opening up the spatial structure of the painting. It is, however, a severe and uncompromised work that does not entangle itself in the intricacies of Cubist space. Although Bolotowsky had a firm grasp of the principles of Suprematism and Neo-Plasticism, he did not rush to orthodoxy and, to his credit as a young artist, sought to enrich his work before narrowing his vision too abruptly. *Painting*, ca. 1936 (cat. no. 10, ill. p. 53), incorporates biomorphic forms, finely delineated diagonal lines, and geometric shapes, all woven together by a sensitivity to weight, tone, balance, and the interaction of forms in space.

Bolotowsky was one of the most successful of the muralists employed by the WPA Mural Division in New York under Diller. Entirely abstract and yet engaging and buoyantly good-humored, his compositions lent warmth and animation to the public institutions for which they were commissioned. His first WPA mural was a major work created for the Williamsburg Housing Project in 1936.

Bolotowsky also created a ten-by-sixteen-foot mural for the Medicine and Public Health Building at the New York World's Fair of 1939–40. This composition is known from an

extant painting of the period, which is a study for the lost mural (cat. no. 13, ill. p. 86). Bolotowsky's lively but subtle handling of color is given full reign in his World's Fair study. Although his painting seems to be full of exuberant activity and vivid color, he has used the latter as accent while employing a warm tonal range as the underlying coloristic structure of the composition. This mural is a synthesis of several sources—Suprematism, biomorphic shapes reminiscent of Arp and Miró, linear structures similar to those of Kandinsky —all reinvented and adapted to Bolotowsky's own needs. He has employed a form of spatial push and pull, accomplished with a wit, openness, and ease that make some of the Hofmann School work seem ponderous by comparison.

In other works of this period, such as *Abstraction (No. 3)*, 1936–37 (cat. no. 11, ill. p. 85), Bolotowsky reveals a desire for clean, articulated structure—something strong and architectonic that would stand on its own in the world of manmade objects. A new severity entered his work of 1940–42, as he narrowed the range of his pictorial elements, gradually eliminating biomorphic form and choosing to work with sharply defined linear structures. His palette turned to cool grays, white, and blue to express more fully the crystalline character of this new imagery. *Blue Diamond*, 1940–41 (cat. no. 15, ill. p. 87), announces this stage of Bolotowsky's work, and *Construction in a Square*, 1940 (cat. no. 14, ill. p. 55), takes it a step further by introducing complex pastel planes of color moving in counterpoint to the strong diagonal thrust of its larger forms. This painting and others like it confirm Bolotowsky's primary path as it would unfold in later decades. His closest professional ties were to others who shared his predilection for hard-edged, smoothly painted, clear-cut form, most notably Diller, Swinden, and Balcomb and Gertrude Greene.

The "American Scene" held no appeal for these artists, even though most of them were employed by the WPA, thanks to Diller's efforts. For them a work of art was not a mystery, a process, or a revelation, but a willed creation by a rational being attempting to construct an aesthetic and intellectual vision of order and clarity. Bolotowsky liked to quote Wilhelm Worringer's influential essay, "Abstraction and Empathy," written in 1908. As Bolotowsky summarized Worringer's thesis, two impulses are at work in the creation of works of art. One is abstraction, which seeks order and knowledge and attempts to make coherent models from human experience; the other is empathy, which is the self-expressive side of man, given to a direct, unedited outpouring of feeling. Although these two impulses are related in that they both exist within the individual, they may never be joined or reconciled, as they are two distinct modes of analysis and response. Thus, for Bolotowsky, certain painters of his generation—for example, Gorky and the Hofmann students—were making "abstractions of empathy" and were unable to achieve a state of conceptual clarity in their art.[37]

One of the most interesting personalities and among the strongest abstract painters of the thirties was Balcomb Greene. Keenly intellectual and politically sophisticated, Greene did much to help construct a theoretical base for abstract art in America during the thirties. Initially a student of literature and psychology, Greene became interested in art after his marriage to Gertrude Glass, a painter and sculptor, with whom he spent several seasons in Paris in the early thirties. By 1931, he had begun to paint and to make carefully constructed collage compositions that served as the basis for his architectonic abstract paintings. Although Greene's early work was in a seminaturalistic style, his love of philosophy and abstract thought soon found expression in nonobjective art. By 1935, he had evolved a cool but powerful hard-edged style with broad horizontal planes of close grayed tones. His stark geometry has the strong lateral sweep of much modern architecture, particularly the domestic buildings of Frank Lloyd Wright, Walter Gropius, and Richard Neutra.

Greene was a forceful writer and speaker who expressed his views in numerous articles. In the January 1936 issue of *Art Front* he discussed the relationship between abstract art and modern architecture:

No revolt against tradition has been more incisive than the "abstract movement." All conscious self-direction we can find in Léger, the Cubists, the Constructivists in Russia, the Bauhaus and Werkbund in Germany. . . . That very conception of functionalism, which was to revolutionize all modern architecture and industrial production, was developed originally by men like Walter Gropius at the Bauhaus. It has remained for the artist as a specialist, to make paintings whose function is to integrate individuals, by clarity and courage transforming them from defensive human beings.[38]

Greene's work also pursued the psychological realm, once the focus of his attention as a graduate student in Vienna. There is an enigmatic quality to much of Greene's work, an initial feeling of clarity and definition that gives way to an atmosphere of isolation and dislocation. His forms exist in a vacuum, with no clear source of light, weight, or three-dimensional substantiality. Thus, despite their austerity and rigor as abstract forms, they hint of Surrealist space and

prompt the viewer to speculate as to their meaning and function.

Much of Greene's early work was lost along with that of Swinden when a fire swept through the studio they shared in 1940. *Composition*, 1940 (cat. no. 66, ill. p. 110), which was purchased by Hilla Rebay for the Museum of Non-objective Painting (forerunner of The Solomon R. Guggenheim Museum), escaped that fate and is a fine work typical of Greene's painting of this period. Mondrian's influence is evident in the strong horizontal and vertical armature. Integrating complex grays, blues, and earthy reds, Greene chose to emphasize the subtle spatial and coloristic relationships of planes and to fuse them into a central image in an open ground. His work is generally cooler and more conceptually based than that of his friends Bolotowsky and Swinden. During the later thirties Greene even endeavored to limit the tactile qualities of his brush stroke by applying pigment with an airgun through cut stencils. The effect, though the antithesis of Hofmann's painterly expressionism, was not sterile or mechanical but technically appropriate for Greene's hard-edged planar imagery.

With the passage of time and some critical distance from the abstract art of the thirties, the work of Gertrude Greene is held in ever greater esteem. Her studio requirements must have been unusual, as she explored a wide range of media in her ambitious constructions in wood, Masonite, and metal. Greene became adept in the handling of wood, the joining and finishing of surfaces, and the calculation of weight and stress upon interdependent materials. Her best work of the thirties is unfailingly dramatic and beautifully resolved, with both warmth and precision. It is well made and satisfying, but its technical properties are clearly secondary to the essential imagery of her art. Best of all, she adds a strong physical sense of encounter and play as her abstract forms engage one another in a direct pull and tug within their planar boundaries. They are not pictures of physical activity, but direct embodiments of it. Such qualities link her work to that of the Russian Constructivists, whom she knew and studied. Early works such as *La palombe* (The Dove), 1935–36 (cat. no. 67, ill. p. 165), owe a substantial debt to the artistic form and spirit of Arp; yet Greene's beautifully modeled shape and its upturned metal bar send her abstract dove soaring through space with an unbridled energy all its own.

Greene's large painted *Composition*, 1937 (cat. no. 68, ill. p. 165), purchased that same year by Gallatin for his Museum of Living Art, is a rougher, more aggressive work. This massive wooden construction is dominated by the tension of two opposing zones, one of reddish brown and the other of black cut at an angle, then tied together again by a connecting bar.

As Greene's art matured, it became more completely nonobjective. She studied the work and writings of Lissitzky, Gabo, and Tatlin. Although she admired Mondrian's work and knew Diller's constructions, she never sacrificed her ability to deal with direct physical activity to Neo-Plastic ideals of pure nonobjectivity. As was also true of Diller, she employed cast shadows, overlapping forms, and optical shifts between real constructed planes and illusory painted ones. There is a high-spirited frankness about her work which allowed her to absorb a great many modernist ideas without interpreting them too narrowly or literally.

One of her last full-scale constructions—and perhaps the closest of all to the Suprematism of Malevich—is *White Anxiety*, 1943–44 (cat. no. 71, ill. p. 111). Its obvious predecessor is the Russian artist's *White on White*, a work well known to Greene. Her construction is a further refinement of her customary use of black, white, and gray. Here she establishes a complex interplay of light and shadow, responding to the warm and cool tonalities of light in the environment as individual members differ in thickness and position on the plane. *White Anxiety* is a work that speaks in hushed tones and subtle rhythms, without the direct interplay and physical energy of her earlier imagery.

By the mid-thirties, as the various social circles of abstract painters and sculptors in New York became increasingly aware of one another, the idea of forming an alliance similar to Abstraction-Création began to take shape in several quarters. In 1935 Rosalind Bengelsdorf, Byron Browne, Albert Swinden, and Ibram Lassaw met in Bengelsdorf's studio at 230 Wooster Street to discuss the possibility of holding a group exhibition. By January 1936, a larger group met in Lassaw's studio at 232 Wooster, including Bengelsdorf, Browne, Diller, Swinden, Holtzman, the Greenes, and George McNeil. At this meeting it was decided to invite John I. H. Baur of The Brooklyn Museum to look at their work and sponsor a show at Brooklyn. Baur came to see a representative sampling of work at Bengelsdorf's studio a short time later, but he declined to sponsor an exhibition.

The group met again at Lassaw's studio to explore the possibility of an exhibition at the Municipal Art Gallery, only to learn that a minimum of twenty-five exhibitors was required by the WPA Federal Art Project, which operated the gallery. As a result, the members of the group began to circulate among their colleagues to present the concept of a

cooperative exhibiting society of abstract artists.

In November 1936 Holtzman rented a studio for the purpose of setting up a school of abstract art, a cooperative workshop, and a forum for discussions. He outfitted the loft with white easels in homage to Mondrian's Paris studio and invited all the abstract artists he knew to a general meeting. Those attending included Josef Albers, Ilya Bolotowsky, Mercedes Carles, Giorgio Cavallon, A. N. Christie, Werner Drewes, Arshile Gorky, Carl Holty, Ray Kaiser, Paul Kelpe, Willem de Kooning, Leo Lances, Ibram Lassaw, George McNeil, Alice Mason, George L. K. Morris, John Opper, Esphyr Slobodkina, Richard Taylor, R. D. Trumbull, Vaclav Vytlacil, and Wilfrid Zogbaum. Also present were the original nine who had been meeting during the early months of 1936.

As the host of the meeting, Holtzman proceeded to outline the purpose and curriculum of his proposed school and expressed the need, as he saw it, for an intellectual forum where both practical and philosophical issues could be discussed. But the attending artists grew restless, eager to get on with their own agenda, which they understood to be the staging of an exhibition of abstract art. The sharp differences in outlook within the assembled group soon became apparent. Holtzman, Gorky, and a few others envisioned an intellectual community of modern artists focusing its efforts on questions of content, style, and philosophy. It is unlikely that their efforts could ever have constituted a true artistic movement, given the vast differences in their work, but they understood that a meeting of minds was an essential prerequisite for any important group effort. However, a significant majority had a simpler, more pragmatic objective. They needed to exhibit their latest work and required a larger group for strength and mutual support. Although many styles and approaches were represented, these artists had already been unified by the single issue of their deviation from the representational norm of American art of the thirties. In 1936 few felt they had the luxury to focus on the aesthetic issues separating one abstract artist from another. Society at large tended to treat their work as a single issue, and so together they would frame a direct response.

During this first meeting Gorky supported Holtzman's concept of a seminar and proposed an "assignment," to be completed for the following session. He instructed each participant to bring a painting of an electric light bulb, a piece of string, and one other object to be composed in a palette limited to red, black, and white. Many objected to the idea and criticized Gorky for assuming the role of instructor. The meeting adjourned in general confusion, only to reconvene about a week later. Several artists reappeared at Holtzman's studio, having dutifully completed the assignment. Gorky also came, not having done so. A heated discussion ensued when Gorky, who considered himself the teacher, proposed to issue a critique of the completed works. Drewes challenged his assumption of leadership and reintroduced the concept of a group exhibition, whereupon Gorky replied that the assembled artists were not ready to exhibit because they lacked the force of one strong personality who would achieve success and open a pathway for the others to follow.[39] Several artists interrupted to inquire if Gorky was suggesting himself as this "strong personality," and the meeting collapsed. Gorky made a dramatic exit, followed a few minutes later by his friend de Kooning.

On January 8, 1937, the remaining members of the group met again, this time in Swinden's studio at 13 West Seventeenth Street, to form the exhibiting society they had envisioned in the first place. After long discussion, they decided to call themselves the American Abstract Artists, acknowledging the open-ended nature of the word "abstract," but also recognizing that the group was too diverse to define itself more precisely. The names of the twenty-two members present were recorded by Holtzman, who functioned as secretary that night. Also invited to join, but not present at the meeting, were Gorky, de Kooning, Drewes, Barbara Bigelow, Arthur Carles, Martin Craig, Marie Kennedy, and Ralph Ward. Both Gorky and de Kooning declined membership, on the grounds that neither felt the need or desire for such a group affiliation and they objected to the heterogeneous nature of the proposed organization. Within the next few weeks, however, Albers, Cavallon, Diller, Gallatin, Kaiser, Morris, Ralph Rosenborg, and Rudolf Weisenborn were accepted as members.

The group issued a prospectus at the meeting of January 29, 1937, which helped to clarify some of the objectives of the new organization:

It is hoped that the American Abstract Artists will help correct these conditions—(1) by providing a center for the exchange of ideas, the comparison of works, the clarification of new tendencies or directions etc., and (2) by giving the individual artist the chance to exhibit his own work at a minimum of expense.[40]

The American Abstract Artists lost no time in renting a gallery in the prestigious Squibb Building at 745 Fifth Avenue for their first exhibition, which was presented from April 3 to 17, 1937. Thirty-nine members participated in the show, each

represented by two or three works, bringing the total to more than one hundred works. Despite the stylistic diversity within the group, it was a strong show and included the geometric abstraction of Swinden, Lassaw's freestanding plaster biomorphs, Shaw's architectonic "Plastic Polygon," one of Gertrude Greene's strong wooden constructions, and several small abstract paintings by Albers alongside Browne's vigorous abstractions. The opening was very well attended, as was the entire run of the show. Gertrude Greene, as the AAA's first salaried employee, stayed at the reception desk and counted well over a thousand visitors in two weeks. Only a few works of art were sold, but the portfolio of original lithographs created by the AAA membership enjoyed a brisk business. Five hundred copies were printed and sold for fifty cents, generating some modest income and welcome publicity.

Jewell, reviewing the exhibition in the April 11, 1937, edition of the *New York Times*, acknowledged its comprehensive character, but found the work and the show too "rarefied."

An artist may use very nice bright paint or modulate his surfaces with no end of subtle manipulation or bring much cunning and ingenuity to bear upon the working out of the problems he sets himself to solve. The fact remains that he has entered a sealed chamber whence there is no outlet. This chamber has been called a vacuum. At any rate, the air is extremely rarefied, nor is there more than just enough of it to keep one from gasping.

Jewell returned to a well-worn analysis presented on the occasion of The Museum of Modern Art exhibition "Cubism and Abstract Art": "On the other hand, abstract work of this sort can often make very effective architectural embellishment. It is decorative."[41]

Writing for *The New Masses*, junior critic Charmion von Wiegand greeted the American Abstract Artists show as a sign of new life in the community of artists in New York:

Thirty-nine artists in search of new forms have opened an exhibition in the Squibb Galleries in New York. Judged by the hundreds of people who thronged to the preview, abstract art has become a vital issue in the U.S.A.

Von Wiegand was impressed by the number and seriousness of the exhibitors:

... the appearance of so many young, capable and articulate artists in the abstract field is significant. ... For the most part, these new painters derive from the latter aspects of abstract art and not from early cubism. There is no dividing line between this type of abstract art and abstract surrealism.[42]

Encouraged by the reviews and the large number of visitors, the AAA redoubled its efforts and gained several new members in the next few months, notably Suzy Frelinghuysen, Fritz Glarner, and David Smith. Among the artists' organizations of the thirties, the AAA was unique in that it cut across social and political lines and brought together artists working in various media, uniting the majority of abstract artists born between 1900 and 1915 who were active in America. Critics of the organization were correct in their charge that it lacked a definite vision, for the very nature of such groups in the United States was at variance with that of their European predecessors. American groups were conceived as loosely constructed alliances, not as true movements, lacking the dynamism, philosophical unity, and avant-garde character of the tightly knit and generally short-lived important European movements of the early twentieth century.

In 1938 invitations to join the American Abstract Artists were rejected by such well-known modernists as Calder, Davis, and Lyonel Feininger. However, the membership rolls grew steadily, and during the early years of World War II major European modernists, including Hélion, Léger, Moholy-Nagy, and Mondrian, participated in AAA exhibitions and publications.

During its second season the American Abstract Artists mounted a small exhibition at Columbia University in October 1937 and sent a smaller survey exhibition on a tour of several midwestern museums in early 1938. Encouraged by the success of the Squibb Galleries exhibition, Holty wrote to Barr, asking him to sponsor the second AAA annual at The Museum of Modern Art. In his letter, Holty asserted, "It is natural that the group looks upon the Museum of Modern Art as the authentic place where contemporary thought and effort is clearly identified. For this reason, we are asking the Museum of Modern Art through you as its director to present our 1938 Annual Exhibition."[43]

Barr's reply reiterated the museum's general policy: "... as a matter of policy the museum does not give exhibitions to artists' groups unless it is given full jury powers to select or omit. Most artists' groups are not willing to agree to this condition which, however, we feel is essential. I am sorry to write to you in this negative manner for I have great sympathy with your group and the work I saw at the Squibb Building last year."[44] This exchange, although cordial, initiated a lengthy dialogue that would become rancorous in 1940.

The second American Abstract Artists annual exhibition was presented from February 14 to 28, 1938, at the Ameri-

can Fine Arts Society at 215 West Fifty-seventh Street, former quarters of the National Academy of Design. The group published a handsome eighty-page yearbook with a Neo-Plastic cover designed by Balcomb Greene and containing eleven essays and forty-six illustrations of current work by its members.

Frank discussion and criticism arose unexpectedly from within the organization's own ranks when George L. K. Morris wrote an open letter to the AAA in his "Art Chronicle" column for *Partisan Review*, published in March 1938. While supportive in tone and responding to the standard criticism of abstract art, Morris went on to identify the larger issue yet to be addressed by the AAA membership:

You have had your troubles in freeing yourselves from the accepted accessories. Many of you still hang on to representation by the eyelids; bottles, pipes, faces protrude from certain corners. And, in your desire to become grounded in the new tradition, a number of you hide your voices so stiffly behind alien fabrics that no tone can emerge at all. However, there is no need for you to make answers to the charge at all. Your exhibition walls resound with native clarity and color-sense that speaks strongly of America. The rest will follow if there is enthusiasm and patience.[45]

Especially during the later history of the AAA, Morris has been regarded as its major spokesman, having taken issue with its critics in *Partisan Review* and other publications. However, his viewpoint was not identical to that of many members, particularly the students of Hofmann and independents like Greene, Bolotowsky, and Diller. Morris neglected to mention the tangible influences of American modernists such as Davis and Matulka, the enormous appeal of Hofmann's teaching, and the effect of Surrealist art and literature upon the aesthetic development of American artists.

Once again, the American Abstract Artists annual exhibition attracted an unusually large number of visitors, this time over five thousand during a two-week run. The title of Jerome Klein's review in the *New York Post* encapsulated the tenor of his longer essay: "Plenty of Duds Found in Abstract Show: More Fizzles than Explosions in Display at Fine Arts Building."[46] However, the *New York Times*'s Jewell had mellowed, concluding, "Let it be said at once that this year's harvest considerably excels the first showing put on by this group last year at the Squibb Gallery.... There are some distinctly handsome designs in the show, and some gratifyingly original ones also."[47]

The exhibition reinforced the success of the Squibb show. The catalogue served to advance the AAA's views, and many members of the group began to gain individual recognition.

In 1939 a second yearbook was published, which contained biographies of members, accompanied by a full-page reproduction of work by each participant in the 1939 annual held at the Riverside Museum from March 7 to 22 of that year. By this time, the AAA was becoming identified, rightly or wrongly, as an association of artists working in hard-edged, geometric styles. Membership lists of the period do not support such a generalization, but some long-time members recall having been urged to show only their most uncompromisingly abstract work in annual exhibitions. According to *New Yorker* critic Robert Coates in 1939, the AAA had gone too far down the purist path:

It's the mood of the show, the tendencies it illustrates, that bothered me. With few exceptions, the trend of the group is toward the purest of "pure" abstraction, in which all recognizable symbols are abandoned in favor of strict geometric form. It seems to be a move in the wrong direction; indeed, it is precisely in the development of symbols, and the exploration of their capacity to express emotion, that the true field of abstract painting lies.[48]

It is difficult to know precisely what Coates meant when he urged AAA members to develop symbols "native in atmosphere," but his perceptive commentary identified a cause of dissension within the organization, which would eventually lead to the departure of some of the more expressionist members.

Meanwhile, there were other urgent issues at hand when in the early months of 1940 The Museum of Modern Art sponsored a major loan exhibition of Italian Renaissance painting under the title "Italian Masters," which was presented alongside its own show, "Modern Masters," featuring late nineteenth-century American and European painting. During the previous year the museum had aroused consternation in some quarters with its presentation of "Art in Our Time." Those expecting to see an exhibition of contemporary work found instead a display of canvases by an earlier generation of American artists, including William Harnett, Winslow Homer, John La Farge, and John Singer Sargent, shown together with work by Picasso, Braque, Léger, and other twentieth-century Europeans. When the museum scheduled an exhibition of drawings and cartoons created for a contest sponsored by the leftist afternoon newspaper, *PM*, in April 1940, many New Yorkers began to question the institution's vision of itself. Young painters and sculptors were increasingly frustrated by the museum's historical approach and its simultaneous support of European modernism and American realism and Regionalism.

In the most dramatic move in its history, the American Ab-

stract Artists organized a picket line of approximately fifty members, who appeared outside the museum on the rainy afternoon of April 15, 1940, to protest the museum's policies and to distribute a provocative and well-designed, one-page broadside entitled, "How Modern Is The Museum of Modern Art?" AAA member Ad Reinhardt, a professional typographer and frequent contributor to *PM*, designed the handout. Its banner headline featured eight different antique and modern typefaces chosen to emphasize what AAA believed to be the antiquated policies of the museum. Speaking of the 1939 "Art in Our Time" exhibition, the broadside queried, "Whose Time, Sargent, Homer, La Farge and Harnett? Or Picasso, Braque, Léger and Mondrian? Which time? If the descendants of Sargent and Homer, what about the descendants of Picasso and Mondrian? What about American abstract art?"[49]

The broadside went on to point out that the only American artists featured in the "Modern Masters" exhibition were Homer, Thomas Eakins, Albert Pinkham Ryder, and James A. McNeill Whistler, all of whom were dead by 1918. Fifty-two AAA members were listed as signators, some of whom did not take part in the picketing. Morris arrived after the demonstration had begun and recalled his own irritation at the language used in the handout: "If I had been around when those were written I would have tried to make sure they were more sane. I came back to the city on a night train. I arrived the morning of the picketing and went down and joined them. I handed out some of the pamphlets.... I recall that Gallatin and Ferren objected to having their names on the list—they weren't at the picketing—but Reinhardt merely listed all the AAA members on the pamphlet."[50] Bolotowsky recalled that the museum sent out some of its secretaries to collect pamphlets, explaining that such an admirable job of typography belonged in its archives.[51]

The Museum of Modern Art protest was soon followed by another AAA pamphlet, entitled, "The Art Critics—! How Do They Serve the Public? What Do They Say? How Much Do They Know? Let's Look at the Record!" Balcomb Greene contributed brief but stinging commentaries, pointing out the general inability of critics to deal with modern painting and sculpture, as evidenced by their reviews of such exhibitions as The Museum of Modern Art's "Cubism and Abstract Art" in 1936. One senses in this pamphlet not so much the fear of a genuine adversary relationship as a desire for constructive dialogue that would put aside, once and for all, the question of abstraction as an issue in and of itself and begin to make finer and more productive discriminations. Indeed, the next generation of critics active in the forties would not address abstraction as a separate issue, and Regionalist art would cease to play a vital role. The entire structure of critical discourse would also change dramatically, passing over the purist, nonobjective styles of the American Abstract Artists in favor of the Surrealist-based abstract art of Gorky, de Kooning, and the emerging group of Abstract Expressionists.

By 1940, everything had changed as a result of the war in Europe and the flood of emigrés reaching New York, which produced a volatile, heady new mixture of art and ideas. Prominent European abstract painters, notably Léger, Moholy-Nagy, and Mondrian, arrived in New York in the late thirties and early forties. Surrealist art and poetry attracted a wider audience as André Breton, Max Ernst, André Masson, Roberto Matta, and Yves Tanguy took up residence in New York. The Museum of Non-objective Painting, containing the Solomon R. Guggenheim Collection, opened in 1939, encouraging expressionist tendencies in abstract art, grounded in precise, yet animated geometric forms. The WPA Federal Art Project was drawing to a close, and many younger artists, among them Bolotowsky, Lassaw, and Reinhardt, had been drafted into military service. With all of these developments, the sense of community so much a part of the thirties also began to fade. In the succeeding decade, artists' organizations such as the American Abstract Artists played a less prominent role, although many of the European emigrés, such as Mondrian, Léger, and Albers, lent their support and participated in group exhibitions.

Among the most influential of the European modernists to settle in America was Josef Albers, who left Germany in 1933 when the Nazis forced the closing of the Bauhaus. The first member of its faculty to teach in the United States, Albers introduced Bauhaus concepts of design and painting to several generations of American students at Black Mountain College and later at Yale University. In his own work, Albers continued his investigations of color theory and composition, producing his "Homage to the Square" series, regarded by many as a forerunner of the hard-edged painting of the sixties.

Bauhaus teacher László Moholy-Nagy came to the United States to realize his vision of a New Bauhaus in America, which opened in Chicago in 1937 and lasted just one year. Reorganized and reopened in January 1939 as the Institute of Design, the school offered a curriculum integrating art and industrial design, based upon the principles outlined in the fourteen Bauhaus books edited by Moholy-Nagy and Gropius. Ever the optimist and visionary, Moholy-Nagy looked forward to a new era of design in the United States.

In the preface to the 1938 second English edition of his influential book, *The New Vision*, he wrote: "America is the bearer of a new civilization whose task is simultaneously to cultivate and industrialize a continent. It is the ideal ground on which to work out an educational principle which strives for the closest connection between art, science and technology."[52] In America Moholy-Nagy pursued his long-standing interest in the activity of light in three-dimensional space and the manner in which such imagery might be rendered photographically or in a painting. His *Space Modulator*, 1938–40 (cat. no. 97, ill. p. 193), is closely related to the imagery he was able to establish with his sculptural light-space modulator and his paintings on Plexiglas.

Another of the pioneer European modernists to take refuge in New York during the war years, from 1940 to 1945, was Léger.[53] Earlier exhibitions in America, notably his highly successful retrospective at The Museum of Modern Art in 1935, had made his work well known to American audiences, and his circle of friends and former students included Alexander Calder, Frederick Kiesler, and George L. K. Morris. Léger's influence in America preceded his long-term stay in the forties, as works of the preceding decade by Davis, Gorky, and Morris clearly indicate. A gregarious personality, Léger was able to acclimate himself to American life and succeeded in producing paintings that are mature and self-confident. His *La forêt* (The Forest), 1942 (cat. no. 91, ill. p. 185), exhibits the movement and compression characteristic of his work in New York, with its numerous cast-off farm machine images, writhing tendrils, and heavily modeled forms.

Like Léger, Mondrian was already a towering influence on American abstract artists when he arrived in New York in 1940. Among those most deeply influenced by him were Bolotowsky, Diller, Holtzman, and Swinden. Holtzman, who had sponsored Mondrian's immigration, helped him to get settled in a small studio on Fifty-sixth Street, where the Dutch artist proceeded to transform it into the Neo-Plastic atelier so vital to his peace of mind and his ability to continue working. Diller was the first of this group to understand the structural language of Neo-Plasticism and was its most profoundly original interpreter in America, but his relationship with Mondrian was distant. Bolotowsky was away in military service during most of Mondrian's New York period and saw him infrequently.

Mondrian's steadiness and integrity made him an important role model for these younger artists, who were suddenly exposed to a personality who had been developing his vision throughout the entire course of the twentieth century.

The freshness of his spirit at the age of sixty-eight was a marvel, as he eagerly embraced the city, its artists, and the adventure of his new life.[54] Although Mondrian did accept an invitation to join the American Abstract Artists shortly after his arrival, he attended meetings infrequently, but did participate in the 1941, 1942, and 1943 annuals.

Most inspiring of all was the sense of adventure and renewal expressed in Mondrian's New York work. The very titles of his paintings in 1941 and 1942 paid homage to his spirited encounter with the city, its rhythms and visual character. In *New York, New York City*, ca. 1942 (cat. no. 99, ill. p. 194), Mondrian allowed color to invade the linear architecture of his canvas and opened up the spatial structure of the work by letting one line overlap another. In America he discovered colored tape, useful in the endless alterations, erasings, and transformations his canvases typically endured before he was satisfied with a composition. This dynamic process is evident in *New York, New York City*, and is as important as the animated, incessant movement of the work itself. These were radical departures from his earlier work, though certain individual elements had occurred just prior to his arrival in New York. However, under the impetus of a changed mood and environment, Mondrian unloosed them all at once, surprising even those who had known his work for many years.

The promise of Mondrian's New York period is emphatically realized in his last and unfinished work, *Victory Boogie Woogie* (cat. no. 100, ill. p. 125), which was found on his easel at the time of his death on February 1, 1944. The energetic profusion of his imagery had built to a crescendo, transforming the dynamic equilibrium of previous years into interconnected circuits of movement and color. They are so dense as to defy simple comprehension, yet compelling and convincing in their pursuit of a state of high visual excitement.

By the early forties, Mondrian's Neo-Plasticism, as well as the Cubist and Constructivist influences that had dominated the abstract art of the early thirties, were being superseded by expressionist tendencies derived from the art of Kandinsky, the abstract Surrealists, and other sources. A major champion of this movement toward expression was—to give its full name—Art of Tomorrow, the Museum of Non-objective Painting, which opened its galleries in New York on May 31, 1939, at 24 East Fifty-fourth Street. Its director, the German aristocrat Hilla Rebay—who since 1929 had served as art adviser to Solomon R. Guggenheim—placed special emphasis on the art of Kandinsky and Rudolf Bauer, a follower of Kandinsky and a friend of the baroness during her years

as a young painter in Germany. The Guggenheim Collection, which by 1939 included more than 800 works, was exceptionally rich in early modernism as well as more recent non-objective art. Throughout the thirties the collection was installed in Guggenheim's suite at the Plaza Hotel in New York.

Rebay, who mixed theosophy with Eastern religions, shared Kandinsky's belief that the spiritual aspirations of mankind might be refined and developed by an understanding of abstract art. To this end, she arranged to have classical music playing in the galleries, where soft lighting and the tranquil atmosphere of a gray and white décor provided the setting for a purer state of contemplation.

Thus the museum supported those European painters considered by Rebay and Guggenheim, the museum's benefactor, as the visionaries of the early twentieth century, among them Kandinsky, Bauer, Moholy-Nagy, Klee, and Léger. The collection emphasized the art of Germany, Holland, and Russia, providing a contrast to the Cubist-centered tastes of Gallatin and the broadly historical thrust of The Museum of Modern Art under Barr. The Museum of Non-objective Painting offered a fine and unusually complete survey of the work of Kandinsky, whose early expressionist paintings were especially influential among younger Americans. While many objected to the transcendental tone of Rebay's installations and would have preferred a more neutral presentation, the museum helped to complete the education of the American audience with regard to twentieth-century art.

By 1942, the collection included work by such Americans as Balcomb Greene, Ilya Bolotowsky, Alexander Calder, Werner Drewes, John Ferren, Raymond Jonson, Ibram Lassaw, Irene Rice Pereira, Rolph Scarlett, Albert Swinden, John Sennhauser, Charles Shaw, Esphyr Slobodkina, and Jean Xceron. One of the few major institutions to sponsor exhibitions of work by some of the younger abstract artists in New York, it also counted many of these artists as members of its staff. Among those who were associated with the museum and became identified, to greater and lesser degrees, with its outlook and style were Pereira, Scarlett, Sennhauser, and Xceron.

As an artist-curator at the museum from 1939 until his death in 1967, Xceron learned much from his daily contacts with the art of Kandinsky, Mondrian, and the Constructivists, and with other works that went beyond Cubism toward nonobjective form. In his own work, however, he pursued a calmer, more classical vision. *Composition No. 250*, 1940 (cat. no. 145, ill. p. 234), owes its strong rhythm to a complex structure of long yellow rectangles and the major black framework at its center. The activity of single colored elements introduces an exciting, uneven beat as one reads the composition from left to right. This precise, yet also animated geometry characterized the work of those who were closest to Rebay and the museum's programs.

The work of Sennhauser reveals a similar desire to fuse a stable abstract structure with strong, dynamic movement. From a spirited form of Social Realism, Sennhauser's early work evolved through Cubism to pure geometry. In 1942 he entered the employ of the Museum of Non-objective Painting as a lecturer and preparator. His work of the early forties is characterized by a remarkable precision and delicacy, notably in his *Lyrical No. 7*, 1942 (cat. no. 124, ill. p. 135). Its darkened background and quickly moving sparks of color reveal a formal language derived from the late work of Kandinsky, but handled with a new degree of refinement.

The art of Xceron and Sennhauser derived its dramatic emphasis from the clarity and precision of form each built into his work. Others in the Rebay-Guggenheim circle had a much more flamboyant, almost Wagnerian sense of drama as they endeavored to render cosmological visions in pure geometric form. Scarlett, for one, participated in early plans for the museum and was subsequently a staff member directly involved in its policies and programs. The sharply defined geometric forms in his *Composition*, 1938–39 (cat. no. 122, ill. p. 134), are close, in many respects, to the late work of Kandinsky, and more particularly to that of Bauer. Scarlett has pushed his format considerably and introduced a tight, almost representational form of light and shade to create volume. Though at times his work is overly complex and almost theatrical, it has a subtler touch and a greater sensitivity than that of Bauer.

The career of Irene Rice Pereira loosely paralleled those of Sennhauser and Scarlett, although she was more deeply involved with the world of technology and industrial design. She was briefly associated with the Museum of Non-objective Painting and believed in the transcendental mission of non-objective art, but her world was broader, and the museum is rarely mentioned in her standard biography. Her explorations of unusual materials were supported by a grand conception of pictorial space. The central goal of her art was to construct and articulate a space that existed in the mind, a nearly literal rendering of her vision of the fourth dimension. As Pereira explained in one of her long prose poems, "Conceptual space of the mind is the reality of the time-space continuum. It is the space of creation."[55]

The work of these artists, although sharing something of Kandinsky's spirit of "inner necessity," was clothed in geometric form. Other artists who frequented the Museum of Non-objective Painting were attracted to the early, more freely expressionist work of Kandinsky's Blaue Reiter period. During his brief tenure as an employee of the museum, Jackson Pollock is known to have been impressed by its collection and especially by the calligraphic expressionism of Kandinsky's early abstract painting.

World War II led many important European Surrealists—Breton, Ernst, Masson, Matta, and Tanguy—to take up residence in New York during the early forties. They staged exhibitions, held public events, and re-created the lively café life they had known in Paris, providing an exciting dialogue for those young Americans fortunate enough to make their acquaintance. By the early forties, American artists were well aware of Surrealist art and poetry and increasingly drawn to the work of abstract Surrealist painters and sculptors. In 1936 The Museum of Modern Art had staged "Fantastic Art, Dada and Surrealism," a large and thoughtful survey in which Barr provided a historical context for Dada and Surrealism while presenting work by its most distinguished practitioners. In 1938 Breton created the notorious and widely publicized "International Surrealist Exhibition" in Paris.

During the thirties several New York galleries had sponsored important exhibitions by Surrealist artists. Julien Levy showed the work of Salvador Dali in 1934, Matta in 1940, and supported the work of Joseph Cornell and Gorky as his program expanded in the forties. The Pierre Matisse Gallery, well known for its support of abstract art, focused on the abstract Surrealists with its exhibitions of Masson in 1935, Miró in 1932 and thereafter, and Calder from 1934 to 1943. Matisse's 1940 exhibition "Artists in Exile" included many prominent abstract and Surrealist artists. Among the fourteen participants were Breton, Ernst, Léger, Masson, Mondrian, Ozenfant, and Tanguy.

In October 1942 Breton and Duchamp staged their "First Papers of Surrealism" exhibition at the Reid Mansion in New York. The work of Duchamp, Masson, Matta, Miró, and Picasso was placed alongside that of the Americans William Baziotes, David Hare, and Robert Motherwell, at once suggesting and promoting a continuity of theory and practice from one generation to the next. Duchamp wove a web of string throughout the exhibition rooms, recalling the diversionary installation he had created for the "International Surrealist Exhibition" in Paris in 1938. October 1942 also saw the opening of Peggy Guggenheim's Art of This Century Gallery in New York, where she offered a survey of her own collection, including work by Arp, Breton, Gabo, and Mondrian. Guggenheim then went on to introduce younger American expressionists such as Baziotes, Hare, Motherwell, Pollock, and Still. In 1944 she presented Hofmann's first New York one-artist exhibition, confirming his ties to the next generation of expressionist painters in New York.

Surrealism offered many abstract artists a way to break out of the Cubist grid, which had lent structure to their art but had also confined it to a set of fixed geometric relationships. While a number of artists—Biederman, Diller, Bolotowsky, Greene, and Holtzman, among others—went beyond Cubism toward Neo-Plastic and Constructivist form, others remained within the Cubist idiom and most often did not achieve a personal style of sufficient breadth and clarity. The Surrealist abstractions of Breton and Ernst offered an open-structured, antigeometric field of pictorial space. Fluid and limitless, it also welcomed the possibility of imagery clothed in a rich, evocative, biomorphic form. Such influences can be seen in the work of Gorky and de Kooning during the early forties.

Surrealist biomorphism was especially attractive to abstract sculptors of the late thirties and early forties. Calder had found such a synthesis early in his career, having understood that a biomorphic form could also be abstract and suggest movement, while existing as a beautiful and complete plastic form. His *Constellation*, 1943 (cat. no. 24, ill. p. 90), is part of a long series, each like a small-scale galaxy exploding in space, its dynamic, fragile forms tethered by the thin wires holding Calder's universe together.

The art of Ibram Lassaw documents this important transition from Cubist and Constructivist structures toward Surrealist biomorphism. In his *Sculpture in Steel*, 1938 (cat. no. 88, ill. p. 183), Lassaw has opened up the inner space of his work by suspending biomorphic elements from a steel rod at various angles. In 1940, however, his *Intersecting Rectangles* (cat. no. 89, ill. p. 120), a planar study in pure geometry, was exhibited at the American Abstract Artists annual show, where it was warmly received by Mondrian. In subsequent work, Lassaw proceeded to use the geometric "box" as a flexible armature, much as he had in the earlier *Sculpture in Steel*. Biomorphic form was more exciting to him, more truly three-dimensional, a more sculptural mode of seeing and experiencing the world.

Sculptors were a distinct minority during the thirties and early forties, as was frequently noted during AAA meetings. As more options became open to the abstract sculptor, some artists who had begun as painters were persuaded to work

in three dimensions. David Smith moved from painting to collage to abstract sculpture in the early thirties, applying the welding techniques he had learned in industry to the creation of small-scale welded sculptures. His *Sawhead*, 1933 (cat. no. 132, ill. p. 225), began as a humble saw and grew to the proportions of a small standing figure with a human face and an abbreviated body. Extremely frontal and rigid in its posture, the work has some of the qualities of a totem or a votive figure.

Although Smith had begun as a painter, his study of Surrealism focused on sculpture, chiefly the early work of Giacometti and the later sculpture of Picasso. He was also devoted to the work of Julio González and made a careful study of African sculpture. In 1940, when Smith was called upon to define the meaning and role of abstract art in society, he did so in Surrealist terms:

The all-inclusive term "abstract" includes Surrealism and tangent schools. It is the language of our time. Within this expression the artist is essentially the instrument, his work stands above him. Relatively, a great abstract work is like a dream. It presents beauty or its associate, imagination. It does not interpret itself. The dream, like the painting, is the product of both the conscious and the unconscious factors of the mind.[56]

As his art developed, Smith was able to achieve a reciprocal rhythm between form and open space, which made the work seem effortless and dreamlike, paralleling the improvisational and automatic processes of the Abstract Expressionist painters.

Smith's characterization of the work of art as a dream and the artist's hand as an instrument of the unconscious stood in direct constrast to the rational, conceptualized approach of the thirties. The first decade of the postwar era would belong to the Surrealist vision, to the Abstract Expressionists, many of whom were of the same generation as the hard-edged geometric painters who had created the AAA. Adolph Gottlieb, Franz Kline, Jackson Pollock, Mark Rothko, and others who had exhibited as figurative expressionists during the thirties turned to abstract form in the early forties, basing their art upon the open-structured field and lyrical expressionism that grew out of early abstract Surrealism.

By the end of the war, abstract artists were no longer a minority in New York. With the tightly bound structures of Cubism supplanted by the new romanticism of abstract form and biomorphic imagery, the group identity of the American Abstract Artists began to seem strangely out of place. In 1943 Gallatin's Museum of Living Art ended its long tenure at New York University and moved to a permanent home at the Philadelphia Museum of Art. The death of Mondrian in 1944 concluded a particularly vital period for his young friends, many of whom later became significant painters. This was not, however, the end of the purist ideology espoused in the thirties by Albers, Biederman, Bolotowsky, Diller, and Reinhardt. The careers of these and other Americans active in that period developed throughout the next several decades as their art deepened and gained in authority and influence. Many were outstanding teachers who created the curricula of American colleges and universities, where basic structural principles of composition are presented in terms defined by Albers, Moholy-Nagy, or Hofmann.

A few exceptional artists like Diller and Reinhardt took the essential structures of purist geometry and developed them for several decades until they arrived at a new and more completely articulated statement of that timeless, purist vision which had inspired the art of their predecessors Malevich and Mondrian. Diller's art evolved from the dynamic asymmetry of Neo-Plasticism toward a state of absolutist symmetry on a vast scale, paralleling and at times anticipating the stark clarity of the art of the sixties. While many artists looked back on the thirties as a period of experimentation, a time to work through the basic language of European modernism, Reinhardt brought the essential principles of nonobjective art forward in time to create an idiom of his own making. In 1966 he observed:

I've taken on all the bad terms of the 30's. Everything that the artists were called that was bad I've picked up and I've made them not bad words. Like meaningless, useless, imageless—those kinds of words. Words like inhuman, sterile, cold. . . . And the others—academic, dogmatic, absolute—I picked them up and said, "Well, why not academic?" . . . I tried to oppose academic to the marketplace.[57]

Reflecting upon the renewed appreciation of nonobjective art during the Minimalist period of the sixties, Reinhardt continued: ". . . I always claim I was there before the Abstract Expressionists and I'm still there with the young. Then it was a virtue being left out."[58]

Many who lived through that vital period between the two world wars felt it had been underestimated; in fact a great deal was actually accomplished. American art passed through a period of isolationism and entered the postwar world fully aware of the visual heritage of the early twentieth century. Our great museums of twentieth-century art were created and assumed their special identities. Successive waves of immigration enriched our cultural life, even as a generation of Americans took advantage of opportunities

to study in Europe. The WPA Federal Art Project gave new dignity and meaning to the role of the artist in America. The modernist painting and sculpture of this era is as ambitious and searching, as beautiful and awkward, as were the abstract artists who found their separate paths during a difficult but significant period in American history.

Note: The title of this essay derives from that of an article by George L. K. Morris in *American Abstract Artists 1938*.

[1] Marsden Hartley, "Dissertation on Modern Painting" (1921), reprinted in *On Art by Marsden Hartley*, ed. Gail R. Scott (New York: Horizon Press, 1982), p. 68.

[2] Katherine Dreier, "Introduction to the Collection of the Société Anonyme," *Collection of the Société Anonyme: Museum of Modern Art 1920* (New Haven: Yale University Press, 1950), p. xv.

[3] Ibid.

[4] Franz Marc, "Excerpt from Letters," quoted in *Collection of the Société Anonyme: Museum of Modern Art 1920* (New Haven: Yale University Press, 1950), p. xxiv.

[5] See *Société Anonyme: The First Museum of Modern Art 1920–44*, vol. 1: Documents, Reprint of Original Catalogue of 1926–27 Exhibition (New York: Arno Press, 1972).

[6] Susan C. Larsen, "Albert Gallatin: The 'Park Avenue Cubist' Who Went Downtown." *ARTnews* 77 (December 1978): 80.

[7] Jean Hélion, "The Evolution of Abstract Art as Shown in the Museum of Living Art," *Museum of Living Art Catalogue 1933* (New York: privately printed, 1933), unpaged.

[8] Balcomb Greene, interview with Susan C. Larsen, 30 January 1973.

[9] Stuart Davis, "Abstract Painting in America," Preface to Exhibition Catalogue (New York: Whitney Museum of American Art, February 12–March 22, 1935), unpaged.

[10] Thomas Craven, "Practising Americans," in *Modern Art* (New York: Simon and Schuster, 1934), p. 320.

[11] Ibid., p. 343.

[12] See Greta German, *The Lost Years: Mural Painting in New York City under the W.P.A. Federal Art Project 1935–43* (New York: Garland Publishing Co., 1978); Helen Harrison, *Social Consciousness in New Deal Murals* (Ann Arbor: University Microfilms, 1975), unpublished M.A. thesis, Case Western Reserve University; Richard D. McKinzie, *The New Deal for Artists* (Princeton: Princeton University Press, 1973); Francis V. O'Connor, *Federal Support for the Visual Arts: The New Deal and Now* (Greenwich, Conn.: New York Graphic Society, 1969); Francis V. O'Connor, ed., *The New Deal Art Projects: An Anthology of Memoirs* (Washington: Smithsonian Institution Press, 1972); Francis V. O'Connor, ed., *Art for the Millions* (Greenwich, Conn.: New York Graphic Society, 1973); Marlene Park and Gerald E. Markowitz, *The New Deal for Art* (Hamilton, N.Y.: Gallery Association of New York State, 1977).

[13] Holger Cahill, "American Resources in the Arts," in O'Connor, *Art for the Millions*, p. 41.

[14] Ibid.

[15] Burgoyne Diller, "Abstract Murals," in O'Connor, *Art for the Millions*, p. 71.

[16] Balcomb Greene, "Society and the Modern Artist," in O'Connor, *Art for the Millions*, p. 265.

[17] Ibid., p. 264.

[18] Stuart Davis, "Abstract Painting Today," in O'Connor, *Art for the Millions*, p. 122.

[19] Edward Alden Jewell, "The Realm of Art: Abstract Pennants Flying," *New York Times*, 8 March 1936, sec. 9, p. 9.

[20] Ibid.

[21] Emily Genauer, "Cubism Exhibit at Modern Museum," *The World-Telegram*, 7 March 1936, p. 12B.

[22] Thomas Craven, "Art: Building Up Picasso Again," *New York American*, 30 November 1936, p. 15.

[23] George L. K. Morris, interview with Susan C. Larsen, 2 February 1973. Transcript in Susan C. Larsen, *The American Abstract Artists Group: A History and Evaluation of Its Impact Upon American Art* (Ann Arbor: University Microfilms, 1975), p. 480.

[24] George L. K. Morris, "Art Chronicle: The Museum of Modern Art as Surveyed from the Avant-Garde." *Partisan Review* 9 (1940): 201–2.

[25] Alfred H. Barr, Jr., *Cubism and Abstract Art* (New York: Museum of Modern Art, 1936), p. 200.

[26] George L. K. Morris, "Fernand Léger Exhibition." *The Museum of Modern Art Bulletin*, Vol. I, no. 3 (October 1935): 3.

[27] Charles G. Shaw, "The Plastic Polygon." *Plastique: Paris-New York* 3 (Spring 1938): 28.

[28] Hans Hofmann, "Plastic Creation." *The League*, Vol. V, no. 2 (Winter 1932–33); reprinted in Sam Hunter, *Hans Hofmann* (New York: Harry N. Abrams, 1963), pp. 35–36.

[29] Harry Holtzman, conversation with Susan C. Larsen, 10 August 1979.

[30] Hans Hofmann, "The Search for the Real in the Visual Arts"; reprinted in Sam Hunter, *Hofmann*, p. 39.

[31] Vaclav Vytlacil, interview with Susan C. Larsen, 10 January 1974; Larsen, *American Abstract Artists Group*, pp. 578–79.

[32] John Graham, "Primitive Art and Picasso." *Magazine of Art* 30 (April 1937): 237.

[33] Ibid.

[34] John Graham, *System and Dialectics of Art* (Paris and New York: 1937); reprinted as *John D. Graham's System and Dialectics of Art*, with introduction by Marcia Epstein Allentuck (Baltimore: Johns Hopkins Press, 1971), Introduction.

[35] Ibid.

[36] See Herbert Lawrence, "The Ten." *Art Front*, Vol. II, no. 3 (February 1936): 12.

[37] Ilya Bolotowsky, "Going Abstract in the Thirties," interview with Susan C. Larsen. *Art in America* 64 (September-October 1976): 72.

[38] Balcomb Greene, "Differences Over Léger." *Art Front*, Vol. II, no. 2 (January 1936): 9.

[39] Ilya Bolotowsky, interview with Susan C. Larsen; Larsen, *American Abstract Artists Group*, p. 516.

[40] American Abstract Artists, *Prospectus* (New York: privately printed, 1937), unpaged.

[41] Edward Alden Jewell, "American Abstractions," *New York Times*, 11 April 1937, sec. 10, p. 10.

[42] Charmion von Wiegand, "Fine Arts," *The New Masses*, 20 April 1937.

[43] Carl Holty, "Letter to Alfred H. Barr, Jr." 23 November 1937. On file and in microfilm with Archives of American Art, Smithsonian Institution, Washington, *American Abstract Artists Society*, Microfilm Roll NY 59-11.

[44] Alfred H. Barr, Jr., "Letter to the American Abstract Artists," 30 November 1937. On file and in microfilm with Archives of American Art, Microfilm Roll NY 59-11.

[45] George L. K. Morris, "Art Chronicle: To the American Abstract Artists." *Partisan Review* 4 (March 1938): 36.

[46] Jerome Klein, "Plenty of Duds Found in Abstract Show: More Fizzles than Explosions in Display at Fine Arts Building," *New York Post*, 19 February 1938, p. 18.

[47] Edward Alden Jewell, "Fine Arts Building Scene of Three Shows," *New York Times*, 15 February 1938, p. 23.

[48] Robert Coates, "The Art Galleries: Abstractionists and What About Them?" *New Yorker*, March 1939, p. 57.

[49] American Abstract Artists, "How Modern Is The Museum of Modern Art?" (New York: privately printed, April 15, 1940). Typography by Ad Reinhardt.

[50] George L. K. Morris, interview with Susan C. Larsen, 2 February 1973; Larsen, *American Abstract Artists Group*, p. 484.

[51] Ilya Bolotowsky, interview with Susan C. Larsen; Larsen, *American Abstract Artists Group*, p. 517.

[52] László Moholy-Nagy, *The New Vision* (New York: Brewer, Warren and Putnam, 1930; 4th revised ed., New York: Wittenborn, 1947), p. 10.

[53] See Charlotta Kotik, "Léger and America," in *Fernand Léger* (New York: Abbeville Press and Albright-Knox Art Gallery, 1982), pp. 41–59.

[54] See Nancy J. Troy, *Mondrian and Neo-Plasticism in America* (New Haven: Yale University Art Gallery, 1979).

[55] Irene Rice Pereira, *The Nature of Space: A Metaphysical Inquiry* (Washington: Corcoran Gallery of Art, 1968), p. 62.

[56] David Smith, "On Abstract Art," reprinted in *David Smith*, ed. Garnett McCoy (New York: Praeger Publishers, 1973), p. 40.

[57] Ad Reinhardt, "An Ad Reinhardt Monologue." *Artforum* 9 (October 1970): 36.

[58] Ibid.

ART AND ARTISTS

JOSEF ALBERS

Born 1888 in Bottrop, Germany; died 1976 in New Haven, Connecticut. Arrived in the United States in 1933; became U.S. citizen in 1939. Studied in Germany at Preparatory Teachers' Training School, Langenhorst, 1902–5; Teachers' College, Buren, 1905–8; Royal Art School, Berlin, 1913–15; Kunstgewerbeschule, Essen, 1916–19 (part-time); Art Academy, Munich, 1919–20; Bauhaus, Weimar, 1920–23.

Born in Bottrop, Germany, Josef Albers was the son of a house painter who instilled in him a lifelong respect for consummate craftsmanship and technical proficiency. From 1908 to 1920, Albers taught elementary school in Bottrop and other Westphalian towns; at the same time, he was producing figurative prints and drawings with a simplicity, clarity of purpose, and grace that foreshadowed his later abstract art as well as his teaching and writing.

As a student and master at the Bauhaus from 1920 to 1933, Albers ventured into abstraction, developing his instincts for precision and objectivity and deliberate anti-expressiveness. He was also exposed to the new directions in painting being taken by Klee and Kandinsky, both of whom he knew and greatly admired. Albers gained recognition for his glass constructions, metalwork, and furniture, as well as for teaching the renowned preliminary course. He married a student in the weaving workshop (Anni Albers has earned international acclaim for textiles and graphics).

When the Nazis forced the closing of the Berlin Bauhaus in 1933, Anni and Josef Albers accepted teaching positions at Black Mountain College in North Carolina, where they remained until 1949. In 1936 his work was shown at the Delphic Studios in New York, along with paintings by Werner Drewes, Paul Kelpe, and Katherine Dreier. One of the original members of the American Abstract Artists, Albers was in the group's early exhibitions, as well as in the major Museum of Modern Art Bauhaus exhibition in 1938. In the late thirties and forties he also had one-artist showings at the J. B. Neumann and Nierendorf galleries in New York.

In 1950 Albers became chairman of the Department of Design at Yale University and began his series of paintings "Homage to the Square"—the ultimate simplification of the language with which he explored color performance and subtle spatial activity. He was recognized as a teacher and writer as well as a painter; his book *Interaction of Color* has been published in eight languages.

From the moment Albers arrived in America, he began to experiment, without nostalgia or reference to the world he had known for forty-five years. What he retained from his past were his constant passions: for the revelation of optical mysteries, for maximum effect attained through the simplest possible means, for an intentional ambiguity. The "subject" of *b and p*, 1937 (cat. no. 1), shows Albers' deep fascination with the subtle nuances of visual communication: by shifting the positions of only the rectangular part of these similar letter images, all meaning, definition, and use are changed. Albers liked crisp reversals; what is a positive form in one

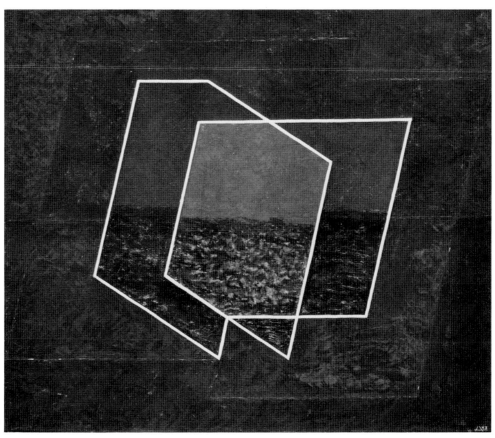

CAT. NO. 2. JOSEF ALBERS
Penetrating (B), 1943
Oil, casein, and tempera on Masonite
21½ × 24⅞ in. (54.6 × 63.2 cm.)
The Solomon R. Guggenheim Museum,
 New York

image is a void in another, causing the viewer's eyes to do strange things with the stem of each letter. *B and p* becomes more effective the longer one examines it. Albers painted each color directly on the panel, while creating an illusion of overlapping planes. In *Penetrating (B)*, 1943 (cat. no. 2), it is even harder to believe that there is no actual overlapping. The discrepancy between the facts of the painting and the viewer's perception was what Albers was striving for. In both paintings, pulsating motion coexists with stillness and calm, animation with serenity. Like all of Albers' abstractions, they stimulate and puzzle as they soothe.

Through his teaching and the exhibition of his work, Albers' methods and ideas have been widely disseminated. Among his students at Black Mountain College were Kenneth Noland and Robert Rauschenberg; at Yale he taught Richard Anuskiewicz, Eva Hesse, and Neil Welliver. In 1940 Albers concluded a speech at Black Mountain College with some of his ideas that have had a far-reaching impact:

Through works of art we are permanently reminded to be balanced, within ourselves and within others; to have respect for proportion, that is to keep relationship. It teaches us to be disciplined, and selective between quantity and quality. Art teaches the educational world that it is too little to collect only knowledge; furthermore, that economy is not a matter of statistics, but of a sufficient proportion between effort and effect.[1]

The values preached by Albers are alive in *b and p* and *Penetrating*, as in all of his experimentation of the thirties and forties. Shortly after arriving in the United States, when he was struggling with English at Black Mountain but had elected to dismiss his translator and work only with limited words and visual demonstrations, Albers cited the simple yet vast goal that these paintings help fulfill: "to open eyes."

Nicholas Fox Weber

[1] Josef Albers, "The Meaning of Art." Typescript of speech delivered at Black Mountain College, 6 May 1940. Collection of Anni Albers and the Josef Albers Foundation, Orange, Connecticut.

CHARLES BIEDERMAN

Born 1906 in Cleveland, Ohio. Apprenticed in commercial art studio, Cleveland, 1922–26. Studied at School of The Art Institute of Chicago, 1926–29.

Born in 1906 in Cleveland, of Czech parents, Charles Joseph Biederman became an apprentice in a commercial art studio at the age of sixteen, where he remained for four years. After attending the School of The Art Institute of Chicago from 1926 to 1929, he remained in that city until 1934, painting in the manner of Cézanne and exploring the Cubist idioms of Picasso and Gris. His move to New York in 1934 gave him the opportunity to meet George L. K. Morris, Charles Ratton, James Johnson Sweeney, Pierre Matisse, A. E. Gallatin, Alfred H. Barr, Jr., and Fernand Léger. At Gallatin's Gallery of Living Art, he admired the work of Léger and Mondrian, and that of Miró at the Pierre Matisse Gallery.

By the end of 1935, Biederman had begun making reliefs, some with geometric designs, others with nails, tacks, and string. A one-artist exhibition of his paintings, gouaches, collages, and reliefs opened at the Pierre Matisse Gallery on March 2, 1936, coinciding with the opening of The Museum of Modern Art's landmark exhibition "Cubism and Abstract Art." Later that month he participated in the Gallatin-sponsored exhibition "Five Contemporary American Concretionists: Biederman, Calder, Ferren, Morris and Shaw," which was subsequently presented at the Galerie Pierre in Paris and at the Mayor Gallery in London.

From October 1936 to June 1937, Biederman lived in Paris, where he was greatly impressed by the technological displays at the World's Fair, then being held in the French capital. He met Mondrian, Pevsner, Vantongerloo, Brancusi, Arp, Miró, Domela, and, again, Léger. His painting style of that period is most closely related to the work of Léger—an influence that ended in the spring of 1937 when Christian Zervos, the writer and founder of *Cahiers d'Art*, visited Biederman's studio in Paris. He saw the artist's three-dimensionally rendered, curved geometric shapes suspended in a flat pictorial space and observed: "This is sculpture, not painting."[1]

Biederman's stay in Paris caused him to miss out on the formation of the American Abstract Artists, a group whose members he knew but whose principles and politics he rejected. After his return to New York, he fashioned geometric reliefs, some after paintings he had done in Paris, and a few models for freestanding sculpture. In 1938 he attended a seminar in Chicago, conducted by Alfred Korzybski, founder of the Institute for General Semantics, which triggered his application of Korzybski's philosophy to the history of world art; it was a project that would be ten years in the making.

An intensive study of Mondrian's work (with whose writings he was unfamiliar) is reflected in Biederman's reliefs of

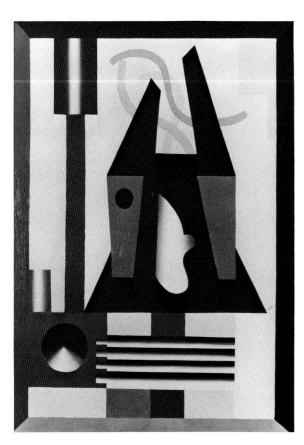

CAT. NO. 3. CHARLES BIEDERMAN
New York, July 1936, 1936
Oil on canvas
42½ × 29⅝ in. (108 × 75.3 cm.)
Private Collection. Courtesy of Grace Borgenicht Gallery, New York

those years. *Work No. 3, New York, 1939* (cat. no. 5) directly translates Mondrian's illusionistic intersections and overlappings of lines and planes into the more physically concrete elements of wood, metal, and Plexiglas.[2] Further removed from its Neo-Plasticist model, *No. 11, New York, 1939–40* (cat. no. 6), with its rhythmic framework of horizontals and verticals creating a louvered and shuttered appearance, might be formally related to Josef Albers' Bauhaus-period glass paintings, as well as to certain architectural details in Frank Lloyd Wright's prairie-style buildings.

Biederman's interest in scientific models and, possibly, America's increased exposure to the Bauhaus led to a number of oversized wall constructions. In *No. 2, New York, February 1940* (cat. no. 7), an elegant and far cry from the artist's plywood, string, and thumbtack reliefs of 1935–36 (which

had their origin in Miró's collages and reliefs), Biederman pays homage to the Constructivism of Pevsner and Gabo, invites comparison with elegantly twisted mathematical string models,[3] and may have cast a glance at Moholy-Nagy's funneling perspective lines.

Perhaps Biederman's most startling and original work in the early forties was meant to be a demonstration of certain color principles rather than a Structuralist relief in the artist's evolving style. *No. 9, New York, July 1940* (cat. no. 8) incor-

CAT. NO. 7. CHARLES BIEDERMAN
No. 2, New York, February 1940, 1940
Painted wood and metal
62½ × 48¾ × 10¾ in. (158.8 × 123.8 × 27.3 cm.)
The Minneapolis Institute of Arts: Gift of Mr. and Mrs. John P. Anderson

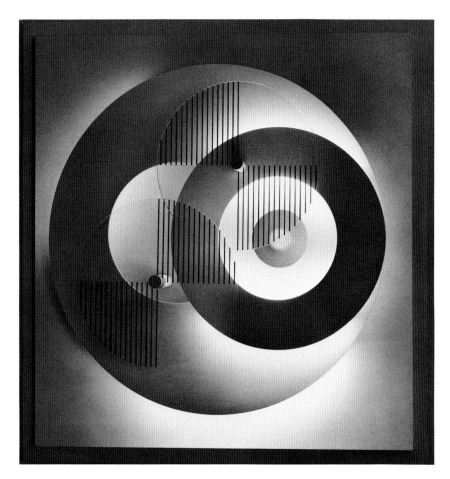

CAT. NO. 8. CHARLES BIEDERMAN
No. 9, New York, July 1940, 1940
Painted wood, glass, and fluorescent tubes
54½ × 51⅞ × 17¾ in. (138.4 × 132.1 × 31.8 cm.)
Collection of Mrs. Raymond F. Hedin

porates fluorescent lamps in the three primary colors, invisible but for the hues they project.[4] There is a striking similarity of intention between this immaterial, artificially arrived-at color effect and the spray-gunned color shading of some 1945–50 reliefs. Ultimately, Biederman rejected color spills and color blends in favor of solid, individually distinguished colors for each plane against solid-colored backgrounds.

Biederman's work in the thirties and early forties is not characterized by the kind of formal complexities or dense colors that occur in his postwar art. Historically, it documents the artist's attempt to create a specifically American art from the heritage of European abstraction, but stops short of the dialectic interpretation of Monet's colors and Cézanne's proto-Cubist forms that distinguishes Biederman's mature Structuralist style.

In 1941 Biederman moved to Chicago, where he exhibited reliefs employing glass, Bakelite, and brass at the Kathar-ine Kuh Gallery and the Arts Club. He married Mary Katherine Moore in December 1941 and the following year moved to Red Wing, Minnesota, where he worked on an army medical project for the duration of World War II. He interrupted making reliefs during the war years, but in his spare time wrote *Art as the Evolution of Visual Knowledge*. He continues to live and work in Red Wing.

Jan van der Marck

[1]Charles Biederman, interview with Jan van der Marck, 1964.
[2]The work was reproduced in Biederman's book *Art as the Evolution of Visual Knowledge*, p. 551, facing a reproduction of the Gallatin Collection's Mondrian, *Opposition of Lines, Red and Yellow*, 1937, eliminating any doubt as to the work's spiritual allegiance.
[3]Charles Biederman, *Art as the Evolution of Visual Knowledge*, p. 567.
[4]*No. 9, New York, July 1940* may be the first recorded instance in history of the use of fluorescent light in art. The hot cathode, low-voltage fluorescent light tube began to be marketed in the United States in 1938.

ILYA BOLOTOWSKY

Born 1907 in St. Petersburg, Russia; died 1981 in New York City. Arrived in the United States in 1923; became U.S. citizen in 1929. Studied at National Academy of Design, New York, 1924–30.

Although as an artist Ilya Bolotowsky was wholly American, he spent the formative years of his life abroad. He was born in 1907 in St. Petersburg, Russia, the second child of a Jewish lawyer and his wife. Bolotowsky's parents, liberal anti-Communists, were forced to move the family out of Russia, then to Constantinople, and finally in 1923 they resettled in New York. Bolotowsky studied at the National Academy of Design from 1924 to 1930 and during the subsequent Depression years worked first on the Public Works of Art Project and then from 1936 to 1941 painted abstract murals for the WPA Federal Art Project in New York. In 1937 he was a founding member of the American Abstract Artists and actively participated in the group's programs and exhibitions. After World War II, during which he served in the U.S. Air Force, he returned to New York and exhibited with J. B. Neumann's New Art Circle Gallery. Beginning in 1946, he replaced Josef Albers for two years as chairman of the art department at Black Mountain College—the first of numerous college teaching positions he held over the next twenty-five years. In the late forties, when Bolotowsky began painting Neo-Plastic works, he had one-artist exhibitions with Rose Fried, Neumann, and finally the Grace Borgenicht Gallery, which represented him from 1952 to 1980. In 1962 he began showing sculpture in the form of "painted columns." A retrospective exhibition of his work was presented at The Solomon R. Guggenheim Museum in 1974.

For Bolotowsky, the years 1927–44 bracket very nearly precisely the period of greatest visible change, development, and diversity in his work. Both before and after beginning to paint abstractly in the mid-thirties, he made delicate, neo-classically inspired drawings from life, expressionist landscapes and interiors, and a few compositions paying direct homage to such masters as Braque, Klee, and Arp. His first abstractions veered between playful interaction of biomorphic forms and rather more severe, geometrically generated arrangements of rectangles, diamonds, and grids. More important, there were compositions alloyed from both sets of materials. Such eclecticism suggests a young artist trying on different styles in the first flush of freedom from the school regime—and Bolotowsky was patently relieved to depart from the National Academy in 1930. The style in which he ultimately made his most important statements—the variant on Mondrian's Neo-Plasticism—was reached only a full fifteen years after his 1933 encounter with the master's work. If his later paintings gave evidence of a more resolved artistic personality, his work of the thirties and early forties gave proof of love—that *coup de foudre* experienced by him and his friends upon discovering European modernism.

51

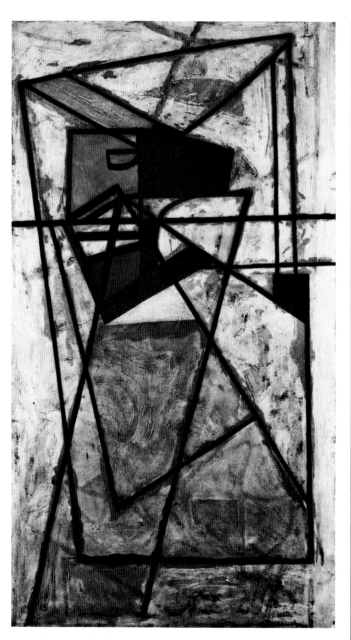

CAT. NO. 9. ILYA BOLOTOWSKY
White Abstraction, 1934–35
Oil on canvas
37 × 19 in. (88.5 × 48.2 cm.)
Robert Hull Fleming Museum, University of Vermont, Burlington

Whether metaphoric and surreal or geometric and austere, abstraction was the essential key opening the artistic culture of the Old World to the young American artists. Bolotowsky's painting placed him firmly within the small avant-garde circle of the American Abstract Artists; yet he was not a partisan of any particular kind of abstraction, nor did he believe abstraction to be superior to other kinds of painting. The certainties of ideology were abhorrent to him, perhaps because he had grown up under the old regime in Russia and witnessed its violent end. As a liberal humanist, he was at odds with the intermingled political and artistic evangelism that colored New York intellectual life in the thirties, and contemptuous of those who confused changing the world with changing the course of painting.

Unlike some of his friends, among them Burgoyne Diller and Rosalind Bengelsdorf, Bolotowsky did not go to study Cubism in Hans Hofmann's classes at the Art Students League. Nor, when major Europeans such as Hélion and Mondrian appeared on the New York scene, did he really attempt to become close to them, as others did. Although he registered the impact of both painters in his work of those years, he seems to have preferred—partly from modesty, partly from a stubborn independence—knowing their work to knowing *them* well. Among his close friends in the thirties and forties were many members of the American Abstract Artists group, but Bolotowsky found his peers' companionship most valuable not in intimate exchanges about work, but in the common goal of forming an avant-garde.

On an emblematic trip to Europe in 1932, Bolotowsky bridged the gap between his early expressionist essays and the new challenge of abstraction. Europe provided in one continuum stretching from past to present the great tradition of plastic invention forgotten by the Academy: Bolotowsky most closely studied the simplified forms and Neo-Platonic geometry of Piero della Francesca and the School of Paris' prismatic, funhouse-mirror images of nature. In Piero's pictures nature stood perfected, idealized; in the Cubism of Picasso and Braque lay its deconstruction. For Bolotowsky, Cubism represented the ultimate answer to the uses of perception—perception that shattered naturalism. Back from Europe, painting his first still life, he paid direct homage to Braque. With the Cubist flattening out of volumes and weaving together of figure and ground, Bolotowsky finally managed to move beyond the Academy's rendering of the object to an architectonics of space. Conscious as he was of Hofmann's teaching of Cubism from life, Bolotowsky went no further in its vocabulary; he was now eager to enter into

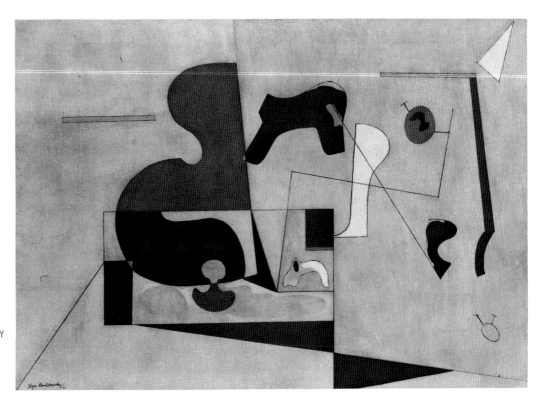

CAT. NO. 10. ILYA BOLOTOWSKY
Painting, ca. 1936
Oil on canvas
25½ × 36¼ in. (64.8 × 92.1 cm.)
Private Collection. Courtesy
 of Washburn Gallery, New York

CAT. NO. 12. ILYA BOLOTOWSKY
Untitled, ca. 1936–37
Oil on canvas
30 × 40 in. (76.2 × 101.6 cm.)
Collection of Edward R. Downe, Jr.

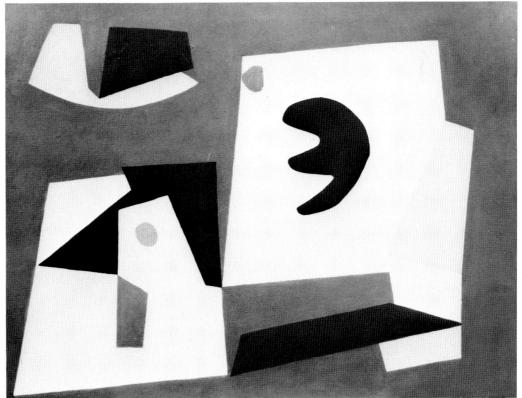

picture-making that dispensed with the object altogether.

Bolotowsky's first nonrepresentational painting, *White Abstraction*, 1934–35 (cat. no. 9), took him a long time to complete. Containing nothing but white space and black lines in the plane, this picture was the first evidence of the impact on Bolotowsky of Malevich's total banishment of the object as either image or volume. The aerial perspective of *White Abstraction* recalls Malevich's antigravitational floating planes, their diagonals zooming into infinity as their shapes all remain clearly fixed and sharply delineated in the plane. Flatness—the embedding of all pictorial tensions in the plane —was the great twentieth-century idea Bolotowsky learned from studying Malevich. Few New York artists of the thirties were so deeply influenced by Malevich as was Bolotowsky, who derived from him not only modern structures but also something more personal: the crisp, rather dry drawing of Suprematism became Bolotowsky's own hand in the thirties and forties. And in the colorist paintings of his Neo-Plastic style, it is Malevich who is evoked in their austere surfaces and exactitude rather than the more sensuous canvases of Mondrian.

Though the absolute nonobjectivity of Malevich's compositions did not hold him for long, Bolotowsky had now become a painter not of things, but of forces. In the anthropomorphic Surrealism of Miró, who said, "For me a form is never something abstract. It is always a sign of something,"[1] Bolotowsky found a vocabulary of images compounded or reduced from nature. In easel paintings such as *Painting*, ca. 1936 (cat. no. 10), and *Abstraction (No. 3)*, 1936–37 (cat. no. 11), and in the mural he completed for the 1939 New York World's Fair, he trapped the ebbing and flowing organic matter of Surrealism in sharp, neat color shapes: using collage to compose studies, he felt out each shape as discrete weight, tension, direction, and set it down on a clear, flat ground. These paintings of the late thirties have wry, playful arrangements of families of forms. If it is hard to forget their parentage in the biomorphic forms of Arp and Miró, their character seems pure Bolotowsky—neat, arch, but never slick.

During the forties, Bolotowsky gradually sifted the Surrealism from his painting. He had reached out in the thirties, in such works as *Abstraction (No. 3)*, to sources like Giacometti, whose angst was always rather foreign to Bolotowsky's own nature; in such compositions, the mysterious aura of Giacometti's haunting *Palace at 4 A.M.* (see fig. 22, ill. p. 224) provided a motive, but failed to provide resonance. In the early forties, Bolotowsky began to reconsider Mondrian, whom

he had first encountered in 1933, and to look closely at the geometric abstraction and Neo-Plasticism, respectively, of his two friends Albert Swinden and Burgoyne Diller. In his own pictures, Bolotowsky responded by beginning to isolate the pure elements of geometric painting and invent with them alone. In *Construction in a Square*, 1940 (cat. no. 14), and *Blue Diamond*, 1940–41 (cat. no. 15), shape, direction, and character of form are derived only from straight lines in a plane. The diagonal is the sole agent of pulling and pushing back and forth in a shallow space; color alone acts to expand and contract the compartments of space.

Bolotowsky's last work before the war reflected his admiration for Hélion's paintings of sphinxlike humanoids. He constructed looming, geometric forms and returned, briefly, to figures on a ground plane. At this point he was still pushing compositions to resolutions as he found them necessary, even if they were inconsistent with what had gone before. Only after the war, in the late forties, would Bolotowsky eliminate the diagonal altogether from his work; beyond that step lay the controlled improvisations of the Neo-Plastic style. In finally coming to Mondrian, Bolotowsky would accept, for the next forty years, a single, idiosyncratic, highly personal path out of the decade of the thirties. As a young man he had dreamed of mastering the new language of European art; in Neo-Plasticism he was finally enabled to speak that language with no trace of an accent.

Deborah M. Rosenthal

[1] James Thrall Soby, *Joan Miró* (New York: Museum of Modern Art, 1959), p. 14.

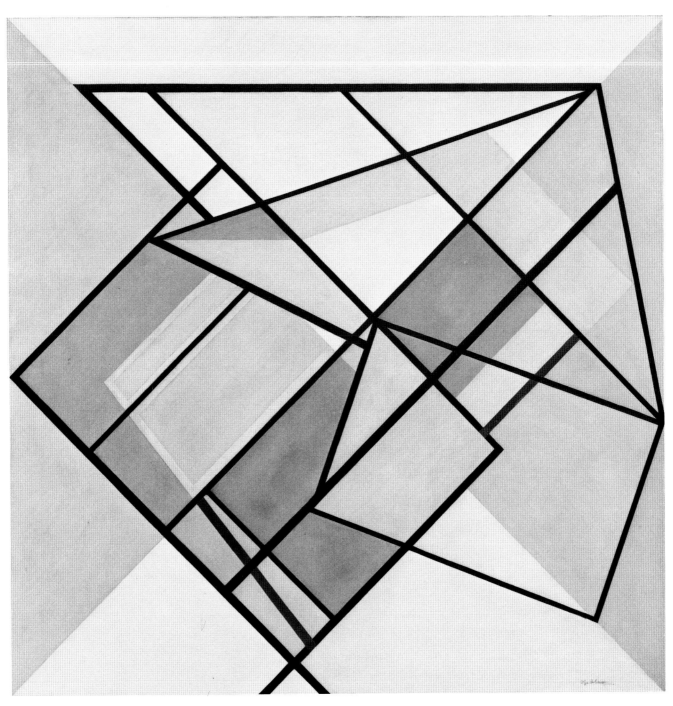

CAT. NO. 14. ILYA BOLOTOWSKY
Construction in a Square, 1940
Oil on canvas
30⅛ × 30⅛ in. (76.5 × 76.5 cm.)
The Museum of Fine Arts, Houston; Museum purchase with funds provided
 by the National Endowment for the Arts and Joan Fleming

BYRON BROWNE

Born 1907 in Yonkers, New York; died 1961 in New York City.
Studied at National Academy of Design, New York, 1925–28.

Byron Browne graduated from the National Academy of Design in 1928, armed with nearly every award its instructors could bestow. By 1930, however, he had discarded every trace of that traditional training to devote his entire career to injecting modernism into American art. His conversion to abstraction and pioneering efforts to establish it as a valid force in American art trace their origins to two major sources. In 1927 A. E. Gallatin opened his Gallery of Living Art in New York, and it was here that Browne first saw Cubist works by Braque, Gris, and Picasso. He was also strongly influenced by the French periodical *Cahiers d'Art*, which carried reproductions of the works of important European modernists.[1] In the belief that Cubism could extricate American art from its Social Realist morass, Browne incorporated these forms into his own vernacular.

Non-Objective Composition, 1935–36 (cat. no. 17), illustrates Browne's interest in a geometricized abstraction. Hard-edged trapezoidal planes intersect surrounding shapes; small splintered forms act as a galaxy, activating the surface to staccato rhythms.

Constructivist-like geometry did not remain central to Browne's oeuvre. For example, the planar elements within a work unique to that oeuvre—a nearly white-on-white canvas titled *Classical Still Life*, 1936 (cat. no. 18)—are more organic and curvilinear. Remnants of figuration are also clearly visible. In much of his work of the thirties and well into the forties, he struggled to break the hold of traditional naturalism by exploring Cubist devices of fragmentation and transparent overlapping planes. Here can also be seen the emergence of a private iconography—the piercing bird's eye, for example.

This symbolic "language" is highly developed in the forms of *Arrangement*, 1938 (cat. no. 19). The dot and circle "eye," shapes reminiscent of parts of animals, and a stamen looming out of the central mass are integral to the composition. Pruning them from objects arranged on a table, always a favored idiom, Browne has distilled from them the barest equivalents.

In a comparison between two paintings bearing identical titles but executed nearly a decade apart, *Still Life with Apples*, 1935 (cat. no. 16), and 1944 (fig. 1), the countershifting push-pull of color planes in the earlier canvas, upon which the embryonic form depends, has nine years later given way to a less formalized structure and a more expressive application of paint. One notes a greater contrast in scale between forms in the earlier work, resulting in an illusion of bounding movement, while a pervasive stillness results from the more

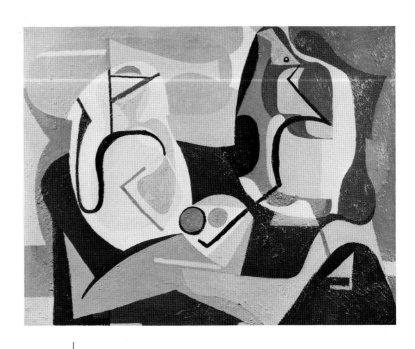

RIGHT
CAT. NO. 16. BYRON BROWNE
Still Life with Apples, 1935
Oil on Masonite
30 × 38 in. (76.2 × 96.5 cm.)
Collection of Mr. and Mrs. Harvey W. Rambach

BELOW, LEFT
CAT. NO. 17. BYRON BROWNE
Non-Objective Composition, 1935–36
Oil on canvas
35½ × 29 in. (90.2 × 73.7 cm.)
Collection of Cornelia and Meredith Long

BELOW, RIGHT
CAT. NO. 19. BYRON BROWNE
Arrangement, 1938
Oil on canvas
38 × 30 in. (96.5 × 76.2 cm.)
New Jersey State Museum, Trenton; Museum Purchase

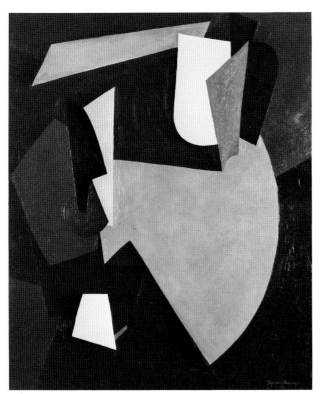

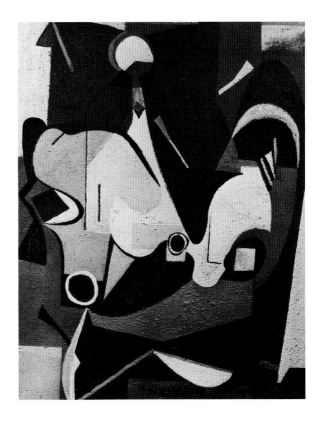

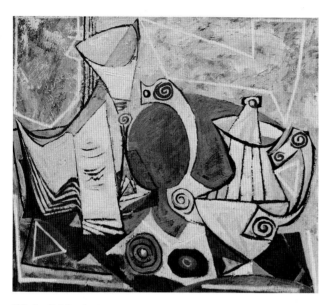

FIG. 1. BYRON BROWNE
Still Life with Apples, 1944
Oil on canvas
24 × 28 in. (61 × 71.1 cm.)
Collection of Frank E. Baxter

homologous-sized objects used in the 1944 painting. Now items such as the teapot, book, and goblet palpably materialize. Here Browne employs black lines to describe his forms, whereas in the earlier example only the meeting of colors functions to delineate shape. Browne's style would become even freer and more expressionistic in the later forties and fifties as he eliminated dependence on European abstraction. Regardless of its foreign origins, Browne's work carries an unmistakable American stamp in its more naive, less formal approach to the complexities of structure and its brighter palette.

Browne's commitment to abstract art impelled him to speak out forcefully during this period. He joined the Artists' Union in 1935 and used the pages of its organ, *Art Front*, to defend abstraction. [2] He was a founding member of American Abstract Artists, and on April 15, 1940, along with some fifty other members of the group, signed his name to a broadside titled, ''How Modern Is The Museum of Modern Art?'' The group also picketed the museum to protest its failure to exhibit abstract work by American artists. Browne also helped draft a lengthy diatribe against the New York art press, [3] and on his own wrote a vitriolic letter that appeared in the *New York Times* in 1940, expressing his opinion of the ''baseball-minded American public'' and its attitude toward the creative painter.[4] As a member of the American Artists' Congress, he took a political stand against Fascism.

Browne shared an intense interest in primitive art with John Graham. Their friendship resulted in Graham's writing the catalogue foreword to one of Browne's exhibitions. [5] Arshile Gorky often engaged in heated discussions with Browne, and many parallel forms can be found in their works of this period.

Of considerable significance is the artistic interchange between the painters and collectors who formed a summer colony at Provincetown, Massachusetts. Giorgio Cavallon, Adolph Gottlieb, Hans Hofmann, Karl Knaths, and Lee Krasner were among the artists whose studios Browne frequented.

During the thirties Browne participated in the WPA Federal Art Project, for which he executed several of his finest murals. [6] In 1945 Samuel Kootz opened his New York gallery and in the ensuing years presented numerous exhibitions of the artist's work. Beginning in 1948, Browne taught at the Art Students League and later at New York University.

April J. Paul

[1]Rosalind Bengelsdorf Browne, interview with April Paul, New York City, 20, 26 August; 2, 8 September 1978. Mrs. Browne recalled that the young artists would trade issues of *Cahiers d'Art*, which also carried reproductions of such sources of modernism as primitive art. Browne also learned Cubism from Hans Hofmann, with whom he studied briefly in 1935.
[2]Byron Browne, et al., Letter, *Art Front* (October 1937): 20–21.
[3]American Abstract Artists, eds., *The Art Critics—! How Do They Serve the Public? What Do They Say? How Much Do They Know? Let's Look at the Record!* (New York: privately printed, 1940). Distributed at the group's fourth annual exhibition and written by the members, its twelve pages were designed by Ad Reinhardt.
[4]Byron Browne, Letter, *New York Times*, 11 August 1940, sec. 10, p. 7.
[5]John D. Graham, foreword to exhibition catalogue, *Byron Browne*. New York: Artists' Gallery, March 1938.
[6]Edward Alden Jewell, ''Abstraction and Music: Newly Installed WPA Murals at Station WNYC Raise Anew Some Old Questions,'' *New York Times*, 6 August 1939, sec. 9, p. X7.

ALEXANDER CALDER

Born 1898 in Lawnton, Pennsylvania; died 1976 in New York City. Studied at Stevens Institute of Technology, Hoboken, New Jersey, 1915–19; Art Students League, New York, 1923–26; Académie de la Grande Chaumière, Paris, 1926.

The son and grandson of renowned sculptors, also named Alexander Calder, the creator of the mobile and the stabile first trained as a mechanical engineer. In 1923 Calder enrolled at the Art Students League. Three years later, his sojourns in Paris began, and for the next decade he was actively involved with the European vanguard.

Calder's first illustrated book, *Animal Sketching*, published in 1926, was based on studies at the Bronx and Central Park zoos in New York. That same year he created his first wire and wooden animals with movable parts. Wire figures followed, giving birth to the miniature *Circus*. Performances of Calder's hand-operated circus helped introduce him to the Parisian avant-garde and to potential patrons, both in the United States and Europe. After fabricating figures, animals, and portraits in wire and carved wood for four years, he began to create abstract constructions in 1930 as the direct result of his visit to Mondrian's studio. Calder was invited to join Abstraction-Création in 1930 (he was one of the few Americans to be actively involved with the group), and in 1931 his first abstract constructions were shown in Paris. That one-artist exhibition was followed the next year by a show of the first hand-driven and motorized mobiles.

Calder's early mobiles were first exhibited in New York at the Julien Levy Gallery in 1932. Thereafter he had yearly New York shows at the Pierre Matisse Gallery. A. E. Gallatin included Calder in his 1936 exhibition at the Reinhardt Galleries in New York, "Five Contemporary American Concretionists," and he was the only American sculptor to be represented in The Museum of Modern Art's landmark exhibition "Cubism and Abstract Art" that same year. In 1938 Calder bought a farm in Roxbury, Connecticut, and thereafter divided his time between visits abroad and longer periods of residence in the United States.

Unlike Isamu Noguchi, who frequently returned to figurative work after his initial metal constructions of 1927, Calder remained fully committed to abstraction during the thirties. Quickly he assimilated biomorphism and Constructivism and developed a personal style. He was encouraged by leading members of the European avant-garde, including Miró, Duchamp, Arp, and Léger. While his American contemporaries were only beginning to discover Constructivism, Calder was already having one-artist exhibitions of his work both in the United States and abroad.

The Pistil, 1931 (cat. no. 20), was one of Calder's first abstract constructions and was included in his one-artist exhibition at the Galerie Percier in Paris in 1931. The work is among the earliest of the studies of the universe that Calder

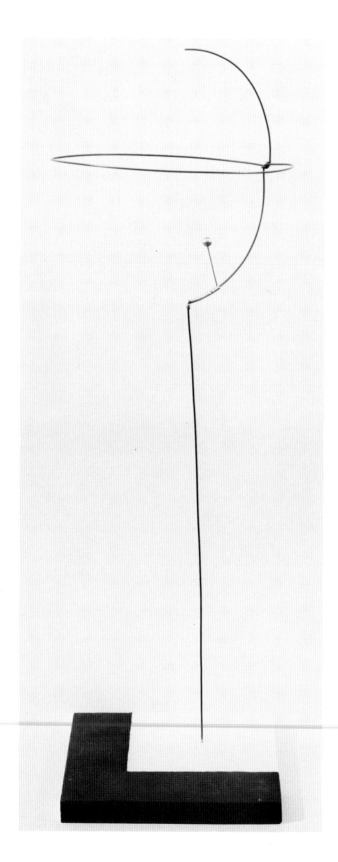

produced during this period. Fascinated by eighteenth-century scientific models, such as the armillary sphere and the orrery, he sought to construct his own model of the cosmos.[1] Geometric forms dominate in Calder's first mobiles, but by 1934 biomorphic elements assume greater importance. For example, *Dancers and Sphere*, 1936 (cat. no. 22), with its painted "backdrop" for a mechanical ballet, suggests links to Miró and Arp. This miniature stage set might also be related to the "plastic interludes" Calder created for Martha Graham ballets—circles and spirals that "performed" on an empty stage between dances.

Calder refined his wind-driven mobiles in subsequent years to produce elegant, space-encompassing abstractions of gracefully bending wires to which metal elements were attached. In 1941 a mobile was commissioned by architect Wallace K. Harrison for the ballroom of the Hotel Avila in Caracas, Venezuela (cat. no. 23). The delicately balanced, rhythmical work was an appropriate complement for an architectural interior intended for ballroom dancing. In 1942 Calder was one of the few American artists invited to participate in "First Papers of Surrealism," the New York exhibition at the Reid Mansion that showed the work of many of the European Surrealists who had come to the United States at the beginning of World War II.

With metal scarce during the war years, Calder began to use pieces of painted wood, which he attached to steel wires for his constructions. These nonkinetic "Constellations" (cat. nos. 24 and 25) were a new development in his work, reflecting the impact of Abstract Surrealism, particularly Miró's paintings of the late thirties (also called "Constellations").

Although Calder refused to join the American Abstract Artists and was not eligible for the WPA Federal Art Project, he did maintain certain contacts with American modernists. As the first American to achieve international success for Constructivist/Surrealist sculpture, he exerted a strong influence on younger American artists committed to abstraction.

LEFT
CAT. NO. 20. ALEXANDER CALDER
The Pistil, 1931
Brass and wire on wooden base
40 × 12¾ × 12¾ in. (101.6 × 32.4 × 32.4 cm.)
Whitney Museum of American Art, New York; Gift of the Howard and Jean
 Lipman Foundation, Inc., and purchase, 1970

OPPOSITE
CAT. NO. 21. ALEXANDER CALDER
Construction, 1932
Painted wood and metal
35 × 30¼ × 26½ in. (76.8 × 88.9 × 67.3 cm.)
Philadelphia Museum of Art; A. E. Gallatin Collection

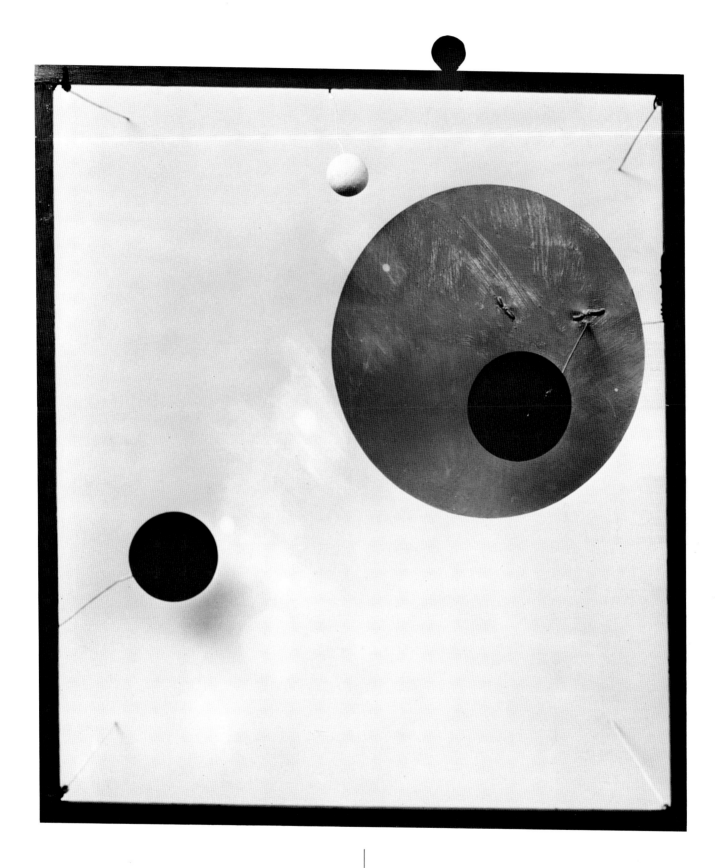

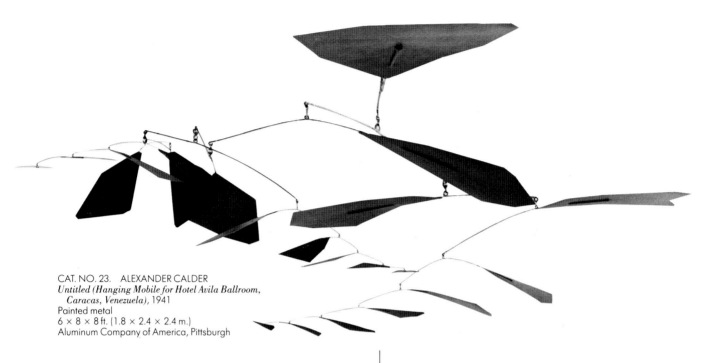

CAT. NO. 23. ALEXANDER CALDER
*Untitled (Hanging Mobile for Hotel Avila Ballroom,
 Caracas, Venezuela)*, 1941
Painted metal
6 × 8 × 8 ft. (1.8 × 2.4 × 2.4 m.)
Aluminum Company of America, Pittsburgh

CAT. NO. 24. ALEXANDER CALDER
Constellation, 1943
Wood and metal rods
22 × 44½ × 11¾ in. (55.9 × 113 × 30 cm.)
The Solomon R. Guggenheim Museum, New York; Collection of Mary
 Reynolds: Gift of her brother

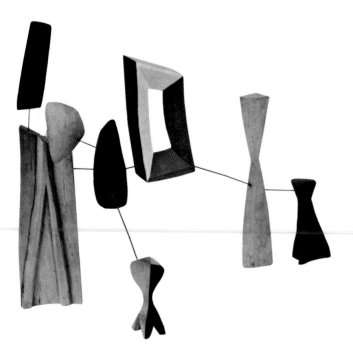

Among 'his major commissions of the thirties were the *Mercury Fountain* for the Spanish Pavilion at the Paris Exposition in 1937 and a fountain with dancing jets for the New York World's Fair in 1939. Beginning in the thirties and into the forties, Calder designed stage sets for ballets and the theater. His work also included oil paintings, prints, jewelry, tapestries, and architectural interiors. By the fifties, he was creating mobiles enlarged to a scale necessary for vast interiors, notably those constructed for the International Arrivals Building at Kennedy International Airport in New York and for the UNESCO Building in Paris. Calder's first monumental stabiles were exhibited in 1959. Three years later he went to Italy to supervise the fabrication of a sixty-foot stabile, *Teodelapio*, which subsequently became a permanent installation in Spoleto. In the following years he completed numerous commissions, including *El Sol Rojo* for the Aztec Stadium, Mexico City, 1966; *Man* for the World's Fair, Montreal, Canada, 1967; and *La Grande Vitesse*, Grand Rapids, Michigan, 1969.

Joan Marter

[1] Joan Marter, "Alexander Calder: Cosmic Imagery and the Use of Scientific Instruments." *Arts* 53 (October 1978): 108–13.

STUART DAVIS

Born 1894 in Philadelphia; died 1964 in New York City.
Studied at the Henri School, New York, 1909–12.

Son of the art director of the *Philadelphia Press*, the newspaper that employed the artists who would compose the nucleus of The Eight, Stuart Davis was born into the nascent modern movement in America in 1894.[1] In 1909, having early on determined to be an artist, Davis was sent to study at Robert Henri's school in New York. There he became close to his teacher John Sloan, absorbed the Ashcan School style of Henri and his associates, embraced the raw vitality of contemporary urban life that informed their art, learned to value individual expression over academic rules, and acquired a taste for art theory. In 1913, a year after leaving the Henri School, he exhibited five watercolors in the Armory Show. Davis considered this exhibition—his first opportunity to see a broad range of European and American modernist art—to be the single most important event in his formative years, as a direct result of which he resolved to become a modern artist.

During the teens Davis worked his way through a variety of Post-Impressionist influences and achieved in the early twenties a remarkably sophisticated grasp of modernism. By 1926, when his painting *Super Table* was included in the Société Anonyme's "International Exhibition of Modern Art" at The Brooklyn Museum, Davis had largely caught up with stylistic and theoretical developments in Synthetic Cubism. At the time, he was virtually the only painter in America addressing the abstract tendencies of Picasso, Braque, Gris, and Léger.

In 1927–28 Davis painted a series of pictures called the "Eggbeaters" that were the first truly abstract paintings to be made in America in nearly a decade. In *Eggbeater No. 1* (cat. no. 26), abstract geometric forms are located in an interior architectural space open to a night sky. The subject matter has been transformed into flat, invented shapes that are no longer descriptive of their sources. Davis wrote about the "Eggbeaters":

In the first place my purpose is to make Realistic pictures. I insist upon this definition in spite of the fact that the type of work I am now doing is generally spoken of as Abstraction. The distinction is important in that it may lead people to realize that they are to look at what is there instead of hunting for symbolic suggestions. A picture is always a three-dimensional illusion regardless of subject matter. That is to say that the most illusionistic types of painting and modern so-called abstractions are identical in that they both represent an illusion of the three-dimensional space of our experience. They differ in subject which means that they choose a different character of space to represent.[2]

In the spring of 1928, with financial support from Juliana

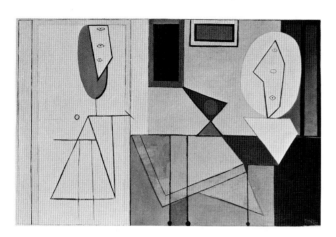

FIG. 2. PABLO PICASSO
The Studio, 1927–28
Oil on canvas
59 × 91 in. (149.9 × 231.1 cm.)
The Museum of Modern Art, New York; Gift of Walter P. Chrysler, Jr.

Force, director of the Whitney Studio Club (after 1930 called the Whitney Museum of American Art), Davis sailed for France and spent a year and a half in Paris before returning to New York in August 1929. The experience seems to have had no immediate impact on the advancement of his art, which during that period evidenced the return of descriptive detail to his paintings of Parisian streets and buildings. He stayed within the American artists' colony in Paris and did not come in direct contact with the leading French modernists. Seemingly more important for his development were the friendships he formed back in New York with John Graham, Arshile Gorky, Jan Matulka, David Smith, and Willem de Kooning, all of whom were interested in Cubism and especially Picasso—an enthusiasm that first drew them together in 1929–30.

Placing great importance on what he called an intuitive "optical geometry" imposed on nature by the artist, Davis began in 1932 to turn sketches of the Gloucester, Massachusetts, waterfront into stark, trued and faired, transparent armatures. *Landscape*, 1932–35 (cat. no. 28), for example, eschewed the more traditional spatial implications of his earlier work in favor of an emphatic flatness. This work found its stylistic source in Picasso's art of the late twenties, particularly the painting *The Studio*, 1927–28 (fig. 2).

Davis' mature style crystallized during the early thirties when he became the only painter of major importance to choose to deal with the subject matter of the then-flourishing American Scene movement and, at the same time, to maintain his modernist ambitions. His distinctive vernacular Cubism is evi-

dent in *Sail Loft*, 1933 (cat. no. 29), a painting that combines multiple images into a synthesis of art and description; the sail loft itself occupies the upper left quadrant, a general dock and harborscape composing the other three-quarters of the picture, and a miniature abstract line drawing stylistically similar to *Landscape*, is located in the center. Flat planes of color are used to refer to different locations in three-dimensional space without sacrificing the integrity of the picture plane by resorting to traditional perspective; the flatness is further reinforced by the presence of the independent and aggressively two-dimensional abstract drawing within a painting.

Davis came to full artistic stride before any of the other important American modernists of the thirties. Gorky wrote of him in 1931:

Yet the silent consequences of Stuart Davis move us to the cool and intellectual world where all human emotions are disciplined upon rectangular proportions.... this man, this American, this pioneer, this modest painter, who renders—clear, more definite, more and more decided—new forms and new objects. He chooses new rules to discipline his emotions.... This artist... expresses his constructive attitude toward his successive experience. He gives us symbols of tangible spaces, with gravity and physical law. He above his contemporaries, rises high—mountain like! Oh, what clarity! One he is, and one of but a few, who realizes his canvas as a rectangular shape with two-dimensional surface plane.... This man, Stuart Davis, works upon that platform where are working the giant painters of the century.[3]

The respect Davis enjoyed in the New York art community is suggested by his election to the presidency of the newly formed Artists' Union in 1934, his appointment as editor of

FIG. 3. STUART DAVIS
Swing Landscape, 1938
Oil on canvas
86¾ × 173⅛ in. (2.2 × 4.4 m.)
Indiana University Art Museum, Bloomington

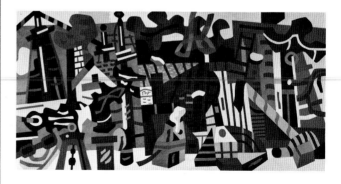

the union's lively journal, *Art Front*, in 1935, and his election as secretary (1936) and chairman (1938) of the American Artists' Congress. In 1932 Davis' art was included in The Museum of Modern Art's exhibition "Murals by American Painters and Photographers" and the Whitney's "First Biennial of Contemporary American Painting." In 1935 his work figured prominently in the Whitney's "Abstract Painting in America," an exhibition whose catalogue also contained an essay by Davis. The most eloquent spokesman for modernist American art with a social conscience during the thirties, Davis believed that artists should enter the "arena of life problems"[4] to play a leadership role in the general movement for social progress.

Davis participated in the various federal art programs from 1933 to 1939. This financial support permitted him to dedicate substantial time to organizational activities and writing. In 1936 he left The Downtown Gallery, where Edith Gregor Halpert had been his dealer since 1927, mounting five one-artist exhibitions of his paintings. Davis renewed this gallery affiliation in 1941 after an unsuccessful attempt to represent his own work. In the meantime he painted major murals for the WPA Federal Art Project at Radio Station WNYC, the Brooklyn College Faculty Lounge, and the Williamsburg Housing Project. The latter, *Swing Landscape*, 1938 (fig. 3), may be the Federal Art Project's most outstanding public-scale abstract work. This mural—a compendium of events, objects, and areas organized on a grand-scale Cubist framework—draws on Davis' familiarity with Léger, particularly the French artist's large painting *La ville* (The City), 1919 (fig. 4). Davis also painted easel pictures for the Federal Art Project, and in such works as *Terminal*, 1937 (cat. no. 30), he combined what he considered to be his basic content, "constructive order," with a more specific reference to working-class subject matter.

During the late thirties Davis was a bellwether for an increasing sense of disillusionment with Stalinist-Marxist political and aesthetic thought within the American artistic community. Many artists began to look to what were perceived to be the more liberal theories of Trotsky and returned to their studios to concentrate on formal concerns. Bitterly discouraged by the Stalinist takeover of the American Artists' Congress, Davis largely withdrew from public art life in 1940 and concentrated on his search for a synthesis between color and design. The end result was the development of his concept of "Color-Space," an intuitive measuring system for handling the optical advance and retreat of colors, paralleling and complementing the "optical geometry" notion of de-

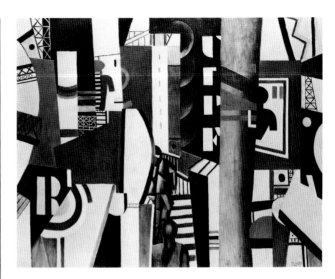

FIG. 4. FERNAND LÉGER
La ville (The City), 1919
Oil on canvas
90¾ × 117¼ in. (2.3 × 3 m.)
Philadelphia Museum of Art; The A. E. Gallatin Collection

sign he had developed in the early thirties.

The culmination of these researches is *Report from Rockport*, 1940 (cat. no. 32), a painting in which there is an especially taut relationship between color and line, surface and depth, that speaks for the dualism of flatness and illusionistic space that characterizes modernist painting. The subject is the town square of Rockport, Massachusetts, and this combination of a regional visual reference to the American Scene with a sophisticated formal construction epitomizes Davis' contribution to American painting.

About 1940 there was considerable frustration among New York artists with the late Cubism of Picasso, and ambitious American painters were seeking a new formal vocabulary to transcend the venerable Synthetic Cubist style. In *Report from Rockport*, Davis, looking toward Miró and Matisse, employed an elaboration of decorative motifs and an emphasis on the constructive properties of color. This development accelerated during the next few years under the influence of Mondrian and the Gestalt psychologists at The New School for Social Research in New York, where Davis had begun teaching in 1940. Although during the thirties he had argued persuasively that all subject matter must find its source in the natural world and common experience, his study of Mondrian's writings during the early forties led to a significant modification of that position and helped Davis to rationalize

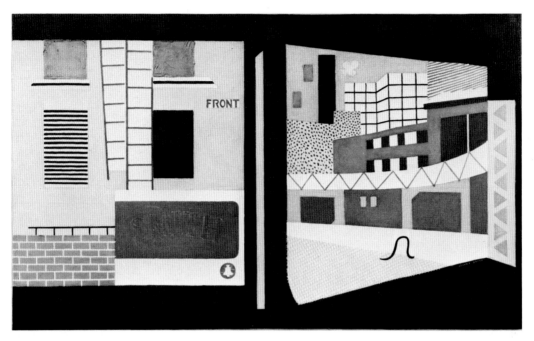

CAT. NO. 27. STUART DAVIS
House and Street, 1931
Oil on canvas
26 × 42¼ in. (66 × 107.3 cm.)
Whitney Museum of American Art, New York

the practice of inventing forms for his own increasingly abstract art.

Gestalt theories—which held that the process of vision integrated significant structural patterns and that images can be extensively abstracted and still retain their affiliation with reality—encouraged further abstraction in Davis' art. They also provided him with a foundation for what he called "configuration theory," the goal of which was to create an all-over pictorial scheme to which the response would be a complete experience rather than a sum of discrete reactions to the parts. This was a post-Cubist ambition, and, in *Ultramarine*, 1943 (cat. no. 33), a painting in which the invented decorative vocabulary overwhelms the structure, and every detail is brought to near equal visual intensity, Davis achieved the tenets of his "configuration theory." While Mondrian stated that Davis was "the most abstract . . . of the young Americans,"[5] the fact is that even in a painting as abstract as *Ultramarine*, his art retained an analogical relationship with the natural world, and he had no more transcended his realist propensities than he had his structural foundations in Cubism.

While Davis predicted the end of European artistic hege-

mony and believed he was a leader in the American vanguard, it was the innovations of Gorky and then Jackson Pollock that were most conspicuously responsible for the enduring shift of the international center of advanced art to New York. Still, Davis may be regarded as the most important American artist of the period immediately preceding the emergence of Abstract Expressionism. Despite a gruff, tough-guy public persona in keeping with his origins in the Ashcan School, he was, through his published writings and copious personal notes, one of the most perceptive and articulate art thinkers of his time. He may be seen as the last American modernist painter of the first rank whose chief contributions were made to a culture that was still provincial.

John R. Lane

[1]There is evidence to suggest that the artist may have been born in 1892. See John R. Lane, *Stuart Davis: Art and Art Theory* (New York: Brooklyn Museum, 1978), p. 18.
[2]Stuart Davis to Edith Halpert, 11 August 1927, Edith Halpert Papers, Archives of American Art, Smithsonian Institution, Washington.
[3]Arshile Gorky, "Stuart Davis." *Creative Art* (September 1931), p. 215.
[4]Stuart Davis, "A Medium of Two Dimensions." *Art Front* (May 1935), p. 6.
[5]Jay Bradley, "Piet Mondrian 1872–1944: Greatest Dutch Painter of Our Time," *Knickerbocker Weekly*, 3, no. 51 (1944), p. 16.

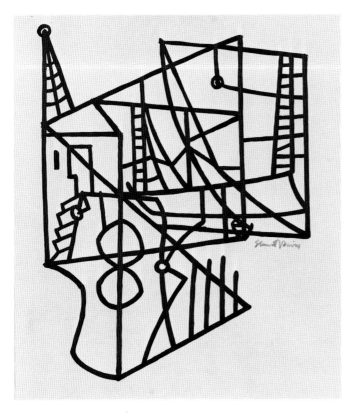

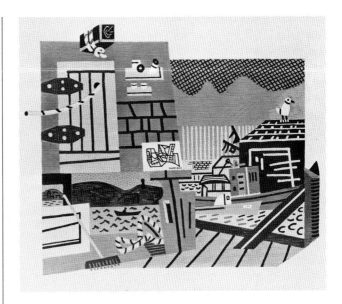

CAT. NO. 29. STUART DAVIS
Sail Loft, 1933
Oil on canvas
15 × 18½ in. (38.1 × 47 cm.)
Collection of Dr. and Mrs. Milton Shiffman

CAT. NO. 28. STUART DAVIS
Landscape, 1932–35
Oil on canvas
32½ × 29¼ in. (82.5 × 74.2 cm.)
The Brooklyn Museum, New York;
 Gift of Mr. and Mrs. Milton Lowenthal

CAT. NO. 31. STUART DAVIS
Hot Still-scape for 6 Colors—7th Ave. Style, 1940
Oil on canvas
36 × 45 in. (91.4 × 114.2 cm.)
Museum of Fine Arts, Boston, and William H. Lane Foundation

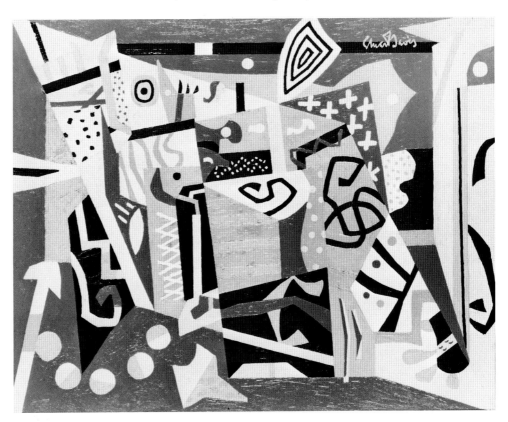

WILLEM DE KOONING

Born 1904 in Rotterdam, the Netherlands. Arrived in the United States in 1926; became U.S. citizen in 1961. Studied as an apprentice to Jan and Jaap Gidding, Rotterdam commercial artists and decorators, 1916–20; with Bernard Romein, art director of Rotterdam department store, 1920–24; evening student at Academie voor Beeldende Kunsten en Technische Wetenschappen, Rotterdam, 1916–24.

After solid academic training in color, figure drawing, composition, and shading, apprenticeship in a commercial art firm, and work with a commercial designer, Willem de Kooning embarked for the United States and what he hoped would be a successful career as an illustrator. At the age of twenty-two, he chose to go to New York in preference to the capitals of Europe, considering them played out. De Kooning arrived in the United States without papers, having worked his passage as a seaman. He did not leave the country again until 1961—the year he became a United States citizen—because he feared being stopped at the border as an illegal entrant.

Of all the New York artists of his time, he had the best formal art education. At first he supported himself as a house painter, which he found far more lucrative and less tiring than doing commercial art. For a year de Kooning lived in Hoboken, New Jersey, and then settled in New York's Greenwich Village, where he became part of a wide circle of artists that included the poet Edwin Denby as well as the painters John Graham, Stuart Davis, Jackson Pollock, and Franz Kline. He had a special relationship with Arshile Gorky, a virtual mentor, whose personality and art profoundly affected the direction and character of de Kooning's own work. In 1937, owing to the fact that he was an alien, de Kooning was dropped from the WPA Federal Art Project. Through the late thirties and early forties, de Kooning and his contemporaries—Gorky, Pollock, Mark Rothko, and Adolph Gottlieb—all came to the brink of their most important statements.

An untitled work of about 1942 (cat. no. 34) represents many of de Kooning's concerns during this period. In contrast to the large-scale works usually associated with the New York School, this painting is of a modest size. A traditional easel painting in dimensions, it characterizes the methodical, uncertain, yet courageous development of these artists. Though many of them had painted murals for the WPA (and de Kooning had painted houses), truly large-scale painting did not appear until 1944 with Gorky's *The Liver Is the Cock's Comb*. In de Kooning's 1942 painting, such massive scale as would subsequently be achieved is not even hinted at, and this intimate work classically divides the canvas into compartments that suggest a cumulative and synthetic meaning (the gift of Surrealism)—both spatially and in terms of subject matter. At the upper left, a rectangle-as-door invites entry, introduces a unit of architectural cadence, and suggests a blank fictive depth behind the picture, while still patterning the surface with a flat design. Vaguely, in the lower right, an articulated biomorphic bundle heralds the world of

living things; it occurs in the same place in the composition that a similar shape appears in Gorky's "Nighttime, Enigma and Nostalgia" series (worked on through the thirties), itself a compositional quotation from de Chirico.

Larger and more accomplished, *The Wave*, ca. 1942–44 (cat. no. 35), displays the rising confidence with which de Kooning approached his art only a short time later. The same window/door that appeared in the 1942 work now floats, on the right, free as any rectangle in Hans Hofmann's work; just so economical had de Kooning become that he no longer tethered his shapes to the canvas edges for the sake of structural or iconographic security. A brilliant red-orange disc glows above the contrasting green field in which the anatomically arranged figure lounges. The whole is so suavely conceived, so assured in execution—with a minimum of colors (flat, if hardly "minimal" monochromes) and thinly painted

sheets deftly adjusted in color scheme—that what we behold, even at this early moment in the forties, can already be termed a classical achievement of abstraction and a plateau of synthesis.

De Kooning had his first one-artist exhibition in 1948 at the Charles Egan Gallery in New York, after he had already shown with a group of modern American and European artists selected by John Graham. Thereafter, he frequently showed his work, becoming—along with Pollock—the virtual polestar of a generation. It has long been assumed that de Kooning's paintings were among the major works described by Harold Rosenberg's phrase "Action Painting." De Kooning taught at Black Mountain College, but has never been associated with any institutional art program. He lives and works in The Springs, East Hampton, Long Island.

Harry Rand

CAT. NO. 35. WILLEM DE KOONING
The Wave, ca. 1942–44
Oil on Masonite
48 × 48 in. (121.9 × 121.9 cm.)
National Museum of American Art,
 Smithsonian Institution, Washington;
 Gift of Vincent Melzac Collection

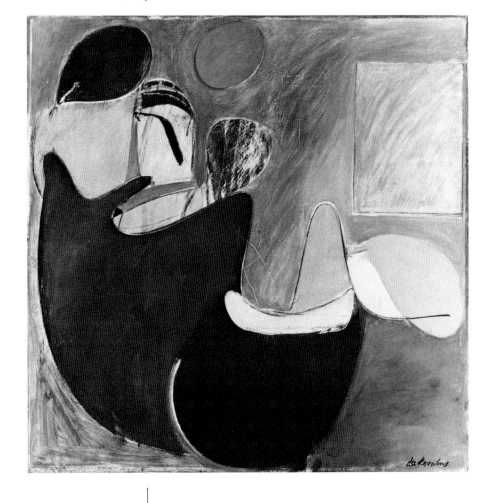

BURGOYNE DILLER

Born 1906 in New York City; died 1965 in New York City. Studied at Art Students League, New York, 1929–33.

A track star with an athletic scholarship might seem to be an unlikely candidate for the role of championing abstract art in America during the thirties and forties, but Burgoyne Diller had already begun to paint and draw in 1920 at the age of fourteen. While an undergraduate at Michigan State University in Lansing, he made frequent trips to Chicago, where he studied Impressionist and Post-Impressionist paintings at the Art Institute. Although he was impressed at first by the pointillism of Seurat's *Sunday Afternoon on the Island of La Grande Jatte*, Cézanne's landscapes and still lifes ultimately had a more profound impact on Diller's development. Under their influence he made a series of several hundred drawings and paintings of three objects placed on a table, seeking to achieve volumetric effects similar to Cézanne's by means of pure color relationships.[1] By 1929, when Diller enrolled in classes at the Art Students League, his paintings reflected a variety of stylistic influences, including those of Analytic and Synthetic Cubism, as well as German Expressionism and the work of Kandinsky, most of which he knew only through reproductions.

During the next five years, Diller studied at the League with several different teachers, including Jan Matulka, George Grosz, and Hans Hofmann. He also took courses in lithography, and Harry Holtzman, a fellow student, recalls that they made lithographs together in 1933.[2] The previous year, both artists had participated, along with Charles Trumbo Henry and Albert S. Wilkinson, in the first exhibition of abstract art held in the League Gallery.

Katherine Dreier, founder and president of the Société Anonyme, must have been aware of these activities when she approached Diller in 1934. As he later recalled: "Katherine Dreier at one point was very much interested in having exhibitions of abstract work. At that time there were no places to exhibit; so Katherine—I knew her and she asked me if she could use the studio and if I could round up some artists to come in and talk about the possibility of if not an exhibition at least a publication.... It was her idea to make a portfolio...."[3]

According to Holtzman, he and Diller, along with Alexander Calder, Stuart Davis, Werner Drewes, Arshile Gorky, John Graham, and David Smith, met with Dreier in the winter of 1934.[4] Diller added Paul Kelpe's name to the list and remembered further: "...the most prominent ones, of course, we'd love to have gotten involved: Stuart Davis, Gorky and Calder. Because Katherine Dreier was going to be there they showed up, but then Calder was receiving a good deal of attention in Paris at that time and he was not too interested obviously.... Gorky and Davis who never got along too well

took the opportunity to insult each other . . . so the rest of us, the younger ones, just sat with them and listened."[5] Thus the meeting produced no direct results, but it may have helped stimulate thinking about the efficacy of a portfolio of prints such as the twenty-seven lithographs produced by the American Abstract Artists three years later.

Diller's painting style was developing rapidly in response not only to his classes at the League but also to reproductions of European art he saw in magazines such as *Cahiers d'Art* and in books he might have perused at Weyhe's Bookshop on Lexington Avenue.[6] Although in 1933 he was completing paintings that contained representational elements, his untitled composition of about 1933 (cat. no. 36) demonstrates that he was beginning to be influenced by reproductions of the nonfigurative work of Russian Suprematist and Constructivist artists. Although in one of his earliest constructions, dating from 1934 (cat. no. 37), Diller seems to have been indebted to Calder's compositional forms in his choice and juxtaposition of three different-sized circles and a fourth, irregularly shaped element, the black ground against which these are placed evokes a deep space that is implied in many works by Malevich and Lissitzky. The use here of real materials projecting into space may also have its roots in Russian Constructivism. In addition, the "push-pull" spatial effect produced by the relational play between sizes and colors attests to the impact of Hofmann's teaching, while the emphasis on primary colors in this as in many of Diller's early works reflects his awareness of De Stijl. Diller's great achievement lies in the fact that eventually he was able to weave these various threads of influence into a fabric that was very much his own.

It is important to deal directly with the notion of influence in order to grasp the high quality and individual character of Diller's art. After he first encountered an original painting by Mondrian, probably toward the end of 1933, virtually all of Diller's work involved the principles of Neo-Plasticism which the Dutch artist had begun to define in his paintings more than ten years earlier. Writing about this issue in 1961, Sidney Tillim stated that Diller's work was not intended to express the moral and philosophical attitudes professed by Mondrian. Thus, Tillim argued, "Diller's work is not 'about' Neoplasticism," which functions in his art as a set of stylistic conventions, a system with rules to which Diller adhered while still introducing many formal innovations.[7] For example, the primary colors, black and white, and the rectangular forms of Diller's *Second Theme*, 1937–38 (cat. no. 38), are clearly indebted to Mondrian, just as the overlapping of linear and planar components can be found in paintings of the late

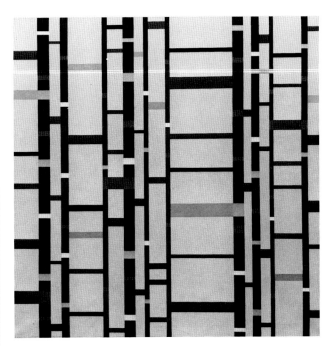

FIG. 5. BURGOYNE DILLER
Third Theme, 1946–48
Oil on canvas
42 × 42 in. (106.7 × 106.7 cm.)
Whitney Museum of American Art, New York; Gift of Miss May Walter

twenties by van Doesburg, but Diller's manipulation of these elements is unique. Whereas in Mondrian's paintings before 1940, color and line almost always remained discrete, color being deployed only in rectangles bound by a framing edge or a black line, here Diller used color in broad bands that function as lines spanning the length of the canvas and changing direction as well. And although van Doesburg had used lines to contrast with rectangular forms, his lines were always black, and thus did not function as planes in the way Diller's band of blue does here.

Second Theme also reflects Diller's interest in the spatial properties of color and form, which received even more attention in the relief constructions he continued to make until 1941. While these sculptural works were obviously generated by Diller's activity as a painter, they differ markedly from both the protruding compositions and the solid, four-sided painted columns made by his friend Holtzman at about the same time. In both *Construction No. 16*, 1938 (cat. no. 39), and *Construction*, 1938 (cat. no. 40), Diller built overlapping colored planar and linear forms in front of a rectangular framing element. The wall on which the constructions hang

is meant to serve as a ground against which the forms seem to hover independently in space, as if only tenuously held together by the surrounding frames that are an integral part of each piece.

Although the decade of the thirties was a prolific period for Diller, he was unable to sell a single work, even after his one-artist exhibitions in 1933 and 1934. The following year he accepted an administrative post in the WPA Federal Art Project in New York as managing supervisor of the Mural Division. It was his job to locate sponsors for mural projects by federally supported artists, and as Audrey McMahon, director of the Federal Art Project for the New York region, later wrote: "This was no mean problem...."[8] Diller was able to arrange mural commissions for Davis, Gorky, Matulka, Ilya Bolotowsky, Byron Browne, Balcomb Greene, Paul Kelpe, Albert Swinden, and many other artists whose work might otherwise have been rejected as too advanced. One artist recalled that Diller "... encouraged and expedited transfers of abstract artists to the mural division, gathering them, so to speak, 'under his wing.'"[9] Many of those he helped were also associated with one another as members of the American Abstract Artists, and although Diller had no time to attend the group's meetings, he was invited to join and showed in its first three annual exhibitions.

Diller served as liaison between the Federal Art Project and the organizers of the 1939 World's Fair in New York. He was subsequently appointed assistant technical director of the Federal Art Project and during World War II worked in the War Service Section of the WPA. In 1945 he joined the design department of Brooklyn College, where he taught for twenty years.

It was probably not until after the war that Diller began to refer to his work in terms of three interrelated visual themes, each determined by the manner and degree to which formal elements of composition were anchored to the surface plane of the painting. During the late forties and early fifties, under the influence of Mondrian's last paintings, Diller developed the "Third Theme" (fig. 5). These were his most complex images, often using strips of paper and tape to arrive at the final composition, just as Mondrian had been doing in his last work, the unfinished *Victory Boogie Woogie*.

Nancy J. Troy

[1]Lawrence Campbell, "The Rule that Measures Emotion." *Art News* 60 (May 1961): 35.
[2]Harry Holtzman, interview with Nancy J. Troy, 3 November 1975.
[3]Burgoyne Diller, interview with Ruth Gurin, 21 March 1964. Typescript, Archives of American Art, Smithsonian Institution, Washington, p. 1.
[4]Holtzman, interview with Troy.
[5]Diller, interview with Gurin, p. 2.
[6]Holtzman has said that during this period "... perhaps one of the most important informational places ... was Weyhe's Bookshop. And Weyhe was a remarkable and sympathetic and decent human being with a very sensitive responsiveness to young people.... I hardly bought a thing there in years of coming in just to look at books which I couldn't afford to buy." Interview with Ruth Gurin, 11 January 1965. Typescript courtesy of Harry Holtzman, Lyme, Connecticut, pp. 11–12.
[7]Sidney Tillim, "Month in Review." *Arts* 35 (June 1961): 78.
[8]Audrey McMahon, "A General View of the WPA Federal Art Project in New York City and State," in *The New Deal Art Projects, An Anthology of Memoirs*, ed. Francis V. O'Connor (Washington: Smithsonian Institution Press, 1972), p. 59.
[9]Rosalind Bengelsdorf Browne, "The American Abstract Artists and the WPA Federal Art Project," in *The New Deal Art Projects*, ed. O'Connor, p. 277.

CAT. NO. 36. BURGOYNE DILLER
Untitled, ca. 1933
Tempera on board
15½ × 9½ in. (39.4 × 24.1 cm.)
Meredith Long & Co., Houston

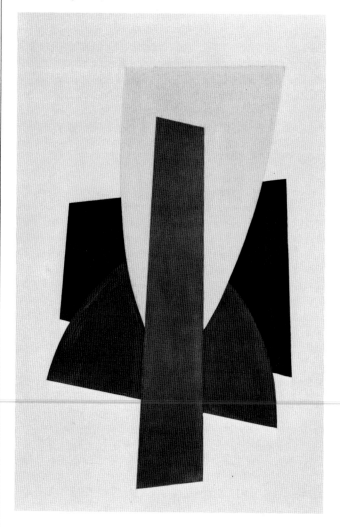

CAT. NO. 37. BURGOYNE DILLER
Construction, 1934
Painted wood and fiberboard
24 × 24 × 2 in. (61 × 61 × 5.1 cm.)
Hirshhorn Museum and Sculpture Garden,
 Smithsonian Institution, Washington

CAT. NO. 38. BURGOYNE DILLER
Second Theme, 1937–38
Oil on canvas
30⅛ × 30 in. (76.5 × 76.2 cm.)
The Metropolitan Museum of Art, New York;
 George A. Hearn Fund, 1963

WERNER DREWES

Born 1899 in Brandenburg, Germany. Arrived in the United States in 1930; became U.S. citizen in 1936. Studied at Stuttgart School of Architecture and Stuttgart School of Arts and Crafts, 1920–21; Weimar Bauhaus, 1921–22; Dessau Bauhaus, 1927–28.

As a young man of twenty-two, Werner Drewes entered the Weimar Bauhaus, where he studied for one year with Johannes Itten and Paul Klee. From 1923 to 1927 he traveled through Italy, Spain, South America, the United States, and Asia, visiting many of the world's great museums. When he returned to Germany in 1927, he studied for a year with Feininger and Kandinsky at the Dessau Bauhaus.

During the twenties Drewes worked in a figurative style with strong expressionist overtones. He was already an accomplished printmaker, specializing in the color woodcut—a lifelong involvement that would become an important aspect of his artistic career. Drewes immigrated to the United States in 1930, already somewhat familiar with American culture as a result of his earlier visits to New York, Chicago, and California. He settled in New York and began a series of woodcuts, "Manhattan," published in 1932.

Drewes taught at Brooklyn College from 1934 to 1936 under the sponsorship of the WPA Federal Art Project. In 1936 he participated in the formation of the American Abstract Artists and joined the group as a founding member. He taught at Columbia University from 1937 until his appointment in 1940 as director of the Graphic Art Project of the WPA Federal Art Project in New York. Since the WPA project drew to a close in 1941, Drewes served in this capacity only one year.

City (Third Avenue El), 1938 (cat. no. 43), is an important transitional work, bringing together the urban imagery of Drewes' earlier woodcuts and drawings and a multiplanar abstract geometry that would characterize his art for many years to come. Its structure is dynamic and rhythmic rather than static and architectonic. Drewes presents the city as a vibrant, colorful environment full of dramatic shifts of light and mood. By the early forties, his nonobjective style had matured in such works as *Escape*, 1941 (cat. no. 44). The essentially graphic nature of his art is confirmed in this painting. Bright red arrows indicate primary spatial vectors, and overlapping planes appear as sharp linear cuts through shifting zones of modulated color. The graphic precision and energy of Drewes' art reflect his early Bauhaus training, as does his complex and unusual handling of color.

Drewes spent 1945 as an instructor of design at the Institute of Design in Chicago, which had been founded by fellow Bauhaus veteran László Moholy-Nagy, and subsequently taught at the School of Fine Arts at Washington University in St. Louis, where he remained until his retirement in 1965. In 1969 the National Collection of Fine Arts in Washington, whose holdings include a substantial number of his prints, circulated a survey exhibition of Drewes' woodcuts. In recent years Drewes' work has been exhibited at Martin Diamond Fine Arts in New York. The artist lives in Reston, Virginia.

Susan C. Larsen

74

CAT. NO. 44. WERNER DREWES
Escape, 1941
Oil on canvas
34 × 36 in. (87.4 × 91.4 cm.)
The Solomon R. Guggenheim Museum, New York

JOHN FERREN

John Millard Ferren grew up in California and graduated from the Polytechnic High School in Los Angeles in 1923. He worked briefly as an engineer for California Telephone and Telegraph, but soon focused his energies on the arts. In 1924 he went to work for a company that produced plaster sculpture, mainly toys and giftware. After a brief, and unsatisfying, attendance at art school in San Francisco the following year, he apprenticed himself to an Italian stonecutter, carving tombstones and ornamental building blocks. In 1926, prompted by modeling materials seen in a store window, he began to make portrait busts, some of which were exhibited in San Francisco and Los Angeles annuals. A bust of Roland Hayes, a black tenor Ferren had seen perform, is broadly modeled with an expressively treated surface, probably inspired by Rodin. Designs for later heads indicate a more geometric, abstract style.

During his years in San Francisco, which he had left by 1931, Ferren developed the foundation of a fecund aesthetic that would inform the next three decades of his life. That aesthetic was based on his belief in an animistic universe in which the most diverse elements are intimately, intuitively related. Ferren's voracious readings and inquiries were often directed toward the mystical connections between man and nature; and in the late twenties that interest centered around oriental philosophies. Through the young abstractionist Yun Gee and other friends in the Chinese community, Ferren became conversant with Zen Buddhism, the *I Ching*, and Taoism —philosophies that stressed spontaneity, chance, and the unity underlying the vagaries of life. He translated those ideas into an aesthetic that prized audacity of color and shape, while seeking an overall balance. He characterized his approach in discussing a work similar to the untitled oil of 1937 (cat. no. 46):

My interest here was in multiplicity—the complexity lying beneath simplicity. I worked the shuttling inner forms to keep their subsidiary interest while contributing to the major swinging movement and counterbalanced the violence of movement by the use of quiet colors.[1]

In 1929, while spending a year in Europe, Ferren met Hans Hofmann and attended with him a Matisse exhibition in Munich—an experience that was decisive in Ferren's shift to painting and his fascination with color. Briefly returning to the United States, he was back in Europe by the end of 1931, where he remained for the greater part of the decade.

Ferren's years in Paris resulted in an abundance of highly praised paintings, pastels, and reliefs. Gertrude Stein noted

Born 1905 in Pendleton, Oregon; died 1970 in Southampton, New York. Studied in Paris at Académie Ranson, Académie Colarossi, Académie de la Grande Chaumière, University of Paris (Sorbonne), all ca. 1929–30; University of Salamanca, Spain, ca. 1932.

CAT. NO. 45. JOHN FERREN
Composition, 1935
Oil on canvas
38½ × 57½ in. (97.8 × 146.1 cm.)
Collection of Edward R. Downe, Jr.

CAT. NO. 46. JOHN FERREN
Untitled (JF 7), 1937
Oil on canvas
44¾ × 57½ in. (113.7 × 146.1 cm.)
The Solomon R. Guggenheim Museum,
 New York

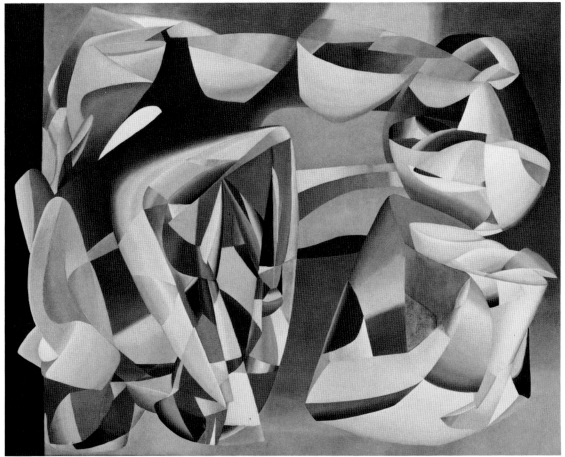

that "Ferren ought to be a man who is interesting, he is the only American painter foreign painters in Paris consider as a painter and whose paintings interest them. He is young yet and might only perhaps nobody can do that thing called abstract painting."[2]

These were times of intense exploration for Ferren. His stints at the various Paris art academies and European universities perhaps served him less than his own gregariousness and his unfailing ability to "recognize the ground current of his time."[3] Early on, he met Picasso and maintained the friendship for years, helping stretch *Guernica* in 1937 and visiting him after the war. But Ferren was chary of influences as pervasive and powerful as those of Matisse and Picasso (though, like most ambitious artists of the period, he had been affected by them). Ferren was at first more influenced by Mondrian and Kandinsky. Though he found the circle around Delaunay humorless, he was drawn to its theories also; he was already attuned to the similar Synchromist approach to color through his friendship with Yun Gee.[4] In 1932 Ferren married Laure Ortiz de Zarate, daughter of a painter, and soon became involved with the large group of Spanish-speaking artists in Paris. Torres-García, who was responsible for Ferren's first exhibition in Paris, probably introduced him to the Abstraction-Création group and its Constructivist aesthetics. During 1932–33 he investigated the straightforward placement of simple geometric planes, but during this time also he became close to Miró, later working with him in Stanley W. Hayter's Atelier 17. By late 1933, Ferren's style bore evidence of Miró's biomorphic invention, Klee's whimsy, and Kandinsky's graphic vitality.

By 1934, informed by sources as various as Léger, Brancusi, and Arp, Ferren had developed a more sharply contoured biomorphism—one that he explored during his remaining years in Paris. Working closely with Hélion, Ferren began to spread a profusion of curvilinear forms against a more coherent ground. *Composition*, 1935 (cat. no. 45), relies on a familiar late Cubist overlapping of transparent planes, but its dense weft of darting shapes and the vigor of its color are noteworthy. Typically, that color encompasses startling juxtapositions within a broader cohesion.

Ferren's association with Atelier 17, where he was introduced to the labyrinthine inventions of Hayter, Miró, Ernst, and others, had a great impact on his art. Hayter introduced him to a nineteenth-century printing technique that produced a series of exquisite reliefs. An etched and inked plate is used to impress wet plaster. After drying, the resulting plaques can be carved, using the etched lines as guides.[5] For his

untitled plaster, ca. 1937 (cat. no. 47), Ferren's exacting, virtuoso carving is combined with a design and color scheme nearly as intricate as that of his concurrent oils.

The large untitled 1937 painting (cat. no. 46) is one of the most sophisticated works of this period. The apparent disarray of forms resolves into two abstract "personages." On the right, a half-dozen loci of spinning planes twist themselves into a figure through an almost haphazard contiguity. To the left, a more elaborate tangle of shapes forms a convoluted, muscular mass. The complex interweaving of shapes makes the larger shapes nearly impossible to read. Yet its intricate color scheme, high energy level throughout, and intricate rhyming of shapes unify the picture, giving it the dynamic balance he sought.

In 1938 Ferren returned to America, troubled by his recent divorce and the threat of war in Europe. For a while he continued his association with A. E. Gallatin, Charles Shaw, George L. K. Morris, Carl Holty, and others he had met in Paris, and he also attended a few meetings of the American Abstract Artists. However, as if starting from scratch, he cut most of these ties and began a series of academic figure and still-life studies. By the late forties, after wartime service as a civilian employee of the Office of War Information, he was working in a broadly brushed Abstract Expressionist style related to his early thirties watercolors. He was an early member of The Club, an informal group at the social and intellectual center of the New York School in the fifties, and became its president in 1955. In the sixties his work returned to a more geometric tenor, still concerned with the rich interplay of color. During his three decades in New York, he taught at The Brooklyn Museum School, Cooper Union, and Queens College.[6]

Craig Ruffin Bailey

[1]John Ferren, [Statement] in Sidney Janis, *Abstract & Surrealist Art in America* (New York: Reynal & Hitchcock, 1944), p. 73.

[2]Gertrude Stein, *Everybody's Autobiography* (New York: Random House, 1937), p. 127.

[3]John Ferren, "Yun Gee," in *Yun Gee* (New York: Robert Schoelkopf Gallery, 1968), n.p.

[4]*Yun Gee*, passim.

[5]Una E. Johnson, "New Expressions in Fine Printmaking: Methods—Materials—Ideas." *The Brooklyn Museum Bulletin* XIV/1 (Fall 1952): 25–26.

[6]Further information on Ferren's life and art may be found in *Ferren: A Retrospective* by Craig Bailey (New York: The Graduate School and University Center of the City University of New York, 1979), from which this essay has, in part, been drawn. *Ferren: A Retrospective* relied heavily on the John Ferren Papers and copies of interviews with Ferren found in the Archives of American Art and on information supplied by Mrs. John Ferren, as well as public sources.

SUZY FRELINGHUYSEN

Born 1912 in Newark, New Jersey. No formal art training.

Estelle Condit Frelinghuysen was born in 1912, a member of a prominent New Jersey family. She did not have formal art training, but from her youth pursued on her own an interest in drawing and painting. In 1935 she married the abstract painter, collector, and critic George L. K. Morris. Her art had been realistic until that time, but Morris' own painting and his enthusiasm for Picasso, Braque, Gris, and Léger led Frelinghuysen to begin working in an abstract Cubist style. Although Morris was very much occupied with the Gallery of Living Art, The Museum of Modern Art, artists' organizations, writing criticism and art theory for a number of publications, and, to some extent, political issues, she did not share an enthusiasm for this kind of involvement. Her political convictions were conservative at a time when many artists leaned, to one degree or another, toward the radical left, and her interest in art was personal and intuitive, not public and theoretical.

Frelinghuysen became a member of the American Abstract Artists group in April 1937, not long after the founding of the organization, and, beginning with the 1938 Municipal Art Galleries exhibition, showed in most of the AAA exhibitions thereafter. She numbered among her closest artist friends Ilya Bolotowsky, A. E. Gallatin, Charles Shaw, and Esphyr Slobodkina. Gallatin acquired her *Composition—Toreador Drinking* for the Gallery of Living Art Collection. She joined the Federation of Modern Painters and Sculptors when it was established in 1940 in the aftermath of the political upheavals in the American Artists' Congress. During the thirties and forties, while she was seriously painting, Frelinghuysen also trained as a professional singer. From the late forties to the mid-fifties, she had a brief but critically acclaimed career on the operatic stage and in the concert hall. She lives in New York and Lenox, Massachusetts, and paints.

When Frelinghuysen began working in an abstract manner, it was the lucid Synthetic Cubism of Gris in the late teens and twenties that interested her the most. She also responded to the post–World War I work of Braque. Her oil and collage paintings of the forties share with Gris a cool elegance of color, contour, and geometric form, but differ from his work in their enrichment of surface and rather tart hues. Furthermore, Frelinghuysen did not approach her art with the kind of intellectuality that characterizes Gris. Rather, she has said she preferred an intuitive process in which she adjusted the formal elements of her pictures "to make something I liked the look of."[1] Deftly employing the plastic elements of corrugated paper, snippings from magazines and printed papers, and oil paints, she created some of the most elegant and restrained collages of the period. In *Composition*,

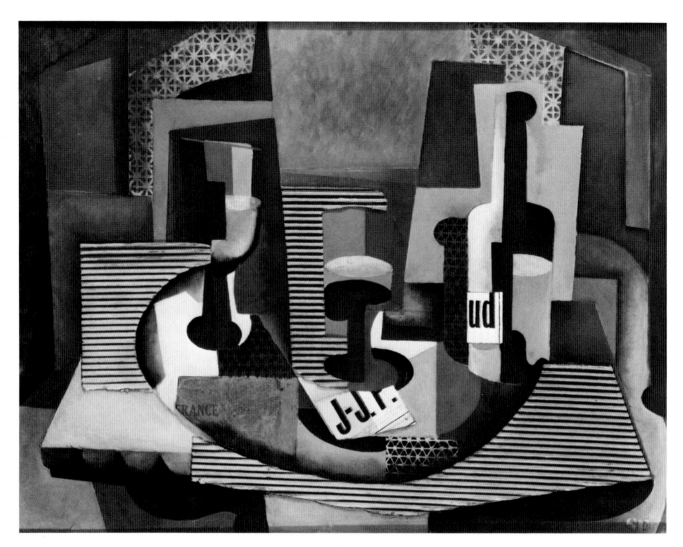

CAT. NO. 49. SUZY FRELINGHUYSEN
Still Life, 1944
Painted collage
29⅝ × 39½ in. (75.3 × 100.3 cm.)
Ertegun Collection Group

1943 (cat. no. 48), a carefully conceived arrangement of forms is further abstracted from its source in the human shape than is the more descriptive *Still Life*, 1944 (cat. no. 49), of objects on a table top, but both works reflect Frelinghuysen's belief that "most art comes from nature."[2] Her position on the issue of the origin of art forms—one shared by Morris, Gallatin, Shaw, Arshile Gorky, and Stuart Davis, among others—reflected the foundations of her aesthetic ideas in Parisian Cubism, an art that abstracted from nature and did

not seek to invent new forms not based themselves ultimately on objects in the natural world. That Frelinghuysen's contribution to Synthetic Cubism came at a late moment in the history of the style does not obviate the poetry resulting from her mastery of this visual vocabulary.

John R. Lane

[1]Suzy Frelinghuysen, interview with John R. Lane, Lenox, Massachusetts, 1 October 1982.
[2]Ibid.

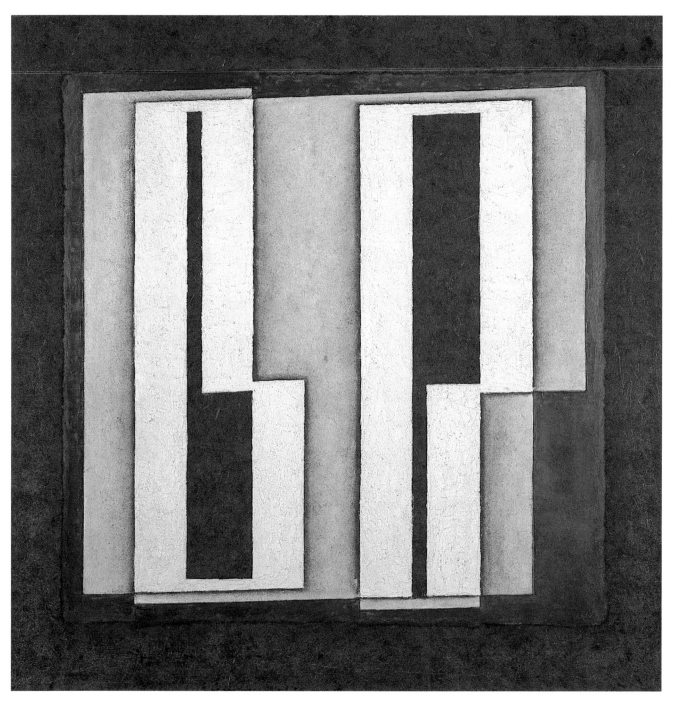

CAT. NO. 1. JOSEF ALBERS
b and p, 1937
Oil on Masonite
23⅞ × 23¾ in. (60.6 × 60.3 cm.)
The Solomon R. Guggenheim Museum, New York

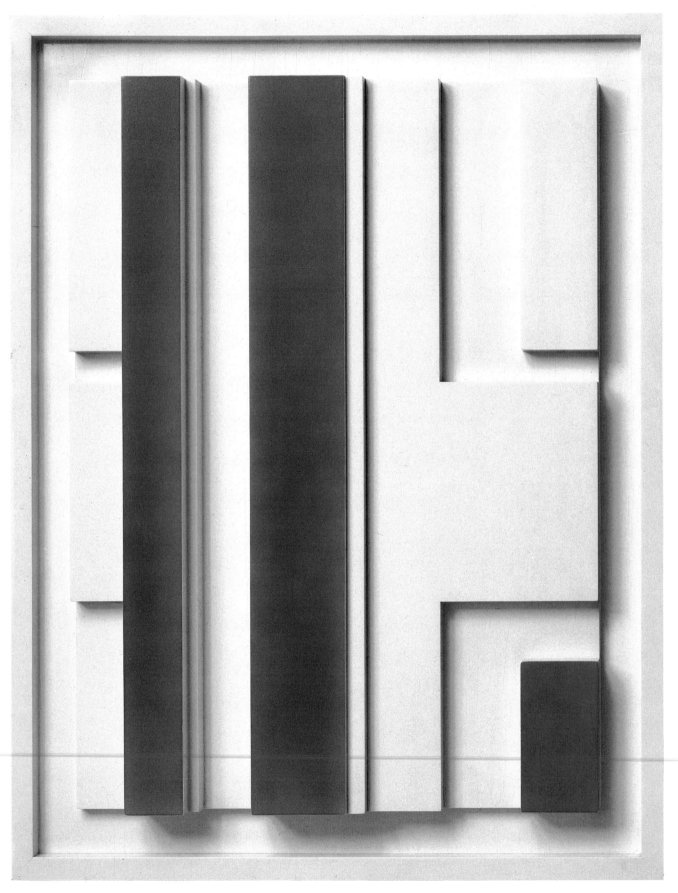

CAT. NO. 4. CHARLES BIEDERMAN
Work No. 16, New York, 1938–39, 1938–39
Painted wood
29 × 22½ × 2½ in. (73.7 × 57.2 × 6.4 cm.)
Collection of Mrs. Raymond F. Hedin

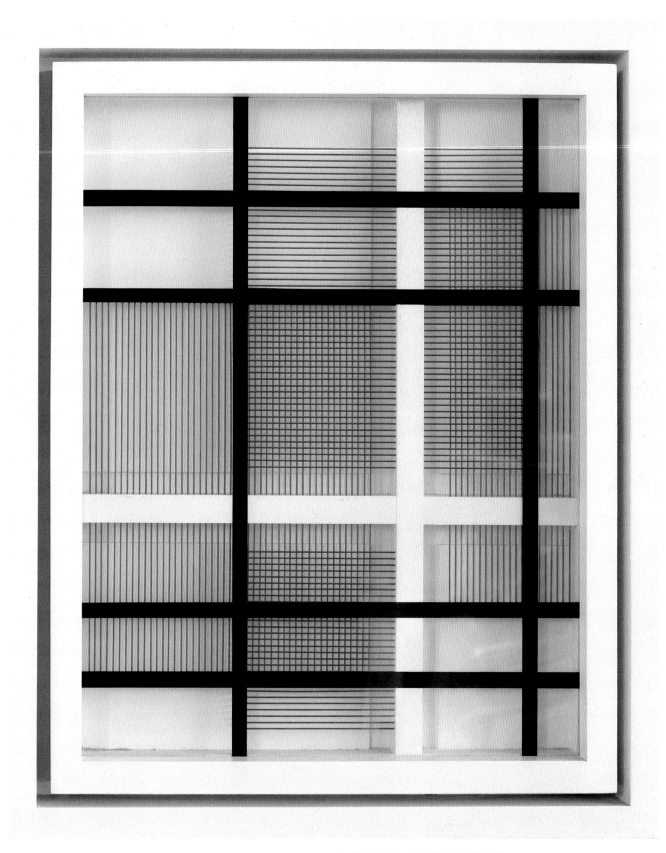

CAT. NO. 5. CHARLES BIEDERMAN
Work No. 3, New York, 1939, 1939
Painted wood, glass, and metal rods
32⁷⁄₁₆ × 26¹¹⁄₁₆ × 3¼ in. (82.4 × 67.8 × 8.3 cm.)
Collection of Mr. and Mrs. John P. Anderson

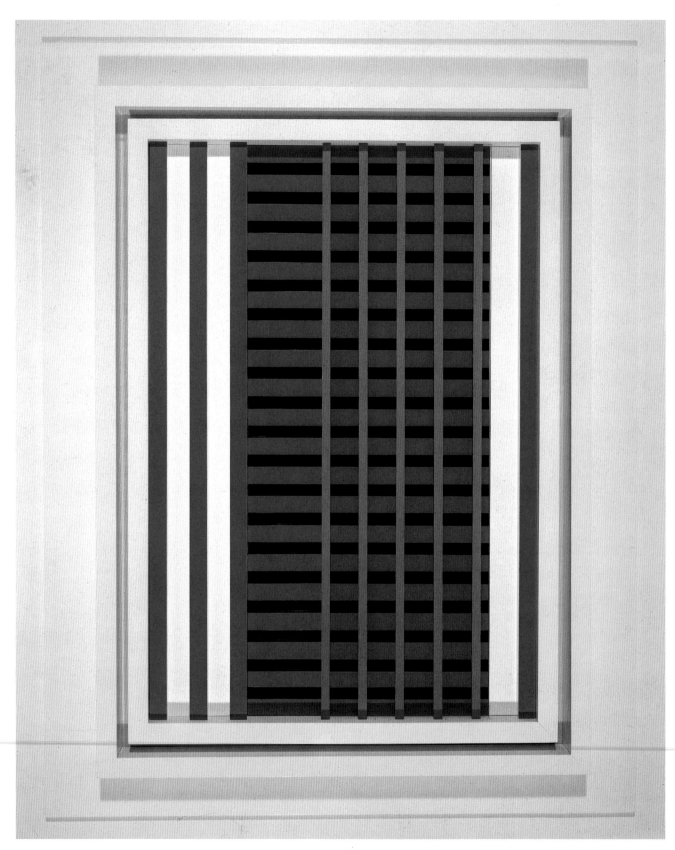

CAT. NO. 6. CHARLES BIEDERMAN
No. 11, New York, 1939–40, 1939–40
Painted wood and glass
29 × 21½ × 1⅞ in. (73.6 × 54.6 × 4.7 cm.)
Museum of Art, Carnegie Institute, Pittsburgh; Edith H. Fisher Fund, 1982

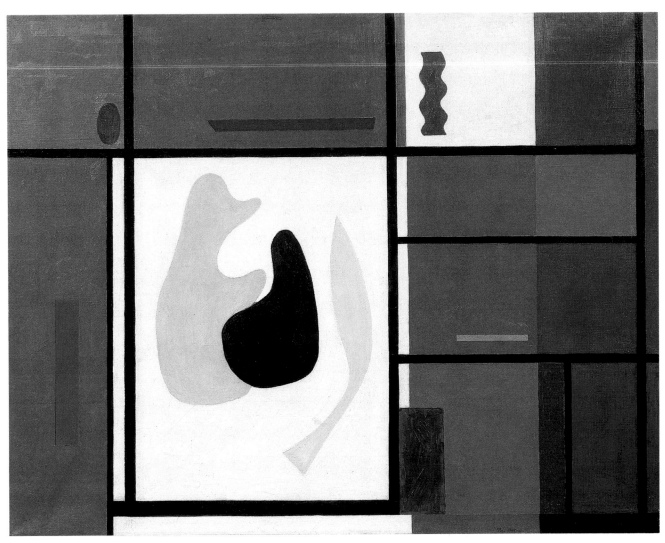

CAT. NO. 11. ILYA BOLOTOWSKY
Abstraction (No. 3), 1936–37
Oil on canvas
27¹⁵⁄₁₆ × 36 in. (71 × 91.4 cm.)
Museum of Art, Carnegie Institute, Pittsburgh; Gift of Kaufmann's and the
 Women's Committee of the Museum of Art, 1981

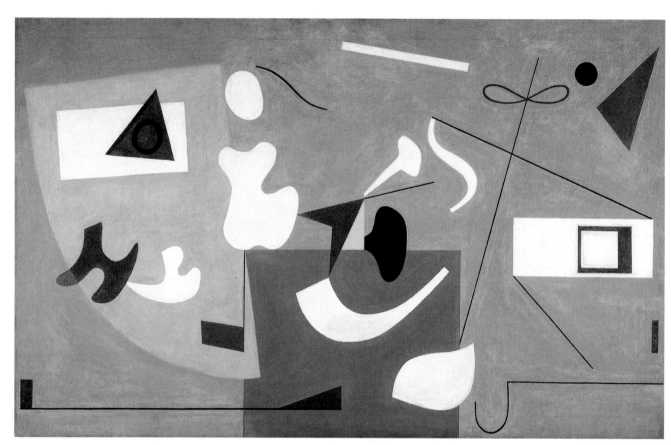

CAT. NO. 13. ILYA BOLOTOWSKY
Study for "Mural for Health Building, Hall of Medical Science, New York World's Fair," 1938–39
Oil on canvas
30 × 48 in. (76.2 × 121.9 cm.)
The Art Institute of Chicago; Wilson L. Mead Fund Income, 77.1

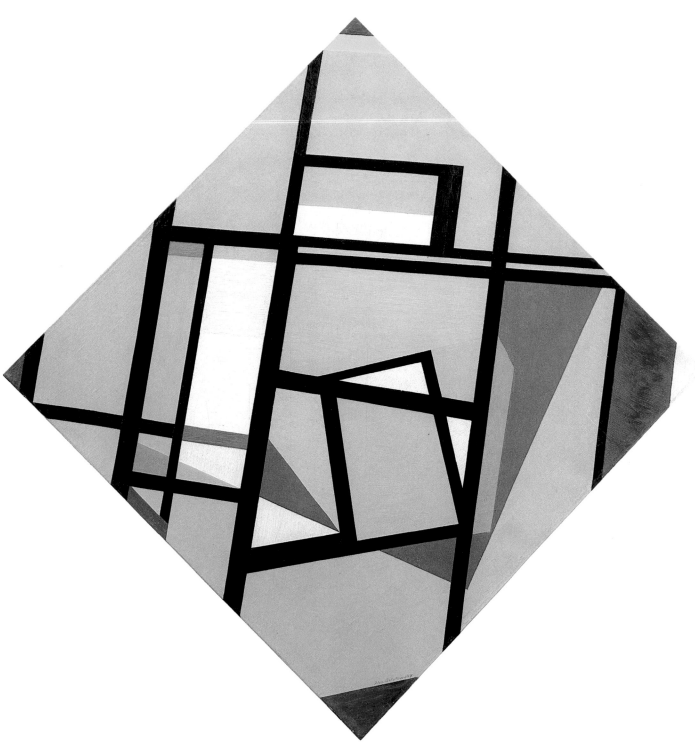

CAT. NO. 15. ILYA BOLOTOWSKY
Blue Diamond, 1940–41
Oil on canvas
21 × 21 in. (53.3 × 53.3 cm.)
Washburn Gallery, New York

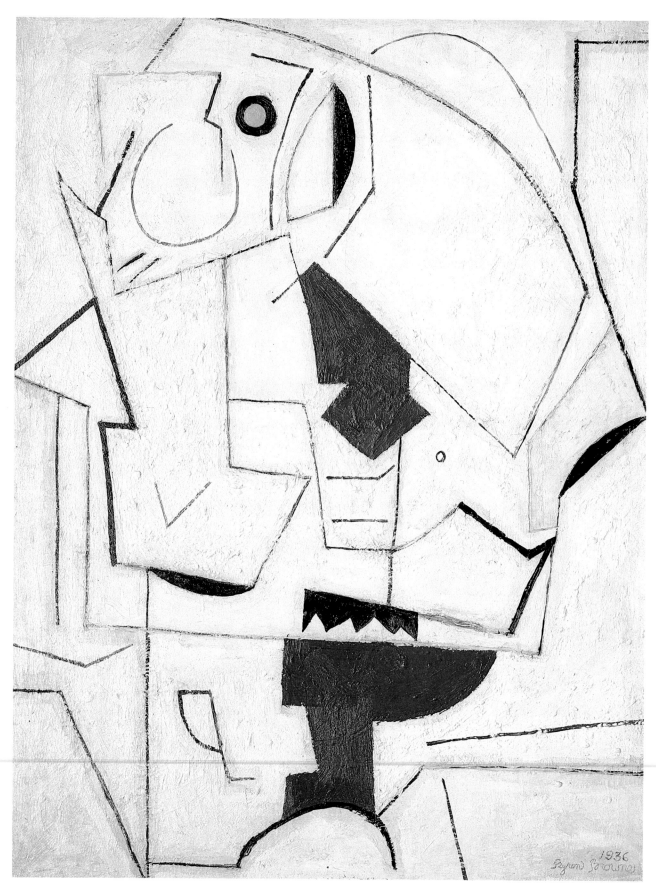

CAT. NO. 18. BYRON BROWNE
Classical Still Life, 1936
Oil on canvas
47 × 36 in. (119.4 × 91.4 cm.)
Collection of Barney A. Ebsworth

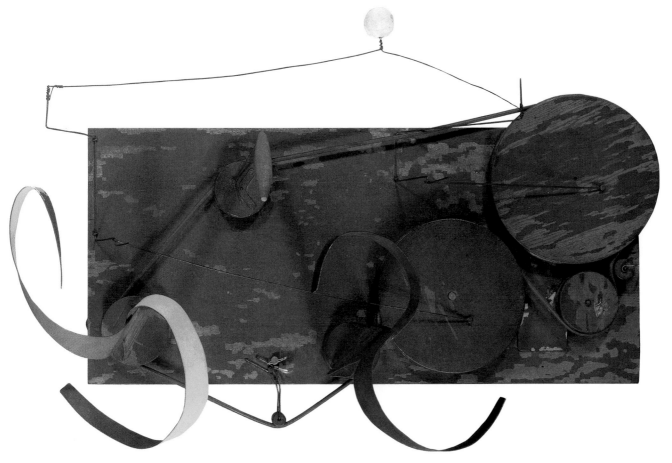

CAT. NO. 22. ALEXANDER CALDER
Dancers and Sphere, 1936
[Viewed from above]
Wood and metal
17¾ in. (45 cm.)
Private Collection

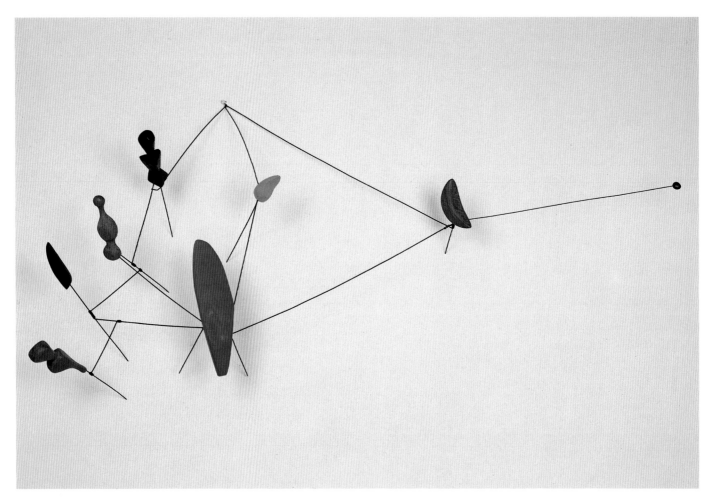

CAT. NO. 24. ALEXANDER CALDER
Constellation, 1943
Wood and metal rods
22 × 44½ × 11¾ in. (55.9 × 113 × 30 cm.)
The Solomon R. Guggenheim Museum, New York; Collection of Mary
 Reynolds: Gift of her brother

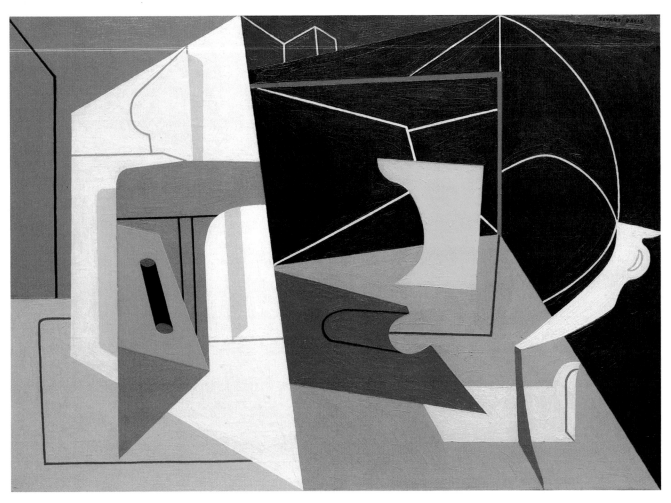

CAT. NO. 26. STUART DAVIS
Eggbeater No. 1, 1927–28
Oil on canvas
27 × 38¼ in. (68.6 × 97.2 cm.)
The Phillips Collection, Washington

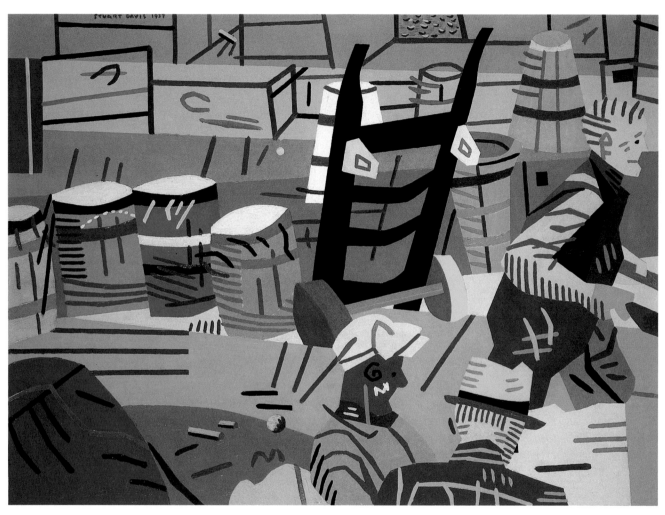

CAT. NO. 30. STUART DAVIS
Terminal, 1937
Oil on canvas
30⅛ × 40⅛ in. (76.5 × 101.9 cm.)
Hirshhorn Museum and Sculpture Garden, Smithsonian Institution,
 Washington

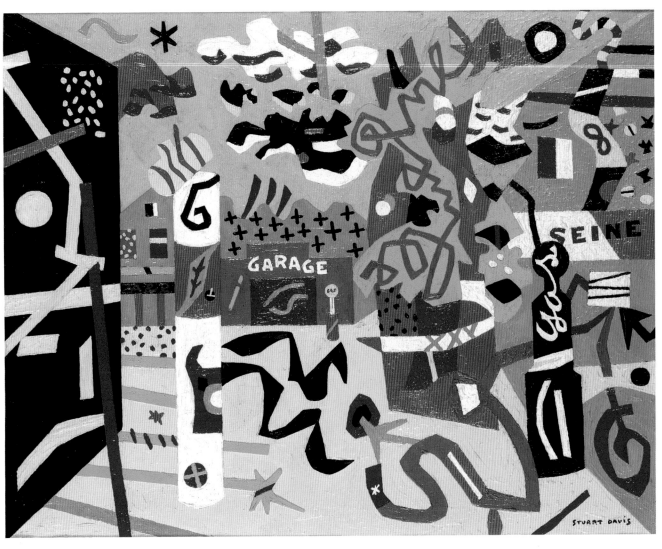

CAT. NO. 32. STUART DAVIS
Report from Rockport, 1940
Oil on canvas
24 × 30 in. (61 × 76.2 cm.)
Collection of Edith and Milton Lowenthal

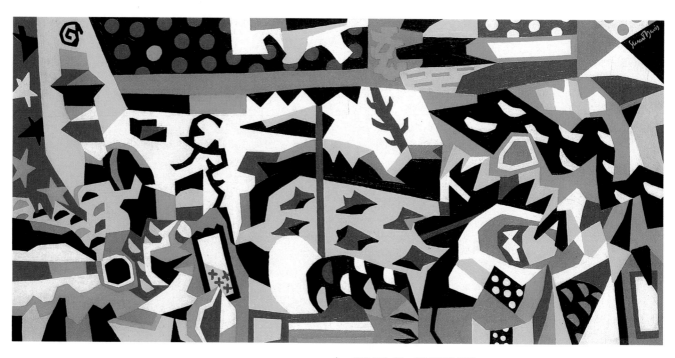

CAT. NO. 33. STUART DAVIS
Ultramarine, 1943
Oil on canvas
20 × 40 in. (50.8 × 101.6 cm.)
Pennsylvania Academy of the Fine Arts, Philadelphia; Temple Fund Purchase

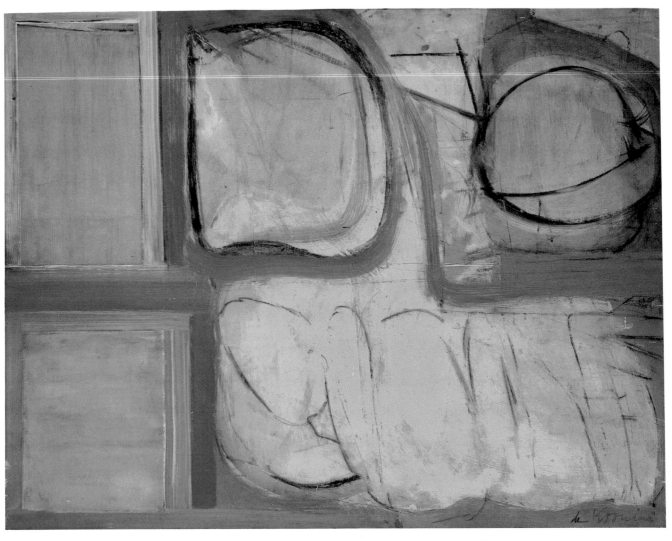

CAT. NO. 34. WILLEM DE KOONING
Untitled, ca. 1942
Oil on canvas
24 × 31½ in. (61 × 80 cm.)
Allan Stone Gallery, New York

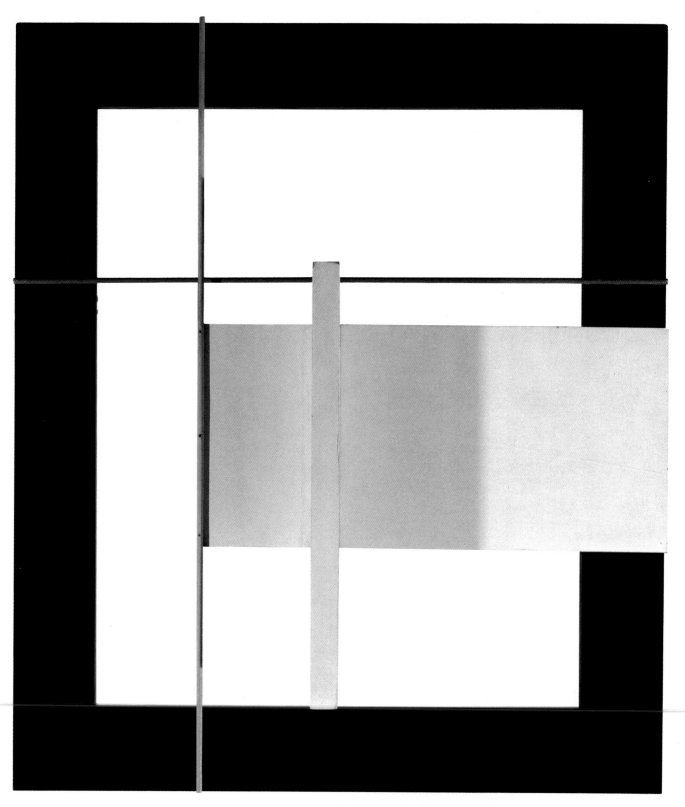

CAT. NO. 39. BURGOYNE DILLER
Construction No. 16, 1938
Painted wood
31⅞ × 27¾ × 5⅛ in. (81 × 70.5 × 13 cm.)
The Newark Museum; Celeste and Armand Bartos Foundation Fund
 Purchase, 1959

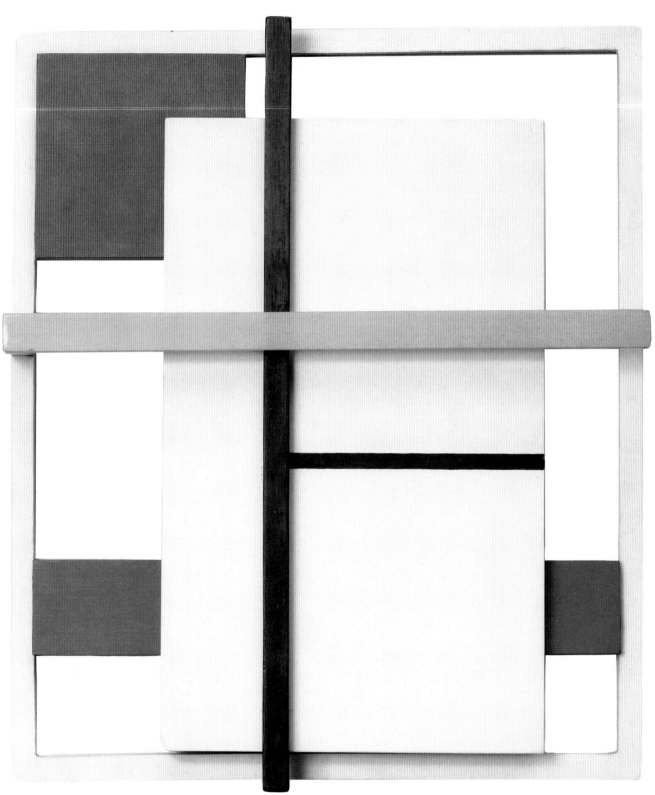

CAT. NO. 40. BURGOYNE DILLER
Construction, 1938
Painted wood
14⅝ × 12½ × 2⅝ in. (37.2 × 31.8 × 6.7 cm.)
The Museum of Modern Art, New York; Gift of Mr. and Mrs. Armand P.
 Bartos, 1958

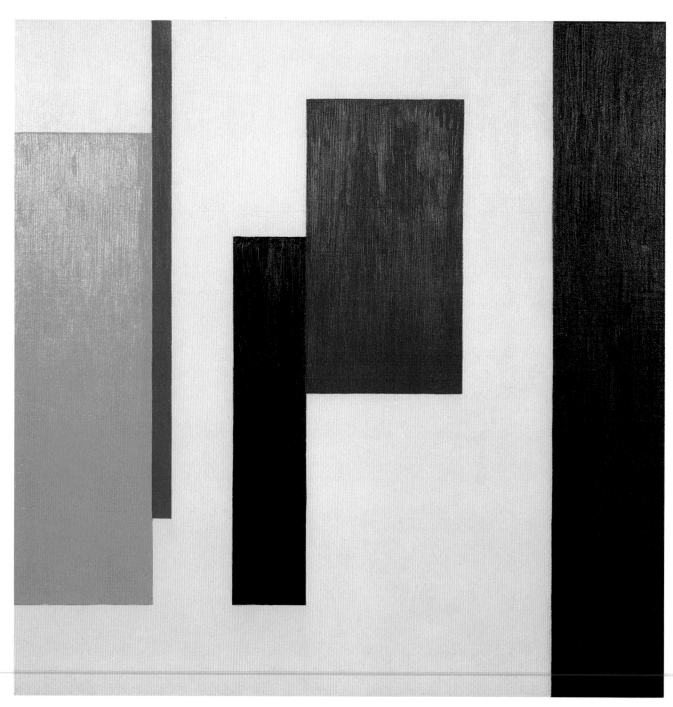

CAT. NO. 41. BURGOYNE DILLER
First Theme, 1943
Oil on panel
34 × 34 in. (86.4 × 86.4 cm.)
Collection of Mr. and Mrs. Fayez Sarofim

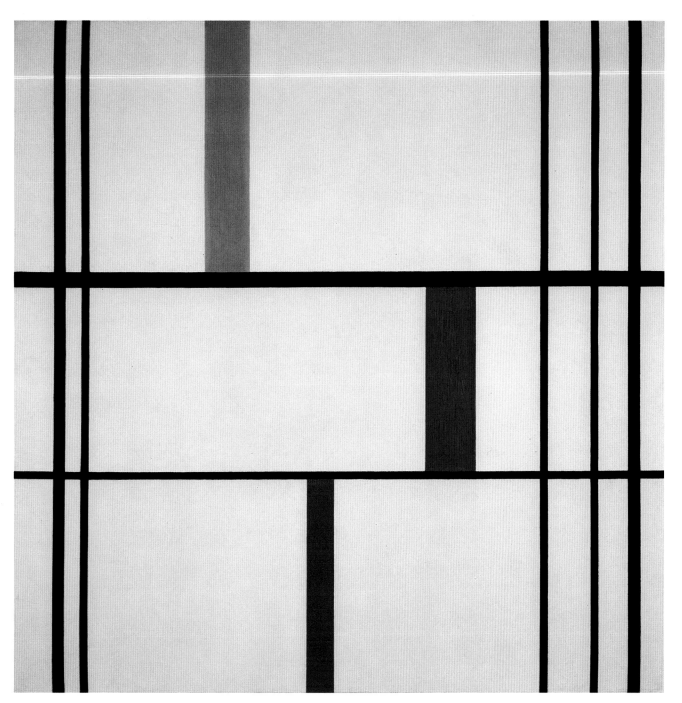

CAT. NO. 42. BURGOYNE DILLER
Untitled No. 21 (Second Theme), 1943–45
Oil on canvas
42⅛ × 42¹⁄₁₆ in. (107 × 106.8 cm.)
Museum of Art, Carnegie Institute, Pittsburgh; Edith H. Fisher Fund, 1981

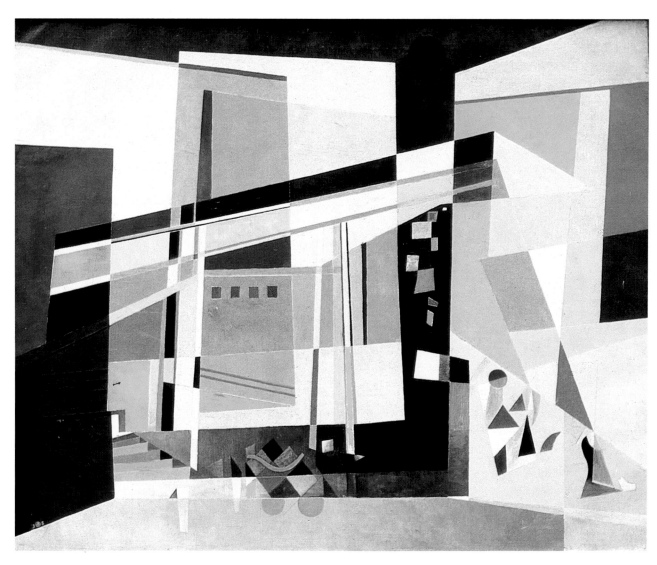

CAT. NO. 43. WERNER DREWES
City (Third Avenue El), 1938
Oil on canvas
33¾ × 42 in. (85.7 × 106.7 cm.)
Collection of Mr. and Mrs. Milton Rose

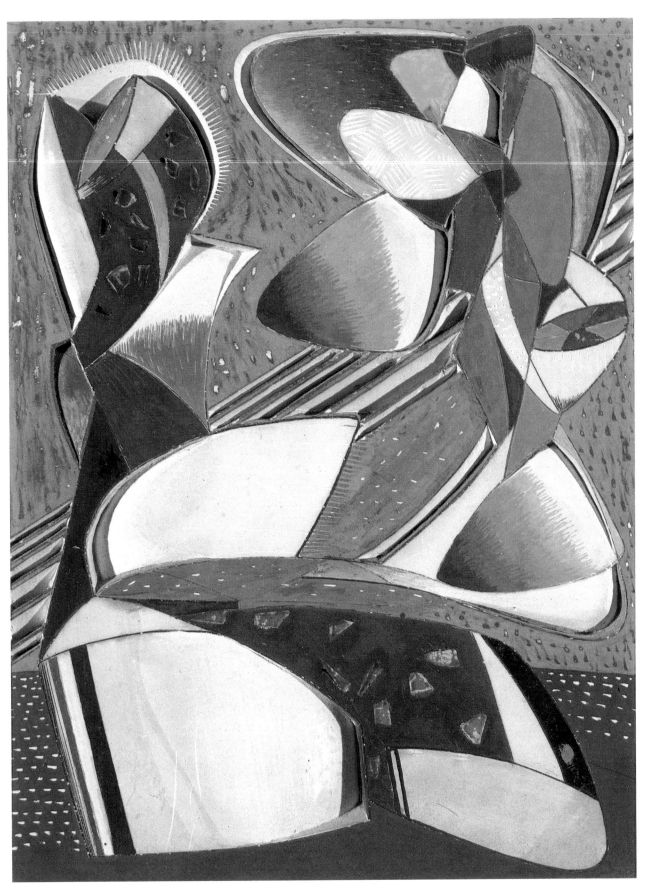

CAT. NO. 47. JOHN FERREN
Untitled, ca. 1937
Painted plaster
11¾ × 9½ in. (29.9 × 24.1 cm.)
Collection of Edward R. Downe, Jr.

101

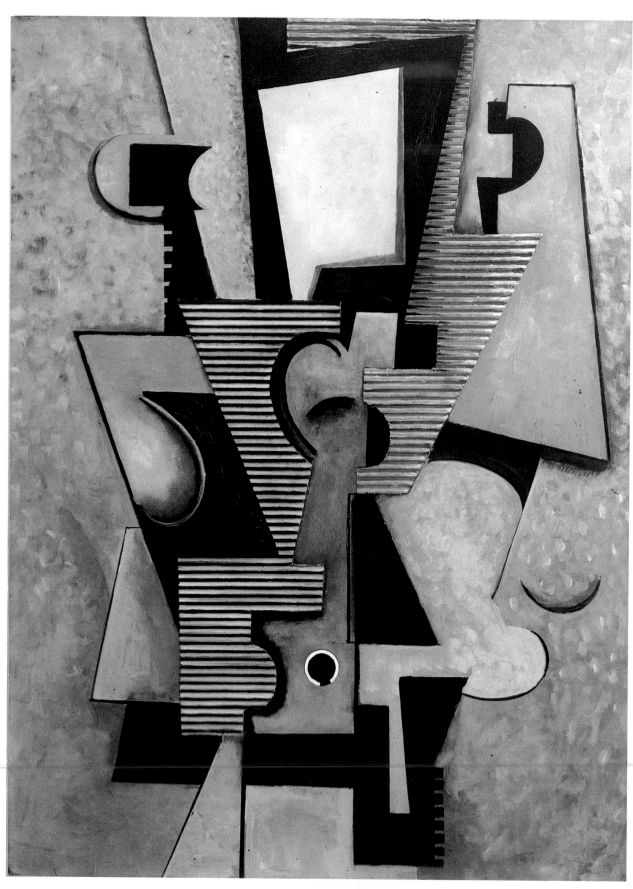

CAT. NO. 48. SUZY FRELINGHUYSEN
Composition, 1943
Mixed media and oil on panel
40 × 30 in. (101.6 × 76.2 cm.)
Collection of Barney A. Ebsworth

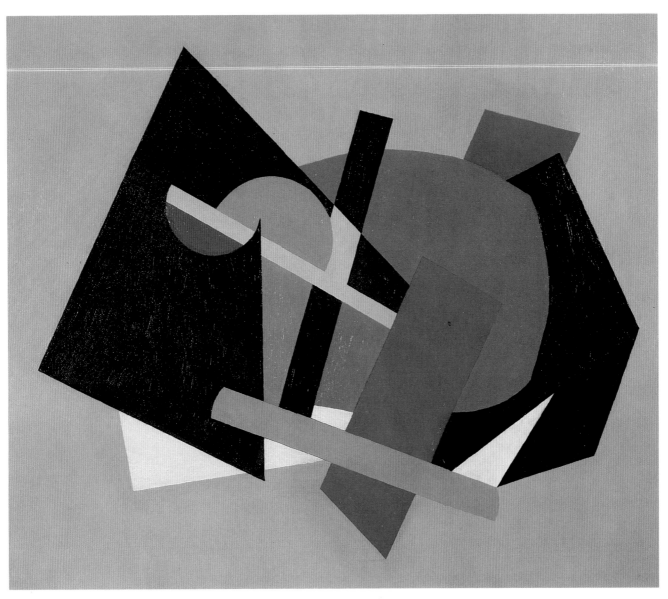

CAT. NO. 51. A. E. GALLATIN
Composition No. 70, 1944–49
Oil on canvas
25 × 30 in. (63.5 × 76.2 cm.)
Collection of Edward R. Downe, Jr.

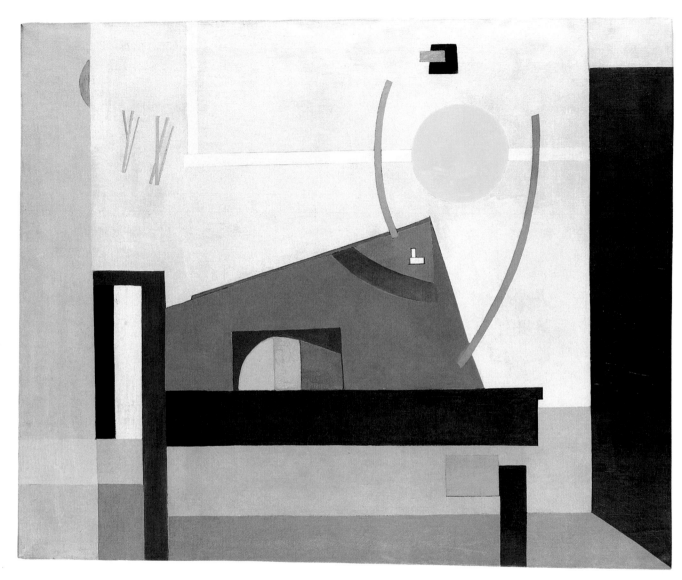

CAT. NO. 52. FRITZ GLARNER
Painting, 1937
Oil on canvas
45 × 55⅞ in. (114.5 × 142 cm.)
Kunsthaus Zürich; Bequest of Mrs. Lucie Glarner

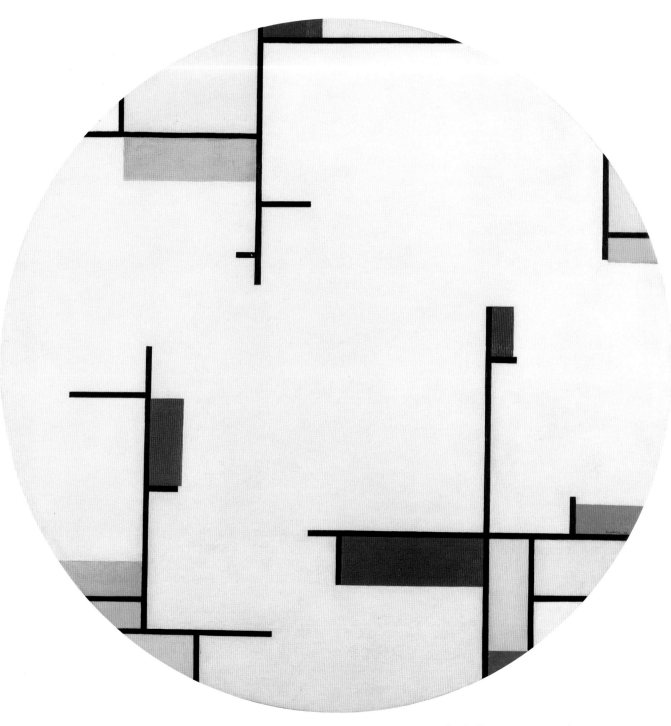

CAT. NO. 54. FRITZ GLARNER
Relational Painting, Tondo No. 1, 1944
Oil on Masonite
52⅜ in. diameter (133 cm. diameter)
Kunsthaus Zürich; Bequest of Mrs. Lucie Glarner

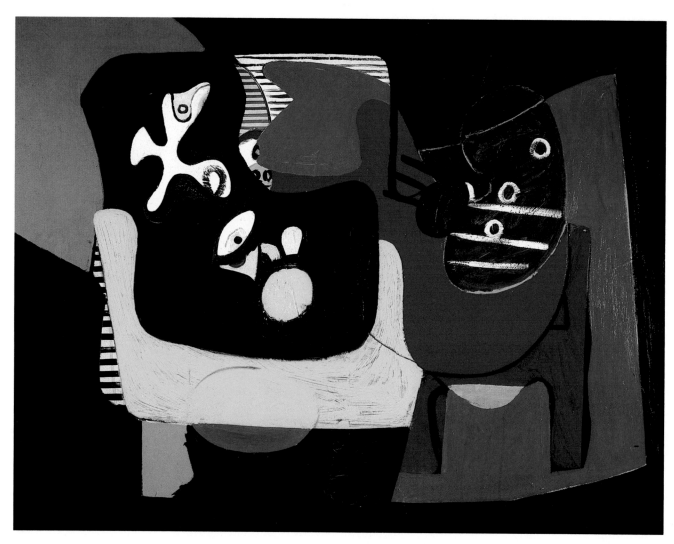

CAT. NO. 55. ARSHILE GORKY
Still Life, ca. 1930–31
Oil on canvas
38½ × 50⅜ in. (97.8 × 128 cm.)
The Chrysler Museum, Norfolk; On loan from the collection of Walter P.
 Chrysler, Jr.

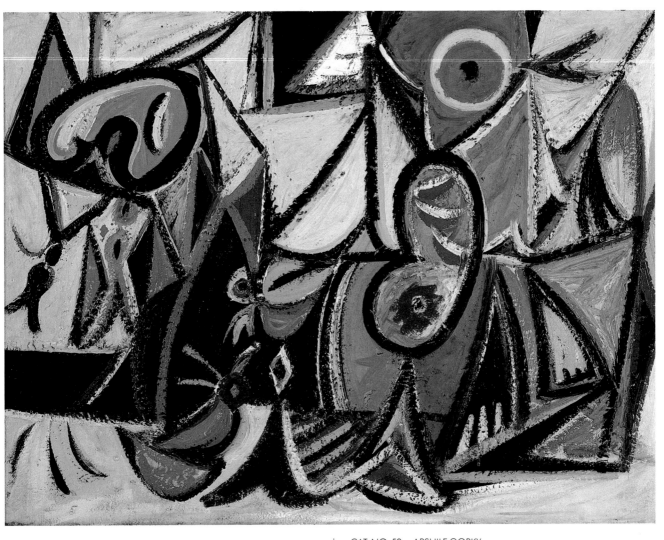

CAT. NO. 59. ARSHILE GORKY
Enigmatic Combat, 1936–38
Oil on canvas
35¾ × 48 in. (90.8 × 121.9 cm.)
San Francisco Museum of Modern Art; Gift of Jeanne Reynal

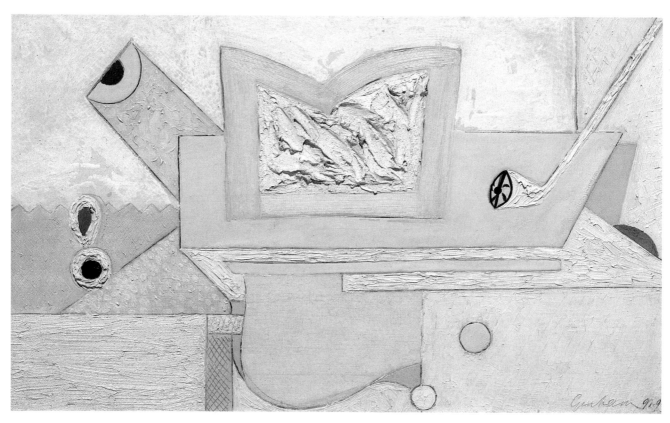

CAT. NO. 61. JOHN GRAHAM
Still Life with Pipe, 1929
Oil on canvas
13¼ × 23 in. (33.7 × 58.4 cm.)
The Museum of Fine Arts, Houston; Purchased with funds provided by
 Mr. and Mrs. George R. Brown and George S. Heyer, Sr.

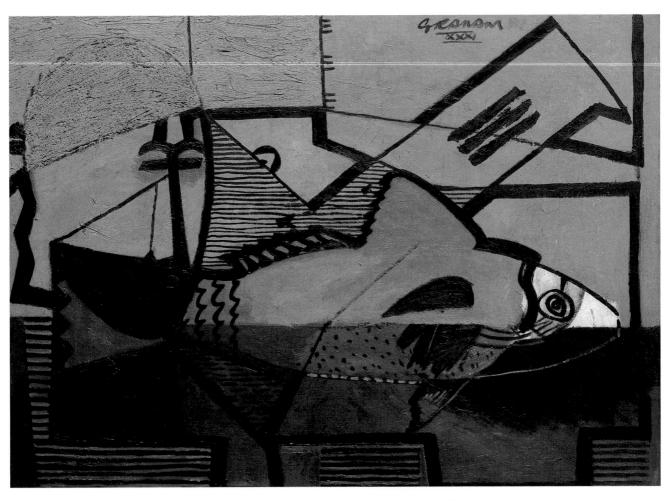

CAT. NO. 64. JOHN GRAHAM
Blue Abstraction (Still Life), 1931
Oil on canvas
26 × 36 in. (66 × 91.4 cm.)
The Phillips Collection, Washington

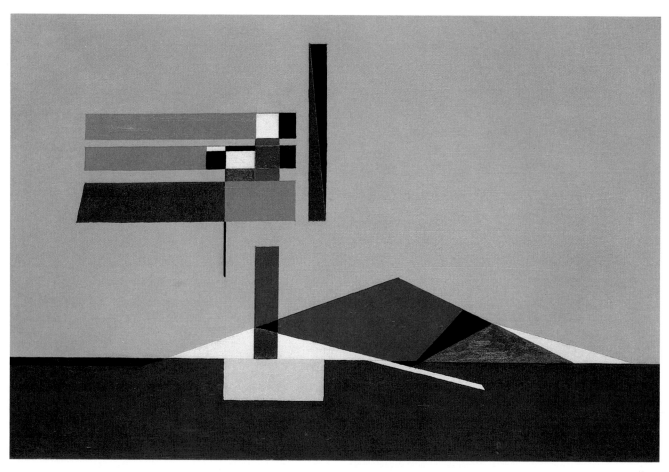

CAT. NO. 66. BALCOMB GREENE
Composition, 1940
Oil on canvas
20 × 30 in. (50.8 × 76.2 cm.)
The Solomon R. Guggenheim Museum, New York

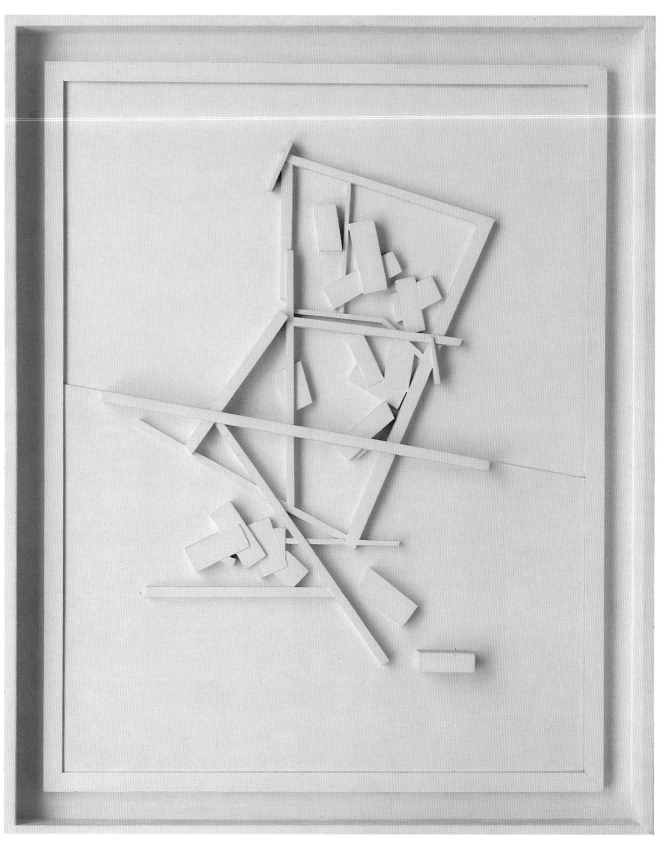

CAT. NO. 71. GERTRUDE GREENE
White Anxiety, 1943–44
Painted wood relief construction on composition board
41¾ × 32⅞ in. (106.1 × 83.5 cm.)
The Museum of Modern Art, New York; Gift of Balcomb Greene

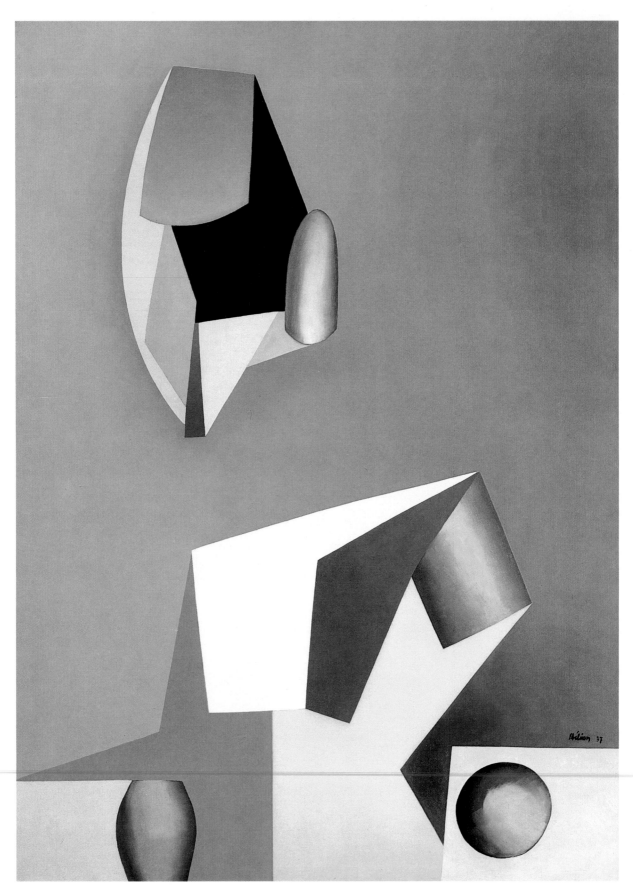

CAT. NO. 73. JEAN HÉLION
Figure d'Espace, 1937
Oil on canvas
52 × 38 in. (132.1 × 96.5 cm.)
San Francisco Museum of Modern Art; Albert M. Bender Collection, Albert
 M. Bender Bequest Fund Purchase

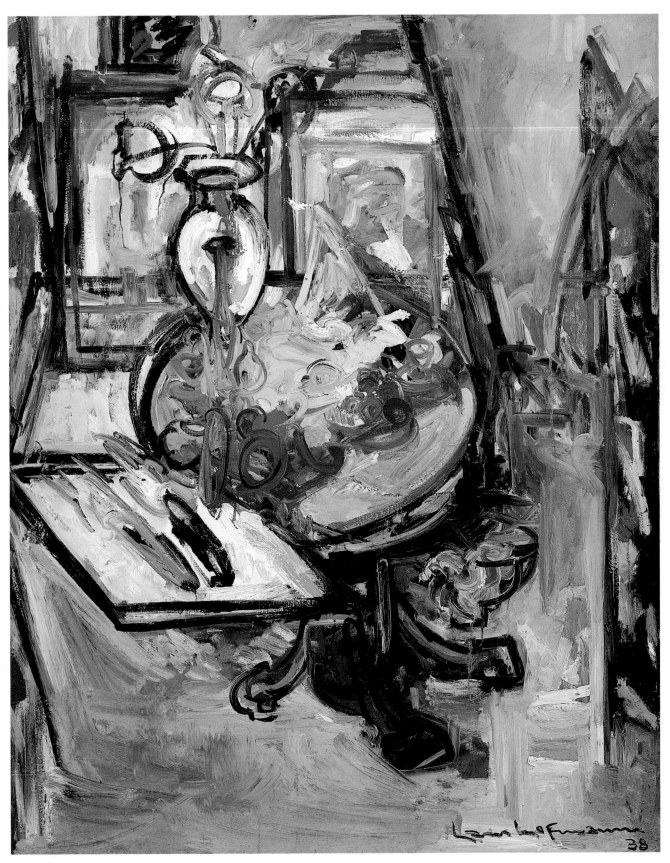

CAT. NO. 74. HANS HOFMANN
Atelier Still Life—Table with White Vase, 1938
Oil on panel
60 × 48 in. (152.4 × 121.9 cm.)
Collection of Mr. and Mrs. James A. Fisher

CAT. NO. 76. CARL HOLTY
Circus Forms, 1938
Oil on Masonite
59¾ × 39¾ in. (151.8 × 101 cm.)
The Archer M. Huntington Art Gallery, University of Texas, Austin; The James
 and Mari Michener Collection

CAT. NO. 78. CARL HOLTY
Of War, 1942
Original painting destroyed. Repainted by the artist from a photograph in
 tempera in 1942; this second version was overpainted by the artist in oils in
 1960.
Oil and tempera on Masonite
54 × 36 in. (137.2 × 91.4 cm.)
Museum of Art, Carnegie Institute, Pittsburgh; Museum purchase: Gift of the
 Robert S. Waters Charitable Trust, 1980

115

CAT. NO. 80. HARRY HOLTZMAN
Square Volume with Green, 1936
Recreated by the artist from the original in 1982
Acrylic on gessoed Masonite
23¾ × 23¾ in. (60.3 × 60.3 cm.)
Collection of the artist

CAT. NO. 83. HARRY HOLTZMAN
Sculpture (1), 1940
Oil and acrylic on gessoed Masonite
78 × 12 × 12 in. (198.1 × 30.5 × 30.5 cm.)
Museum of Art, Carnegie Institute, Pittsburgh; Edith H. Fisher Fund, 1983

117

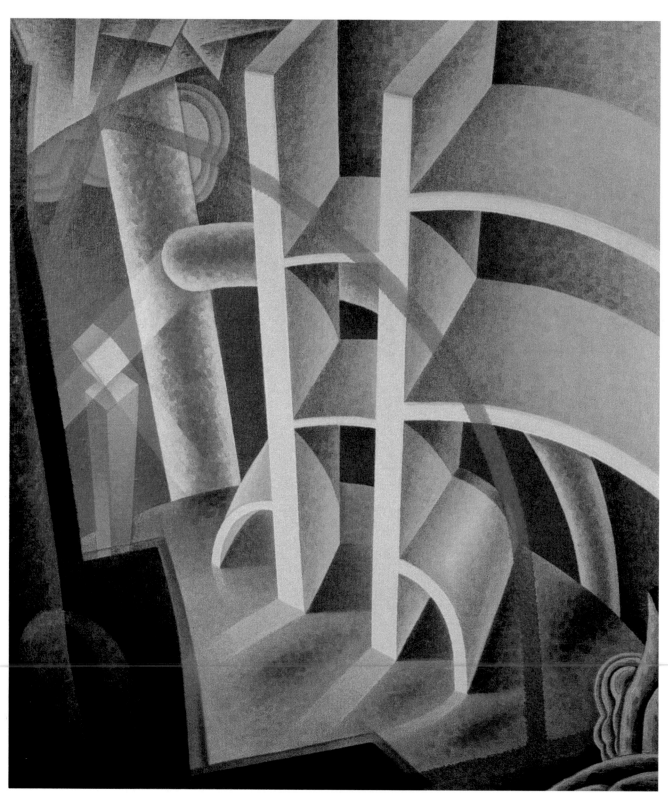

CAT. NO. 84. RAYMOND JONSON
Variations on a Rhythm—H, 1931
Oil on canvas
32½ × 28½ in. (82.6 × 72.4 cm.)
Collection of Dr. and Mrs. Phillip Frost

118

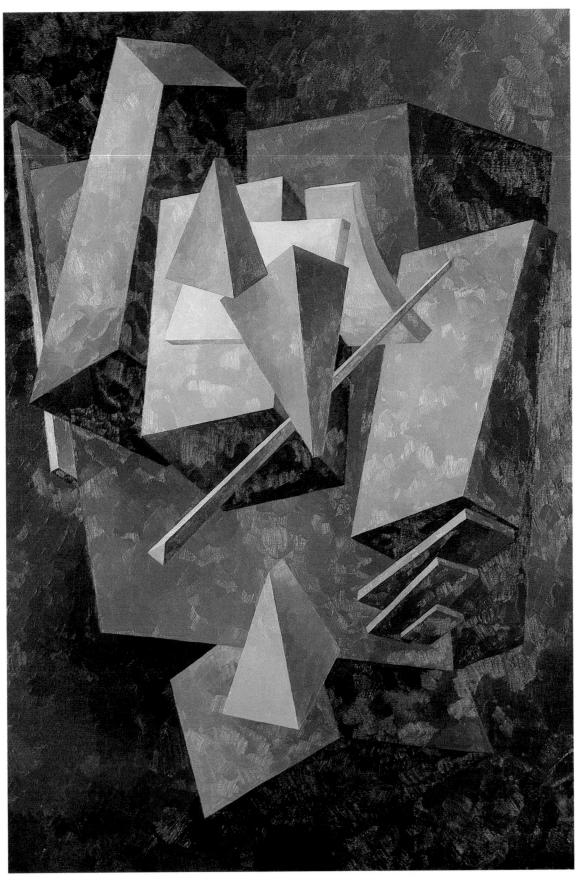

CAT. NO. 87. PAUL KELPE
Weightless Balance II, 1937
Oil on canvas
33 × 23 in. (83.8 × 58.4 cm.)
Collection of Louise and Joe Wissert

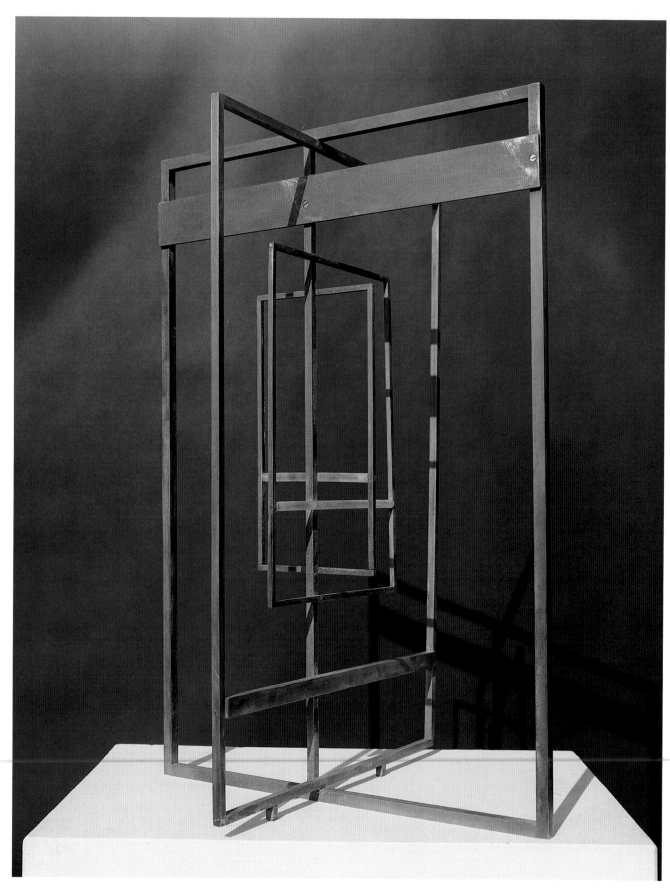

CAT. NO. 89. IBRAM LASSAW
Intersecting Rectangles, 1940
Steel and Lucite
27½ × 19 × 19 in. (69.9 × 48.3 × 48.3 cm.)
Collection of the artist

120

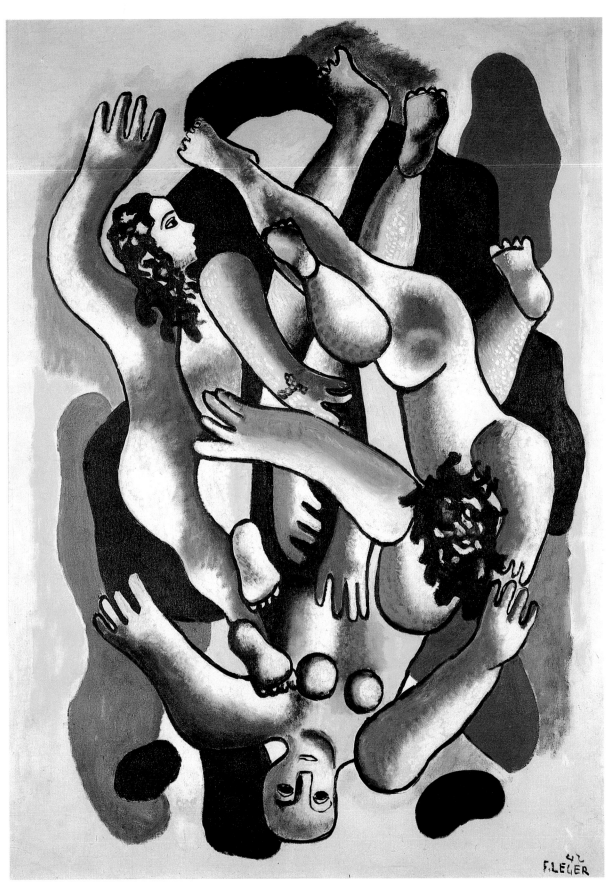

CAT. NO. 90. FERNAND LÉGER
Plongeurs (Divers), 1942
Oil on canvas
49½ × 35½ in. (125.7 × 90.2 cm.)
Sidney Janis Gallery, New York

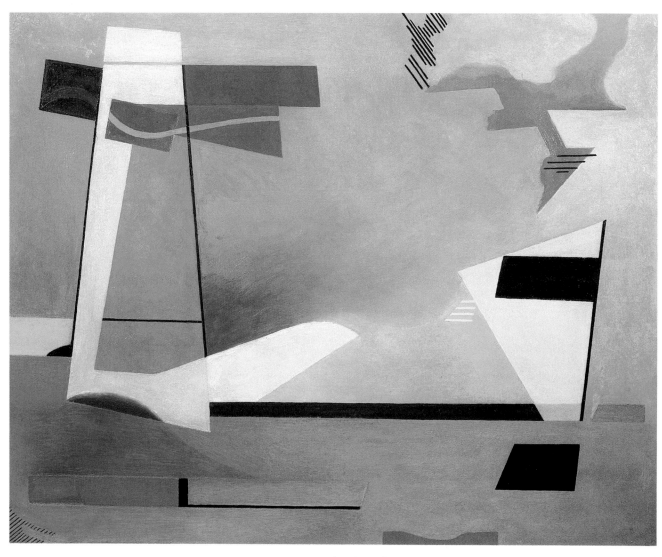

CAT. NO. 92. ALICE TRUMBULL MASON
Untitled, ca. 1940
Oil on Masonite
22 × 28 in. (55.9 × 71.1 cm.)
Washburn Gallery, New York

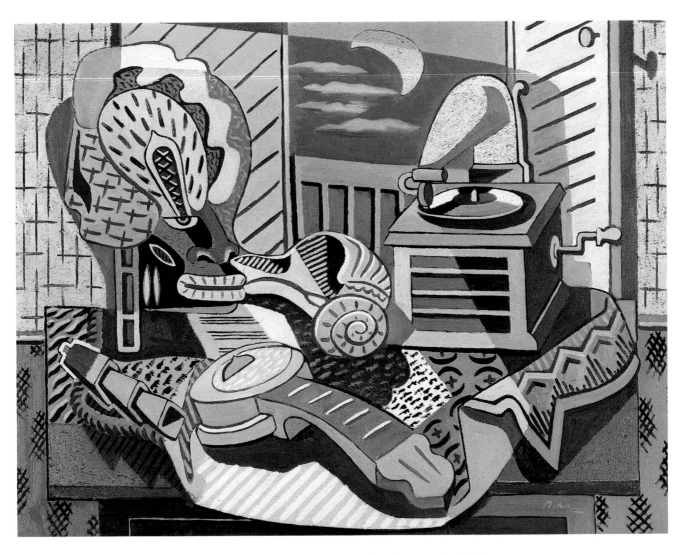

CAT. NO. 94. JAN MATULKA
Arrangement with Phonograph, 1929
Oil on canvas
30 × 40 in. (76.2 × 101.6 cm.)
Whitney Museum of American Art, New York

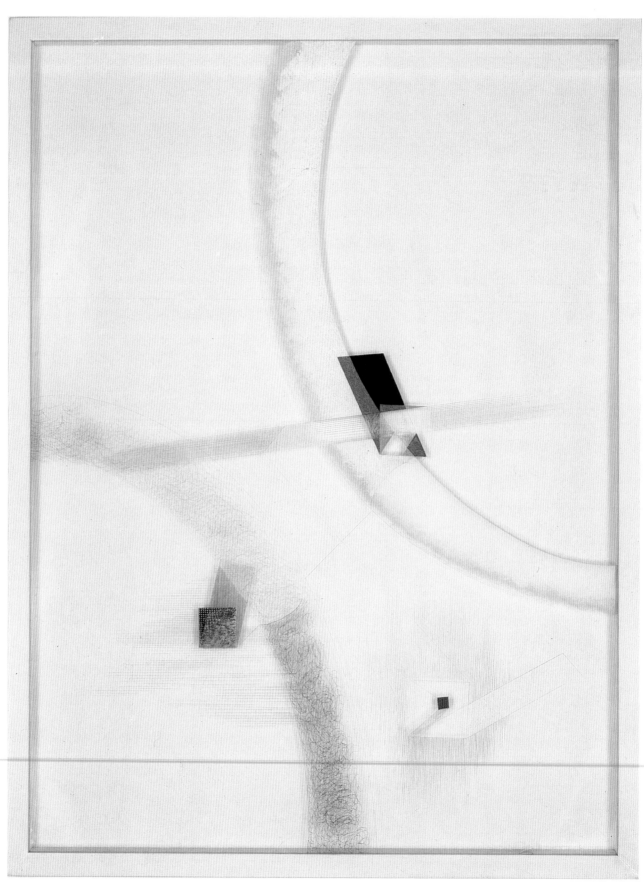

CAT. NO. 98. LÁSZLÓ MOHOLY-NAGY
Mills No. 1, 1940
Oil on Plexiglas
34¾ × 25¾ in. (87.4 × 65.4 cm.)
The Solomon R. Guggenheim Museum, New York

124

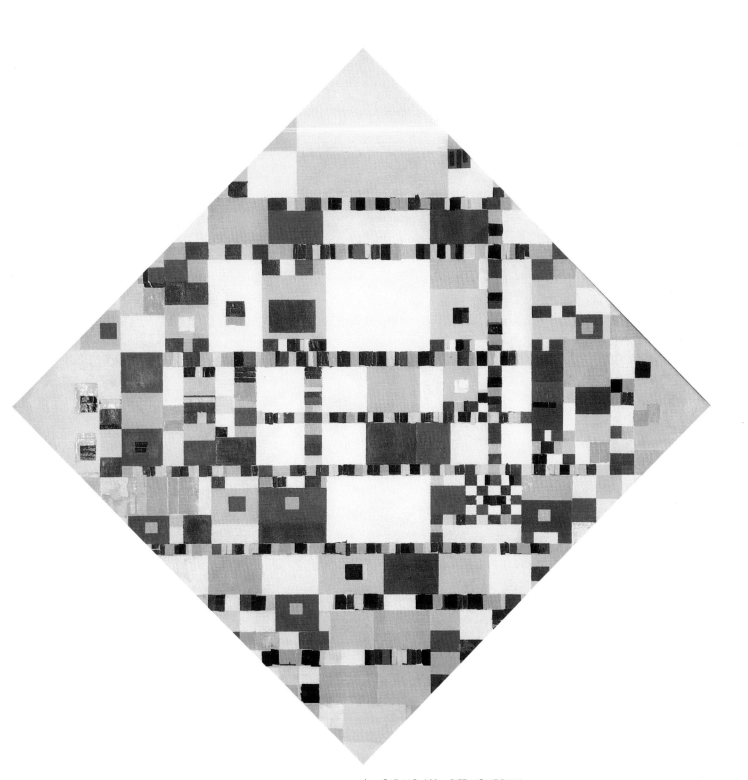

CAT. NO. 100. PIET MONDRIAN
Victory Boogie Woogie, 1943–44
Oil on canvas with colored tape and paper
49⅝ × 49⅝ in. (126.1 × 126.1 cm.)
Collection of Mr. and Mrs. Burton Tremaine

125

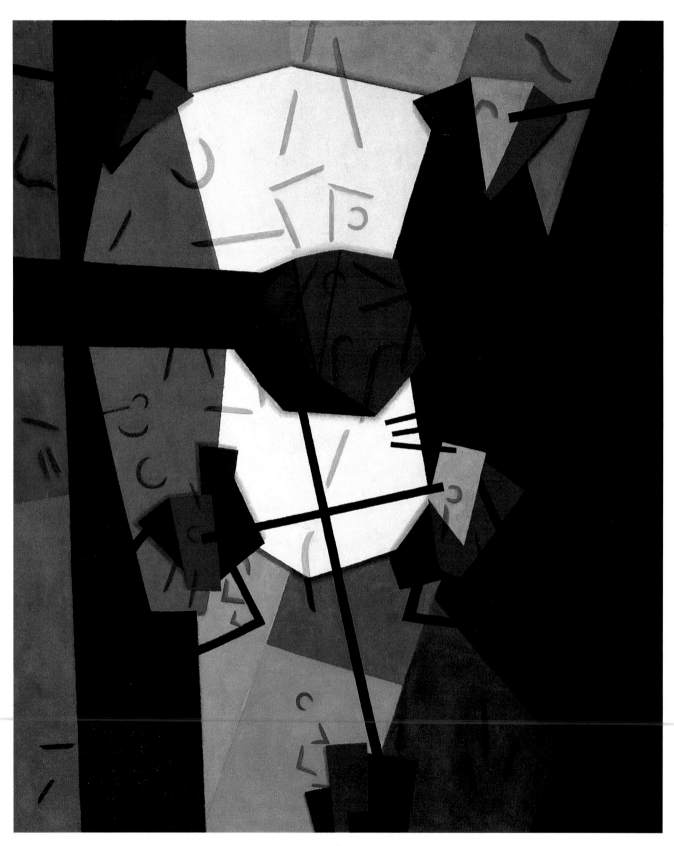

CAT. NO. 102. GEORGE L. K. MORRIS
Stockbridge Church, 1935
Oil on canvas
54⅛ × 45¹⁄₁₆ in. (137.4 × 114.4 cm.)
Museum of Art, Carnegie Institute, Pittsburgh; The A. W. Mellon Acquisition
 Endowment Fund, 1980

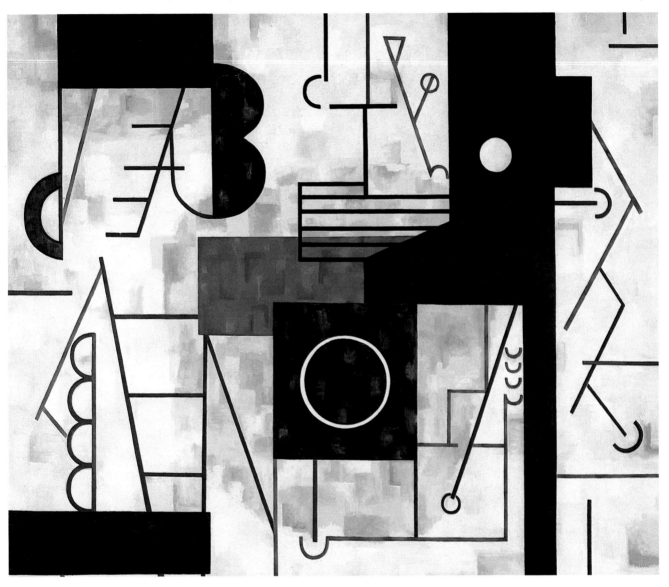

CAT. NO. 105. GEORGE L. K. MORRIS
Mural Composition, 1940
Oil on canvas
52 × 62½ in. (132.1 × 158.8 cm.)
Collection of Mr. and Mrs. John T. Whatley

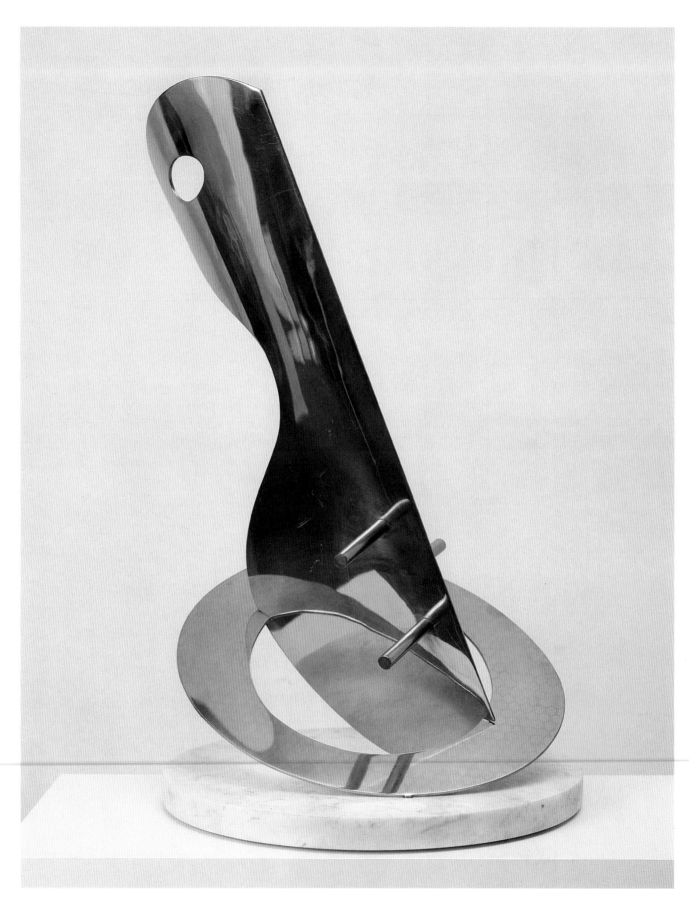

CAT. NO. 107. ISAMU NOGUCHI
Leda, 1928
Brass with marble base
24½ × 14½ × 11 in. (62.2 × 36.8 × 27.9 cm.)
The Isamu Noguchi Foundation, Inc.

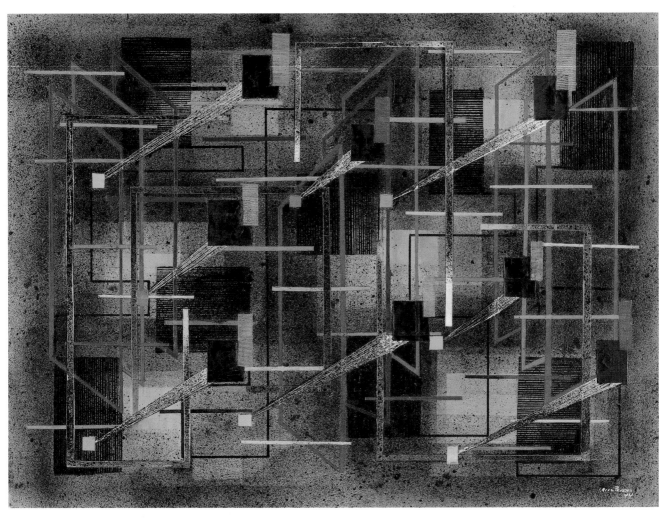

CAT. NO. 112. IRENE RICE PEREIRA
Green Depth, 1944
Oil on canvas
31 × 42 in. (78.7 × 106.7 cm.)
The Metropolitan Museum of Art, New York; George A. Hearn Fund, 1944

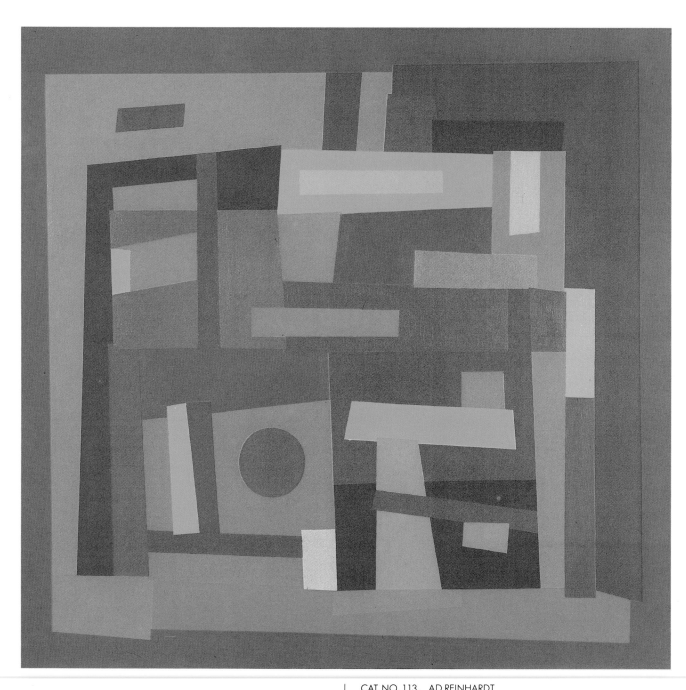

CAT. NO. 113. AD REINHARDT
Number 30, 1938
Oil on canvas
40½ × 42½ in. (102.9 × 108 cm.)
Promised gift of Mrs. Ad Reinhardt to the Whitney Museum of American Art,
 New York

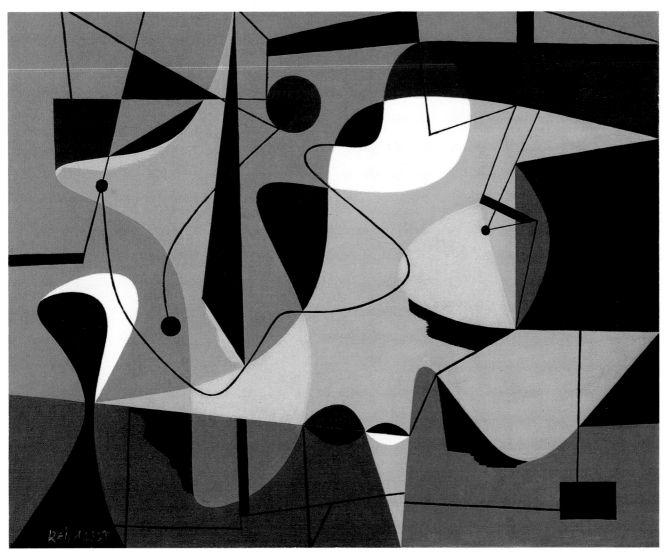

CAT. NO. 115. AD REINHARDT
Untitled, 1940
Oil on canvas
16 × 20 in. (40.6 × 50.8 cm.)
Collection of Edward R. Downe, Jr.

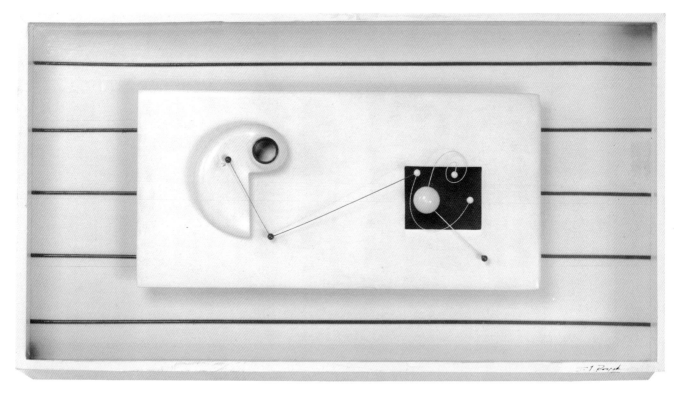

CAT. NO. 119. THEODORE ROSZAK
Trajectories, 1938
Metal, plastic, and wood
18¾ × 30 × 4 in. (47.6 × 76.2 × 10.2 cm.)
Private Collection

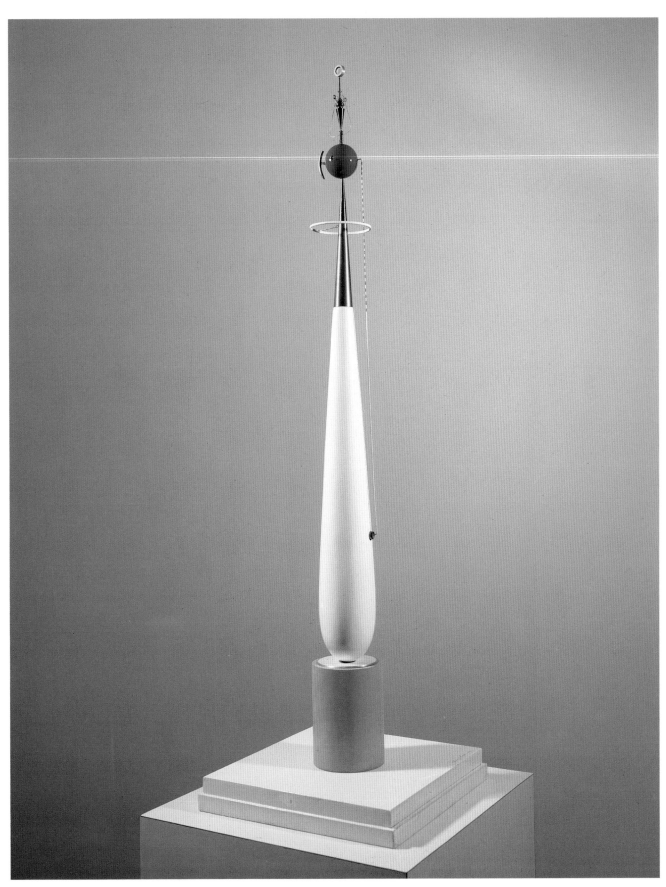

CAT. NO. 120. THEODORE ROSZAK
Ascension, 1939
Wood, steel, and bronze
32¼ in. (81.9 cm.)
Collection of Suzanne Vanderwoude

133

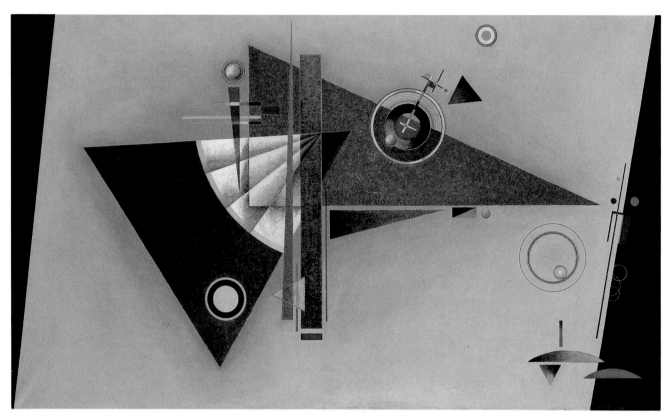

CAT. NO. 122. ROLPH SCARLETT
Composition, 1938–39
Oil on canvas
31 × 53 in. (78.7 × 134.6 cm.)
The Solomon R. Guggenheim Museum, New York

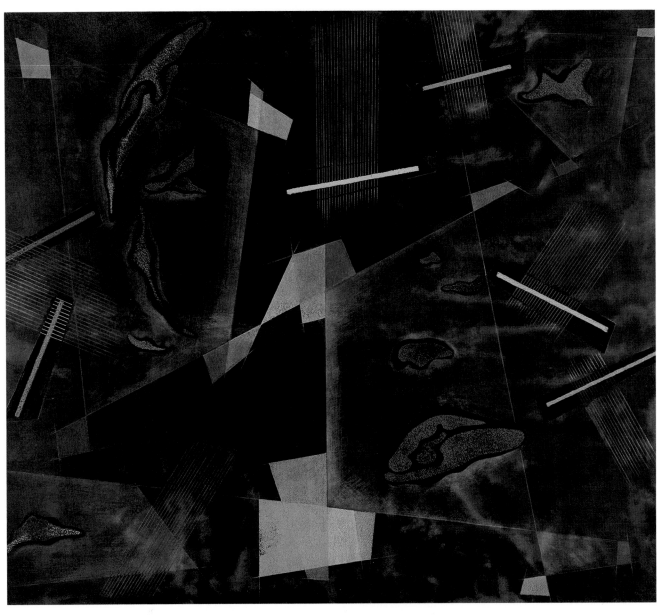

CAT. NO. 124. JOHN SENNHAUSER
Lyrical No. 7, 1942
Oil on parchment
22 × 25 in. (55.9 × 63.5 cm.)
Collection of Dr. Peter B. Fischer

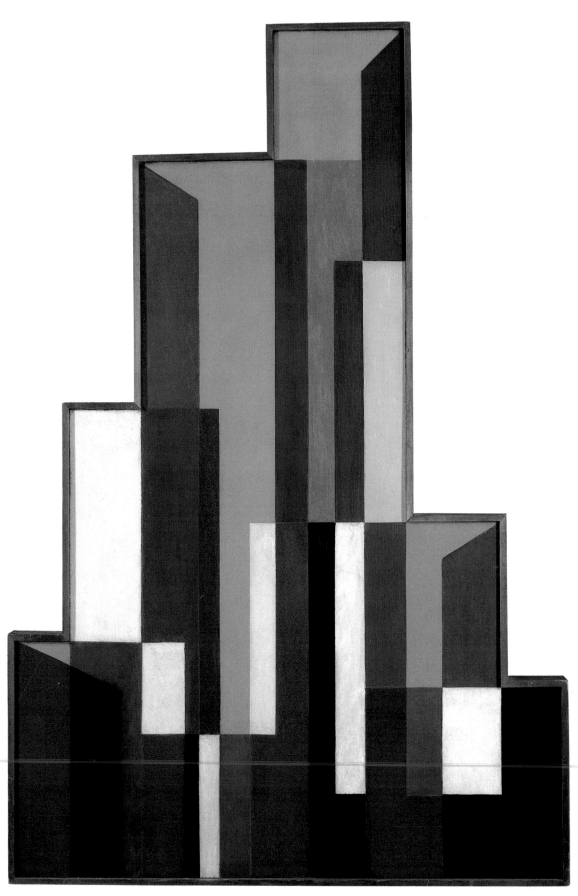

CAT. NO. 126. CHARLES SHAW
Plastic Polygon, 1937
Oil on wood
45 × 30 in. (114.3 × 76.2 cm.)
Collection of Mr. and Mrs. Rolf Weinberg

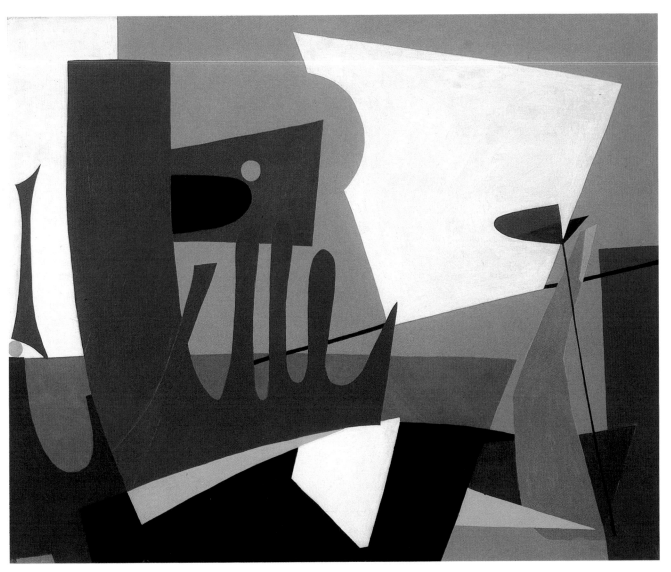

CAT. NO. 131. ESPHYR SLOBODKINA
Ancient Sea Song, 1943
Oil on board
35 × 44 in. (88.9 × 111.8 cm.)
Collection of Barney A. Ebsworth

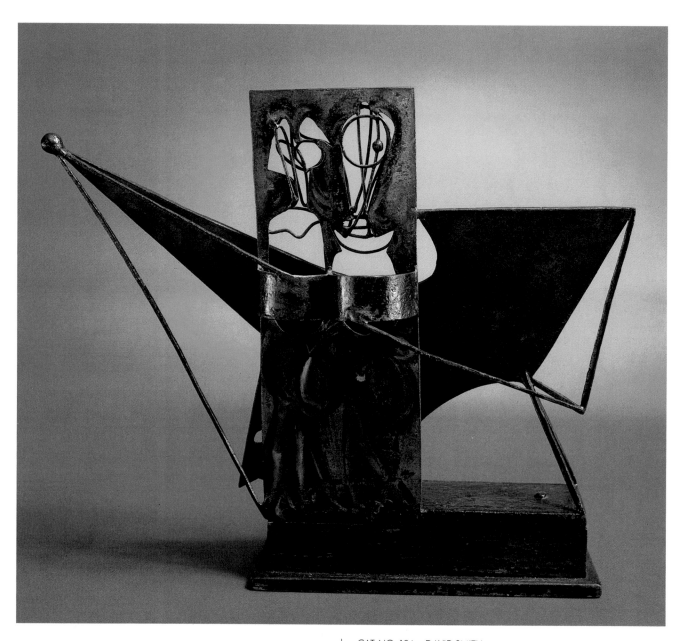

CAT. NO. 134. DAVID SMITH
Billiard Player Construction, 1937
Iron and encaustic
20½ × 23½ × 17¼ in. (43.8 × 52.1 × 16.2 cm.)
Collection of Dr. and Mrs. Arthur E. Kahn

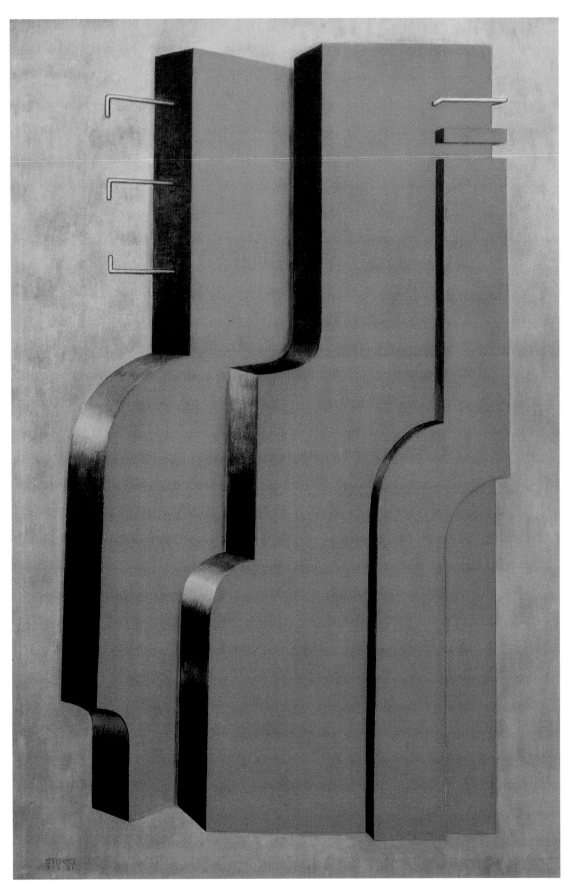

CAT. NO. 136. JOHN STORRS
Double Entry, 1931
Oil on canvas
45¼ × 30¼ in. (114.9 × 76.8 cm.)
Collection of Barney A. Ebsworth

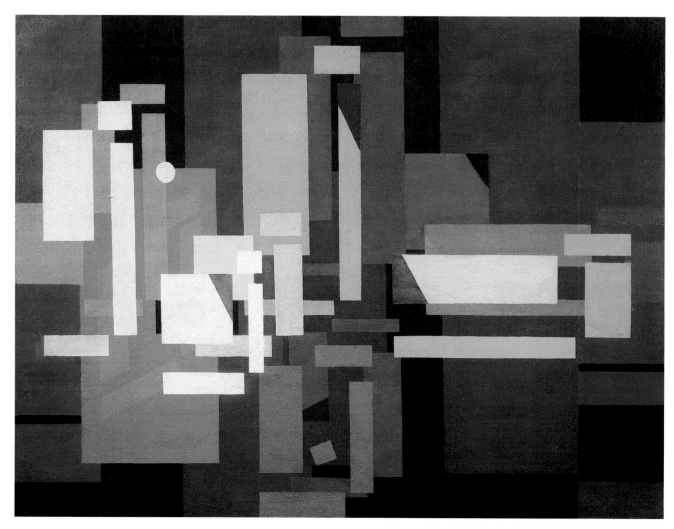

CAT. NO. 140. ALBERT SWINDEN
Introspection of Space, ca. 1944–48
Oil on canvas
30 × 40 in. (76.2 × 101.6 cm.)
Whitney Museum of American Art, New York; Gift of the Herbert and
 Nannette Rothschild Fund

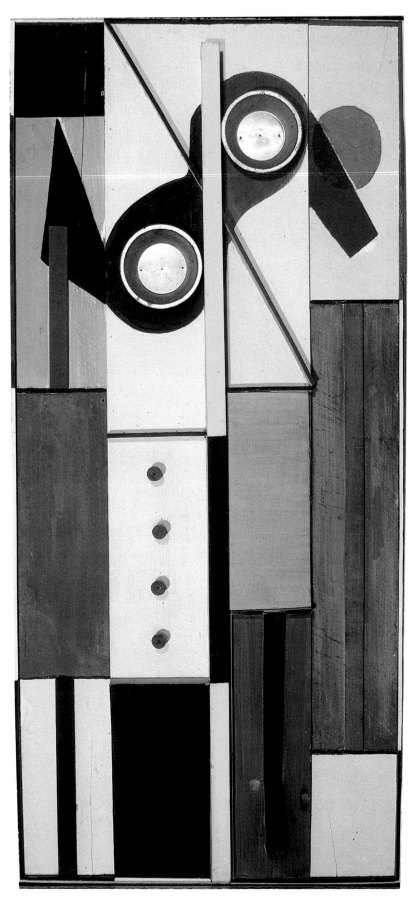

CAT. NO. 141. VACLAV VYTLACIL
Untitled, 1937
Painted wood and mixed media
52 × 24 in. (132.1 × 61 cm.)
Collection of Olga Hirshhorn

141

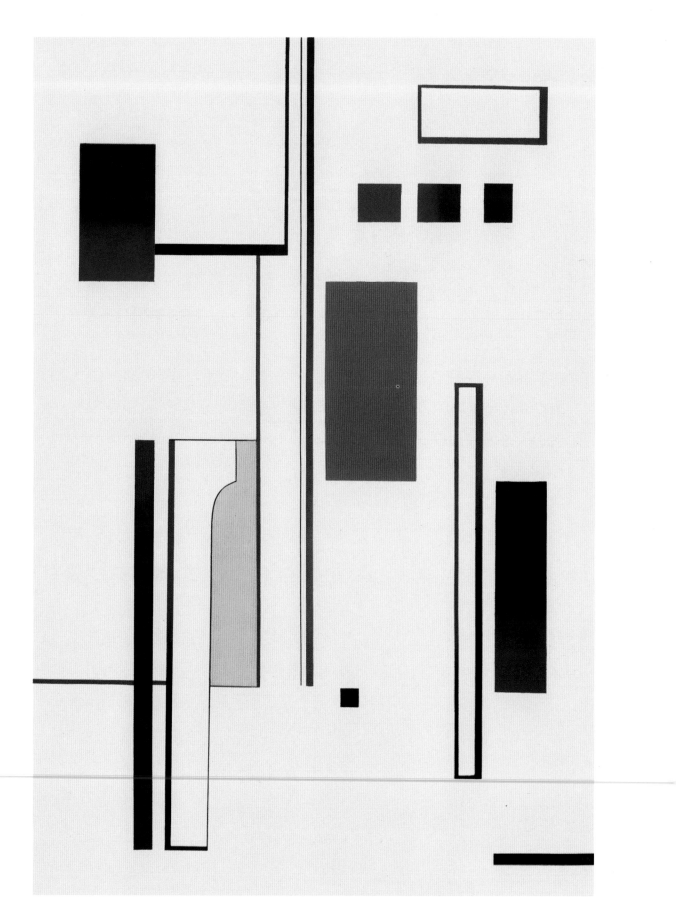

CAT. NO. 144. JEAN XCERON
Composition No. 239A, 1937
Oil on canvas
51 × 35 in. (129.5 × 89 cm.)
Collection of Barney A. Ebsworth

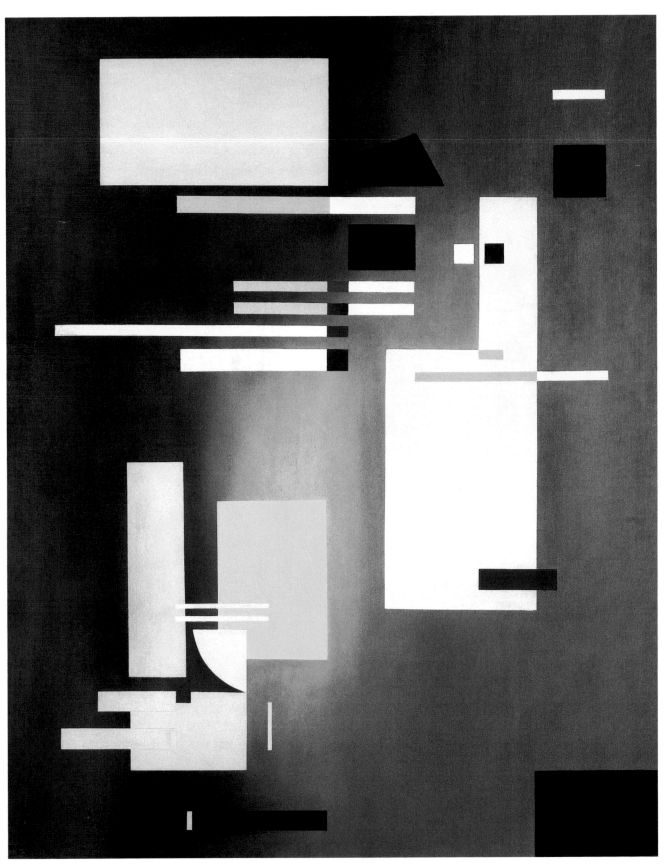

CAT. NO. 146. JEAN XCERON
Composition No. 263, 1943
Oil on canvas
50⅛ × 40⅛ in. (127.3 × 101.9 cm.)
The Solomon R. Guggenheim Museum, New York

A. E. GALLATIN

Born 1881 in Villanova, Pennsylvania; died 1952 in New York City. Studied at New York Law School.

Rarely does a patron play so vital a role in the art of his own time as did the collector, writer, and painter Albert Eugene Gallatin. Born in 1881 in Villanova, Pennsylvania, the great-grandson and namesake of the Secretary of the Treasury under Madison and Jefferson, Gallatin grew up in a cultivated atmosphere supported by generations of great wealth. His famous great-grandfather sat for portraits by Gilbert Stuart and Charles Willson Peale. Family holdings in Egyptian and Greek art formed the basis of his early education in the history of art, as well as the foundation of Gallatin's own private collection.

As one of New York society's most eligible bachelors, Gallatin was a great party-giver and first president of the Motor-Car Touring Society. The introspective side of his nature became more pronounced when he began to involve himself in studying and collecting art. As early as 1903, Gallatin published his first significant catalogue, *Aubrey Beardsley's Drawings*, a meticulously documented, well-written commentary stressing the aesthetic, or, as Gallatin put it, the "decorative" qualities of Beardsley's work.

It was followed in 1904 by *Whistler's Art Dicta*, the first of Gallatin's scholarly volumes devoted to the artist. *Whistler: Notes and Footnotes* appeared in 1907, followed by *Whistler's Pastels and Other Modern Profiles*, published in 1912. In the latter volume, Gallatin's description of Whistler reads like his own autobiography—the story of a cultivated man living his life through the arts and endeavoring to make an imprint on the tastes of society at large: "... always was Whistler an aristocrat. Into an age dominated by commercialism, vulgarity and the spirit to gain, came Whistler to beauty and the search for perfection."[1]

Gallatin arrived at his understanding of modern art slowly through his admiration of French Impressionism, the art of Cézanne, and his study of the work of the American artists Charles Demuth, John Marin, and Charles Sheeler. Each phase of Gallatin's development as a collector is documented by his fine volumes of essays on these artists—sources that are still widely read today.

During World War I, from April 1917 to November 1918, Gallatin served as chairman of the Committee on Exhibitions and Pictorial Publicity of the United States Government Committee on Public Information and worked with a number of painters, graphic artists, and sculptors. His illustrated book, *Art and the Great War* (1919), chronicled his experiences and documented the work produced by the division.

By 1927, Gallatin's vision of the future of American art had undergone a significant change. He began to view it in

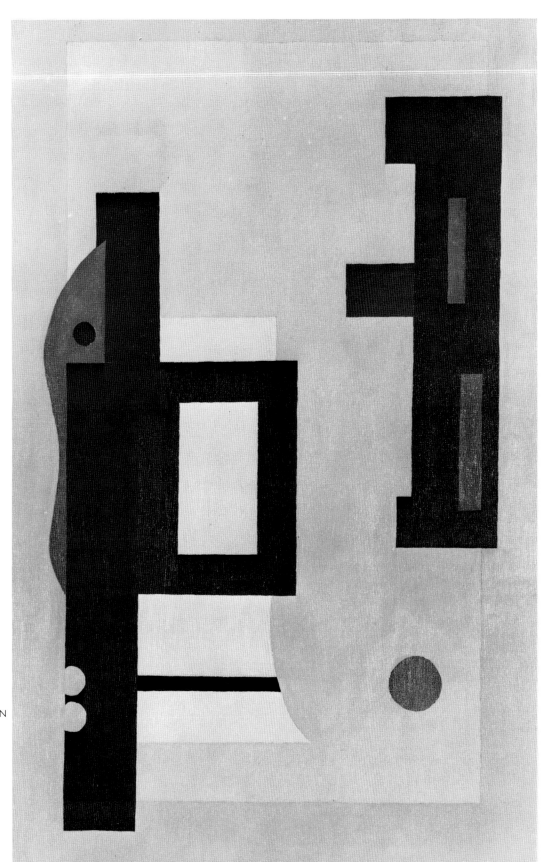

CAT. NO. 50. A. E. GALLATIN
Untitled, 1938
Oil on canvas
30 × 20 in. (76.2 × 50.8 cm.)
Collection of Edward Albee

FIG. 6.
View of A. E. Gallatin's Gallery of Living Art at New York University, ca. 1930

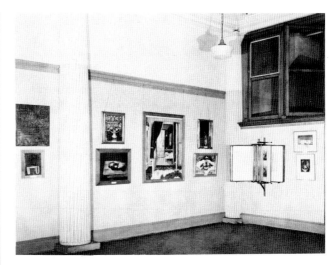

FIG. 7.
View of A. E. Gallatin's Gallery of Living Art at New York University, ca. 1930

a larger context, connected to the modern art of Europe and possessed of its own dynamism and special destiny. Gathering up his own personal collection, which included works by Cézanne, Picasso, Gris, Léger, Demuth, Hartley, Marin, and Sheeler, he proposed to his fellow trustees of New York University that he be allowed to house his collection in the reading room of the library overlooking Washington Square (figs. 6 and 7). Thus the Gallery of Living Art was founded, its significant tenure in Greenwich Village lasting from 1927 to 1943. (In 1933 Gallatin changed its name to the Museum of Living Art.) Year by year, the collection grew and changed as Gallatin acquired such important single works as Miró's *Dog Barking at the Moon*, Léger's *La ville*, and Picasso's *Three Musicians*, augmenting his already fine and extensive holdings of works representing Cubism, Neo-Plasticism, Constructivism, and other major movements in twentieth-century art.

Gallatin himself ran the Gallery of Living Art, published his own catalogues, handled the mailing list, and encouraged young artists to spend a good deal of their leisure time in the library study hall. Open most evenings and offering free admission, the gallery proved to be a popular spot for meetings and discussions throughout the thirties. Gallatin's familiarity with the younger artists in New York was enhanced by his own activity as a painter. His serious involvement in painting began in 1926 when he was studying and collecting Cubist art in Paris. Gallatin's personal style was almost entirely

influenced by the later phases of Cubism, Picasso's work of the twenties, and that of Gris. His art is studied, based upon essential principles of Cubist construction, but handled with a personal, idiosyncratic taste for unusual clustered shapes and relatively large areas of open space.

Gallatin joined the American Abstract Artists group in 1937 and participated in the organization's exhibitions from 1938 to 1952. His closest circle of friends included George L. K. Morris, Suzy Frelinghuysen, and Charles G. Shaw, all early AAA members.

In late 1942 Gallatin received a letter from New York University requesting the removal of his collection in order to make more library space available for books. With a mixture of surprise and bitterness, Gallatin revoked his bequest to the university and accepted the invitation of the Philadelphia Museum of Art to receive and permanently house the collection, where since 1943 it has been installed as one of the major components of that museum's great holdings in twentieth-century art.

Susan C. Larsen

[1] Albert E. Gallatin, *Whistler's Pastels and Other Modern Profiles* (New York: John Lane, 1912), p. 4.

FRITZ GLARNER

Born 1899 in Zurich, Switzerland; died 1972 in Locarno, Switzerland. Visited the United States in 1930–31; settled in the United States in 1936 and became U.S. citizen in 1944. Studied at Regio Istituto di Belli Arti, Naples, 1914–20; Académie Colarossi, Paris, 1924–26.

Although born in Switzerland, Fritz Glarner spent most of his youth in France and Italy. While living in Chartres, he was inspired by the cathedral windows to paint his first watercolors. At the outbreak of World War I, his family moved to Naples, where Glarner received a traditional academic training for six years. It was not until he moved to Paris in 1923 that he became aware of progressive art movements. He studied intermittently at the Académie Colarossi and frequented cafés such as the Closerie des Lilas, where he met the Delaunays, Arp, Taeuber-Arp, Hélion, Léger, van Doesburg, Mondrian, and other advanced artists. Glarner later described the evolution of his work—mostly abstracted renderings of still-life subjects and interior scenes—in the late twenties and thirties: "I began to represent objects in flat tones and I felt [a] need to dematerialize them—eliminating shadows—outlining them to give them a more definite size and proportion—not copying the relationship that they occupied in nature, but relating them to the size and limits of the canvas."[1]

In *Painting*, 1937 (cat. no. 52), a table top is indicated by an irregularly shaped plane of blue tipped up toward the canvas surface. This flattening effect is reinforced by the dispersion of geometrically rendered still-life elements and the basic rectangular divisions of the image, while recession into depth is suggested by the diagonal edge in the bottom right corner and the light colors of the background. Glarner's principal goal in the ensuing years was to resolve the spatial tensions evident here: "To bring about a purer and closer interrelationship between form and space has been my problem since that time."[2]

In 1930–31, two years after their marriage in Paris, Glarner and his American wife, the former Louise Powell, spent nine months in New York, where he had a one-artist exhibition at the Civic Club. Glarner also participated in an international exhibition of abstract art organized by Katherine Dreier at the Albright-Knox Art Gallery in Buffalo.[3] However, he was discouraged by the chauvinism of the American art scene and, unable to find an audience for his increasingly abstract work, he returned to Europe. During the next five years he became a member of Abstraction-Création and the Allianz group of Swiss Constructivists. When the Spanish Civil War broke out in 1936, Glarner returned to New York, where he lived for the next thirty-five years, becoming an American citizen in 1944. From 1938 until the mid-forties, he participated in the annual exhibitions of the American Abstract Artists. Although for many years he was forced to support himself by working as a portrait photographer, his painting style matured in the context of the international artistic community of New York during World War II.

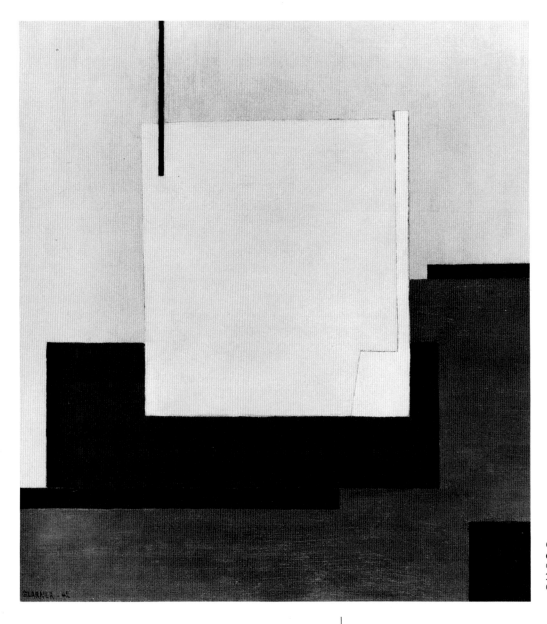

CAT. NO. 53. FRITZ GLARNER
Composition, 1942
Oil on canvas
21 × 19½ in. (53.3 × 49.5 cm.)
Collection of Mrs. Robert C.
 Graham, Sr.

Glarner was on friendly terms with Duchamp, Gabo, Moholy-Nagy, and other artist-exiles in America, but his deepest and most important relationship was with Mondrian, of whom Glarner once said: "He was my friend . . . and he was my master."[4] Indeed the influence of Mondrian's Neo-Plastic style is evident in all of Glarner's subsequent work.

No longer making abstractions from natural motifs, in paintings of the early forties such as *Peinture Relative*, 1943 (fig. 8), Glarner nonetheless continued to explore the relations of forms in space, deploying black lines and rectangular planes of primary color, black, and gray at the edges of the canvas to suggest their centripetal extension beyond the frame.[5] In *Relational Painting, Tondo No. 1*, 1944 (cat. no. 54), the first of many compositions in this shape, probably inspired by the unusual diamond format of Mondrian's *Victory Boogie Woogie*, Glarner's immediate concern was to establish a sense of movement: "I found that a line stopped abruptly created dynamic movement. If we assume that a line is a succession of points, the last one has a different activity than the others, because it is not succeeded by another point. Somewhat as

a pebble whose momentum, stopped by the surface of the water, creates concentric motion, so that last point acts as a point-center. The relationship between these point-centers increased the activity of the space-area."[6] Although the forms here are still placed against—rather than fully integrated with —the white ground, they no longer overlap one another to produce a sense of depth as in *Peinture Relative*. Instead, the colored planes are bound on two sides by black lines that together suggest a partial gridlike structure holding all the forms at the surface of the painting.

Not until after Mondrian's death in 1944, and his own abstention from painting during the following year, did Glarner achieve the synthesis of form and space he appreciated in Mondrian's late work. In all of Glarner's subsequent compositions, which he titled "Relational Paintings" (fig. 9), the traditional distinction between figure and ground is no longer operative because there is no ground as such. The paintings are entirely composed of numerous rectangles, each of which contains two wedges of color. The wedges pulsate with en-

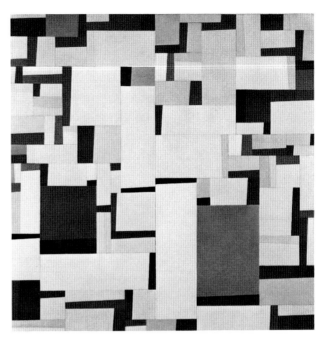

FIG. 9. FRITZ GLARNER
Relational Painting, 1947–48
Oil on canvas
43⅛ × 42¼ in. (110 × 107.3 cm.)
The Museum of Modern Art, New York

FIG. 8. FRITZ GLARNER
Peinture Relative, 1943
Oil on canvas
46⅛ × 44⅛ in. (117.2 × 112.1 cm.)
Yale University Art Gallery, New Haven; Gift of Katherine S. Dreier to the
 Collection Société Anonyme

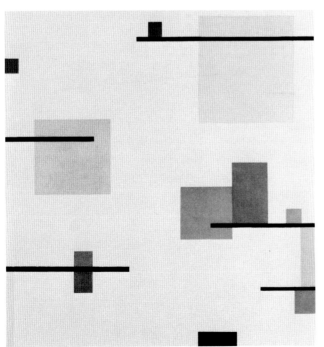

ergy because of their color relationships and the dynamic fifteen-degree slant of their common edge, so that each wedge forms at once a figure and a ground in relation to its companion within a given rectangle. Although Glarner found ways to vary this basic formula, even his last paintings dating from the mid-sixties reveal a debt to the dynamic quality of Mondrian's *Victory Boogie Woogie*, left unfinished more than two decades before.

Nancy J. Troy

[1]Fritz Glarner, "Relational Painting." Lecture delivered at Subject of the Artists, a New York City school, 25 February 1949, quoted in Virginia Pitts Rembert, "Mondrian, America, and American Painting" (Ph.D. dissertation, Columbia University, 1970), p. 178.
[2]Ibid.
[3]Dagmar Hnikova, *Fritz Glarner im Kunsthaus Zürich*. Kunsthaus Zürich Sammlungsheft 8 (Zürich: Kunsthaus, 1982), p. 226.
[4]B[elle] K[rasne], "Fifty-Seventh Street in Review: Fritz Glarner." *Art Digest* 25 (February 15, 1951): 20.
[5]Glarner wrote of *Peinture Relative*: "It is a fact that Mondrian came several times to see this painting before his death. He was especially interested in the abrupt stopping of the black horizontals. He felt that the dynamic relationship of these horizontals increased the sense of space of the composition." Fritz Glarner, Letter to Katherine S. Dreier, 28 January 1946, Katherine S. Dreier Papers, Yale Collection of American Literature, Beinecke Rare Book and Manuscript Library, Yale University, New Haven, Connecticut.
[6]Glarner, "Relational Painting," quoted in Rembert, p. 183.

ARSHILE GORKY

Born 1904 in Turkey (Turkish Armenia); died 1948 in Sherman, Connecticut. Arrived in the United States in 1920; became U.S. citizen in 1939. No formal art training.

Born into an ancient Armenian family settled on the shores of Lake Van, then part of the Ottoman Empire, Vosdanig Manoog Adoian witnessed and suffered many early tragedies. His father fled to America rather than become a conscript of the Turks, and before the boy and his sister escaped the ensuing Turkish genocide of the Armenians, he witnessed his mother's starvation after a 125-mile death march. This early ineradicable trauma molded his personality and, subsequently, his art. Armenia and its folkways, lost forever in a nightmare of slaughter and wandering, merged in his experience with an acquired cosmopolitan sophistication to provide the foundation of a gigantic talent in the New World.

The young refugee worked ceaselessly at refining what he saw in modern art. In Boston he became a proficient mimic of Impressionism and then mastered Cézanne's Post-Impressionism; Cubism in its variety of forms came under his careful scrutiny, was absorbed, mastered, and integrated into an ever-widening reservoir of expressive devices. In 1925 he moved to New York and presented himself as Arshile Gorky, cousin of Maxim Gorky—whose own name was a pseudonym and who was not a relative. Despite his assumed name, adopted styles, and embroidered history (he claimed to be Russian, to have studied with Kandinsky), Gorky was quickly recognized as a major original talent and soon promoted from student to teacher at the Grand Central School of Art, where he taught from 1925 to 1931. It was during this period that he met John Graham and Stuart Davis and also formed a long-lasting, intense friendship with Willem de Kooning. Although Gorky did attend the first meeting of the American Abstract Artists, he never officially joined the group nor participated in its exhibitions. Gorky was assigned important mural commissions by the WPA Federal Art Project, notably at Newark Airport in New Jersey, where he executed the first abstract murals done in the United States, but he was most prolific and effective as an easel painter.

Still Life (Composition with Vegetables), 1928–29 (fig. 10), may serve as a gauge of Gorky's deliberation of modern art. The table-top view, its surface tilted up, areas of white brightening otherwise low-value and intensely colored objects, and the squared monochromatic forms surrounding the vegetables all indicate the degree to which Gorky isolated the components of Synthetic Cubism as useful and independent units, considered separately in his own work. In this, and in countless other paintings of Gorky's early period, design and color were continuously adjusted to assay their relationships; these revisions were made on the initial canvas rather than introducing alterations in each work within

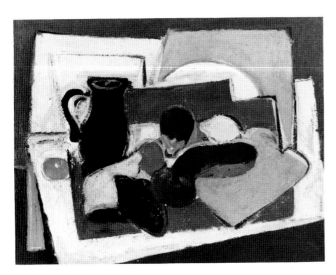

FIG. 10. ARSHILE GORKY
Still Life (Composition with Vegetables), 1928–29
Oil on canvas
28¹/₁₆ × 36¹/₁₆ in. (71.3 × 91.6 cm.)
The Archer M. Huntington Art Gallery, University of Texas, Austin; Gift of
 Albert Erskine, 1974

an evolving series. The paint surface of these early works, piling up successive layers of experiment, is not, in itself, an appealing aspect of Gorky's art.

Over a period of two decades, Gorky refined his painting and liberated his rare natural gift for paint handling. His treatment changed from being rugged to seeming apparently effortless. Eventually the graceful suavity of his last works came to be criticized, just as his early stylistic dependence had been viewed suspiciously. *Still Life*, ca. 1930–31 (cat. no. 55), also displays a rough and irregular surface, indicating levels of submerged amendment and adjustment, but this painting's most prominent feature is its specific debt to Picasso.

Gorky had long been a follower of Picasso—as were many aspiring American artists—but the degree of Gorky's success in comprehending the Spanish master as a precedent and model was unequaled. Many critics faulted Gorky's inability to express himself in any but the borrowed style of Picasso, while his defenders claimed that to mimic Picasso in America in the thirties was itself an act of intellectual courage. Ultimately, it was not Gorky's dogged subordination to Picasso that proved significant, but his own virtuosity in the practice of the inherited style. In *Still Life*—and in the other Gorky works in this exhibition (which intentionally does not follow his career into its full maturity in 1943, seeing that

accomplishment as beyond its scope)—it is precisely his success as an apprentice, as one who *apprehends*, learning rather than making self-declarations, that sets him apart (much as Jackson Pollock came to his art gradually, evolving from Thomas Hart Benton's mannerism). In *Still Life*, Gorky employed the shapes of Picasso's artist-and-model interiors, with a striped pattern that was ultimately derived from Picasso as well. This hatching, which appeared in many American graphic works at that time and as parallel lines in painting, signals a distinctly American phase in the dissemination of modern art. Pre-eminently for Gorky, hatching shaded tones from the lightest to the very darkest gave him a chance to extend and intensify the labor and concentration he lavished on each work; therefore, he adopted it wholeheartedly, setting an example for other artists such as Graham, who looked to Gorky's experiments. He continued this breathtakingly difficult means of shading his drawings into the early forties, long after it had been discarded by other, less obsessed artists. Only when he started using washes of translucent colors above opaque underpainting—the ancestor of stain painting—was hatching supplanted in his repertoire.

During the thirties it was often difficult for Gorky to afford paint. As a result, some of his thematic concerns were developed almost exclusively in drawings. Such was the fate of "Nighttime, Enigma and Nostalgia," a theme that occupied

FIG. 11. ARSHILE GORKY
Nighttime, Enigma and Nostalgia, ca. 1931–32
Ink on paper
24 × 31 in. (61 × 78.7 cm.)
Whitney Museum of American Art, New York; 50th Anniversary Gift of Mr.
 and Mrs. Edwin A. Bergman

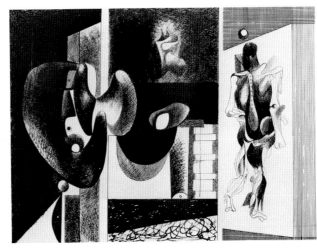

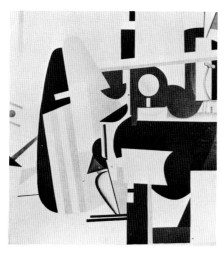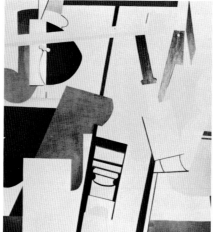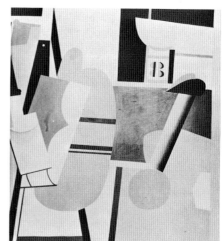

FIG. 12. ARSHILE GORKY
Activities on the Field (lost), three successive, overlapping views of one panel
 from "Aviation: Evolution of Forms under Aerodynamic Limitations," 1936
Oil on canvas
Photographed in WPA/FAP Studio

his attention throughout the early thirties (fig. 11); there are no more than a handful of small oils of this period. The Great Depression deepened, compounding Gorky's poverty and curtailing his painting. Thus *Organization (Nighttime, Enigma and Nostalgia)*, ca. 1933–34 (cat. no. 56), serves as the ambassador of what might otherwise have been an extended series. This painting is full of compositional experiments and motific devices that were not repeated elsewhere in either drawings or paintings. Based ultimately on a 1913 painting by de Chirico, *The Fatal Temple*, which Gorky could have seen at the Gallery of Living Art in New York, the theme of *Organization (Nighttime, Enigma and Nostalgia)* is related in subject matter—an abstracted domestic interior—to *Still Life* and helps describe a progression in Gorky's thinking. *Organization*, 1933–36 (see frontispiece), was developed over a long period and underwent many revisions, but it was painted on a most ambitious scale. A work of this size (50¼ by 60¼ inches) by an American modernist was extraordinary at the time, and Gorky's special brand of audacity can be gleaned from this painting in which his dependence on Picasso was neither obscured nor denied. He challenged Picasso on Picasso's own territory.

Gorky engaged Léger as well. In his mural project for Newark Airport, Gorky worked from a series of photocollages, translating these designs (prepared by Wyatt Davis, brother of Stuart) in large painted panels. An untitled, independent oil, a detail from the Newark mural, ca. 1935–36 (cat. no. 57), is derived from the left panel of Gorky's "Activities on the Field" section of his airport commission (fig. 12). Léger's manner of softly modeling rounded machine forms was enthusiastically adopted by Gorky, adding a certitude and evenness of articulation that never again appear in his painting.

Composition (Still Life), ca. 1936–38 (cat. no. 58), is neither so imposing as *Organization* (let alone the airport murals) nor so beholden to Picasso or Léger as other works of the time, and in it are the visible beginnings of Gorky's concern for shapes and designs and vivacious execution that would eventually become the distinguishing characteristics of his art alone. The subject of the vase of flowers had repeatedly attracted him, but in *Composition (Still Life)* he extended the level of abstraction and presaged the kind of paintings, such as *Enigmatic Combat*, ca. 1936–38 (cat. no. 59), of which he was capable. *Enigmatic Combat* combines the close-up shapes of an interior with a horizon to create complex space. This combination of elided background and foreground views

152

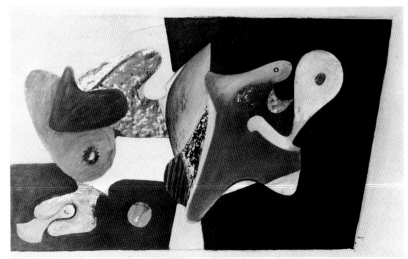

CAT. NO. 56. ARSHILE GORKY
Organization (Nighttime, Enigma and Nostalgia), ca. 1933–34
Oil on board
13½ × 21⅝ in. (34.3 × 55 cm.)
University of Arizona Museum of Art, Tucson; Gift of Edward J. Gallagher, Jr.

CAT. NO. 57. ARSHILE GORKY
Untitled (detail from "Aviation: Evolution of Forms under Aerodynamic
 Limitations"), ca. 1935–36
Oil on canvas
30 × 35½ in. (76.5 × 90.3 cm.)
The Grey Art Gallery and Study Center, New York University, New York; Gift
 of May Walter, 1965

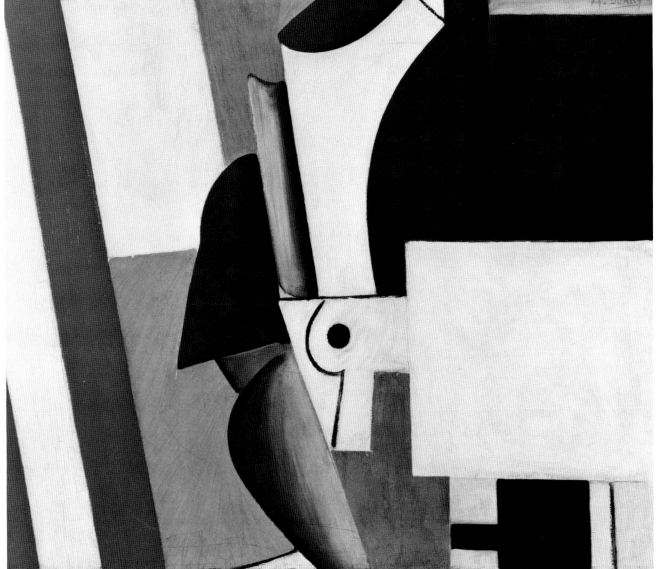

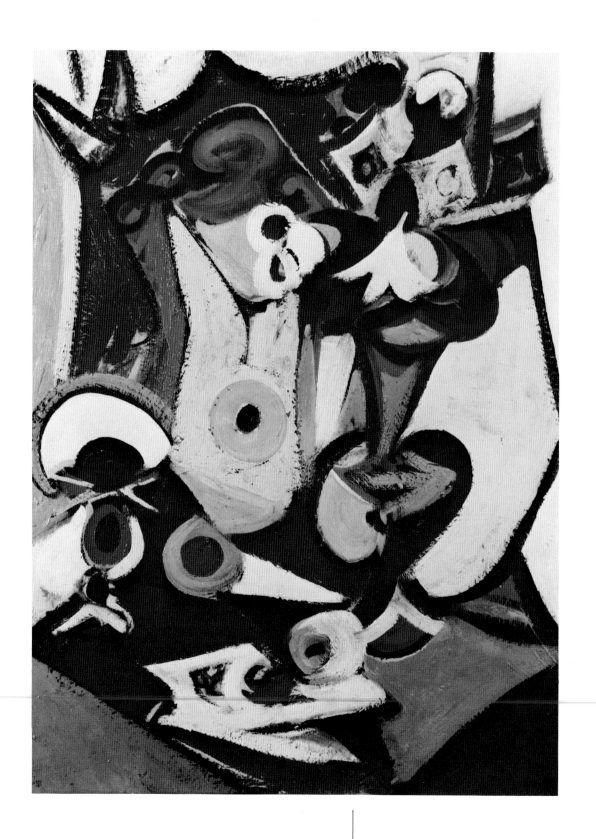

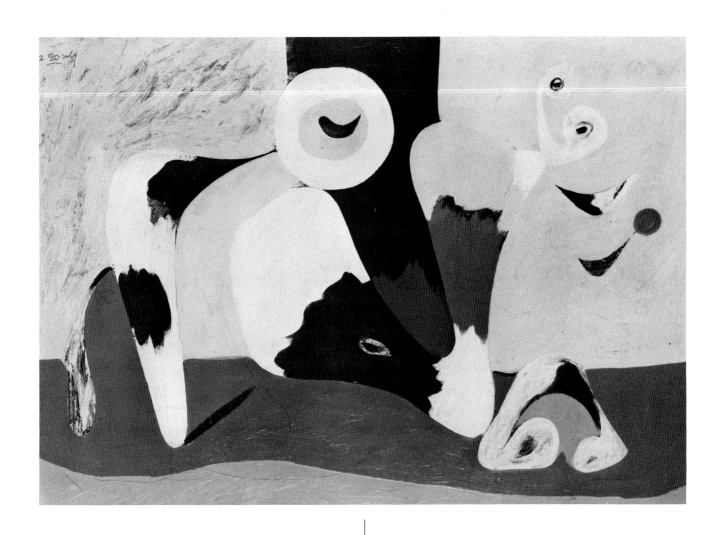

CAT. NO. 58. ARSHILE GORKY
Composition (Still Life), ca. 1936–38
Oil on canvas
34⅛ × 26⅛ in. (86.7 × 66.4 cm.)
Collection of Thomas Weisel

CAT. NO. 60. ARSHILE GORKY
Mojave, 1941–42
Oil on canvas
28⅞ × 40⅝ in. (73.4 × 103.2 cm.)
Los Angeles County Museum of Art; Gift of Burt Kleiner

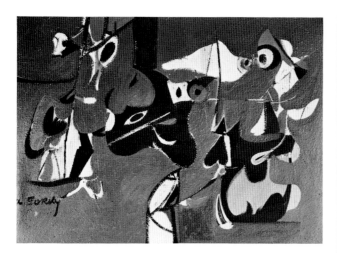

FIG. 13. ARSHILE GORKY
Garden in Sochi, 1941
Oil on canvas
44¼ × 62¼ in. (112.4 × 158.1 cm.)
The Museum of Modern Art, New York; Purchase Fund and Gift of Mr. and
 Mrs. Wolfgang S. Schwabacher (by exchange)

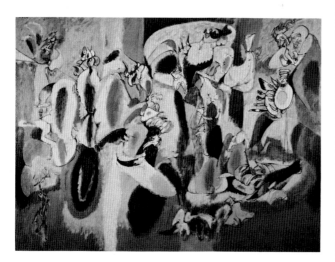

FIG. 14. ARSHILE GORKY
The Liver Is the Cock's Comb, 1944
Oil on canvas
72 × 98 in. (182.9 × 248.9 cm.)
Albright-Knox Art Gallery, Buffalo; Gift of Seymour H. Knox

creates a stressed depth of field that the human eye cannot actually experience as we traverse the world; while this device appears for the first time in Gorky's paintings of the period, such as *Enigmatic Combat*, the tension of spatial depth was a consideration he never thereafter abandoned. Like de Chirico's use of extreme distance that abuts the picture plane, such elisions connote profound emotional states. The projection of the visual material onto one plane provides the painter with a wealth of design choices. As Gorky balanced and adjusted, changed and reconsidered these many alternatives, his pigment grew ever thicker on the canvas until only a Herculean frame like his own could easily lift such paintings.

In his "Garden in Sochi" series of the early forties, Gorky recounted some of the folkways of Armenia and his boyhood, but in the most sophisticated vocabulary of international art. *Garden in Sochi*, 1941 (fig. 13), exemplifies the final moments of dependence and provinciality in Gorky's work, as well as in the history of American art. The forms in the painting are derived from Miró and make evident Gorky's assimilation of Surrealism. The "Sochi" series shares a similar treatment and formal division of the canvas with *Mojave*, 1941–42 (cat. no. 60), a work almost certainly derived from landscape studies.

In Gorky's mature and fully individualistic art of the mid-forties, for example, *The Liver Is the Cock's Comb*, 1944 (fig. 14), Matta's graceful draftsmanship found its equal and was combined with Miró's haunting world. His paintings recall the riches of Matisse's paint handling and, simultaneously, Kandinsky's nervous improvisations. Gorky integrated both Picasso's intellectual and stylistic invention as part of a dialogue with Ingres, for Gorky's ambitions were of the highest order: to challenge the history of art in its most exalted instances. In doing so, he set the standard of achievement for his generation.

Success, however, always eluded Gorky. His life, which had begun in misery and uncertainty, never did become cheerful or secure. Meager support came from a circle of students and friends. His first marriage was short-lived, ending in divorce during the pervasive gloom of the Depression; he remarried in 1941. Tragedy dogged his path in the following years. In 1946 Gorky's studio burned, destroying many of his laboriously constructed works, and shortly thereafter he was operated on for cancer. In 1948 his neck was broken and his painting arm immobilized in an automobile accident, and subsequently his second marriage failed. In unrelieved despair, Gorky hanged himself.

Harry Rand

JOHN GRAHAM

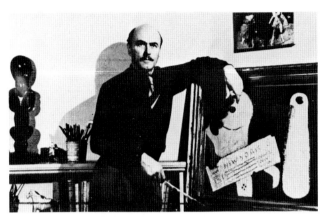

Born 1886 (by the Julian calendar), Kiev, Russia; died 1961 in London, England. Arrived in the United States in 1920; became U.S. citizen in 1927. Studied in Russia at the Imperial Lyceum and University of Kiev (law); Art Students League, New York, especially with John Sloan, 1922–24.

Scion of an ancient and noble Polish family living in Russia, Ivan Gratianovitch Dombrowski (or Dabrovsky) was educated in elite schools. Credentialed as a czarist lawyer, he moved within the society of the imperial court and served as a second lieutenant in Grand Duke Michael's Circassian Regiment. A counterrevolutionary, he was captured by the Bolsheviks, escaped, and made his way to the United States, where he changed his name to John—the English equivalent of Ivan—and chose Graham as his surname because it most closely resembled the Cyrillic spelling of Dabrovsky.

Graham was a dashingly handsome man who married several times and had many lovers; in addition to being an artist, he was a yoga, a mystic, a cosmopolite, a bit of a dandy, a highly informed connoisseur, an amateur anthropologist, and an art theorist. A transmitter of Europe's most evolved thinking, Graham served as a conduit to America, escorting significant art and ideas across the Atlantic in whichever direction he thought would do the most good. In this capacity he was a singularly important catalytic figure—a force for sophistication, quality, and high ambition in American art of the thirties and forties. Once Graham emigrated, the artistic talent that had been merely a hobby in Russia came to occupy him completely in America, and at times he functioned simultaneously as artist, aesthetician, dealer, patron, promoter of other artists, author, critic, and educator of a generation.

When Graham first settled in Baltimore in the mid-twenties, his genius was recognized by Duncan Phillips, who in 1920 established the Phillips Memorial Gallery (now called The Phillips Collection) in Washington, as the first museum of modern art in the United States. As patron and collector, Phillips befriended Graham, with whom he shared an aristocratic sensibility—although the artist was then living in reduced circumstances.

In 1928 Graham exhibited in Paris, and the following year at the Phillips Memorial Gallery and the Dudensing Gallery in New York; in 1930 he again exhibited in Paris. With his prodigious knowledge of many areas of art history, both ancient and modern, Graham supplemented his meager painter's income by being an art dealer, specializing in Italian Renaissance bronzes and African sculpture. Among the notable collections assembled by Graham was that of publisher Frank Crowninshield devoted to African objects.

From Graham's intimacy with all of art history grew new hybrids. In the thirties he coined the term "minimalism" to describe an art of "minimum ingredients for the sake of discovering the ultimate, logical destination of painting in the

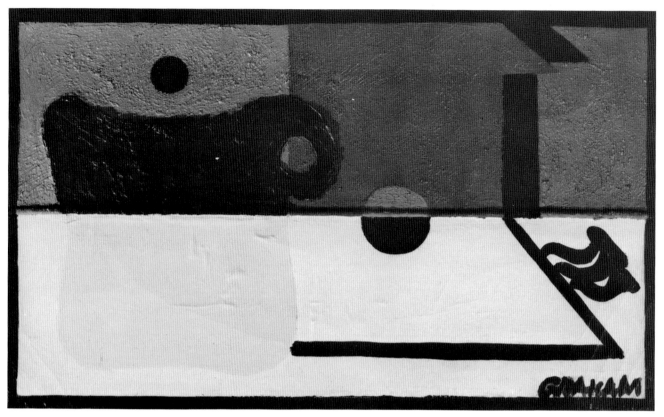

CAT. NO. 62. JOHN GRAHAM
Lunchroom Coffee Cup, 1930
Oil on canvas
11 × 18 in. (27.9 × 45.7 cm.)
Allan Stone Gallery, New York

process of abstracting. Painting starts with a virgin, uniform canvas and if one works ad infinitum it reverts again to a plain uniform surface (dark in color), but enriched by process and experience lived through. Founder: Graham."[1] Graham's minimalism ought not to be confused with that of the sixties and seventies; his was an art in which each variation canceled the preceding one in order to arrive at a nub, a kernel. This stripping away produces an art that is reductive and final, serene and classical. Later minimalist art presents a starting position that provides a minimum amount of information to the viewer; it is the beginning rather than the end of a process, resulting in an art that is not final but potential, not classical but romantic and sublimely dramatic.

A work such as *Still Life with Pipe*, 1929 (cat. no. 61), precisely locates Graham's concerns during these years. The painting is pale, almost to the point of evanescence, but rig-

orously structured. The composition's dividing lines dip and flow briskly through the bordered white shapes assembled as if by cloisonné. In the middle of this pale delicacy veined with the most sensitive lineation, thick pasty paint thrusts a clotted section of the surface forward, while, on the left, over a scalloped horizon, sight plunges backward into a distant zone. Thus, with the utmost economy, Graham encountered and gracefully mastered a whole set of lateral and depth considerations. Viewed innocently on the table, the "pipe" repeats throughout the work a Léger-like motif that, magnified and rotated in space, supplies the linear vocabulary for the center of the painting.

Despite the addition of a wider range of colors—monochromatic and opaque planes of red and blue—*Lunchroom Coffee Cup*, 1930 (cat. no. 62), is an even more narrowly focused work. The relationship of edges and shapes carries

OPPOSITE
CAT. NO. 63. JOHN GRAHAM
Crucifiction, 1931
Oil on canvas
40 × 32 in. (101.6 × 81.3 cm.)
Allan Stone Gallery, New York

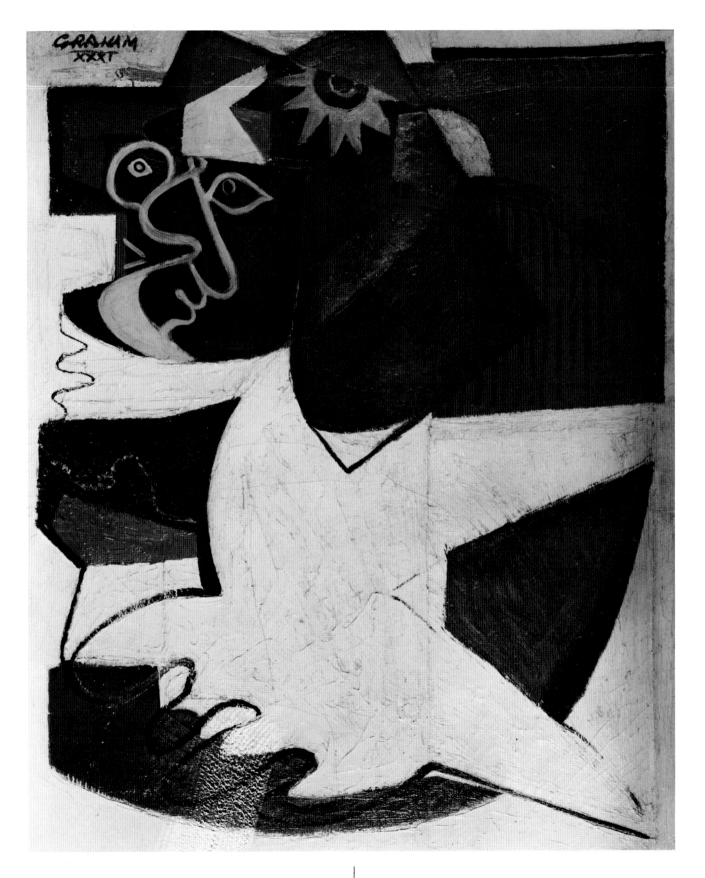

the burden of the painting, and the presentation is unmistakably that of a formal Synthetic Cubism adopted without reservation. Its edges crepuscular black (with even deeper shadows falling at the right—homage to de Chirico), this could be the very cup from which Picasso's *Three Musicians* might drink. Such diligence in the absorption of Synthetic Cubism was neither slavish nor uninventive, but a discipline that many a European Cubist did not master nearly so well as did Graham. Again, as in *Still Life with Pipe*, gritty textural passages dictate the rhythm by which we scan the painting, syncopating and projecting the work into that space shared with the spectator.

By 1931, Gráham's introspection was no longer completely placid. Borders of shapes became nervous and unclassically irregular. Lines swerved when moving through patches of color, as if encountering resistance, but when a line was used as the boundary between colors, it seemed to be held in place by the pressure of color on each side. Although his basic concerns were unchanged, in a painting such as *Crucifiction*, 1931 (cat. no. 63), reactions between pictorial elements accelerated, with amplified effects; this work inherits many assumptions of his previous paintings, yet in *Crucifiction* he nervously tests his limits. The classicism, repose, and harmony that beckoned were yet but distantly espied.

In a work such as *Blue Abstraction (Still Life)*, 1931 (cat. no. 64), we glimpse the unexpected quarter from which rescue would come—for Graham as well as for Arshile Gorky, Jan Matulka, David Smith, Stuart Davis, and other American artists who briefly shared an agenda for modern art. Beginning in the late twenties, Picasso—so much the source of direction for twentieth-century art—began to use hatching to shade his classically inspired works. This hatching, borrowed from Renaissance engraving, first appeared in the early twenties in Picasso's Surrealist phase. It marked a sharp break with the immediate past and precipitated a doctrinal problem of allegiance for those traveling in Picasso's wake. Close black parallel stripes became one of the pre-eminent traits of American modernist art of the thirties. Patterned surfaces distinguished one area from another without invoking a hue shift (or the inoculation of the canvas with textured material, employed by Graham and others to raise a surface different from even the thickest paint).

In *Blue Abstraction*, Graham's monochromaticism and striped style supply the predominant characteristic of the work. Emerging from the left of the painting is an oval face that, often compared with an egg, would form an increasingly important motif in Graham's work until this intrusive figuration abolished abstraction for Graham. *Blue Abstraction* masterfully resolves the complex requirements of an agenda that sometimes included apparent contradictions and that incorporated citations of an essentially Post-Impressionist composition (ultimately derived from Japanese woodblock prints relying on elements injected from the enframing edge that locked the picture into place, jigsaw-like). The arrangement depended on quotations or precedents from Picasso's classical "Blue" and Synthetic Cubist periods; figuration determined the subject matter, for Graham disdained nonobjectivity; and secretive Golden Rectangle relationships sustained the composition. All is accomplished with the least show of strain or unease.

During Graham's lifetime, few of his writings, except for an occasional article or catalogue introduction, appeared in print. His major work, *System and Dialectics of Art*, 1937, gave voice to a generation. Much that is to be found in this paradoxical and idiosyncratically articulated book—constructed as a lengthy Socratic dialogue, and hence "dialectic" —would have been subscribed to by his fellow artists, but the volume, despite its great influence, was in few of their hands. Graham published it in a limited edition of only one thousand copies; nonetheless, it made its way into the most effective libraries.

In 1942 it was Graham who organized the exhibition in New York that first seriously presented the work of Jackson Pollock (and it was through Graham that Pollock met his future wife, the artist Lee Krasner). Graham was the center of a circle of friends and intensely engaged artists that included Gorky, Davis, and Willem de Kooning. It was Graham who gave David Smith one of the first sculptures by Julio González in the Western Hemisphere and decisively influenced Smith to concentrate on sculpture. Smith moved close to Bolton Landing, New York, near Graham's dwelling.

Graham changed his outlook and style, so that the appearance of his art was no longer easily reconcilable with his earlier pronouncements, and he repudiated Picasso entirely as an aberration in the evolution of art. By the early forties, Graham had abandoned modernism and turned his back on minimalism to produce a synthetic art that was gracefully Italianate, bedecked with mystical emblems.

Harry Rand

[1]John Graham, *System and Dialectics of Art* (Paris and New York: 1937), Section 32. Published in an edition of 1,000 copies; reprint ed. with introduction and notes by Marcia Epstein Allentuck, Baltimore: Johns Hopkins Press, 1971.

BALCOMB GREENE

Born 1904 in Millville, New York. Entirely self-taught except for classes in 1931 at Académie de la Grande Chaumière, Paris.

Balcomb Greene was born in Millville, New York, near Niagara Falls, the son of a Methodist minister who christened him John Wesley Greene. Originally intending to be a preacher, he attended Syracuse University on a scholarship for sons of Methodist ministers, but gradually broke away from the church and majored in philosophy. In his senior year, while visiting The Metropolitan Museum of Art during a trip to New York, he met Gertrude Glass, a young and attractive art student. As soon as he received his B.A. degree in 1926, he returned to New York to court and soon thereafter marry her.

Already committed to the ideal of free individual expression, Greene, with his new wife and her fellow progressive artists, was eager to learn of and support new ideas in philosophy, literature, and art. He was at this time, however, a writer, with special interest in philosophy and psychology, particularly the writings of Sigmund Freud.

In 1926 the Greenes went to Vienna, where Balcomb had a fellowship in psychology at the university. He transferred the fellowship to Columbia University after a year, but before completing his dissertation was offered a job teaching English literature at Dartmouth College. The Greenes moved to New Hampshire, where Balcomb taught and wrote from 1928 to 1931. In 1931 they moved to Paris, using their savings to pursue interests in avant-garde art and literature. Although he began to write novels in Paris, Balcomb was soon attracted through Gertrude's activities to the Parisian art scene. Abandoning the idea of a writing career, Balcomb enrolled at the Académie de la Grande Chaumière and began to embrace wholeheartedly the art of painting. Like his wife and many of the young radical students around him, Balcomb espoused the post-Cubist notions of geometric abstraction. Fascinated by Picasso and Matisse, the young American was, however, especially influenced by Mondrian and Gris and members of the Abstraction-Création group. Their goal was the "cultivation of pure plastic art to the exclusion of all exploratory, anecdotal, and literary and naturalistic elements."[1]

The Greenes returned to New York in 1932, and in the next few years Balcomb developed the basic structure of his work. Keeping tight control over his interest in abstraction, he worked on what he has called his "straight line, flat paintings."[2] These early abstractions were subsequently referred to as "off-beat purist" in *Art News*.[3]

In 1937 American Abstract Artists was founded, and Balcomb Greene—young, ambitious, and vocal—was elected the group's first chairman, a position to which he was re-elected in 1939 and 1941. Calling upon his early train-

FIG. 15. BALCOMB GREENE
Cover for 1938 *Annual of American Abstract Artists*, 1938

ing as a writer, Greene helped draft the charter of this society, whose interest was solely to help the artists rather than to support political ideals. "Our purpose is to unite abstract artists living in the United States, to bring before the public their individual works, and in every possible way foster public appreciation for this direction in painting and sculpture."[4]

Greene also helped edit the AAA Yearbook and in 1938 designed its cover—an elegant pattern of lines and planes, in gray, red, and black, that served as the basis for the printed blocks of copy (fig. 15).

During the thirties Greene also worked for the WPA Federal Art Project, designing an abstract mural for the Federal Hall of Medicine at the 1939 New York World's Fair, a mural for the Williamsburg Housing Project in Brooklyn, and a stained-glass window for the Bronx School of Arts and Sciences. During this period he also began to study for an M.A. degree in the history of art at New York University.

Greene's acute perceptions of the role of the American abstract artist at this time, underscored by his firm grounding in philosophy and psychology, were brilliantly expressed in his essay "Expression as Production," published in the 1938 AAA Yearbook:

It is actually the artist, and only he, who is equipped for approaching the individual directly. The abstract artist can approach man through the most immediate of aesthetic experiences, touching below consciousness and the veneer of attitudes, contacting the whole ego rather than the ego on the defensive. There is nothing in his amorphous and geometric forms, and nothing within the consciousness or within memory from which he improvises, which is deceptive. The experience is under its own auspices. To whatever extent it helps reconstruct the individual by enabling him to relive important experiences in his past—to that extent it prevents any outward retrogression.[5]

Greene's painting *Angular*, 1937 (cat. no. 65), reveals the artist's elegant use of straight lines, flat color areas, and simple interlocking geometric forms. The strong, black-outlined open rectangular area, seemingly superimposed upon a lower horizontal darker area, appears to float in open space while, at the same time, it holds down or "grounds" the lower support area. In its use of ideas gleaned from Cubism and Neo-Plasticism, Greene's sophisticated geometric abstraction apparently disregards the biomorphic curved forms, derived from Surrealism, that characterize the styles of so many of his American contemporaries, including his wife. The insistence on straight lines and overlapping geometric shapes is perhaps more akin to the work of Albers or Diller than that of any of his other fellow AAA members. An overall feeling

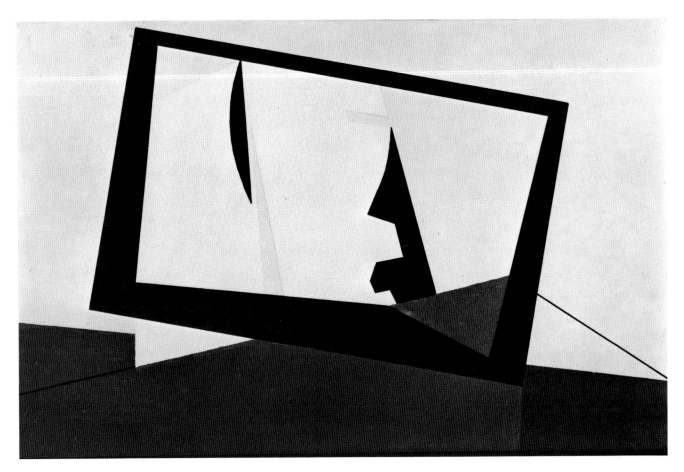

CAT. NO. 65. BALCOMB GREENE
Angular, 1937
Oil on panel
15½ × 24 in. (39.4 × 61 cm.)
Collection of the artist. Courtesy of ACA Galleries, New York

of space—indeed, of three-dimensional forms occupying a recognizable landscape-like setting defined by a horizon line—is what characterizes Greene's work at this time and distinguishes it from that of his colleagues.

This early sense of composing a geometric abstraction reminiscent of a landscape is carried even further in Greene's *Composition*, 1940 (cat. no. 66). Here there is a much more defined horizon line denoting a darkened foreground. The diagonal lines forming a pyramidal shape that appeared in *Angular* are repeated in *Composition*, but seem in this case more like a hill-type form further defining the foreground and horizon. Strictly speaking, both paintings are pure, nonrepresentational geometric abstraction. But, in their specific uses

of compositional devices, including spatial and perspectival references, they seem to prefigure Greene's later landscape paintings, which in fact he began in the early forties and continues to this day.

Linda Hyman

[1]*Abstraction-Création, Art Non-Figuratif*, no. 1 (Paris, 1932), title page.
[2]Robert Beverly Hale and Niké Hale, *The Art of Balcomb Greene* (New York: Horizon Press, 1977), p. 12.
[3]*Art News* (October 1959): 13.
[4]Balcomb Greene, "Organization," in *American Abstract Artists Annual 1938*; reprinted in *American Abstract Artists, Three Yearbooks (1938, 1939, 1946)* (New York: Arno Press, 1969).
[5]Balcomb Greene, "Expression as Production," in *American Abstract Artists Annual 1938*; reprinted in *American Abstract Artists, Three Yearbooks (1938, 1939, 1946)* (New York: Arno Press, 1969).

GERTRUDE GREENE

Born 1904 in Brooklyn, New York; died 1956 in New York City. Studied at Leonardo da Vinci School, New York, 1924–26.

Gertrude Greene, née Glass, was born in Brooklyn in 1904, the youngest child of prosperous Latvian Jewish emigrés.[1] She was self-taught except for classes with sculptor Césare Stea at the Leonardo da Vinci School in New York from 1924 to 1926. In 1926 she married Balcomb Greene, who subsequently taught at Dartmouth College in Hanover, New Hampshire, where Gertrude had her first studio. In 1931 the couple spent the year in Paris, where Gertrude absorbed firsthand—in the shadow of the newly formed progressive organization Abstraction-Création—concepts of Constructivism, Suprematism, Neo-Plasticism, and Surrealist biomorphism.

In 1933 Gertrude helped form the Unemployed Artists' Group in New York, later renamed the Artists' Union, and joined in strikes and demonstrations to gain government work projects for artists. A founding member of the American Abstract Artists in 1937, she was the group's first salaried employee.[2]

A. E. Gallatin purchased *Composition*, 1937 (cat. no. 68), for his Museum of Living Art, the first of her works to be in a public collection. Two years later, in 1939, she designed a wall relief for the WNYC Municipal Building in New York as part of a WPA Federal Art Project commission, working under Burgoyne Diller, who headed the Mural Division. Entry of the United States into World War II terminated the project before its completion. The Greenes moved to Pittsburgh in 1942, and thereafter, until her death in 1956, Gertrude commuted whenever possible between studios there and in New York.

As an expatriate in Paris during an era of incredible artistic activity, Gertrude Greene was a bridge between European avant-garde forces and American geometric abstraction. One of the original abstract sculptors in the United States, she may well have been the first in this country to construct wood reliefs.[3] Her earliest documented work was three-dimensional and figurative, absorbing the styles of others as a student might learn from his or her professors. An Expressionist-Cubist vocabulary gradually evolved into relief constructions of idiosyncratic shapes within a geometric framework. She admired the work of Brancusi, preferring his African-inspired sculpture to the smooth-surfaced marble and bronze bird forms, and was particularly responsive to the concepts of Mondrian and Gabo. A frequent visitor to The Museum of Modern Art, she was profoundly affected by the museum's 1936 landmark exhibition "Cubism and Abstract Art," curated by Alfred H. Barr, Jr., and including works by Malevich, Lissitzky, Rodchenko, Tatlin, and Pevsner.

Greene acquired a forge and developed skills with carpentry tools. She investigated issues of flatness, interpenetrating spatial schemes, and implied movement as well as

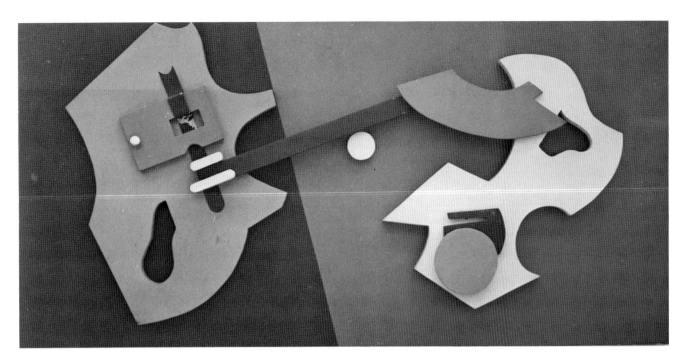

CAT. NO. 68. GERTRUDE GREENE
Composition, 1937
Wood
20 × 40 in. (50.8 × 101.6 cm.)
The Berkshire Museum, Pittsfield, Massachusetts; Gift of A. E. Gallatin

CAT. NO. 67. GERTRUDE GREENE
La palombe (The Dove), 1935–36
Wood and metal
10 × 18⅝ × 1½ in. (25.4 × 47.3 × 3.8 cm.)
Ertegun Collection Group

CAT. NO. 69. GERTRUDE GREENE
Construction in Blue, 1937
Wood
48 × 32 in. (121.9 × 81.3 cm.)
Private Collection

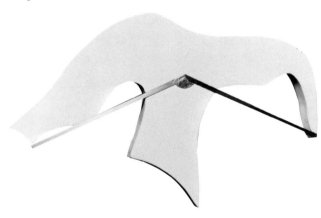

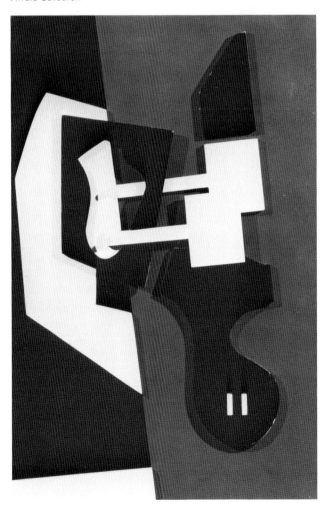

the aesthetic possibilities of wood and metal. Illusionistic drawings in 1933 of built-up, geometrically shaped discs, depicted as structures in the round, had already indicated a gravitation toward Suprematist-Constructivist principles.

La palombe (The Dove), 1935–36 (cat. no. 67), identifies Greene's shift to two dimensions. Frontally perceived metal parts are flush with the thick wood construction's picture plane. The semi-abstract form has an affinity to the work of Arp, whose wood relief *Vase Buste* was in Gallatin's Museum of Living Art. Like a moving object in suspended animation, the work unmistakably bears a reference to Brancusi's birds.

Turning to more complex and totally abstract compositions, between 1937 and 1939 Greene worked with layers of cut-

165

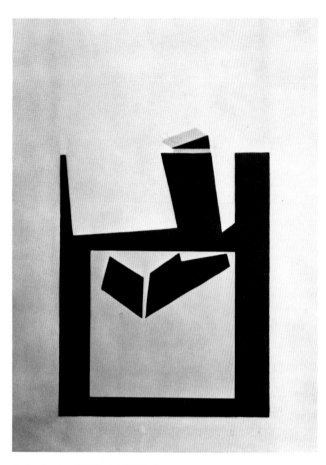

CAT. NO. 70. GERTRUDE GREENE
Space Construction, 1943
Wood and Masonite
36 × 27 in. (91.4 × 68.6 cm.)
Ertegun Collection Group

changing solids and voids within a multiple-level spatial scheme. Overlapping box shapes, already an evolving characteristic of her work, are a focal point. The motif consists of flat rectangles or squares connected to diagonal projections and comes close to forms evident in the work of Malevich and Lissitzky, as well as the De Stijl-Constructivist César Niewenhuis-Domela—all highly visible in The Museum of Modern Art exhibition. Variations on this form of the box motif continue until 1942.

A transition to more simplified structures, the illusion of pieces tipping or fracturing within a shallower, flatter plane, is concurrent with the introduction of collages about 1939. The direct process of paper cutting permitted a new freedom unattainable with wood.

Also relevant is Mondrian's move to New York in 1940 and his supportive membership in American Abstract Artists. His statement that "... equilibrium involves a large uncolored surface or an empty space, and a rather small colored surface or space filled with matter"[4] seems to have been a direct influence on Greene's *Space Construction*, 1943 (cat. no. 70), in which a yellow surface set against a larger uncolored space correlates with smaller "matter" forms. However, her application of Mondrian's theories was conceptual rather than concrete. Executed in relief, her trapezoidal and mechanistic patterns come closer to the watercolor collages of Lissitzky. Similarly, the box motif, now a separate entity, appears to be "equivalent to the surface of the picture,"[5] according to Neo-Plasticism, but is actually raised in front of it.

Still another stylistic change was imminent, this in reaction to the Pittsburgh move and the inaccessibility of necessary tools. Instead of the diversity of cutout shapes screwed and cemented into a complex and provocative geometric design, Greene now glued blunt-ended lath strips in a gestural format against a clear rather than delineated ground support. *White Anxiety*, 1943–44 (cat. no. 71), signals this last phase. A seemingly intuitive composition with its emphasis on lights and shadows, it is as meticulously planned as the previous body of work. The spontaneous appearance points to the end of the constructions and a transition toward canvas painting, although architectonics continued as a basic format.

Jacqueline Moss

out wood placed against a flat wood or Masonite support, as exemplified by *Composition*, 1937 (cat. no. 68). The dreamworld biomorphics of artists such as Miró and Masson, both of whom were represented in "Cubism and Abstract Art," are evoked, although right angles, echoing spheres, and smooth edges point to a crystallizing concern with geometrics.

The development of Greene's constructions was considerably influenced by her membership in American Abstract Artists and her growing friendships with artists such as Rosalind Bengelsdorf, Ilya Bolotowsky, Byron Browne, Suzy Frelinghuysen, Ibram Lassaw, and George L. K. Morris. *Construction in Blue*, 1937 (cat. no. 69), reproduced in the first American Abstract Artists yearbook, reveals a style different from anything she had previously attempted, counterbalancing geometric and free forms against a diagonal axis and inter-

[1]Biographical information is derived from interviews granted the author by Balcomb Greene and by Dorothy Brenner, sister of the artist.
[2]Archives of American Art, Smithsonian Institution, Washington, Microfilm Roll NY 59–11.
[3]Ilya Bolotowsky, interview with Jacqueline Moss.
[4]Piet Mondrian, "Principles of Neo-Plasticism," cited by Michel Seuphor, *Piet Mondrian, Life and Work* (New York: Harry N. Abrams, 1956), p. 166.
[5]Ibid., pp. 166–68.

JEAN HÉLION

Born 1904 in Couterne, France. Visited the United States in 1932, 1933–34, 1936–40, 1942–46. Attended evening classes in drafting at Ecole des Arts Décoratifs, Paris, 1921–22. No formal art training.

Jean Hélion arrived in Paris in 1921 to work as an architectural draftsman, but by 1925 he was painting full time and exhibiting at Montmartre art bazaars. (Before 1929, he used the pseudonym of Bichier when signing his paintings.) By 1929, two years after the Uruguayan artist Joaquín Torres-García introduced him to contemporary art, especially Cubism, he was fully in stride with the Montparnasse avant-garde as an abstractionist and recognized as a vociferous young upstart.

Hélion collaborated with van Doesburg and others in the group Art Concret (1929–30) and edited its single review. In 1931 he helped found Abstraction-Création and was editor of the first of its five *cahiers* (1932–36). Included in major exhibitions of vanguard art at Stockholm (1930) and Lucerne (1935), for which he also wrote catalogue essays, he showed frequently in Paris, with one-artist exhibitions at the Galerie Pierre (1932) and Galerie Cahiers d'Art (1936). His writings appeared in numerous periodicals, including the British publication *Axis*, for which he played a significant role.

"We are the painters who think and measure,"[1] proclaimed the adherents of Art Concret, whose theories underscored Hélion's "Orthogonale" series (1929–32), which evolved from the loosely organized, expressively brushed still lifes of 1927 to become disciplined, right-angled planes in the flat, pure hues of Neo-Plasticism. These works reflected his mentor, van Doesburg. Strictly nonobjective, they were intended as a universal language to be understood by a classless society.[2] This belief continued, but the influence of Mondrian soon tempered Hélion's intransigence, permitting intuition to overtake regimentation, even as his work became increasingly spare and refined.

Later, with the "Equilibres" (1932–35), which paralleled his activity in Abstraction-Création and its broader embrace of abstract styles, planes became flexed and brush strokes fluid, while a sensitive, nuanced palette emerged. At first centered, an image suggesting a set of scales (cat. no. 72) began to multiply and fill out the space of the canvas with overlapping and interlocking curved and flat planes. Subtle *dégradé* developed into fully rounded modeling of elements, whose machine-like surfaces reflected the influence of Léger.

With the "Figures" (1935–39), references to the human form gradually became more explicit as Hélion made his transition to the emerging figurative style and to the belief that humanism, rather than the machine, would bring about a better world. *Figure d'Espace*, 1937 (cat. no. 73), with its cluster of planes suspended above a lower group that expands over the base of the canvas, makes its impact through the force of its tensions, its impeccably brushed forms interacting with a supple field.

Writing about Hélion in 1929, Jean Xceron praised his "native force, energy and feeling for form,"[3] and advanced his view that art should accord with the mechanical and industrial age, also noting Hélion's belief that only New York had the modern spirit.

Xceron was one of several Americans in Paris who responded to Hélion's painting and to his eloquence in communicating ideas in English as well as in French. Another was Alexander Calder, with whom Hélion began a long, enduring friendship. Hélion's *Equilibre*, 1933 (cat. no. 72), whose leaflike elements illusively turn and flutter in space, was among the "painted mobiles"[4] that seemed to anticipate those still to emerge in Calder's oeuvre. Others influenced by Hélion were Harry Holtzman and George L. K. Morris. The latter's *Mural Composition*, 1940 (cat. no. 105), reveals the impact of Hélion's "floating forms."[5] Later, John Ferren was closely linked with Hélion in his work. The rounded planes that spread over his *Composition*, 1935 (cat. no. 45), reflect Hélion's style.[6]

Hélion made his first visit to America in 1932, the same year in which he married Jean Blair, a member of a prominent Virginia family, whom he had met a few years earlier in Paris. During his increasingly frequent visits to New York thereafter, he widened his associations and his influence. At the time of his one-artist exhibition at the John Becker Gallery (December 1933–January 1934), he showed his drawings for murals inspired by Manhattan skyscrapers to Arshile Gorky—convincing evidence that Hélion's work was a source for Gorky's Newark Airport murals.

Hélion's third New York sojourn in the winter of 1936–37 coincided 'with the inauguration of the American Abstract Artists—he had encouraged Carl Holty, Holtzman, and Morris to form such a group—for which he was the principal mentor until Mondrian's arrival in New York. His influence pervaded the work of members such as Ad Reinhardt, as revealed in the bulging clusters of planes in his *Red and Blue Composition*, 1939–41 (cat. no. 114).[7] And in New York Hélion also became a close friend of the distinguished art historian Meyer Schapiro, who shared his left-wing political convictions.

Hélion's introductions, advice, and assistance were invaluable to A. E. Gallatin in acquiring abstract art for his Gallery of Living Art. As the anonymous editor of the gallery's 1933 catalogue, Hélion wrote an essay, "The Evolution of Abstract Art"—the first survey of its kind to be published in America—which served as an influence, along with his paintings, on artists of the next generation, including Willem de Kooning, Robert Motherwell, and Philip Guston.[8]

Besides the Gallatin Collection, where many emerging artists such as Richard Diebenkorn and Roy Lichtenstein viewed his work,[9] Hélion's paintings were shown in New York at the Valentine Gallery (1936, 1937–38), Georgette Passedoit (1940), and Peggy Guggenheim's Art of This Century (1943).

As a gifted abstract painter and a highly articulate spokesman on behalf of that tradition, Hélion prepared the ground for its transfer from Paris to New York. Sculptor David Hare maintains that his contribution was far more effective in still another way. According to Hare, Hélion "assured the American artist that there was a place in society, in world culture, for the avant-garde artist. . . . What he really had to give was the conception of the avant-garde artist as a man necessary and important to his times."[10]

Hélion had planned to remain in the United States when he arrived for the third time in 1936, but left to fight in the French army in January 1940. Taken prisoner that June and interned in a camp near Poland, he escaped in 1942 and made his way back to the United States, where he wrote the best-seller *They Shall Not Have Me* (New York: Dutton, 1943), a moving account of his World War II experiences. He returned to France in 1946. Painting his last abstraction in 1939, he turned to figurative work, which has been widely exhibited in Europe, the People's Republic of China, and the United States.

Merle Schipper

[1] *Numéro d'Introduction du Groupe et de la Revue Art Concret* (Paris, 1930): 3.
[2] A member of the Association of Revolutionary Writers and Artists (1929–34), Hélion believed that the "Orthogonales" would be seen as "collectivist" art through their impersonal, mechanistic forms.
[3] Jean Xceron, "Who's Who Abroad: Jean Hélion," *Chicago Tribune* (Paris), 5 June 1929.
[4] Sidney Janis, *Abstract & Surrealist Art in America* (New York: Reynal & Hitchcock, 1944), p. 51. Janis, interview with Merle Schipper, 25 April 1972, noted in Paris in 1932 he viewed Hélion's "Equilibres" with Calder, who assimilated ideas of suspension and tension which he applied to mobiles.
[5] George L. K. Morris, interview with Merle Schipper, New York, 26 April 1972.
[6] John Ferren, transcript of interview with Dorothy Seckler, 12 June 1965. John Ferren Papers, Archives of American Art, Smithsonian Institution, Washington.
[7] Lucy Lippard, *Ad Reinhardt* (New York: Harry N. Abrams, 1981), pp. 25, 34.
[8] Willem de Kooning, telephone conversation with Merle Schipper, 3 May 1973; Robert Motherwell, conversation with Merle Schipper, New York City, 26 January 1973; Philip Guston, letter to Merle Schipper, 27 March 1973.
[9] Richard Diebenkorn, letter to Merle Schipper, 5 July 1972, acknowledges Hélion as a source of style. Roy Lichtenstein, letter to Merle Schipper, 20 October 1971, discusses interest in Hélion's work.
[10] David Hare, tape-recorded interview with Merle Schipper, 13 December 1971.

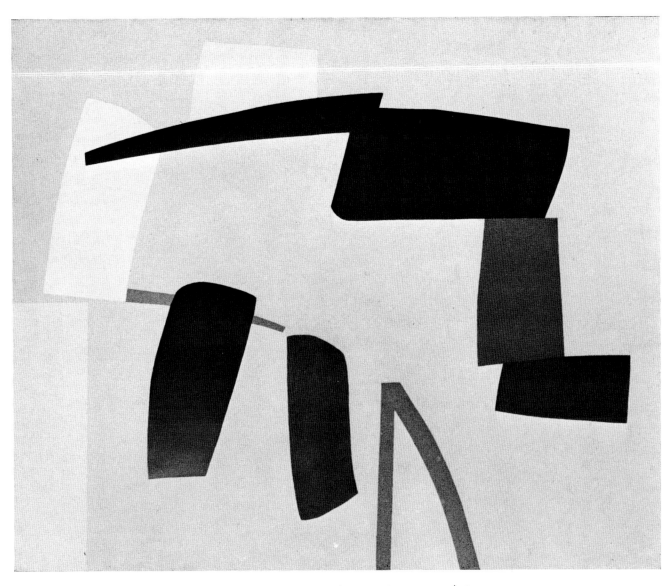

CAT. NO. 72. JEAN HÉLION
Equilibre, 1933
Oil on canvas
32½ × 39½ in. (82.6 × 100.3 cm.)
Collection of Louis Hélion Blair

HANS HOFMANN

Born 1880 in Weissenberg, Germany; died 1966 in New York City. Visited the United States in 1930, 1931; settled in the United States in 1932 and became U.S. citizen in 1941. Studied at Moritz Heymann's art school, Munich, Germany, 1898; later studied with a succession of teachers never fully identified, including Michaelof, Aspe, Ferenzi, Grimwald, and Willi Schwarz; Académie de la Grande Chaumière, Paris, ca. 1904.

Born in Weissenberg, Germany, in 1880, Hans Hofmann was educated in Munich, where his father had a government position. In 1898 he rejected his parents' hopes for him as a scientist and enrolled in Moritz Heymann's art school. From 1904 to 1914, he studied in Paris, where he became interested in Fauvism and Cubism and met many of the major figures of the modern art movement, including Picasso, Braque, Delaunay, and Gris. In the evenings he attended the Académie de la Grande Chaumière, a public studio where artists went to draw from the model.

In 1908 and 1909 Hofmann was included in exhibitions of the Berlin Secession group, and in 1910 Paul Cassirer gave him his first major exhibition at his Berlin gallery. In the years after 1915, when Hofmann opened his Schule für Moderne Kunst in Munich, he had little time to paint while teaching, but he drew continuously. With the rise of Nazism, Hofmann gladly accepted an invitation to teach at the University of California at Berkeley during the summers of 1930 and 1931. After several other teaching positions in the United States, including the 1932–33 school year at the Art Students League, Hofmann opened his own school in New York in 1933.

Between 1927 and 1935, Hofmann concentrated on drawing landscapes and figure studies, many of which show their Cubist heritage. It was not until 1935 that he began painting steadily again. From 1935 until 1944, the majority of his work falls into three categories: landscapes, portraits, and interior scenes. Of particular interest in these paintings is the manner in which his earlier Parisian training continues to be both constantly referred to and transformed. The large circular table laden with fruit and flowers in *Atelier Still Life—Table with White Vase*, 1938 (cat. no. 74), appears frequently in his paintings of interiors, most of which reveal their debt to the Fauvist palette and the spatial dislocations of Matisse. However abstract certain elements of Hofmann's interiors, the basic components are always fairly recognizable. Yet in a group of Provincetown landscapes of the same period, the range of his styles is more extreme—from descriptive, almost anecdotal depictions of the harbor, recalling Dufy, to much more expressive landscapes of a fiery intensity reminiscent of Jawlensky. Kandinsky also looms as a presence in many of Hofmann's landscapes of this period.

Although never ceasing to proclaim the importance of nature as his point of departure, Hofmann also began to increase the freedom of linear elements to such an extreme that entire landscapes became vivaciously colorful arrays of lines. As early as 1939, his investigations with random splatters and dribbles of paint manifested a spontaneity unmatched by other members of the New York vanguard.

Paintings such as the historic *Spring* of 1940 demonstrate that Hofmann's experiments with pouring paint antedate even the highly acclaimed achievements of Jackson Pollock. There was great mutual respect between these two artists after their introduction by Lee Krasner, one of Hofmann's students and the future wife of Pollock.

At Peggy Guggenheim's Art of This Century Gallery, where Hofmann had his first one-artist exhibition in New York in 1944, he became part of a stimulating milieu that included Pollock, Robert Motherwell, William Baziotes, Clyfford Still, and Mark Rothko. With some members of this group and others of the emerging New York School, he shared an interest in aquatic and mythic imagery as well as a fascination with the astonishing freedom offered by the Surrealist method of automatism.

Like his landscapes, Hofmann's portraits of the thirties and forties exhibit a wide range of styles. Some are quite representational, while others are less portraits than studies of volumes in space. In a totally different vein, *Abstract Figure*, 1938 (cat. no. 75), is so literal in its borrowing of the form of Picasso's *Harlequin* of 1915 that Hofmann's painting seems almost a specific exercise to create an updated version of this painting from Picasso's Synthetic Cubist period. In 1944 many of Hofmann's portraits became much less recognizable likenesses than architectural studies of the structure of the human body. His compositions began to be inhabited by mechanical-looking creatures virtually devoid of human references. The year 1944 also marks Hofmann's loss of interest in executing drawings in ink and his turning exclusively to color.[1]

As the unique figure of the New York School who had witnessed firsthand the development of the modern art movements in Europe, Hofmann transmitted these ideas to the United States and played a crucial role in the development of the new American painting. In the thirties and forties he was a pervasive influence on the American art scene. His influential series of lectures during the 1938–39 school year were attended not only by his students but by many others who later became prominent artists and critics, notably Pollock, Arshile Gorky, Willem de Kooning, Clement Greenberg, and Harold Rosenberg. Although Hofmann never officially joined the American Abstract Artists, a remarkable number of the group's original members were his students. None of the first-generation Abstract Expressionists studied with him, but many of the important members of the second generation did. By the time Hofmann closed his schools in 1958, he was considered the most influential art teacher in America. Among his students were Louise Nevelson, Carl

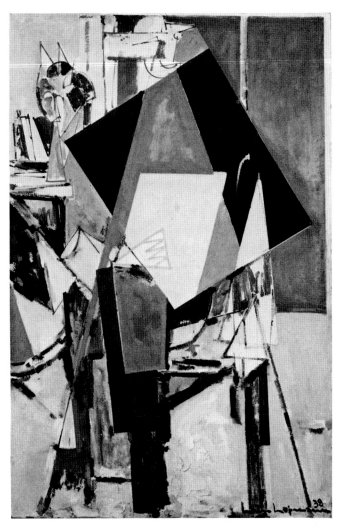

CAT. NO. 75. HANS HOFMANN
Abstract Figure, 1938
Oil on panel
67½ × 43¾ in. (171 × 109 cm.)
Estate of Hans Hofmann. Courtesy of André Emmerich Gallery

Holty, Harry Holtzman, Burgoyne Diller, Helen Frankenthaler, and Larry Rivers.[2]

Cynthia Goodman

[1] Barbara Rose, *Hans Hofmann: Drawings* (New York: André Emmerich Gallery, 1977), ff. 3.
[2] For further information on Hofmann's career as a teacher, see Cynthia Goodman, "The Hans Hofmann School and Hofmann's Transmission of European Modernist Aesthetics to America" (Ph.D. dissertation, University of Pennsylvania, 1982).

CARL HOLTY

Born 1900 in Freiburg, Germany; died 1973 in New York City. Studied at School of The Art Institute of Chicago, 1919; Parsons School of Design and National Academy of Design, New York, 1920–21; with Hans Hofmann, Munich, 1926–ca. 1928.

Carl Robert Holty was born in Germany in 1900 to American parents from Milwaukee. His father was completing medical studies in Freiburg, and the family returned to Wisconsin the same year. Holty's first art studies were with Munich-trained teachers at the Milwaukee Normal School. He briefly attended the School of The Art Institute of Chicago (1919), Parsons School of Design and the National Academy of Design, both in New York (1920–21), flirted with medical school, and then, with a legacy from his grandfather that would allow him two decades of financial independence, married and departed for Munich in 1926 to become an artist.

For the cultured Bavarian-American families of Milwaukee, Munich was the European art city that beckoned. Holty, who spoke German fluently, enrolled in Hans Hofmann's school there, where he received his first real instruction in the principles and practice of modernist drawing and painting. Not attracted to Germany's expressionist contribution to modernism, he definitively turned to the structural precepts of Cubism around 1928. Holty traveled widely in Europe from 1926 to 1935 and, beginning in 1928, lived a good deal of the time as a member of the American art colony in Paris. He lost his first wife to illness and remarried in France. Holty knew many of the leaders of the French avant-garde, including Mondrian and Miró. Robert Delaunay sponsored Holty's election to membership in Abstraction-Création in 1932.

Returning to New York in 1935, Holty quickly became involved in the American abstract movement. His best friend was Hilaire Hiler, and he was close to Stuart Davis and John Graham. Holty was a founding member of the American Abstract Artists in 1937, showed in most of the AAA exhibitions, and served as the group's chairman in 1938. His dealers in New York were J. B. Neumann's New Art Circle and the Nierendorf Gallery. In the late thirties he taught at the Art Students League, where Ad Reinhardt was his student and gained membership in the AAA through Holty's encouragement. Holty was not involved in the WPA Federal Art Project and, although he participated in the artist meetings of the exceptionally activist decade of the thirties to show his solidarity with fellow painters, he preferred the civilized atmosphere of the European café to the ugliness of the American cafeteria and a more conservative *burgerlich* existence to the leftist and bohemian life of many of his fellow artists.[1]

Holty commented that it was Hofmann who "first opened my eyes to the plastic nature of drawing" and later taught him about color and painting.[2] About 1928, in his first modernist work, he turned to the example of the art of Gris, "the

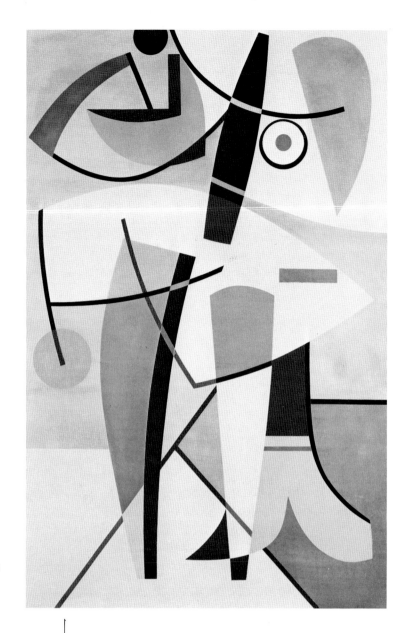

CAT. NO. 77. CARL HOLTY
Table, 1940
Oil on Masonite
60½ × 40⅝ in. (153.7 × 103.2 cm.)
The Archer M. Huntington Art Gallery, University of Texas, Austin;
 The James and Mari Michener Collection

CAT. NO. 79. CARL HOLTY
City, 1942
Oil on Masonite
36 × 48 in. (91.4 × 121.9 cm.)
The Museum of Fine Arts, Houston; Museum purchase:
 George R. Brown Funds in honor of his wife, Alice Pratt Brown

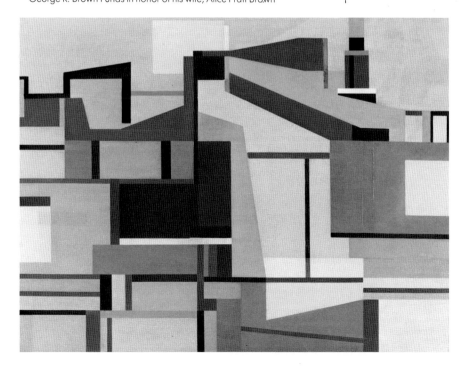

most pedantic cubist," and "the pursuit and admiration of the structural."[3] Holty felt that his compulsive interest in structure was a characteristic of his German heritage, and he accepted Miró's criticism of his work of the late thirties and early forties—that it was "interesting and serious, but also over-problematic and over-conscientious"—as generally applicable to his art.[4] Through the mid-thirties, his paintings retained a close affinity to Synthetic Cubism, modified by the cool, broad, and clean-edged style that characterized the work of many members of Abstraction-Création. Back in New York and under the influence of the thirties biomorphic abstractions of Miró and the more geometric abstract work of Kandinsky, Holty began to open up his pictorial structure. *Circus Forms*, 1938 (cat. no. 76), with its vigorous, curvilinear forms cavorting as overlapping cutouts in the shallow space in front of a flat blue background, is a far more abstract painting than any of his earlier works. There is, it should be mentioned, a restraint to Holty's dancing configurations that separates them from the exuberant freedom of Miró's inventions. This propensity for structure is even more evident in *Table*, 1940 (cat. no. 77), in which the traditional Synthetic Cubist still life has been trued and faired, its colorful forms flattened and spread with care across the painted surface.

Holty, like a number of other artists about 1940, was exploring ways to correct what he felt was a decorative weakness in the late Cubism of Picasso, Léger, and Davis.[5] Mondrian was one of the most important influences on American painters wrestling with the development of a formal strategy to get around or through the impasse of late Cubism. Holty became one of Mondrian's few close American friends when the Dutch master arrived in New York in 1940. Holty stated that he was persuaded by Mondrian's arguments on behalf of a pure abstract art and himself claimed to have abandoned forms derived from nature in his paintings. However, like most Americans, he did not go so far as to embrace Neo-Plasticism's spiritual content.[6] Instead, the signal virtue he discerned in pure abstract painting was that, because it was stripped of literary symbols and its formal elements were comprehensible to all, it was closer to being a universal means of expression.[7] Formal properties of modernism were highly important to him. In 1940 he wrote, "The space as we conceive it today is the surface itself:—the maximum space—the *whole* surface. . . . A piece of white collarboard with a hole punched accidentally in it gives me as real a feeling of discomfort mentally as to see a man minus a hand. . . . Modern painting wants to be true and beautiful only as optical truth."[8]

City, 1942 (cat. no. 79), shows Holty using a highly personal interpretation of Mondrian's compositional innovations to work toward an all-over surface effect. In *Of War*, 1942 (cat. no. 78), he set aside rectilinear geometry in favor of highly activated, staccato rhythms of curved forms to accomplish this desired all-over effect. Both paintings belie Holty's stated ambition to be rid of external references in favor of abstract form, since in *City* a complex structure of buildings is evident and in *Of War* (the title is derived from Karl von Clausewitz's book *On War*), the allusion to frantic, violent activity is visually inescapable. Like Davis, whom he had criticized and who also sought to advance beyond late Cubism, Holty really did not take that next step. The formal structure of his work of the thirties and forties remained in the context of Cubism, and his subject matter was ultimately referential to nature. He did begin to loosen up his paintings in the late forties and in the fifties developed quite a lyrical style, but this, too, retained an underlying Cubist structure.

Holty taught at a number of art schools and universities and retired from a professorship of fine arts at Brooklyn College.

John R. Lane

[1]Carl Holty Papers, Archives of American Art, Smithsonian Institution, Washington, Reel ND68:93, April 28, 1962.
[2]Ibid., January 8, 1963.
[3]Ibid., "Autobiography," ca. 1966.
[4]Ibid., March 2, 1962.
[5]Hilaire Hiler Papers, Archives of American Art, Smithsonian Institution, Washington, Reel D302, August 19, 1940.
[6]Ibid.
[7]Ibid., January 12, 1941.
[8]Ibid., August 19, 1940.

HARRY HOLTZMAN

Born 1912 in New York City. Studied at Art Students League, New York, 1928–33.

A precocious intellectual, Harry Holtzman, at the age of fourteen, visited the Société Anonyme's 1926 "International Exhibition of Modern Art" at The Brooklyn Museum and developed an early interest in advanced art with the guidance and encouragement of a high school teacher. At sixteen, in 1928, he began attending the Art Students League and became an active participant in League activities, serving as a monitor and contributing to the quarterly magazine. At a membership meeting in early 1932, Holtzman's remarks against the xenophobia of the League's director were instrumental in carrying a membership vote that brought George Grosz and Hans Hofmann to teach at the League. At the close of this meeting, Burgoyne Diller, a Hofmann protagonist, taken by Holtzman's independence of mind, introduced himself, beginning an important lasting relationship.[1]

It was Diller who convinced Holtzman to enter Hofmann's class in the fall of 1932. Hofmann was immediately impressed by the work of his new student, although he did not share Holtzman's intense philosophical concerns, nor his interest in contemporary psychology and anthropology. Holtzman has noted that Hofmann "certainly admired Picasso but it was Matisse that was most important to him, and as far as artists like Kandinsky were concerned, he considered their approach as more of an exercise...."[2] Holtzman appreciated Hofmann's emphasis on structural concepts and set aside his masterly figure drawings of the late twenties and the expressionistic abstract works of the years 1930–32, encouraged by Hofmann's Cubist-based methods. In late 1932 he became Hofmann's teaching assistant at the Art Students League and then accompanied him to Gloucester, Massachusetts, the following summer to teach at an art school founded by former Hofmann student Ernst Thurn. In the fall of 1933 Hofmann established his own school in New York, and Holtzman taught there briefly then and also in the summer of 1935 after his return from Europe.

By January 1934, Holtzman recalls, "... in my completely independent development I'd struck in a direction which, without knowing it, was taking me in a direction similar to Mondrian. One day Diller was seeing some works in my studio and I was explaining to him the peculiar reasons I felt driven toward these things and what happened to me consequently by implication. He asked me if I had seen the recently opened Museum of Living Art [A. E. Gallatin's collection] at the New York University library on Washington Square. I hadn't. I went. This was the first clue I had to Mondrian's perception, the two paintings that Gallatin had acquired...."[3] In the ensuing months, Holtzman "became obsessed with

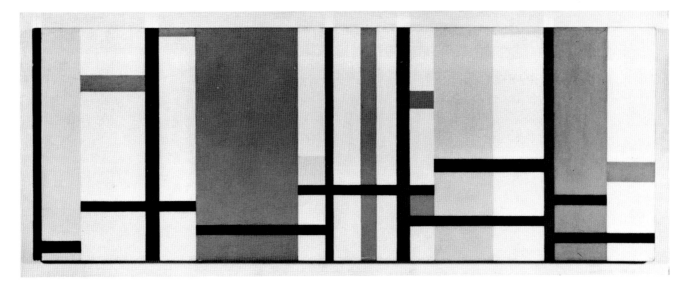

CAT. NO. 81. HARRY HOLTZMAN
Horizontal Volume, 1938–46
Oil on gessoed linen
12 × 33 in. (30.5 × 83.8 cm.)
Collection of the artist

not only the paintings of Mondrian, but with the idea that the man had to think certain things about the historical transformation, the values and function of art. I really had to go to Europe to speak with him.''[4] By the end of November, Holtzman had raised enough money to pay for passage to France. In mid-December he introduced himself to Mondrian in the Dutch artist's Paris studio. Despite a language barrier and an age difference of forty years, the two men became good friends during the four months of Holtzman's stay in Paris. Holtzman also became a close friend of Jean Hélion and his American wife. Among the other artists he met were Hayter, Niewenhuis-Domela, Ferren, Gabo, Le Corbusier, Léger, and Pevsner; and he was impressed by the effectiveness of organizations such as Abstraction-Création, which publicly united advanced European artists.

When Holtzman returned to New York in 1935, he joined the WPA Federal Art Project, but was first assigned to write for the public relations department since his art was considered too extreme for public placement. When Diller was promoted as managing project supervisor of the Mural Division in New York, he appointed Holtzman as his assistant supervisor in charge of the abstract mural painters.[5] In this capacity, Holtzman came into regular contact with progressive artists who shared his aesthetic concerns and who, he soon realized, recognized the need for an organization that would foster intellectual and artistic interaction, as distinguished from the primarily political focus of such organizations as the Artists' Union and the American Artists' Congress. As a result, in 1936 Holtzman was instrumental in bringing together the nucleus of painters and sculptors who established the American Abstract Artists in 1937. Although he opposed the group's emphasis on exhibitions, and the attempts of certain influential members to exclude all but ''pure-abstractionists,'' Holtzman maintained an active role for several years, serving as secretary in 1938 and again in 1940 and arranging for the three-week AAA exhibition and its educational component at the American Art Today Building of the New York World's Fair in 1940, directed by Holger Cahill.

Although familiar with the writings of Marx, Engels, and Lenin, Holtzman always remained independent, subscribing neither to the communist social theories then popular in intellectual circles nor to the conviction of many leftist artists that art should be secondary to the service of social change. He felt that Franklin D. Roosevelt's New Deal art programs created a remarkably beneficent climate, unprecedented in the lives of American artists.[6]

Despite the compositional and color ''heresies'' of *Square Volume with Green*, 1936 (cat. no. 80), the influence of his association with Mondrian was readily apparent in Holtzman's work, and by 1940 he demonstrated a concern to expand the principles of Neo-Plasticism into the domain of sculpture. The exceptionally thick stretcher of *Vertical Volume No. 1*, 1939–40 (cat. no. 82), for example, projects the painting noticeably outward from the wall. Extension of the composition around the edges—a feature of many paintings by Mondrian—is intensified here, so that the work involves a literal engagement of three dimensions, which Holtzman developed further in *Sculpture (1)*, 1940 (cat. no. 83). Of this work Mondrian commented: ''In the present three-dimensional works of H. H. [Harry Holtzman] the picture

moves still more from the wall into our surrounding space. In this way the painting more literally annihilates the three-dimensional volume."[7]

Holtzman took the opportunity to leave the Federal Art Project in 1938 and was able to improve his financial situation considerably by means of an administrative business association, through family, that lasted until 1943. During this time he was able to assist Mondrian economically.[8] In 1938, after the Munich Pact, Mondrian asked Holtzman, Jean Xceron, and Frederick Kiesler to sponsor his immigration to America, but then decided to go to England.[9] During the German blitz of London in 1940, Holtzman arranged for Mondrian to come to New York, where he arrived that October. Holtzman rented an apartment-studio for him, and during the next three and a half years he was one of Mondrian's most intimate associates. (By coincidence, one of Holtzman's closest artistic relationships of the period was with another Dutch painter, Willem de Kooning.) As executor of Mondrian's estate, Holtzman continues his involvement with Mondrian's art to this day. He is presently preparing for publication a volume of Mondrian's complete essays.

In 1947 Holtzman became a faculty member of the Institute for General Semantics, where he taught with Alfred Korzybski until 1954. Later he edited the journal *trans/formation: arts, communication, environment*. For many years he participated in the conferences of the National Committee on Art Education of The Museum of Modern Art, and from 1950 to 1975 he was a faculty member of the art department at Brooklyn College, City University of New York. Holtzman lives and works in Lyme, Connecticut.

John R. Lane

[1] Harry Holtzman, conversation with John R. Lane, 30 October 1982, Lyme, Connecticut.
[2] Harry Holtzman, interview with Ruth Gurin, 11 January 1965. Typescript edited by Harry Holtzman, November 1982, courtesy of Harry Holtzman, Lyme, Connecticut.
[3] Ibid.
[4] Ibid.
[5] Harry Holtzman, conversation with John R. Lane, 30 October 1982, Lyme, Connecticut. Abstract murals were hard to place in public buildings, and Holtzman recalls that one of the duties Diller gave him while the Williamsburg Housing Project abstract murals were being painted was to urge the artists involved not to finish since there was nowhere else for them to work.
[6] Ibid.
[7] Piet Mondrian, unpublished notes, 1943, courtesy of Harry Holtzman, Lyme, Connecticut.
[8] Harry Holtzman, conversation with John R. Lane, 30 October 1982, Lyme, Connecticut.
[9] Ibid.

CAT. NO. 82. HARRY HOLTZMAN
Vertical Volume No. 1, 1939–40
Acrylic and oil on gessoed Masonite
60 × 12 in. (152.4 × 30.5 cm.)
Collection of the artist

RAYMOND JONSON

Born 1891 near Chariton, Iowa; died 1982 in Albuquerque, New Mexico. Studied at Portland Museum School, 1909; Chicago Academy of Fine Arts, 1910–12; School of The Art Institute of Chicago, 1910–12.

Raymond Jonson is known today as the central figure of the Transcendental Painting Group, which was active in the American Southwest during the thirties and forties. Born in 1891 on a farm near Chariton, Iowa, the son of a minister who had emigrated with his family from Sweden, Jonson studied at the Portland Museum School in Oregon in 1909, then moved to Chicago the following year to study at the Chicago Academy of Fine Arts. He also attended classes at the School of The Art Institute of Chicago.

In 1913 Jonson saw the Armory Show at the Art Institute, which served to confirm his direction as an artist and to stimulate his interest in modern European art. He enjoyed early success and participated in group exhibitions at the Art Institute in 1913, 1914, and 1915. By 1917, he was employed as an instructor of painting at the Chicago Academy of Fine Arts and was making summer trips to Colorado, Oregon, and other western states.

In 1924, strongly attracted to the western landscape, Jonson moved to Santa Fe, New Mexico, which was to be the geographical center of his life as an artist and the source of much of his imagery. Jonson's work is animated by his mystical outlook on life. As a young student in Chicago, he had been deeply affected by his reading of Kandinsky's *Concerning the Spiritual in Art*. Jonson was also a friend of the Russian artist-mystic Nicholas Roerich and during the twenties participated in the formation of Cor Ardens, Roerich's organization dedicated to establishing an international brotherhood of artists.

Jonson's unusual handling of pigment was extremely precise and his geometry idiosyncratic as he constructed his visionary landscapes with finely granulated tonal ranges of color. He used an airbrush to apply pigment to many of his tempera and watercolor paintings after 1938. At times, his style is crystalline and forbidding. Throughout his career, whether working in an abstract or a nonobjective manner, Jonson transformed natural forms into geometric ideographs.

In 1930 Jonson began a series of twenty-six "Variations on a Rhythm," running through the entire alphabet from A to Z. Searching for an abstract art freed from subject matter, he looked toward the mental abstractions of numbers and letters, at first producing a group of paintings based on numbers which he called "digits," then the longer series derived from graphic characteristics of the alphabet. *Variations on a Rhythm—H*, 1931 (cat. no. 84), exhibits the careful gradation of tone and precise though variegated brushwork that lend great animation to the surfaces of Jonson's work of the thirties. Again and again he invented formal devices in order to repeat the letter *H*, turning it on its side, fusing it with the

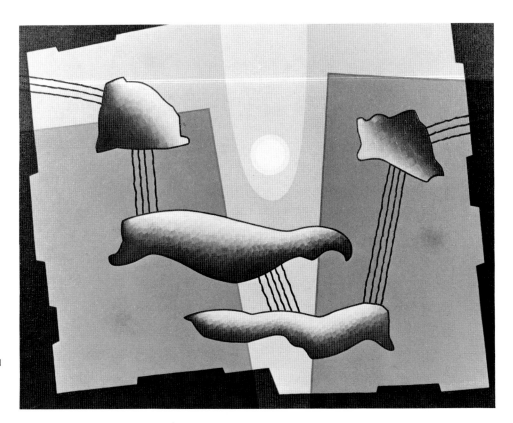

CAT. NO. 85. RAYMOND JONSON
Oil No. 2, 1940
Oil on canvas
29 × 38 in. (73.7 × 96.5 cm.)
Collection of Joseph Erdelac

background, adapting it to the necessity of dynamic variation.

Jonson made periodic visits to New York and Chicago during the thirties and forties. Among the galleries exhibiting his work were the Howard Putzel Gallery in Hollywood, California, in 1936 and the Katharine Kuh Gallery in Chicago in 1938. It was in Santa Fe, however, that Jonson found a community of artists who shared his vision and his life. In 1938 nine artists—Emil Bisttram, Robert Gribbroek, Lawren Harris, Bill Lumpkins, Florence Miller, Agnes Pelton, H. Towner Pierce, Stuart Walker, and Jonson—created an informal alliance known as the Transcendental Painting Group. Their association grew out of a mutual commitment to abstract art, and yet the typical style of the Transcendentalists is not nonobjective but rather a type of hard-edged biomorphic abstraction. It is nature mysticism in the American tradition, paralleling the writings of Emerson, Whitman, and Thoreau. In Jonson's words, their art expressed "the soul-life-rhythms —vibrations which may form the historical statement of the age."[1] The Transcendentalists exhibited together in 1939 at the Golden Gate International Exposition in San Francisco and in 1940 at the Museum of Non-objective Painting (forerunner of The Solomon R. Guggenheim Museum) in New York.

Jonson joined the faculty of the University of New Mexico at Albuquerque in the early forties. Several exhibitions of his work were held in the university's galleries during the forties, and in 1950 a separate gallery to house Jonson's paintings was completed. In 1964 the Jonson Gallery staged a retrospective exhibition of the artist's work. An extensive survey of the Transcendentalist Painting Group was held at the university galleries in 1982.

Susan C. Larsen

[1]Ed Garman, *The Art of Raymond Jonson, Painter* (Albuquerque: University of New Mexico Press, 1976), p. 165.

PAUL KELPE

Born 1902 in Minden, Germany. Arrived in the United States in 1925; became U.S. citizen in 1936. Studied art history and architecture in Hanover.

Paul Kelpe was born in Minden, Germany, in 1902 and grew up in the city of Hanover, where as a student of art and architecture he was acquainted with the work of Schwitters, Kandinsky, Vordemberge-Gildewart, the Russian Constructivists, and other early twentieth-century abstract and nonobjective artists. Kelpe immigrated to the United States in 1925, settling briefly in rural New Jersey before moving to Chicago, where he had his first one-artist exhibition at the Little Gallery in 1931. That same year he participated in a group exhibition at the Society of Independent Artists in New York.

Even at this early date, Kelpe's art evidenced a tendency toward the concrete. His early assemblages and constructions made of found objects parallel some of the *Merz* constructions of Schwitters, but they are more rigorously geometric and already show the clear sense of order and discipline for which Kelpe would later be known. One Chicago reviewer covering Kelpe's 1932 exhibition observed that "they are as much architecture and engineering as anything else."[1]

Kelpe's crisp, faceted style of painting was incomprehensible to most reviewers and to the general public in Chicago during the thirties. *Machine Elements*, 1934 (cat. no. 86), is typical of his painting of this period—forms invented for their shapes and contours, hovering in an indefinite space, yet so clearly and precisely defined by light and shadow that they almost seem to be real.

In *Weightless Balance II*, 1937 (cat. no. 87), Kelpe works with pure geometric solids moving through an open field of colored air. His small, faceted brush strokes act like magnets tugging and pulling at the forms ever so slightly, so that they move backward or forward in space.

Kelpe's vigorous abstractions were regarded as unsuitable by the WPA supervisors heading the Federal Art Project in Chicago. Favoring scene painting based on social themes in American life and history, they rejected Kelpe's 1935 application for employment with the local Mural Division. After a few unsuccessful attempts to accommodate his style to that of fellow WPA artists in the city, Kelpe moved to New York, where from 1936 to 1939 he found employment with the WPA Mural Division headed by Burgoyne Diller.

While in New York, Kelpe participated in the early discussions that led to the formation of the American Abstract Artists group. He joined as a founding member in 1937 and served as treasurer in subsequent years. Even while Kelpe became an active and articulate member of AAA, he was frequently criticized by others within the group who maintained that his use of perspectival space, solid geometric forms, and limitless open space could not properly be re-

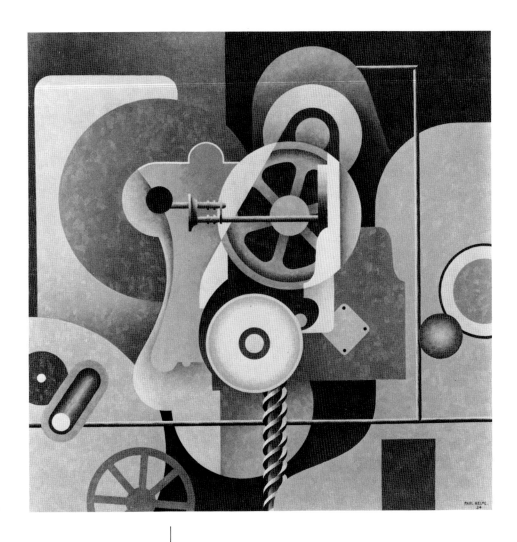

CAT. NO. 86. PAUL KELPE
Machine Elements, 1934
Oil on canvas
24 × 24 in. (61 × 61 cm.)
The Newark Museum; Purchase 1978
 Charles W. Engelhard Bequest Fund

garded as abstraction. Many of Kelpe's stacked and float-ing forms appeared as three-dimensional projections or imagined constructions. Most of the artists within AAA had given up the use of perspectival space, but Kelpe chose to exploit it to new ends.

Kelpe's unusually small, precise, multidirectional brush strokes lend clarity and concreteness to his paintings of the thirties and forties. His surfaces are built one stroke at a time; each discrete and carefully controlled gesture abuts its neigh-bor until, mosaic-like, the painting acquires a continuous, beautifully textured skin. Although an active presence in his painting, Kelpe's textured stroke supports the three-dimen-sionality of his geometric forms as they move through a dy-namic space where everything is clear, concrete, and precise.

Kelpe's interest in the history of art led him to obtain an M.A. (1948) and a Ph.D. (1957) from the University of Chicago. He has taught both art and art history at several American colleges and universities. In 1969 he retired as pro-fessor emeritus from East Texas Teachers College and now lives in Austin, where he devotes his time to art. Kelpe's work was included in the Zabriskie Gallery's 1972 exhibition "American Geometric Abstraction of the 1930's." A survey exhibition of thirty-three works by Kelpe was presented in 1980 at the Long Beach Museum of Art, Long Beach, California.

Susan C. Larsen

[1]*Chicago Daily News*, 16 January 1932.

IBRAM LASSAW

Born 1913 in Alexandria, Egypt. Arrived in the United States in 1921; became U.S. citizen in 1928. Studied at The Brooklyn Children's Museum, 1926–27; Clay Club (later Sculpture Center), New York, 1928–31; Beaux-Arts Institute of Design, New York, 1931–32.

Ibram Lassaw's art instruction began with traditional clay modeling under the direction of Dorothea Denslow, first at The Brooklyn Children's Museum and later at the Clay Club. After his initial work modeling clay figures in a style related to Brancusi and Archipenko, Lassaw turned to nonobjective sculpture in 1933. His interest in modern art had its beginnings in 1926 when he saw the "International Exhibition of Modern Art" at The Brooklyn Museum, organized by the Société Anonyme. This was his introduction to avant-garde painting and sculpture, and it changed the direction of his work. He began to read *Cahiers d'Art, Transition,* and other publications devoted to contemporary trends in the arts. Another essential source for his development of a personal style was László Moholy-Nagy's *The New Vision,* which Lassaw read shortly after the English edition first appeared in 1930. In 1931–32 he attended evening classes at the Beaux-Arts Institute of Design, while attending City College of the City University of New York.

By 1933, Lassaw was one of the pioneers in the creation of nonobjective sculpture among American artists. These early open-space constructions, which combine biomorphism with Constructivist methods, were influenced by Gabo, Pevsner, Arp, and Lipchitz. Lassaw also examined welded constructions by Julio González and Picasso, which were illustrated in French periodicals. The artist has also acknowledged his indebtedness to Buckminster Fuller, whose drawings for the "Dymaxion House" were reproduced in *Shelter* in 1932. At Alexander Calder's exhibition at the Pierre Matisse Gallery in New York in 1934, Lassaw met the creator of the mobile. He was fascinated by Calder's brightly painted motorized devices and became aware of the new possibilities for sculpture offered by kineticism.

Lassaw shared an interest in science and cosmology with some of his American contemporaries, such as Calder and Theodore Roszak. He wrote:

At the same time [the thirties] I read books on science, astronomy, cosmological theories, the atomic structure of matter, etc. as well as a three-volume edition of human anatomy with superb plates. All these books were grist to my mill. Whitehead and Jung greatly affected my concepts. I began to see reality as a process.[1]

The artist's earliest open-space constructions were made of reinforced plaster on pipe and wire armatures (fig. 16). By 1937, he had purchased a powered jigsaw and brazed together iron rods to which he fastened carved wooden shapes. An example is *Sing Baby Sing,* which has the whimsical quality of Calder's wire constructions or Miró's witty abstractions.

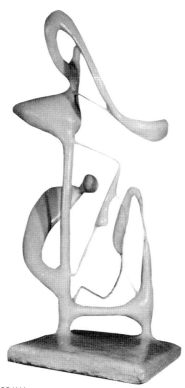

In the following year Lassaw produced his first welded work, *Sculpture in Steel* (cat. no. 88). The leaflike elements suspended from a metal bar seem indebted to Giacometti's Surrealist sculptures of the thirties. In 1938 Lassaw also fabricated a series of wooden shadow boxes with a hidden electric bulb to illuminate the interiors of each. These constructions, combining found objects, wooden elements, and painted metal shapes, were an innovative fusion of biomorphism and Moholy-Nagy's idea for light-space constructions.

Lassaw's interest in kineticism came to fruition in a motor-driven sculpture designed in 1939 in collaboration with George L. K. Morris, Charles Shaw, and A. E. Gallatin for the American Abstract Artists exhibition at the New York World's Fair.[2] The arrival of Mondrian in New York in 1940 resulted in a renewed interest in Neo-Plasticism among American modernists. Lassaw's *Intersecting Rectangles* of that year (cat. no. 89) is the most severely geometrical of his works and predicts his continued involvement with cage constructions during the forties—an interest shared with Isamu

Noguchi, Seymour Lipton, Herbert Ferber, and other American sculptors. During the forties, Lassaw also experimented with acrylic plastics, adding color by applying dye directly to the surface. With the acquisition of equipment for oxyacetylene welding in the fifties, he began to combine molten materials colored with acids and alkalis in an improvisational manner that can be related to the drip paintings of Jackson Pollock.

Lassaw was employed by the WPA Federal Art Project from 1935 to 1942. When the American Abstract Artists group was formed in 1937, he was a founding member, exhibited in its annual shows from 1937 to 1951, and served as president from 1946 to 1949. In 1942 he served in the U.S. Army, where he learned the direct welding techniques that he came to prefer in his mature works after 1950. Lassaw has taught at American University, Duke University, and the University of California, Berkeley.

Joan Marter

[1] Ibram Lassaw, "Perspectives and Reflections of a Sculptor: A Memoir." *Leonardo* I (1968): 353–54.
[2] Ibid., p. 352. The sculpture was subsequently destroyed. Ibram Lassaw, interview with Joan Marter, East Hampton, New York, 27 May 1978.

CAT. NO. 88. IBRAM LASSAW
Sculpture in Steel, 1938
Steel
18½ × 24 × 15 in. (47 × 61 × 38.1 cm.)
Collection of the artist

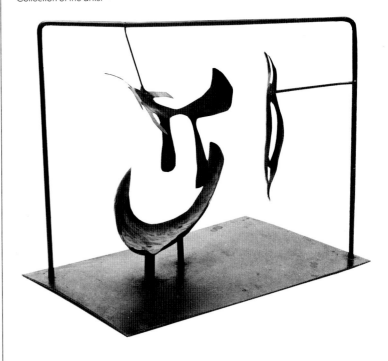

FERNAND LÉGER

Born 1881 in Argentan, France; died 1955 in Gif-sur-Yvette, France. Visited the United States in 1931, 1935–36, 1938–39, and extended stay from 1940 to 1945. Apprenticed to an architect in Caen, 1897–99; draftsman for architect in Paris, 1900–02. Studied at Ecole des Arts Décoratifs, Académie Julian, and in ateliers of Jean-Léon Gérôme and Gabriel Ferrier, Paris, 1903.

Joseph Fernand Henri Léger grew up in Normandy and studied in Paris before settling there in 1908. In the development of his early Cubist style, from approximately 1909 to 1911, Léger was influenced by the work of Cézanne, Picasso, and Braque. He was a friend of Delaunay, knew the artists associated with the Section d'Or, and exhibited his work in Paris at the gallery of Daniel-Henri Kahnweiler. During World War I, from 1914 to 1917, Léger served in the military and suffered the effects of gas poisoning. When he resumed painting in 1918, his work frequently represented figures and objects as tubular, machine-like forms.

During the early twenties, Léger became a close friend of Le Corbusier, collaborated with Blaise Cendrars on films, designed sets and costumes for the Ballet Suédois, and made his first experimental film, *Ballet mécanique* (1924). He decorated the French Ambassador's Pavilion at the Exposition Internationale des Arts Décoratifs (1925) and exhibited at Le Corbusier's Pavillon de l'Esprit Nouveau (1925). In 1924, together with Amédée Ozenfant, Léger opened an atelier, the Académie Moderne, which existed until 1931. His influential role as a teacher continued with the Académie de l'Art Contemporain (1933–39) and the Atelier Fernand Léger (1946–55).

During the thirties and forties, Léger's style shifted between abstraction and figuration. In his search for a monumental, dynamic form of pictorial expression, he investigated variations in scale and distinctions between easel painting and murals. Léger's Cubist and Purist work was followed by paintings in which themes emerged and subject matter became a primary concern. Divers, cyclists, acrobats, and musicians are readily identifiable and meaningful images. Within the pictures of a given theme (for example, the divers), there is significant diversity in style and in degree of abstraction. While some figures are depicted with realistic detail and three-dimensional modeling, other divers become flat, boldly colored shapes or mere outlines. *Plongeurs* (Divers), 1942 (cat. no. 90), depicts intertwining limbs of several figures within a compressed space and exemplifies the free use of color zones dissociated from form. Léger's interest in the movement of diving figures, inspired by watching a group of swimmers ready to plunge into the water at Marseilles in 1940, persisted and was developed during subsequent years in the United States.

In *La forêt* (The Forest), 1942 (cat. no. 91), manmade objects are contrasted with nature. During the summers of 1943–45, Léger painted abandoned farms at Rouses Point in New York State near the Canadian border; he was fasci-

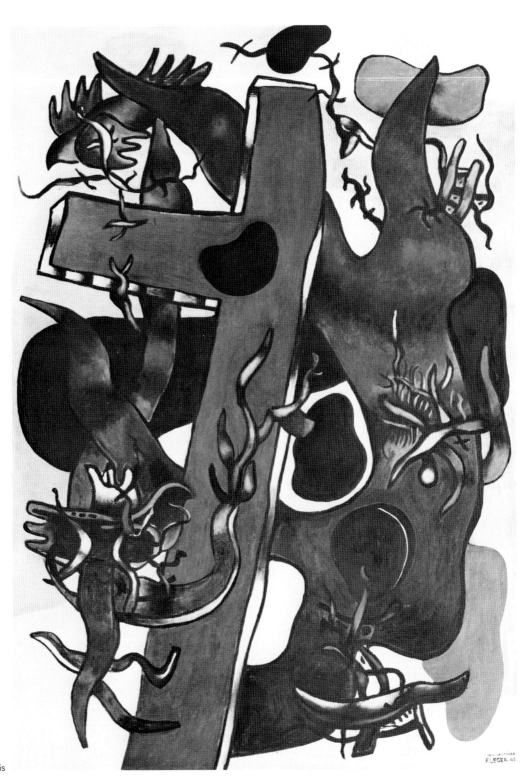

CAT. NO. 91. FERNAND LÉGER
La forêt (The Forest), 1942
Oil on canvas
72$\frac{1}{16}$ × 49$\frac{5}{8}$ in. (183 × 126 cm.)
Musée National d'Art Moderne, Paris

nated by broken-down farm machines left in overgrown fields and woods. "For me it became a typical feature of the American landscape, this carelessness and waste and ... disregard of anything worn or aged."[1]

It is difficult to separate the American and European works, as styles and subjects merge. Although his sojourn in the United States did not significantly change Léger's work, it did bring about a new energy and dynamism. Modern man, seen within contemporary society, transmitted a social content pervasive in Léger's American work.

In the United States in 1944 he painted *Three Musicians*, which returns to the motif of a 1924 drawing, but the artist pointed out that the picture "would have been less tense and colder had it been done in France."[2] Conversely, *Adieu New York* was begun in that city in 1945 and completed in Paris the following year.

Even before Léger's first visit to the United States in 1931, he had become acquainted with the American artists Gerald Murphy, Alexander Calder, Stuart Davis, George L. K. Morris (his student in Paris in 1929), as well as with James Johnson Sweeney, John Dos Passos, and others. During his first trip, which lasted from September to mid-December 1931, Léger visited New York (where his work was shown at the John Becker Gallery) and Chicago. His enthusiastic reactions to both cities were published almost immediately in *L'Intransigeant* and soon reprinted in *Cahiers d'Art* and *Plans* respectively. During his second visit, from October 1935 to March 1936, Léger returned to these cities, probably because of the retrospective exhibition of his work at The Museum of Modern Art and The Art Institute of Chicago.

Through Frederick Kiesler, Léger met the architects Harvey Wiley Corbett and Wallace K. Harrison, who designed Rockefeller Center. He began work on murals for the French Line in New York, a commission arranged for him by Burgoyne Diller, head of the Mural Division of the WPA Federal Art Project. Byron Browne and Willem de Kooning assisted Léger with the project, which was never completed. Léger's left-wing political sympathies dismayed the officials of the French Line, who dismissed him. During Léger's third visit to America from October 1938 to March 1939, his work included an unfinished project for kinetic murals in the lobby of Radio City Music Hall, as well as wall paintings commissioned by Nelson Rockefeller and installed in his Fifth Avenue apartment.

Thus, when World War II and the political situation in France necessitated Léger's extended stay in the United States, he was familiar with the country, and his work had already been exhibited in American museums and galleries. Through Pierre Matisse's New York gallery, where Léger's work was exhibited, he had contact with other Europeans: Tanguy, Matta, Ernst, Breton, Chagall, Mondrian, and his old friend Ozenfant. In New York he saw such other old friends as Harrison, Sweeney, and photographer Herbert Matter, and he became acquainted with many younger artists, notably Arshile Gorky. Although Léger spoke only French, he was known for his gregarious, fun-loving personality.

During the summer of 1941, when Léger taught at Mills College in California, he took the opportunity to travel across the country by bus and was amazed by the variety and enormity of the American landscape. He painted in New Hampshire in the summer of 1942 and near Rouses Point during the following three summers. During his wartime sojourn in the United States, Léger painted more than a hundred canvases and an even greater number of works on paper. The photographer Thomas Bouchard made a film documenting Léger's American production. In 1945 he returned to his homeland, where he joined the French Communist party.

Vivian Endicott Barnett

[1] James Johnson Sweeney, "Eleven Europeans in America: Fernand Léger." *The Museum of Modern Art Bulletin.* Vol. XIII, no. 4–5 (1946): 14.
[2] Ibid.

ALICE TRUMBULL MASON

Born 1904 in Litchfield, Connecticut; died 1971 in New York City. Studied at British Academy, Rome, 1923; National Academy of Design, 1923–27; Grand Central School of Art, New York, 1928–29.

One of the most serious and sensitive abstract artists of the thirties and forties was Alice Trumbull Mason. A direct descendant of a prominent colonial New England family, Alice Bradford Trumbull counted among her forebears the painter John Trumbull, one of the artistic leaders of the new republic. Her childhood was a privileged and unusual one, with frequent trips to Europe and an education that included the study of painting, sculpture, Latin, and Greek. In 1923, at the age of nineteen, she entered the British Academy in Rome; after almost a year, she returned to New York to enroll at the National Academy of Design under Charles W. Hawthorne. There she met fellow student Ilya Bolotowsky and began to form a circle of artists with common interests in modern art.

Her early work as an abstract painter dates from the late twenties, just after she encountered the powerful personality of Arshile Gorky in 1928–29 as a student in his classroom at the Grand Central School of Art. Gorky was an outspoken advocate of modernist art, even while serving a self-imposed apprenticeship to Cézanne and the Cubist Picasso. Following Gorky's advice, if not his example, Trumbull made her own initial moves in the direction of the lyrical, nonobjective art of Kandinsky. By 1929, she was among the earliest of her generation to be doing strong and original nonobjective paintings. Her work, then and subsequently, bore no traces of orthodoxy. She took elements from Synthetic Cubism, Kandinsky, Miró, and later from Mondrian's Neo-Plasticism, but combined many styles freely in a manner uniquely her own. At times her work is reminiscent of the art of Arthur Dove in its affinities to biomorphic form, earthy color, and preference for imagery based upon concrete experiences in nature.

Upon her marriage to Warwick Mason in 1930 and the subsequent birth of two children, she adjusted her own career to the demands of family life and virtually ceased her activities as a painter until 1935. During those few years, however, her thoughtful, introspective nature manifested itself in poetry—a serious, lifelong avocation and the source of some of her visual imagery.

Mason was a founding member of the American Abstract Artists and counted among her friends the liveliest and most active artists in the group, including Bolotowsky, Balcomb and Gertrude Greene, Ibram Lassaw, and George McNeil. During the thirties and early forties she enjoyed some measure of public success. Her first one-artist exhibition was presented by A. E. Gallatin at his Museum of Living Art in 1942. He purchased *Brown Shapes White*, 1941 (cat. no. 93), a work that looks toward her mature style of that decade, in

which she attempted to decentralize her compositions, focusing activity in four corners rather than in the center. Most likely this was a reaction against Cubist composition as it was conceived by many Americans, with its central motif and secondary background space. Within *Brown Shapes White*, her desire to decentralize works well, enabling her to deal with the entire field of the canvas. Mason based her unusual system of composition on what she called her principle of "displacement."[1] Coming from an expressionist emphasis, she did not subscribe to Cubist principles or structures. Thus, her work does not imply the existence of a grid and her forms move freely in an unstructured space.

Mason's untitled painting of about 1940 (cat. no. 92) is a more personal and expressive work, suggestive of a vast abstracted landscape with islands of earth and colored light. Her composition rests upon a dark horizontal band supported by a plane of rich ochre. Geometric fragments in red, yellow and blue, black and white place the rest of her soft-toned palette into high relief. This painting looks forward to her work of the later forties, which would become more geometric; yet it is softened by a lyricism that would remain and lend a special music to the most structured of her later works. In her work after 1950 she was influenced by Mondrian, although characteristically she did not choose to adopt the compositional restrictions of Neo-Plasticism. Instead, her work, reflecting her character, retained its quiet, rather wistful sense of the poetic.

A small retrospective exhibition of Mason's work was presented at the Whitney Museum of American Art in 1973, two years after her death. Since 1974, frequent exhibitions of her painting have been held at the Washburn Gallery in New York.

Susan C. Larsen

[1]Alice T. Mason, "A Statement on 'Bearings in Transition,'" ca. 1947. Alice T. Mason Papers, Archives of American Art, Smithsonian Institution, Washington, original manuscript, p. 1.

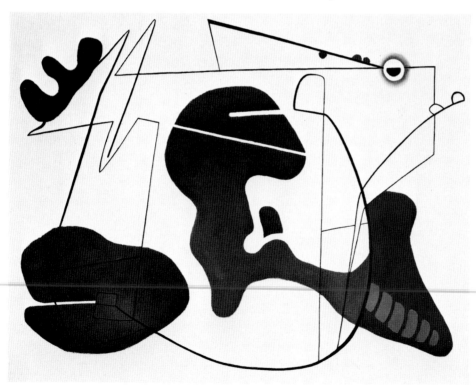

CAT. NO. 93. ALICE TRUMBULL MASON
Brown Shapes White, 1941
Oil on board
21 × 31¾ in. (53.3 × 80.7 cm.)
Philadelphia Museum of Art;
 A. E. Gallatin Collection

JAN MATULKA

Born 1890 in Vlachovo Brezi, Bohemia (now Czechoslovakia); died 1972 in Jackson Heights, New York. Arrived in the United States in 1907; became U.S. citizen in 1930. Studied at National Academy of Design, New York, 1908–17; Art Students League, New York, 1924–25.

Jan Matulka began his study of art at the age of fifteen in Prague, eighty-five miles southwest of the small town in Bohemia where he was born and raised. Two years later, in 1907, he immigrated to the United States with his parents and five younger sisters. Shortly after his arrival in New York, he started taking classes at the National Academy of Design, where his training was comprehensive but highly conservative. He received numerous awards, culminating in the $1500 Joseph Pulitzer Traveling Scholarship in 1917, which provided Matulka with the first real financial security of his life. He first resolved to travel to Europe, but changed his plans owing to postwar complications of his citizenship and instead spent several months in 1917 and 1918 in the American Southwest and Florida. His contact with Hopi Indians in Arizona stimulated more sophisticated experiments in the Cubist idiom, which he had begun to utilize about 1916. Back in New York, he encountered the fledgling modernists James Daugherty and Jay Van Everen. As a "Simultaneist," he showed with them and Patrick Henry Bruce in the second exhibition of the Société Anonyme in 1920. His association with the Société Anonyme's founding patron, Katherine Dreier, was typical of most of his contacts within the art community—in turn, full of promise, then combative, and finally acrimonious.

From 1920 until the early thirties, Matulka traveled frequently between the United States and Europe, maintaining a studio-apartment in Paris from the mid-twenties through 1934. His contacts in Paris, where he returned often during the twenties, strengthened his adaptation of Cubist ideas. By 1930, Matulka had developed a special bond with other second-generation modernist artists such as fellow immigrants Arshile Gorky and John Graham and the native American Stuart Davis, all of whom regularly visited one another's studios. Davis rented Matulka's studio in Paris in 1928–29 during his only stay in Europe. Davis, who taught at the Art Students League in 1931–32, is believed to have organized an exhibition of his own work and that of his three colleagues at the League in the fall of 1931 in honor of Léger's first visit to New York. Davis and Gorky wrote about each other's work,[1] and Graham singled out Davis, Gorky, and Matulka for special praise in his *System and Dialectics of Art*.[2] Beyond personal feelings, they shared stylistic attitudes: the utilization of still life for abstract ends and a predilection for banded, repetitive, multitextured, and flattened interlocking forms. Along with Matulka's growing artistic sophistication in the late twenties, his work turned political and openly expressed sympathy with the working class. He frequently contributed drawings to the *New Masses* and illustrated and served as art adviser for the *Dělnik Kalendar*, a left-wing, intellectual Czech-American journal.

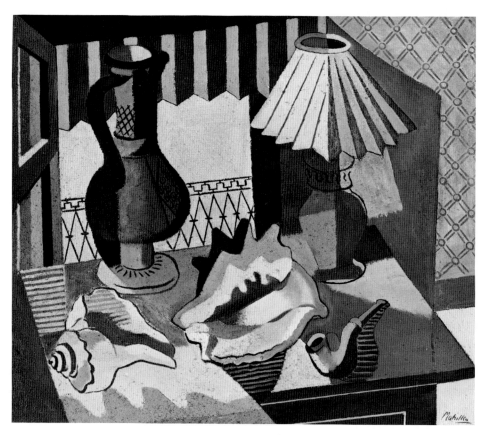

CAT. NO. 95. JAN MATULKA
*Still Life with Lamp, Pitcher, Pipe,
 and Shells*, 1929–30
Oil on canvas
30 × 36 in. (76.2 × 91.4 cm.)
The Museum of Fine Arts, Houston;
 Museum Purchase

Matulka's first one-artist exhibition was held at the Artists Gallery in New York in 1925, and his second took place the following year at the Whitney Studio Club, where he often exhibited during the twenties. Dreier arranged another show for him in 1926 at the Art Center in New York, and he was loosely affiliated with the prestigious but conservative Frank K. M. Rehn Gallery from 1927 to 1935. From 1929 to 1931, he produced the thickly painted and decorative-patterned still lifes, such as *Arrangement with Phonograph*, 1929 (cat. no. 94), that form such an important and lively aspect of his art. As a singularly advanced teacher of abstraction at the Art Students League during that period, he attracted an extraordinary group of dedicated students, including Dorothy Dehner, Burgoyne Diller, George McNeil, Irene Rice Pereira, and David Smith. Among occasional visitors to his classes were Francis Criss, Wyatt Davis, Leo Lances, Lillian O'Linsey (later Mrs. Frederick Kiesler), Michael Loew, George L. K. Morris, and Frederick Whiteman.

Although many of his former students joined the American Abstract Artists, Matulka never became a member of the group. He was never totally comfortable with nonobjectivity, and even at the times of greatest abstraction in his art, he also painted thoroughly conventional works. Nonetheless, Matulka was listed with six AAA members—Rosalind Bengelsdorf, Byron Browne, Herzl Emanuel, Hananiah Harari, Leo Lances, and George McNeil—who signed a letter, printed in the October 1937 issue of *Art Front*, the Artists' Union publication, championing the establishment of The Solomon R. Guggenheim Foundation. He also participated in an AAA-related invitational group show in 1940.

Although he was otherwise reliant on his wife's salary, Matulka's main support from 1933 to January 1934 came from the U.S. Treasury Department's Public Works of Art Project. Beginning in 1935, he produced two murals under the auspices of the Mural Division of the WPA Federal Art Project. Diller, the head of the division and a former student of Matulka's, chose him and eleven other leading abstract painters to create murals for the Williamsburg Housing Project in Brooklyn; Matulka's mural is among those now lost. In subsequent years, Matulka's fortunes declined. Aside from

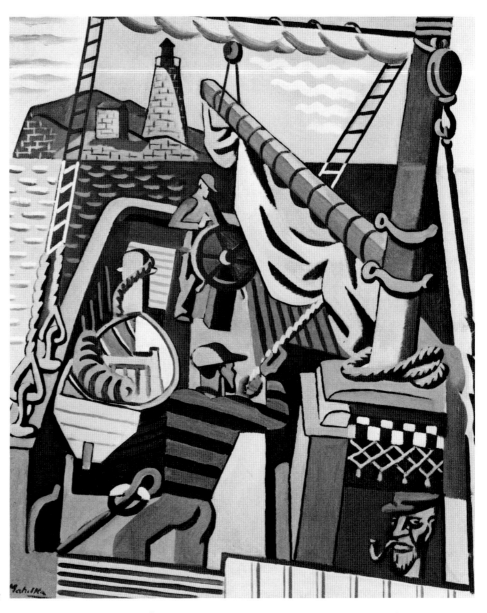

CAT. NO. 96. JAN MATULKA
View from Ship, ca. 1932
Oil on canvas
36 × 30 in. (91.4 × 76.2 cm.)
Collection of Mr. and Mrs. Raymond Learsy

a show of expressionist figurative work in 1944 at the A.C.A. Gallery in New York, his 1933 one-artist exhibition at the Rehn Gallery was his only show of recent work before his death in 1972. Though his paintings were regularly exhibited in the annual shows at the Whitney Museum of American Art and at the Pennsylvania Academy of the Fine Arts and Carnegie Institute, few sales resulted. His art, after a quasi-surreal phase in the mid-to-late thirties, grew increasingly conservative. Matulka is best recalled as an inspiring teacher in a dispirited age and as the fashioner

of compact, taut works, always tempered by European art, of singular forwardness.

Patterson Sims

[1]Stuart Davis, "Arshile Gorky in the 1930's: A Personal Recollection," in *Stuart Davis: A Documentary Monograph in Modern Art,* ed. Diane Kelder (New York: Praeger Publishers, Inc., 1971), pp. 178–83 (first printed in *Magazine of Art* XLIV, February 1951). Arshile Gorky, "Stuart Davis," ibid., pp. 192–94 (first printed in *Creative Art* IX, September 1931).
[2]John Graham, *System and Dialectics of Art.* Annotated from unpublished writings with a critical introduction by Marcia Epstein Allentuck (Baltimore and London: Johns Hopkins Press, 1971), pp. 128–29, 154.

LÁSZLÓ MOHOLY-NAGY

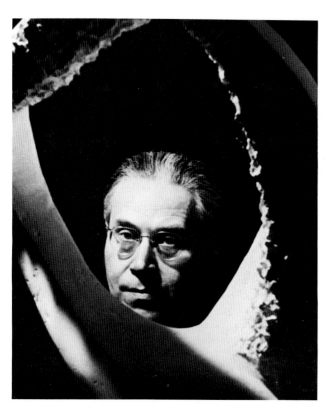

*Born 1895 in Bacsbarsod, Hungary; died 1946 in Chicago.
Arrived in the United States in 1937. Studied at the University
of Budapest (law degree), 1918.*

As a young artillery officer during World War I and as a law student, László Moholy-Nagy drew and painted in a German Expressionist manner which he first learned from books. From 1918 to 1925, he collaborated on the revolutionary Hungarian magazine *MA* (Today), while becoming a Constructivist in art and philosophy. He moved to Berlin in 1921, met Kurt Schwitters, began to take photographs, and developed the photogram. At the Bauhaus from 1923 to 1928, Moholy-Nagy taught the advanced foundation course and, with Walter Gropius, edited the series of Bauhaus books. He lived in Berlin from 1928 to 1934; then, forced to leave Germany following the rise of the Nazis, he and his wife, the former Sibyl Peech (whom he had met in 1929), moved to Holland. A retrospective exhibition of his work was presented at the Stedelijk Museum in 1934. In 1935 he and his family moved to England. Two years later he was invited, at the suggestion of Gropius, to become director of a design school being founded in Chicago "along Bauhaus lines," and the final decade of his life was spent in Chicago.

When Moholy-Nagy arrived in the United States in 1937, at the age of forty-two, he was a figure of international stature at the height of his powers. The English edition of his book *The New Vision* had been published in 1930 and had exerted a strong influence on many American artists. This former faculty member of the Bauhaus was at once a remarkable organizer and an inspiring teacher. Of equal impact was Moholy-Nagy's position as an early proponent of Constructivism and an artist always eager to experiment with new, unlikely, or untried materials. He made experimental films, painted and made prints and constructions, designed stage sets, and did much to reinvent typography. By 1937, Moholy-Nagy numbered among his friends and colleagues Arp, Brancusi, Delaunay, Hepworth, Léger, Mondrian, Nicholson, Piper, Rebay, and Vantongerloo, as well as his Bauhaus associates.

His overall goal, like that of the Bauhaus, was the advancement of society through artistic measures, involving the redesigning of every element of everyday use. As a revolutionary youth, Moholy-Nagy espoused a philosophy that had much in common with that of the Russian Constructivists, though he was not as mystical as Malevich or Pevsner. In *MA*, he wrote that the revolution must lead to reformation and create a new spirit to fill the void produced by the advent of the machine. Art, which crystallizes the emotions of an era, he said, would be the teacher, and the art of our time must be precise, fundamental, and all-inclusive.[1]

When the New Bauhaus in Chicago failed after a year for lack of financial support, Moholy-Nagy—whose legendary energy was reinforced by a positive outlook—was by then determined to establish a successful design school in the United States. With the encouragement of Gropius, John Dewey, Julian Huxley, and Alfred H. Barr, Jr., he opened the School of Design (later known as the Institute of Design) in January 1939.

In addition to teaching and managing the School of Design, Moholy-Nagy continued as a creative artist, painting and making three-dimensional constructions. Like others of that era, he was fascinated with the properties of light, both scientific and as a mystical ideal, and from the early twenties on, light was his chief medium. Early in that decade he constructed a "light modulator" made of perforated metal and transparent plastics. In 1928 he completed the film *Light Play: Black White Gray*, which explores the play of light on his light modulator. In 1936, while working with Alexander Korda on special effects for the futuristic film *Things to Come*, Moholy-Nagy was attracted by various newly developed plastics and began a series of "space modulators." In these (cat. nos. 97 and 98), he would set a transparent plastic sheet an inch or so in front of a piece of white-painted plywood. He then scratched or perforated designs into the plastic. Light passing through the plastic caused shadows of these designs to fall upon the white surface. When various pigments were rubbed into the incised areas, the dimension of translucent color was added. A kinetic effect was also possible if the light source or the viewer caused the shadows to move.

Katharine Kuh gave Moholy-Nagy a one-artist exhibition at her gallery in Chicago in 1939, and he exhibited regularly with the American Abstract Artists in New York. He was also, with Kandinsky and Rudolf Bauer, a major figure at the Museum of Non-objective Painting (forerunner of The Solomon R. Guggenheim Museum). He had met the director, Hilla Rebay, in Paris in 1928 just as she was beginning to advise the Solomon Guggenheims on purchasing the works that would be the basis for the future museum. Moholy-Nagy's painting, *T1*, 1926, was one of the first works to enter the Guggenheim Collection. He and Rebay, both visionaries gifted with formidable energy and the ability to bring their visions into tangible form, discovered many shared aspirations for the role of art in shaping society. Although five years younger than Rebay, Moholy-Nagy had more experience in directing an organization, and Rebay regularly sought

his advice as she struggled to create the museum she had envisioned. She included his paintings and constructions in exhibitions, beginning in 1936, and gave him three one-artist shows, the last a memorial exhibition in 1947. Thus Moholy-Nagy was not only a significant force in the renewal of American industrial design in the forties but also an influential artist in the Constructivist vein by means of his exhibitions in New York.

Joan M. Lukach

[1]Sibyl Moholy-Nagy, *Moholy-Nagy: Experiment in Totality* (New York: Harper & Brothers, 1950), p. 19.

CAT. NO. 97. LÁSZLÓ MOHOLY-NAGY
Space Modulator, 1938–40
Oil on canvas
47 × 47 in. (119.4 × 119.4 cm.)
Whitney Museum of American Art, New York; Gift of Mrs. Sibyl Moholy-Nagy

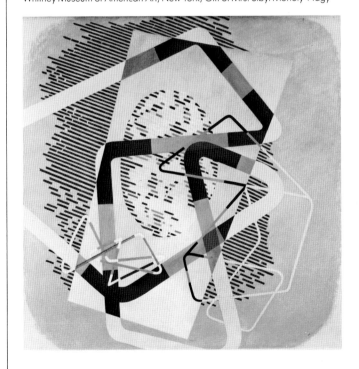

PIET MONDRIAN

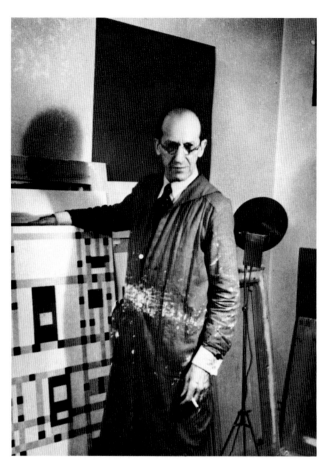

Born 1872 in Amersfoort, The Netherlands; died 1944 in New York City. Arrived in the United States in 1940. Studied at Academy of Fine Art, Amsterdam, 1892–95, 1896–97.

Born into a Calvinist family in the Dutch town of Amersfoort, Pieter Cornelis Mondrian[1] was almost forty years old and relatively well established as a painter of landscapes—initially in the manner of the Hague School and subsequently indebted to Symbolism and Neo-Impressionism—when a new awareness of Cézanne and the Cubists enticed him to Paris for the first time at the beginning of 1912. During the next two and a half years he developed a personal interpretation of Cubism, concentrating on architectural and isolated landscape motifs rather than the still life and portraiture that distinguish Analytic Cubism, with which Mondrian's work of this period is often compared. Inspired partly by theosophical beliefs, Mondrian was already engaged in a search for fundamental principles of plastic form, by means of which he hoped to express the true reality that is veiled by natural appearances. He therefore avoided both the monumental subject matter and the tension between two- and three-dimensional space that characterize the work of many French Cubists. Instead, Mondrian progressively liberated the formal elements of line and color from their traditional functions of indicating specific objects or representing three-dimensional spatial relationships on a flat surface.

Mondrian continued to develop in this direction while in neutral Holland during World War I. He painted what is considered to be his first nonreferential painting in 1917, the same year he joined van Doesburg and several other Dutch artists and architects in founding a magazine called *De Stijl*, where a number of his most important theoretical essays were published during the ensuing seven years. In 1919 Mondrian returned to Paris, and by 1922 he had established the basic character of the style he called Neo-Plasticism: asymmetrical division of the canvas into rectangular planes of primary color (red, yellow, blue) and noncolor (black, white, gray), the edges of which are defined by black bands in horizontal and vertical positions. By varying the size, placement, and relationship of these few simple elements, Mondrian produced an astonishingly wide range of compositions during the last two decades of his career.

The profundity of his commitment to the tenets of Neo-Plasticism is reflected in his decision to sever connections with *De Stijl* in 1925, after van Doesburg introduced a diagonal axis in his otherwise Neo-Plastic paintings. Van Doesburg thus stressed contrast rather than dynamic equilibrium, which was the essential feature of Mondrian's work and of the world view it was intended to express. Subsequently, during the early thirties Mondrian was affiliated with the Cercle et Carré and Abstraction-Création groups, but for the most part he

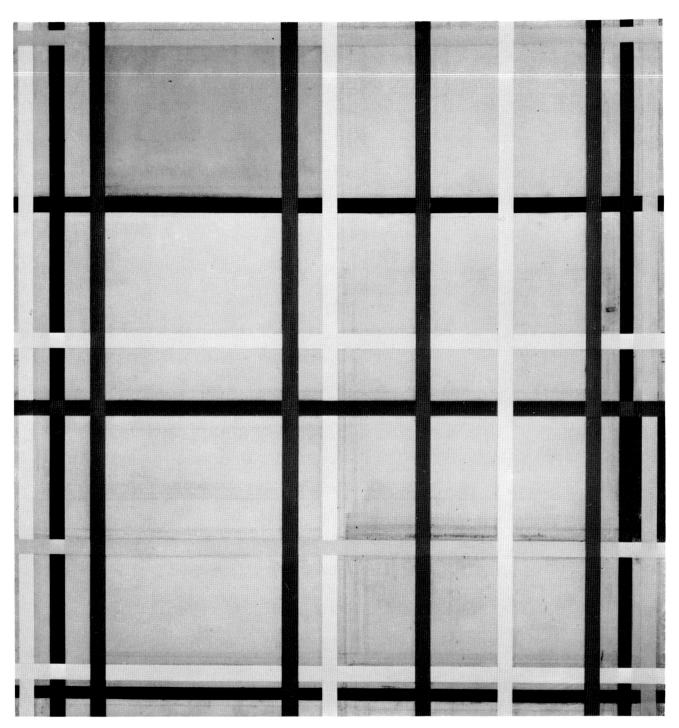

CAT. NO. 99. PIET MONDRIAN
New York, New York City, ca. 1942
Originally pencil, charcoal, oil, and tape on canvas. Restored by Harry
 Holtzman with the help of Bill Steeves in 1977, at which time the colored
 tapes were replaced by paper strips painted with acrylic paints. Of the
 tapes, only the black ones are original.
Oil, pencil, charcoal, and painted tape on canvas
46 × 43½ in. (116.8 × 110.5 cm.)
Sidney Janis Gallery, New York

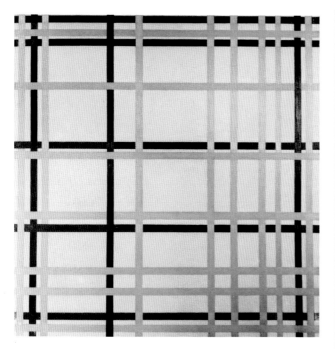

FIG. 17. PIET MONDRIAN
New York City I, 1942
Oil on canvas
47 × 45 in. (119.4 × 114.3 cm.)
Sidney Janis Gallery, New York

refrained from joining artists' associations until 1940 when he accepted an invitation to become a member of the American Abstract Artists several months after arriving in the United States from London, where he had spent the previous two years.

By that time, Mondrian's work was already well known to progressive American artists and art audiences in New York. As early as 1926, Frederick Kiesler and Marcel Duchamp had advised Katherine Dreier to include paintings by Mondrian in the "International Exhibition of Modern Art," which she organized at The Brooklyn Museum. Not only was Dreier the first American to visit Mondrian and to exhibit his work in the United States, she was also a pioneering collector, purchasing a painting from him in 1927. Five years later, A. E. Gallatin followed her lead, including Mondrian's 1932 *Composition* in the permanent exhibition of his Gallery of Living Art. It was there, about 1933, that young American painters including Burgoyne Diller, Harry Holtzman, and Ilya Bolotowsky first saw original examples of Mondrian's work. Holtzman was so moved by the experience that in 1934,

despite very limited finances, he decided to visit Mondrian in Paris, thus establishing a bond that brought the Dutch artist to the United States at the beginning of World War II.

The influence of Mondrian's work had become evident in paintings of the late thirties by several Americans who saw his version of "pure abstraction"[2] as the culmination of a process that had begun with Cubism's destruction of naturalistic imagery. Artists such as Carl Holty and Albert Swinden, as well as Diller, Holtzman, and Bolotowsky, were concerned with the aesthetic issues raised by recent trends in European painting—the meaning of abstraction, in particular—but the economic realities of the Great Depression forced them to rely on public support for their work and therefore to confront questions concerning its political and social relevance. They saw Mondrian's Neo-Plasticism not as an art for art's sake, but as a style whose internal consistency and essential purity presented the basic truths of painting. In their view, a decision to adhere to Neo-Plasticism signified their freedom as artists to work outside the limitations imposed by Social Realism and American Scene painting; this, they believed, was the most effective means of declaring their independence, both as Americans and as artists.

Although Holty's claim that "Mondrian had no effect on America during his lifetime that he didn't have before he came here"[3] may be slightly exaggerated, it is clear that the Dutch artist's impact in the United States resulted primarily from the experience of his work and writings, rather than from his personal interaction with the artistic community in New York, where he had two independent exhibitions, participated in numerous group shows, and published several essays in English. When asked by the American Abstract Artists to lecture at the Nierendorf Gallery in 1942, Mondrian chose to have Balcomb Greene read the text of his essay "A New Realism," rather than deliver it himself. His characteristic reticence is also demonstrated by the fact that he made only a few close friends in New York, including Charmion von Wiegand and Fritz Glarner, as well as Holty and Holtzman.

However, Mondrian's presence in New York proved to be an important factor in the evolution of his own work during the last three and a half years of his life. Shortly after his arrival, he began a series of paintings, the first of which he described as having been inspired by "what New York meant to me when I first saw it from the boat," and another as "the city as it appeared to me after living in it."[4] He also reworked paintings that he brought with him from Europe, often by adding thin rectangles of color, not bound by black, to the

edges of the composition, and eventually he introduced colored bands that seem to traverse the entire surface of a painting, as in *New York City I*, 1942 (fig. 17). In making this innovation, which amounted to the merging of plane and line—elements whose coloristic differentiation had heretofore insured their independent function in his work—Mondrian was prompted by what Sidney Janis described as a "technical shortcut" in the form of colored adhesive tape manufactured by the Dennison Company.[5] Instead of his previous practice of laying out the preliminary structure of a given painting with strips of paper, in New York Mondrian transformed the notion of the preliminary sketch by using rolls of red, yellow, and blue tape to which Charmion von Wiegand had introduced him.

Holty later recalled how Mondrian worked with these tapes to arrive at the ultimate form of *New York City I*: "He had varied the overlapping of the colored strips mechanically at first ('Because I like to be logical'), placing red above blue, yellow above red, red above yellow in the respective corners. As he used only three colors, the fourth corner was embarrassing for a time. After giving the matter some thought, Mondrian decided that the logical process governing the layout was not binding on him in the further development of the picture. He proceeded to adjust the sections of the long colored strips to the canvas as a whole, and disregarded the earlier disposition and variations."[6] At this point Mondrian removed the strips of tape one by one, replacing each with a correspondingly colored linear plane of paint. The interweaving of the tapes that is still visible in unfinished works such as *New York, New York City*, ca. 1942 (cat. no. 99), is maintained as a latent feature of the completed painting: bands of color are broken at the points where they seem to intersect and overlap one another, thus producing a sense of limited depth as well as flickering optical effects and a syncopated rhythm that Mondrian associated directly with the boogie-woogie jazz music he discovered in New York.

These qualities are greatly intensified in *Broadway Boogie Woogie*, 1942–43 (fig. 18), where the basic grid structure originally established by yellow tape is broken up by small red, blue, and gray rectangles that produce a pulsating effect which Mondrian further complicated by occasionally embedding small rectangles in larger ones to suggest a push-pull play in depth that was unprecedented in his work. Here the pristine surfaces of his earlier pictures give way to a thickly painted canvas on which brush strokes are readily evident. Rather than restricting his composition to the relationship of a few relatively large formal elements, the plastic incidents

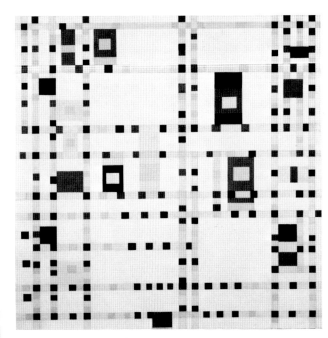

FIG. 18. PIET MONDRIAN
Broadway Boogie Woogie, 1942–43
Oil on canvas
50 × 50 in. (127 × 127 cm.)
The Museum of Modern Art, New York; Given anonymously

are quite small and spread out across the entire surface, which they activate as a whole. Thus Mondrian's last paintings, particularly the unfinished *Victory Boogie Woogie*, 1943–44 (cat. no. 100), can be said to look forward to the expressionistic handling and all-over compositional modes that characterized American painting in the years following Mondrian's death in 1944.

Nancy J. Troy

[1] In English and French, Mondrian did not use the second "a" of the Dutch spelling of his name.
[2] This term was coined by Alfred H. Barr, Jr., on the occasion of The Museum of Modern Art's 1936 exhibition "Cubism and Abstract Art," which included nine paintings by Mondrian.
[3] Carl Holty, interview with Paul Cummings, 1 October 1968. Typescript, Archives of American Art, Smithsonian Institution, Washington, p. 136.
[4] Quoted in Sidney Janis, "School of Paris Comes to U.S.: Piet Mondrian." *Decision* 2 (1941): 91.
[5] Janis, "School of Paris," p. 90.
[6] Carl Holty, "Mondrian in New York: A Memoir," *Arts* 31 (September 1957): 20–21.

GEORGE L. K. MORRIS

Born in 1905 in New York City; died 1975 in Stockbridge, Massachusetts. Attended Yale University, 1924–28; Art Students League, New York, fall 1928 and fall 1929; Académie Moderne, Paris, spring 1929 and spring 1930.

Throughout his life, the fortunate circumstances of his well-established family provided George Lovett Kingsland Morris with unusual opportunities for learning, traveling, collecting art, and supporting cultural endeavors. After graduating in 1928 from Yale University, where he studied both art and literature, Morris decided to become a painter and undertook further training at the Art Students League and the Académie Moderne in Paris.

Literary and artistic studies, both classical and modern, enabled Morris to pursue a combined career as writer and artist. Classical art provided him with a model for accepting modern formalism and structural abstraction, which emphasized order, precision, simplicity, and geometrical harmony. This underlying aesthetic led Morris to appreciate the Cubist tradition of abstract art, particularly the work of Picasso, Gris, Léger, and, later, Mondrian.

Between 1935 and 1943, Morris devoted considerable attention to critical writing and became known as a spokesman for American abstract art. His influence reached a zenith in the early forties, by which time the movement had become more solidly established. The rise of Abstract Expressionism in the late forties impelled Morris to intensify his support, both in his painting and his writing, for the Cubist-based tradition of structural abstraction. His insistent expression of the need for geometrical order and rational control was an important part of the process of self-examination occurring within the American art world at that time.

During the fifties and sixties, Morris was a leading member of the American Abstract Artists, among other groups, organizing many international exhibitions and serving as an American delegate to international cultural conferences. This was also a period when his work was actively exhibited and attained its greatest recognition. Despite general disenchantment with many new developments in the art of the sixties and seventies, Morris resolutely pursued his aesthetic goals as an artist, confident in the tradition he had espoused since the thirties.

The teaching and work of Léger were the major sources for Morris' early development between 1929 and 1935. Not only did Léger's work epitomize for Morris the structural order of Cubism, but it also embodied the element of primitivism, that is, a simplified formal vocabulary conveying authentic meaning. At this time, Morris was incorporating into his painting American Indian imagery, which he viewed as being part of the international language of primitivism in modern art.[1] He believed that only through the synthesis of national and international elements could an authentic American art be

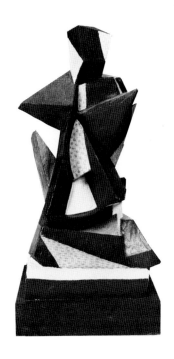

FIG. 19. GEORGE L. K. MORRIS
Personnage, 1935
Painted plaster
22 in. (55.9 cm.)
H. F. Spencer Museum, University of Kansas, Lawrence; Gift of the National
 Endowment for the Arts and Mr. and Mrs. John M. Simpson

FIG. 20. GEORGE L. K. MORRIS
Concretion, 1936
Oil on canvas
54 × 72 in. (137.2 × 182.9 cm.)
The High Museum of Art, Atlanta; Museum purchase in honor of Mrs. Rufus
 Chambers

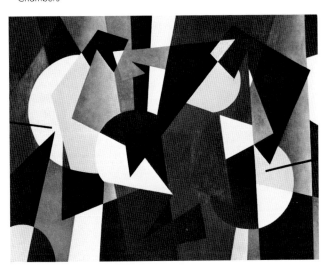

established.[2] In a representative work of this period, *Poca-hontas*, 1932 (cat. no. 101), native American imagery is presented through Légeresque abbreviated figuration and Synthetic Cubist space consisting of overlapping planes of color and pattern. Significantly, Léger was also the subject of Morris' first major art criticism, establishing the precedent for writing about artists whose work influenced his own.[3]

In addition to Léger, several other European artists were important for Morris' early development, notably Matisse, Delaunay, Gris, and Hélion. Surface rotational movement of overlapping planes remained fundamental to his compositional organization, which became more abstract, angular, and complex. By 1935, Morris had reached a personal synthesis of these sources, which is evident in his painting *Stockbridge Church* (cat. no. 102) and in his first major sculptural piece, *Personnage* (fig. 19).[4] Throughout his career, Morris' sculpture followed the lead of his painting, and it became more abstract in 1936 when he completed a series of completely abstract paintings that included *Concretion* (fig. 20). *Configuration*, a sculpture of the same date (cat. no. 103), further reveals the greater degree of abstraction, recalling a streamlined version of the more distinctly figurative *Personnage*.

Although the angular forms of geometric abstraction dominated the work of this period, Morris simultaneously experimented with the biomorphic abstraction of Arp and Miró. Following the integration of geometric and biomorphic vocabularies, the work between 1938 and 1942 became more ordered by rectilinear grids, as seen in *Mural Composition*, 1940 (cat. no. 105). This painting was a successful synthesis of a new set of sources—Stuart Davis, Ben Nicholson, and Mondrian—while retaining much of Léger. Characteristically, Morris introduced figurative references into some of these rectilinear compositions—a tendency evident in *Nautical Composition*, 1937–42 (cat. no. 104), which incorporated both geometrical and biomorphic forms. A change from implicit to explicit figuration occurred between 1942 and 1945 in both his painting and sculpture in response to war images of street fighting, bombing, and shipbuilding. During the war, Morris experimented with a variety of materials embedded in plaster, including glass and linoleum, exemplified in *Posthumous Portrait*, 1944 (cat. no. 106).

Throughout the thirties and early forties, Morris maintained close contact with European modernism through frequent trips to Paris and London. A. E. Gallatin became a close friend and colleague who introduced him to many European artists, including Hélion, who was an invaluable source of

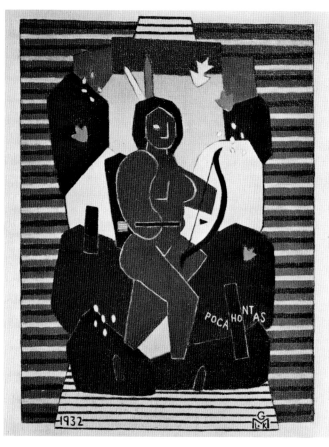

CAT. NO. 101. GEORGE L. K. MORRIS
Pocahontas, 1932
Oil on canvas
25 × 19 in. (63.5 × 48.3 cm.)
Collection of Robert L. B. Tobin

least political of the editors, he supported a revolutionary cultural transformation led by artists and writers, who reflected Leon Trotsky's belief that full artistic freedom—even abstract forms of modern art—could express the spirit of the Marxist revolution. *Partisan Review* represented the fervent attempt by some of the leaders of the left to establish an independent vehicle for revolutionary cultural dialogue.

In 1939 Morris joined the League for Cultural Freedom and Socialism, which condemned Soviet totalitarianism. In a statement published in *Partisan Review*, the League called for the revolutionary reconstruction of society and the freedom of art and science from political dictation. The magazine continued to support open discussion of complex political issues as they affected world culture. However, early in 1942, following the entrance of the United States into the war, the editors (by then including Clement Greenberg) issued a statement indicating intense political disagreement among themselves. As a result, there could be no unified editorial stand on the war. It is likely that these political differences and the growing preoccupation with war led Morris to withdraw from *Partisan Review* in late 1943.

Along with his international activities, Morris was involved with the founding of the American Abstract Artists in New York in 1937, and he remained a major supporter of the organization as an elected officer, editor of yearbooks, and organizer of exhibitions. In addition, he was a founding member of the Federation of Modern Painters and Sculptors in 1940 and became active in Artists Equity during that decade. Morris, Gallatin, Charles Shaw, and Suzy Frelinghuysen, Morris' wife, formed a close-knit group of artists who often exhibited together and belonged to many of the same organizations, including the American Abstract Artists.

Melinda A. Lorenz

information about the European art world and an enthusiastic supporter of their efforts to promote abstract art in the United States. In their quest for international communication, Gallatin and Morris collaborated, from 1937 to 1939, with Arp, Taeuber-Arp, and César Niewenhuis-Domela on *Plastique*, a Paris-based art magazine. Sharing a desire to counteract the growing influence of veristic Surrealism in Paris and elsewhere, the editors of *Plastique* emphasized their support of abstraction, Constructivist, and Dada traditions.

In New York, Morris also served as an editor and helped finance *Partisan Review*, which was reorganized in 1937 under new editors with a political philosophy opposing Stalinism and any form of totalitarianism. Although Morris was the

[1]Morris' use of American Indian imagery may have been encouraged by working at the Art Students League in 1929 with John Sloan, a leading participant in the revival of American Indian art about 1930.

[2]Morris' attitude about the importance of fusing native American imagery with international modernism represents a significant intermediate stage in using native American culture as artistic source material. Like the American Scene artists in the thirties, he believed that distinctly American qualities could be found in this material. However, he felt that they could be expressed through the abstract language of Cubism. Unlike the American Scene artists and Morris, the Abstract Expressionists in the forties used this source to achieve distinctly non-nationalistic, archetypal abstract imagery.

[3]George L. K. Morris, "On Fernand Léger and Others." *The Miscellany* (March 1931): 1–17. Morris, "Léger versus Cubism." *The Museum of Modern Art Bulletin* III/1 (October 1935).

[4]*Personnage*, 1935, can be related to the Cubist tradition of plaster polychrome sculpture by Picasso, Archipenko, Laurens, and Gris. Morris executed a second piece, *Personnage*, 1936, similar to the 1935 work.

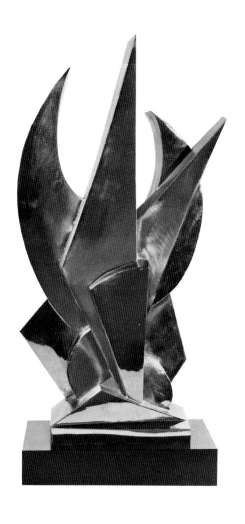

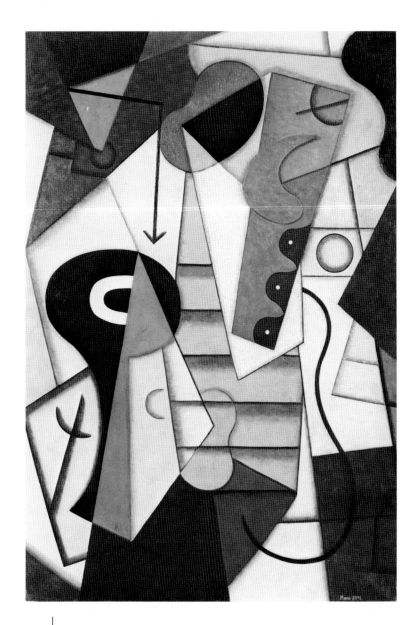

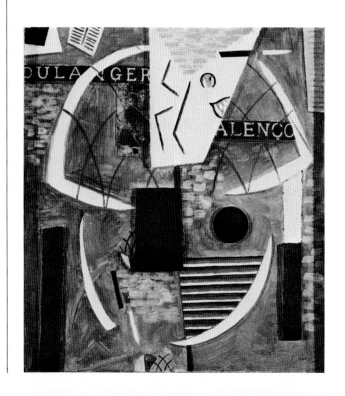

ABOVE, LEFT
CAT. NO. 103. GEORGE L. K. MORRIS
Configuration, 1936
Bronze
25½ × 11 × 6 in. (64.8 × 27.9 × 15.2 cm.)
Private Collection

ABOVE, RIGHT
CAT. NO. 104. GEORGE L. K. MORRIS
Nautical Composition, 1937–42
Oil on canvas
51 × 35 in. (129.5 × 88.9 cm.)
Whitney Museum of American Art, New York

RIGHT
CAT. NO. 106. GEORGE L. K. MORRIS
Posthumous Portrait, 1944
Oil on board and plaster relief
21 × 19½ in. (53.3 × 49.5 cm.)
Collection of Dr. and Mrs. Phillip Frost

ISAMU NOGUCHI

Born 1904 in Los Angeles. Moved to Japan in 1906; returned to the United States in 1918. Studied at Columbia University, 1922–24; Leonardo da Vinci School, New York, 1924; Académie de la Grande Chaumière, Académie Colarossi, Paris, 1927.

Born in 1904 in Los Angeles to a Japanese father, poet Yonejiro Noguchi, and an American mother, writer Leonie Gilmour, Isamu Noguchi spent his childhood in Japan, returning to the United States in 1918. From 1922 to 1924 he was enrolled as a premedical student at Columbia University, and in 1924 he also began to study art at the Leonardo da Vinci School. Forsaking his medical studies in favor of art, Noguchi began as an academic sculptor, although he was a frequent visitor to avant-garde galleries in New York. An exhibition of Brancusi's work at the Brummer Gallery in 1926 was of particular importance in changing the direction of the young sculptor's work. The following year he was awarded a Guggenheim Fellowship that enabled him to go to Paris and work as Brancusi's studio assistant. He also attended evening drawing classes at the Académie de la Grande Chaumière and the Académie Colarossi. During his Paris sojourn, Noguchi made the acquaintance of Alexander Calder, Stuart Davis, Tsugouharu Foujita, and Jules Pascin.

Working with Brancusi, Noguchi responded to the master's distillation of the quintessential in nature and also developed a sensitivity to the properties of materials. However, the Rumanian sculptor's severe reductivism precluded his own involvement with more varied organic morphology, which the young American preferred. After producing a simple geometric sphere with one quarter section cut away from the marble, Noguchi began his experimentation in various metals. *Leda*, 1928 (cat. no. 107), was fabricated of sheet brass, cut and bent into an organic shape. The work's highly polished reflective surfaces are reminiscent of Brancusi's *Fish*, but its imagery seems derived from the biomorphism of Miró and Arp. In other metal abstractions produced in Paris, Noguchi used tension and gravity to construct his work of disparate elements. These innovative early sculptures were shown in his first one-artist exhibition at the Eugene Schoen Gallery in New York in 1928, a year after his return to America, but the work attracted no buyers. Turning to portraiture in terra-cotta and bronze in order to support himself, Noguchi achieved a degree of financial success with an exhibition the following year that enabled him to return to Paris and then travel to the Far East. After spending eight months in Peking studying calligraphic brush drawing with Chai Pai Shi, he traveled to Japan and worked with Uno Jinmatsu, a potter who made terra-cotta objects reminiscent of pre-Buddhist *haniwa* mortuary figures.

Noguchi's work after his return to New York in 1932—a period in which he experimented with clay and various metals —exemplifies his fusion of the *haniwa* tradition with Euro-

pean modernism. Some of his most innovative works of the thirties were unrealized designs for monuments or environmental works. *Play Mountain*, 1933 (cat. no. 108), for example, included in his 1935 exhibition at the Marie Harriman Gallery in New York, was a proposal for a communal playground in Manhattan. Conceiving of the project as an ideal environment for a child, Noguchi explained: "I want the child to discover something I created for him, and I want him to confront the earth as perhaps early man confronted it."[1] Noguchi's design was rejected by the New York City Parks Commission, but many of his environmental projects and playgrounds were realized in subsequent decades.

Although Noguchi was not active in any artists' groups during the thirties, like many of his contemporary artist friends during the grim Depression years he had leftist political leanings. His belief in art as a form of social protest continued into the forties. After his metal sculpture of a lynched black man was attacked by critics, he refused to show his work in galleries.

Noguchi worked briefly for the Public Works of Art Project, but his application to design gardens for the WPA Federal Art Project was rejected. Among the models he submitted was his *Play Mountain*, which was either too severely conceptual or too visionary for the taste of those in charge.

Noguchi therefore had to support himself by seeking private commissions and entering design competitions. In 1935 he designed the sets for Martha Graham's ballet *Frontier*, the first of many successful collaborations with the dancer. In 1935–36 he lived in Mexico City, where he created a seventy-two-foot-long high-relief polychrome wall mural representing the history of the Mexican Revolution. In 1938 he was commissioned to construct a fountain for the Ford building at the 1939 New York World's Fair.

During the forties Noguchi continued to produce many works in various mediums. He began to incorporate light bulbs into his magnesite reliefs and also returned to stone carving. *Noodle*, 1943–44 (cat. no. 109), is an example of his virtuosity in carving marble into smooth organic forms. The new imagery of the forties is related to Surrealism, and undoubtedly results from Noguchi's wartime experiences. In 1942 he voluntarily entered an internment camp for Japanese-Americans in Poston, Arizona. Within the same year he returned to New York, where he continues to live today.

Joan Marter

[1]Statement by Isamu Noguchi in Martin Friedman, *Noguchi's Imaginary Landscapes* (Minneapolis: Walker Art Center, 1978), p. 39.

CAT. NO. 108. ISAMU NOGUCHI
Play Mountain, 1933
Bronze
29¼ × 25¾ × 4½ in. (74.3 × 65.4 × 11.4 cm.)
The Isamu Noguchi Foundation, Inc.

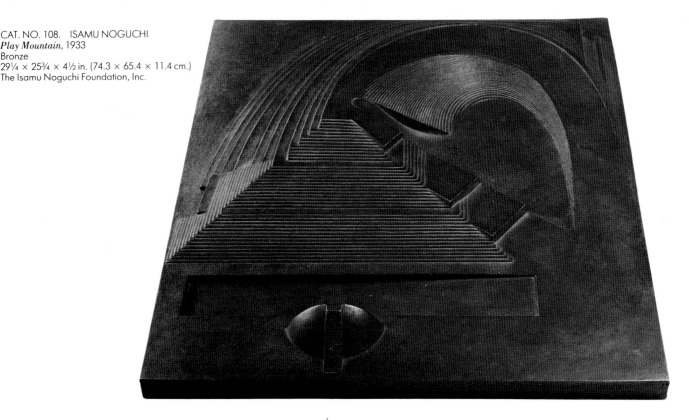

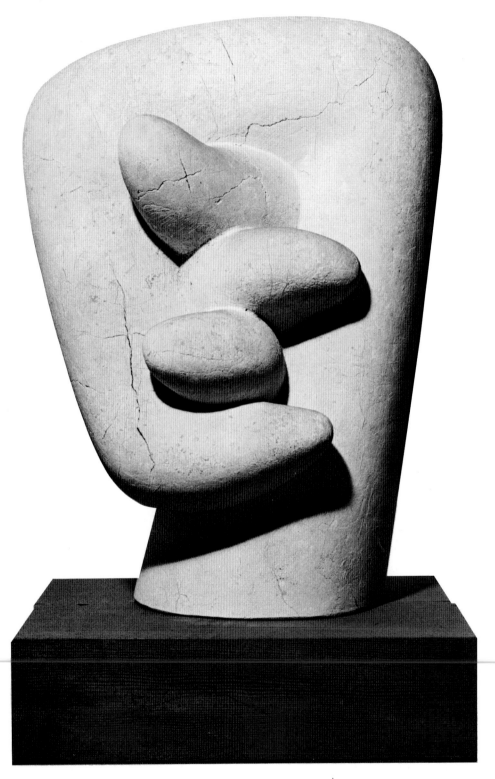

CAT. NO. 109. ISAMU NOGUCHI
Noodle, 1943–44
Marble
26¼ × 19½ × 12¼ in. (66.7 × 49.5 × 31.1 cm.)
Collection of the artist; in trust for Jody Spinden

204

IRENE RICE PEREIRA

Born 1907 in Boston, Massachusetts; died 1971 in Málaga, Spain. Studied at Art Students League, New York, 1927–30.

Irene Rice Pereira came into prominence in the thirties as an early advocate of rational and technologically based design. She used new forms of glass, metal, industrial plastics, and reflective substances to create panoramic images of a vast geometric universe seen only in the mind's eye. Hers was a visionary art fusing the technological and the transcendental, grounded in abstract geometry but aspiring toward an even more rarefied realm.

Born in Boston in 1907, Pereira had a difficult childhood beset by financial and family problems. The illness of her mother and the early death of her father made it impossible for her to continue her education. Self-supporting at an early age, she enrolled in night classes at New York University during the late twenties, then went to the Art Students League in 1927 to study with Jan Matulka. Throughout these years she worked as a designer during the daytime. Her marriage to Umberto Pereira in 1929 was not a happy or long-lasting relationship. Shortly after it ended, she took a trip to Europe and North Africa in search of broader experience and growth as an artist. Her work at this time was figurative and dealt with themes of man and machine technology.

In 1935 Pereira helped to found the WPA-sponsored Design Laboratory in New York, and she remained active in that organization until 1939. She began painting nonobjective canvases in 1937, producing work that was predominantly rectilinear and based upon design principles derived from the teachings of the Bauhaus. Deeply influenced by C. Howard Hinton's book, *The Fourth Dimension*, Pereira sought to work directly with light traveling through translucent planes, reflecting from metallic pigments and other shiny substances, like marble dust, that were ground into her pigments. A synthesis of twentieth-century art and science might be achieved, she felt, by the artist working with the materials and scientific principles of her day. Pereira wished to find visual imagery to deal with recent revolutionary discoveries in mathematics, physics, biochemistry, and radioactivity.

Pereira's art is frequently hard-edged and crystalline, with sharply defined horizontal and vertical lines and thickened pigment raised slightly from the surface of the canvas. She experimented with many ways of applying paint—scraping, spattering, carving with the blade of a knife—all of which gave her work a precise, taut, expressive edge. She also painted on glass, parchment, plastic, canvas, and Masonite and was perhaps most successful when placing planes of transparent materials in front of opaque ones, thereby creating a complex interwoven field of light and color.

Ascending Scale, an early work of 1937 (cat. no. 110), flirts

with biomorphic form and has something of the tightly constructed overlapping planes of Synthetic Cubism. Yet its delicate horizontal and vertical linear framework has a strength of its own which projects forward, freeing itself from the heavier planes that threaten to tie it to the background. Pereira's focus upon light and translucent industrial materials put her in touch with László Moholy-Nagy, who was briefly involved with the WPA Design Laboratory before founding his own New Bauhaus in Chicago in 1937.

A prolific writer, Pereira published several volumes of her essays and drawings, including *The Nature of Space* (1956), *The Lapis* (1957), and *The Transcendental Formal Logic of the Infinite* (1966). Her work was the subject of retrospective exhibitions at The Museum of Modern Art in 1946 and the Whitney Museum of American Art in 1953. In recent years her work has frequently been shown at the André Zarre Gallery in New York.

Susan C. Larsen

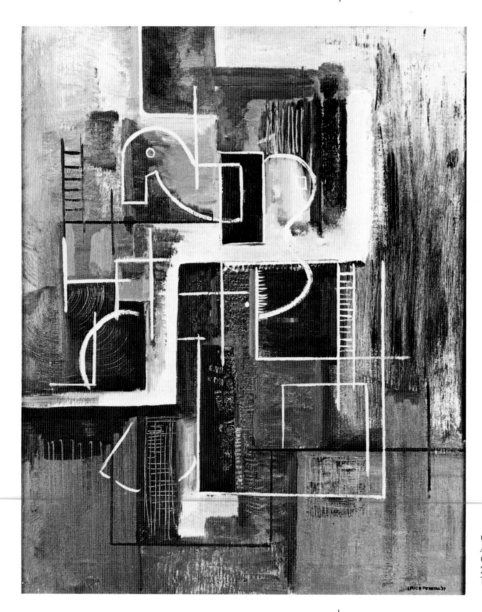

CAT. NO. 110. IRENE RICE PEREIRA
Ascending Scale, 1937
Oil on canvas
27 × 22 in. (68.6 × 55.9 cm.)
The Lowe Art Museum, The University of Miami,
 Coral Gables; Gift of John V. Christie

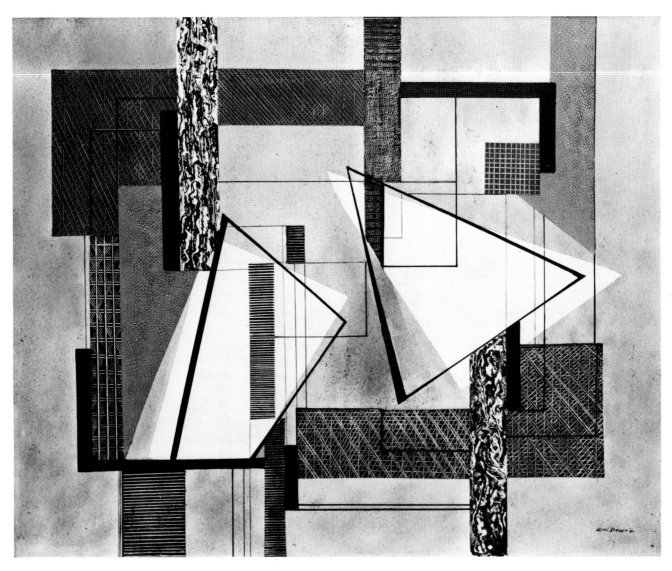

CAT. NO. 111. IRENE RICE PEREIRA
Abstraction, 1940
Oil on canvas
30 × 38 in. (76.2 × 96.5 cm.)
Honolulu Academy of Arts; Gift of Philip E. Spalding, 1949

AD REINHARDT

Born 1913 in Buffalo, New York; died 1967 in New York City.
Studied at Columbia University, 1931–35; National Academy
of Design, New York, 1936; American Artists' School, New
York, 1936; Institute of Fine Arts, New York University,
1943–52.

Adolph Frederick Reinhardt described his birth as having taken place nine months after the close of the Armory Show in New York, on the eve of Europe's entry into World War I, and during the year in which Malevich painted the first geometric-abstract painting. He was the elder of two sons of immigrant Americans. His Russian-born father and German-born mother were ardent unionists, and their son's razor-sharp political sense originated in his father's lifelong activity as a Socialist and labor organizer.

As a student at Columbia University, Reinhardt initially studied literature and associated mostly with writers, but he soon turned to courses in art history and aesthetics. However, he maintained his interest in writing and subsequently produced some of the most notable prose by a painter in the twentieth century. Columbia art-history professor Meyer Schapiro directed Reinhardt's abundant energies into what was then considered radical campus politics: he fought to abolish fraternities and produced controversial cartoons on this and other university issues. Reinhardt became the editor of *Jester*, the campus humor publication, designing its covers in a flattened Cubist style and reveling in imaginative layouts.

Although Reinhardt's decision to be an artist was encouraged by his years at Columbia, the university offered little practical instruction. After graduating—and eschewing the Art Students League—he studied painting with Karl Anderson and John Martin at the National Academy of Design. In 1936 he also took private classes at the American Artists' School with Francis Criss, who stressed an asymmetrical geometry in his depictions of the city, and with Carl Holty, whose art at that time flattened and separated the figure into complex, sweeping geometric shapes of solid color. At Criss's and Holty's small school on Fourteenth Street, Reinhardt was one of a small band of artists offering alternatives to the dominance of Social Realism. In 1937 he joined the newly formed American Abstract Artists group, and subsequently he became affiliated with the Artists' Union and the American Artists' Congress, thereby allying himself with the three major avant-garde American artistic-political organizations of the late thirties. Stuart Davis, also a member of the Artists' Union and the American Artists' Congress, was a neighbor of Reinhardt's and became a quasi-mentor to the younger artist.

From 1936 to 1941, Reinhardt's financial support was derived from the WPA Federal Art Project. On the recommendation of his AAA colleague Burgoyne Diller, he was employed in the Easel Division. Numerous paintings resulted, several of which are extant. Reinhardt seems to have attained a kind of immediate artistic maturity. In the late thir-

ties his art consisted of solid-toned linear, interlocking geometric forms, as in *Number 30*, 1938 (cat. no. 113). Using the formal vocabulary of late thirties American geometric nonobjectivity, Reinhardt forged a distinctively vivid, spatially flat, and asymmetrically balanced style. While the foundation of his art was collage, through the early forties organic and gestural markings gradually replaced precise and hard-edged shapes. As the decade progressed, embellished linear activity increasingly marked the paintings and drawings. His work assumed a character related to that of the budding Abstract Expressionists.

Between 1941, when his WPA work came to an end, and 1947, when he commenced teaching art history at Brooklyn College, Reinhardt ran the gamut of commercial and industrial jobs (including among his employers the innovative industrial designer Russel Wright) and free-lance graphic work. From 1942 to 1947 he was an artist-reporter for the short-lived, leftist-oriented New York newspaper *PM*, for which he produced many of his most trenchant cut-and-pasted cartoon collages. Recognition for his art began in the mid-forties. His earliest one-artist exhibitions took place in 1943 (Teachers College Gallery, Columbia University) and 1944 (Artists Gallery, New York), and thereafter he was affiliated with the Betty Parsons Gallery.

Reinhardt's age and the artistic affinities of his work of the forties allied him for a time with the Abstract Expressionists. But though they evolved together, Reinhardt reached a completely contrary conclusion. The biomorphism, emotionalism, and cult of individuality favored by the Abstract Expressionists were abhorred by Reinhardt. His connections with the New York School painters dissolved in the fifties when he began to produce single-color, symmetrical geometric paintings—radical simplifications founded upon his pioneering geometric abstractions of the late thirties.

Patterson Sims

CAT. NO. 114. AD REINHARDT
Red and Blue Composition, 1939–41
Oil on Celotex
23½ × 29¼ in. (59.7 × 74.3 cm.)
Collection of Dr. and Mrs. Phillip Frost

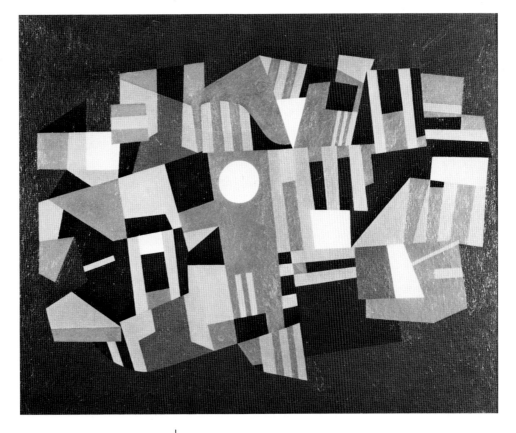

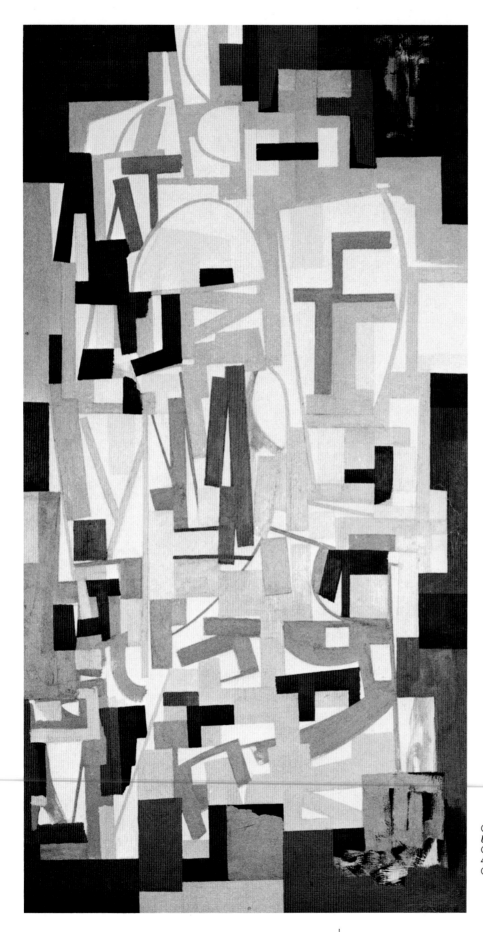

CAT. NO. 116. AD REINHARDT
Untitled, 1940
Oil on Masonite
47 × 25 in. (119.4 × 61 cm.)
Collection of Dr. and Mrs. Phillip Frost

THEODORE ROSZAK

Born 1907 in Poznan, Poland; died 1981 in New York City. Arrived in the United States in 1909; became U.S. citizen in 1919. Studied at Art Institute of Chicago, 1922–26, 1927–29; National Academy of Design, New York, 1926.

When he was two years old, Theodore Roszak's family settled in Chicago, where he attended public schools. Having taken evening classes in painting at The Art Institute of Chicago until his graduation from high school, he enrolled there as a full-time day student in 1925. The following year he went to New York and briefly studied painting with Charles Hawthorne at the National Academy of Design before beginning private instruction with George Luks. He also attended classes in logic and philosophy at Columbia University. Returning to Chicago in 1927, he resumed the study of painting and lithography at the Art Institute. Roszak's first one-artist exhibition of lithographs was held at the Allerton Gallery, Chicago, in 1928; he also began at this time to teach drawing and lithography at the Art Institute.

Roszak's first awareness of abstract painting and Constructivist trends in sculpture occurred in 1929 when a fellowship gave him the opportunity to study in Europe for two years. Most of his time was spent in Czechoslovakia, but he also visited other countries, and in Paris was introduced to the works of Picasso, Miró, and de Chirico. The latter's Metaphysical paintings had the most immediate impact on his work. While in Czechoslovakia, Roszak learned of new developments in architecture and was introduced to the concept of the artist as a potential molder of industrialized society. Although he did not visit the Bauhaus, his contacts with Czech Constructivists made him aware of the school's utopian ideology. Before returning to the United States in 1931, he purchased a copy of the first English edition of László Moholy-Nagy's *The New Vision*, a book that was to have a profound impact on the first generation of American Constructivists.[1]

After settling in New York, Roszak continued his painting, which during this period reflected the influence of artists discovered during his years abroad. He was included in the first Biennial of the Whitney Museum of American Art in 1932. Roszak also began his experimentation with sculpture in plaster and clay, but quickly lost interest in this method and turned to direct metal construction, taking courses in tool-making and designing. In 1934 he set up his own shop.

Among his early three-dimensional works is *Large Rectilinear Space Construction*, 1932 (cat. no. 118). An asymmetrical composition of intersecting planes and linear elements, this sculpture is evidence of his technical mastery of various metals and his growing interest in the machine aesthetics of the Bauhaus. Freestanding objects of metal were followed by brightly painted wall reliefs that were fabricated through his skillful use of both hand and power tools.

Roszak's early constructions exemplify his exploration of

diverse approaches to the use of machines, both as technical devices and as sources for new imagery. Later the sculptor recalled that for him "the machine was a tool, not an ideological entity." In the fabrication of his work, the machine was the "handmaiden" for the creation of ideal or fantastic forms.[2]

Airport Structure, 1932 (cat. no. 117), marks a transition

CAT. NO. 118. THEODORE ROSZAK
Large Rectilinear Space Construction, 1932
Bronze, copper, and plastic
23 × 10¼ × 10 in. (58.4 × 26 × 25.4 cm.)
Private Collection

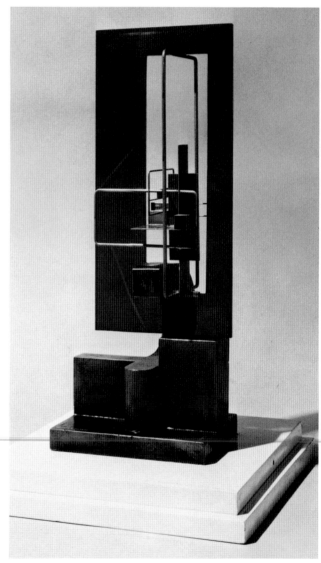

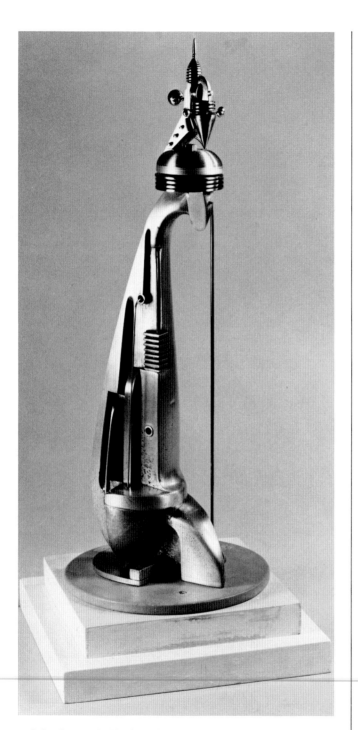

CAT. NO. 117. THEODORE ROSZAK
Airport Structure, 1932
Copper, aluminum, steel, and brass
23 in. (58.4 cm.)
The Newark Museum; The Members Fund Purchase 1977

from his earlier anthropomorphic forms in bronze and attests to Roszak's fascination with the turbines and aviation instruments that were a part of the mechanical age. (Later, during World War II, Roszak taught aircraft mechanics and built airplanes at Brewster Aircraft Corporation.) Not only are such works undeniably machine-made, but they have the appearance of industrial forms that could actually function. The majority of Roszak's painted constructions date from 1936 to 1945. The serious, machine-derived Constructivist approach of the earlier works was modified by a playful spirit that is to be found in *Trajectories*, 1938 (cat. no. 119), and *Ascension*, 1939 (cat. no. 120). In some of these works Roszak seems stimulated by the fantastic forms of Miró and Arp, but *Trajectories* combines a Schlemmer-inspired abstraction of a human head with the suggestion of orbiting planetary bodies or atomic particles. *Trajectories* may allude to celestial mechanics, phenomena also found in the constructions of Alexander Calder during these years, or the wooden spheres attached to wires may also relate to contemporary diagrams of atoms. Roszak's suggestion of erratic orbital paths may be connected with Werner Heisenberg's "uncertainty principle," expounded in 1927. The scientist theorized that it was impossible to know simultaneously the momentum and position of an electron with sufficient precision to draw a picture of this element in a particular energy level. The sculptor may be referring to this principle in his presentation of small wooden spheres in no fixed "orbit" around a larger sphere.

Ascension exemplifies Roszak's lifelong interest in aviation, which he shared with many other artists of the thirties, including José de Rivera, Arshile Gorky, and J. Wallace Kelly. As a reader of science fiction, Roszak was undoubtedly aware of illustrations and descriptions of interplanetary vessels and space stations. *Ascension* is one of a series of vertical painted constructions that has been described as "crazy rockets about to be launched into space."[3] In 1939, Roszak also collaborated with Norman Bel Geddes on the Futurama diorama at the General Motors pavilion at the New York World's Fair.

The major event of the previous year for Roszak had been his first meeting with Moholy-Nagy and his appointment as instructor in composition and design at the Design Laboratory in New York, a school founded by Moholy-Nagy and dedicated to the perpetuation of the principles and methods of the Bauhaus. *Watchtower*, ca. 1939–40 (cat. no. 121), represents an attempt to monumentalize his earlier constructions and appears to be a model for a larger public sculpture.

In any consideration of the thirties, Roszak is significant as the first American artist to assimilate the machine aesthetics of the Bauhaus and to create a coherent body of work based on the Constructivist ideology. By the mid-forties, his Con-

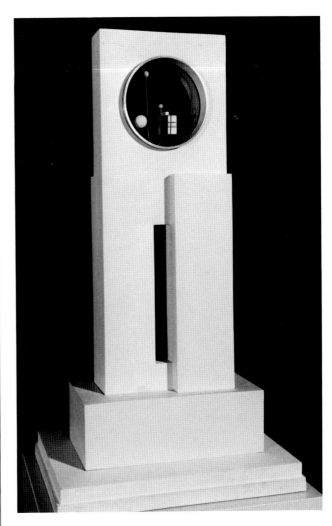

CAT. NO. 121. THEODORE ROSZAK
Watchtower, ca. 1939–40
Wood, plastic, metal, and paint
23 1/16 × 10 3/8 × 5 1/4 in. (58.6 × 26.3 × 13.3 cm.)
Museum of Art, Carnegie Institute, Pittsburgh; Fine Arts Discretionary
 Fund, 1982

structivist approach was replaced by organic, more expressionistic forms welded in steel or created in brazed alloys.

Roszak taught at Sarah Lawrence College from 1940 to 1956 and at Columbia University from 1970 to 1972.

Joan Marter

[1] For more information on the influence of Moholy-Nagy's *The New Vision* on American artists, see Joan Marter, "Constructivism in America: The 1930s." *Arts* 56 (June 1982): 73–80.
[2] Theodore Roszak, interview with Joan Marter, New York, 24 January 1979. See also Joan Marter, "Theodore Roszak's Early Constructions: The Machine as Creator of Fantastic and Ideal Forms." *Arts* 54 (November 1979): 110–13.
[3] Hilton Kramer, "Roszak Evokes Spirit of Bauhaus," *New York Times*, 1 December 1978.

ROLPH SCARLETT

Born 1889 in Guelph, Ontario, Canada. Worked in New York City as apprentice jeweler, 1907–14. Settled permanently in the United States in 1918; subsequently became U.S. citizen. No formal art training.

Lessons in painting taught him by his grandmother and at secondary school as a child were the extent of Rolph Scarlett's formal art training. His family was in the jewelry business, however, and as an apprentice he learned to evaluate precious and semiprecious stones and to design and execute settings for them. It was for further training in this exacting craft that Scarlett first came to the United States in 1907 to work in New York City. In 1914, at the beginning of World War I, he returned to Canada, where he remained until moving permanently to the United States in 1918. Scarlett subsequently worked in other areas of commercial design while continuing to paint as an avocation. A trip to Europe in 1923 left him with vivid memories of Klee's paintings, references to which appear in Scarlett's work of the thirties and forties. After 1939, he devoted himself to painting, although he has continued to design jewelry throughout his life.

Before settling in New York in 1936, Scarlett worked as a designer in New York, Toledo, and southern California, where for nearly a decade he designed sets for the Pasadena Playhouse and for the movies. Shortly after his return to New York in 1936, he learned of the collection of nonobjective art being formed by Solomon and Irene Guggenheim under the guidance of Hilla Rebay. Scarlett sent work to Rebay and attended her criticism sessions, and she in turn considered him one of her strongest discoveries. Between 1939 and 1952, she purchased many of his paintings, watercolors, and drawings for the Solomon R. Guggenheim Foundation.

In a letter to Rebay dated April 3, 1939, Scarlett wrote that *Composition*, 1938–39 (cat. no. 122), was his "best work to date," adding that it expressed his "understanding of the nonobjective ideal," which had been expanded under Rebay's guidance. By then, he would have seen the Guggenheims' collection installed in their suite in the Plaza Hotel, with fine paintings by Kandinsky, Klee, Moholy-Nagy, and Rudolf Bauer. In August 1939 Bauer arrived in New York from Germany with nearly all of his life's work, much of it already acquired by Guggenheim. Scarlett believed that in Bauer he had discovered a mentor. Though neither artist consistently painted hard-edged forms, that aspect of Bauer's painting was the one Scarlett most admired, finding the circle, square, triangle, rectangle, and segment the five elemental shapes from which a nonobjective painting can be made. Like Bauer (fig. 21), Scarlett traced these shapes from stencils, blocks, tin cans, and other machine-made objects. With Rebay, Scarlett would say that these shapes represent cosmic order.

Reminiscences of both Klee and Bauer may be noted in *Composition*. At the same time, it reveals Scarlett's personal strengths, particularly his sensitivity to color, which lends a

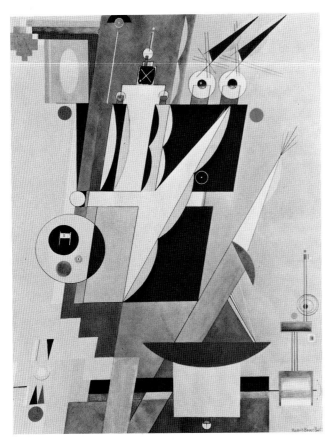

FIG. 21. RUDOLF BAUER
Great Fugue, 1929
Watercolor, tempera, and India ink
17¼ × 12½ in. (43.8 × 31.8 cm.)
The Solomon R. Guggenheim Museum, New York

were over nomenclature, a far deeper issue related to fundamental beliefs, and this issue, still controversial, deserves consideration. To Rebay (and a considerable number of her contemporaries), art was the expression of man's spiritual nature, and a truly creative artist did not repeat forms already existing; however, with the guidance of a higher power (which she at times specifically named "God"), one could create new forms united by a rhythm expressing cosmic forces.

Scarlett can be fairly defined as one of the key interpreters of the position of the Museum of Non-objective Painting. In addition to having his work included in numerous exhibitions throughout the forties, he was the museum's chief lecturer for five years of that decade. Scarlett now lives in Woodstock, New York. The most recent exhibition of his work took place in 1982 at the Washburn Gallery in New York.

Joan M. Lukach

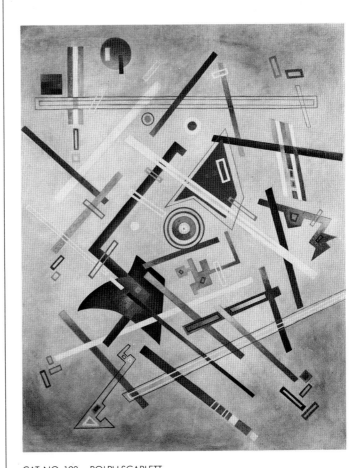

CAT. NO. 123. ROLPH SCARLETT
Untitled, ca. 1940–44
Oil on canvas
38 × 32 in. (96.5 × 81.3 cm.)
Zabriskie Gallery, New York

sensuality quite lacking in Bauer's work. Scarlett also sought a three-dimensional effect, as in certain of the round forms that are like mysteriously glowing, floating spheres rather than flat circles. Moreover, all the elements appear to be suspended in an undefined deep space; this sensation of vastness grows in Scarlett's subsequent paintings.

Scarlett has warmly recalled Solomon Guggenheim's enthusiasm for the art he patronized. The artist's relationship with Hilla Rebay, the gifted but volatile woman who had originally envisioned the museum, was sympathetic. Like Guggenheim, he shared Rebay's beliefs about the nature of this art, which she, along with others of her generation, had derived from oriental and Near Eastern mystical religions. Like Rebay, Scarlett preferred to call his painting "nonobjective" rather than "abstract," explaining that the forms were not abstracted from anything. But if the liveliest arguments

215

JOHN SENNHAUSER

Born 1907 in Rorschach, Switzerland; died 1978 in Escondido, California. Arrived in the United States in 1928; became U.S. citizen in 1930. Studied at Royal Academy of Venice, Italy, 1926–27; Cooper Union Art School, New York, 1930–33.

John Sennhauser came to the United States from Switzerland in 1928 at the age of twenty-one, well schooled in the medieval and Renaissance art of Europe, especially that of Italy. He had just spent two years at the Royal Academy in Venice, and his first paintings done in America are romantic visions of the street life of urban New York City. Sennhauser saw the city in a mythological and playful context at variance with the pragmatic realities he was to confront as a young artist living in New York during the early years of the Depression. From 1930 to 1933, while he was a student at the Cooper Union Art School, his work changed radically as he explored pure geometric form. Sennhauser taught at the Leonardo da Vinci School in New York from 1936 to 1939 and at the Contemporary Art School from 1939 to 1942.

An important chapter in Sennhauser's career began in 1943 when he joined the staff of the Museum of Non-objective Painting as a lecturer and preparator. His own work had much in common with the outlook, collection, and program of the museum, and Sennhauser appreciated the support of its director, Hilla Rebay, as well as his relationships with other staff members, especially Jean Xceron.

While working at the museum, Sennhauser acquired a small quantity of parchment donated to members of the staff to encourage their exploration of unusual materials. Sennhauser's *Lyrical No. 7*, 1942 (cat. no. 124), was painted on parchment, which contributes to the work's remarkable depth of color and the effect of recessed space. Within a blue-black field, trajectories of brightly colored forms shoot through space as though on fire with luminous energy. The painting is one of many of his works that reflect the strong influence of Kandinsky's late work, which Sennhauser knew intimately as a museum staff member. However, Sennhauser's style has a special lightness of touch, a desire for vast areas of open space, and a precision that uniquely characterize his art of this period. A more grand and complex space is described in *Lines and Planes No. 1*, 1944 (cat. no. 125). Color plays a major role in this work, once again glowing and luminous but seen in the light of day, as large ribbons of matter and bold arcs of color hover in a sunlit field.

Sennhauser remained with the Museum of Non-objective Painting until 1945. That same year he joined the American Abstract Artists and participated in the group's annual exhibitions until the early seventies. He was also an active member of the Federation of Modern Painters and Sculptors. During the fifties Sennhauser was employed in New York as a restorer of antique papers and a designer of murals for the Goertler Studios, and from 1957 to 1973 he worked for C. R. Grace and Sons. A survey exhibition of Sennhauser's work of the thirties and forties was presented in 1980 by Martin Diamond Fine Arts in New York.

Susan C. Larsen

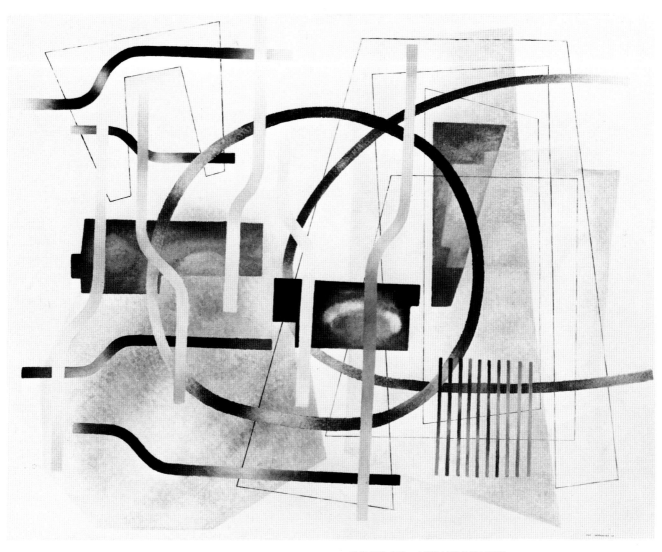

CAT. NO. 125. JOHN SENNHAUSER
Lines and Planes No. 1, 1944
Oil on canvas
35¾ × 45¾ in. (90.8 × 116.2 cm.)
Museum of Art, Carnegie Institute, Pittsburgh;
Mary Oliver Robinson Memorial Fund, 1982

CHARLES SHAW

Born 1892 in New York City; died 1974 in New York City.
Studied at Yale University; Columbia University School of
Architecture, and Art Students League.

Possessing a natural elegance that manifested itself in his love of art, society, and good living, Charles Green Shaw was one of the most interesting and flamboyant personalities involved in the arts during the thirties. Heir to a fortune based in part upon the Woolworth empire, he shared the privileged background of his long-time friends A. E. Gallatin and George L. K. Morris. Shaw attended Yale University and studied architecture at Columbia University before enrolling at the Art Students League, where he studied with Thomas Hart Benton. He also studied privately with George Luks.

Shaw's first success came in the twenties as a writer for such magazines as *The New Yorker*, *The Smart Set*, and *Vanity Fair*, chronicling the café society whose life he intimately knew and shared. While traveling in Europe, in pursuit of material for his articles, he often visited museums and galleries, where his path increasingly crossed that of Gallatin and Morris. Their serious involvement with art impressed Shaw and led to a gradual change in his outlook and lifestyle. While in Paris in 1929, he applied himself to the study of art and began to paint in a style notable for its clarity of form and unusual, almost architectural construction. Many of his paintings are actually constructed of separate planes of wood or Masonite, carefully joined at the seams so that three- and two-dimensional planes appear to slip over and under one another. These and other works reflect the influence of Arp, whose style Shaw reinterpreted into more geometric, regularized, and very beautiful forms possessing some of Arp's dynamism and humor, but little of his mystery.

In 1933 Shaw began a series of paintings titled the "Plastic Polygon." Exploring this theme for several years, he created a group of lively and original works that are the most significant within his oeuvre. *Plastic Polygon*, 1937 (cat. no. 126), one of the finest, most complete paintings of this series, is strongly architectural in character and was, in fact, inspired by the profile of the Manhattan skyline and the stepped-back style of building practiced in the thirties.

One of the most interesting aspects of Shaw's architectural series is his use of the shaped canvas—an exceptionally early use of this format in twentieth-century American art. Shaw felt that this series had a special affinity for the American urban and industrial landscape. "The polygon sprouting, so to speak, from the steel and concrete of New York City, I feel to be essentially American in its roots."[1]

Shaw's desire to incorporate three-dimensional elements in his painting is a goal he shared with Morris, Charles Biederman, John Ferren, and Alexander Calder. All of them sought to combine real and illusionary form—Ferren to carve out the painting's surface, Biederman to change his format

to the more three-dimensional realm of Constructivism, Morris to multiply an ever greater number of flat and illusionistically painted planes, and Calder to draw in space with wire and curved metal planes. Within the "Plastic Polygon" series, Shaw literally cut planes out of his painted wooden surfaces, then put them back again as the tightly fitting parts of an abstract configuration. *Polygon*, 1938 (cat. no. 127), and *Plastic Polygon*, 1939 (cat. no. 128), are two such compositions that also share the characteristic of repeated or rhymed shape observable in the art of Morris. Shaw was especially fond of circles, using this elemental geometric shape for its multiplicity of connotations.

Shaw had his first one-artist exhibition at the Curt Valentin Gallery in New York in 1934. Gallatin put together a show of Shaw's work at the Museum of Living Art in 1935, and in 1936 included him in an exhibition at the Paul Reinhardt Galleries, "Five Contemporary American Concretionists: Biederman, Calder, Ferren, Morris and Shaw."

Shaw joined the newly formed American Abstract Artists and participated in the group's first exhibition in April 1937.

CAT. NO. 127. CHARLES SHAW
Polygon, 1938
Painted wood relief
19½ × 22 × 3 in. (49.5 × 55.9 × 7.6 cm.)
Washburn Gallery, New York

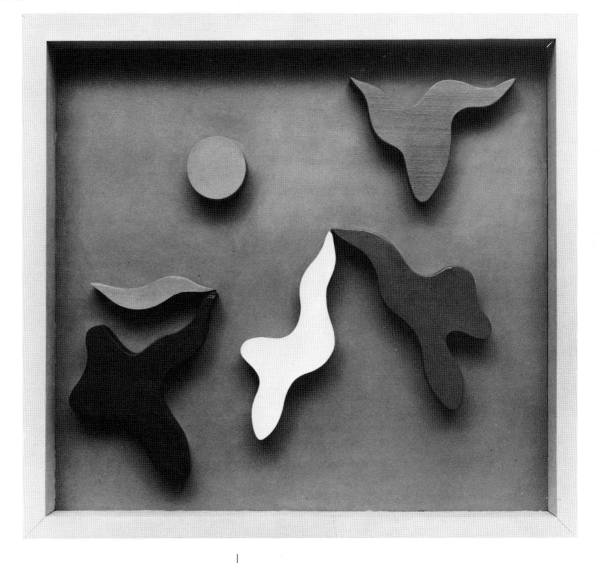

His friends Suzy Frelinghuysen, Gallatin, and Morris were also members of the group. Their involvement kept the four in touch with a cross section of the New York art community, even though their closest ties were to one another. They were sometimes called the "Park Avenue Cubists" by some of their more irreverent, and perhaps envious, contemporaries.

Shaw's style grew broader and more painterly during the late forties and into the fifties. His strongly graphic sensibility showed itself in his centered, boldly reductive compositions, many of which prefigure the holistic imagery used by such painters as Ellsworth Kelly and Kenneth Noland during the late fifties and early sixties. During the seventies, and in more recent years, several exhibitions of Shaw's work have been presented at the Washburn Gallery in New York.

Susan C. Larsen

[1]Charles G. Shaw, "The Plastic Polygon." *Plastique: Paris–New York* 3 (Spring 1938): 28.

CAT. NO. 128. CHARLES SHAW
Plastic Polygon, 1939
Painted wood
26½ × 17½ in. (67.3 × 44.5 cm.)
Collection of Dr. Peter B. Fischer

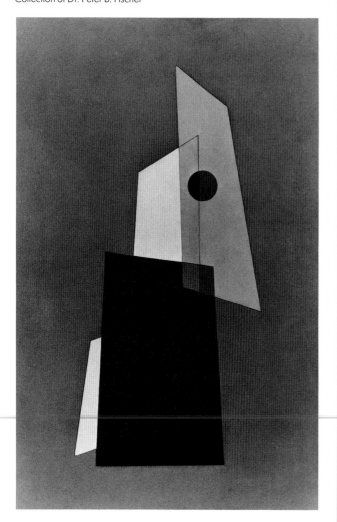

CAT. NO. 129. CHARLES SHAW
Top Flight #1, 1944
Oil on panel
50¼ × 32¾ in. (127.6 × 83.2 cm.)
Washburn Gallery, New York

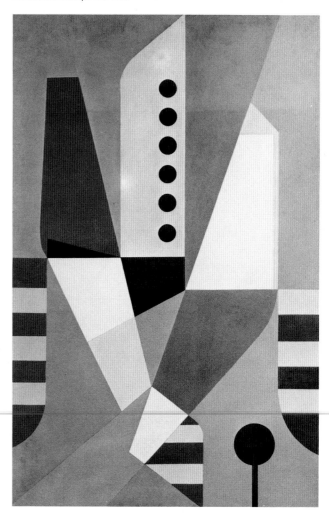

ESPHYR SLOBODKINA

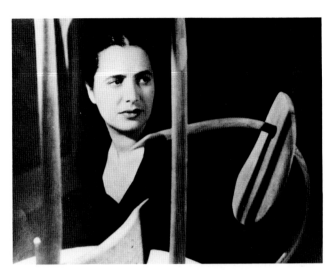

Born 1908 in Russian Siberia. Arrived in the United States in 1928; became U.S. citizen in 1933. Studied at National Academy of Design, New York, 1929–34.

The early life of Esphyr Slobodkina was one of displacement and rapid geographical and social change. Born in Siberia in 1908, she lived through the Russian Revolution and its aftermath. With her family, she fled Russia in 1922, traveling eastward on the Trans-Siberian Railroad to Vladivostok, then onward to Harbin, Manchuria, on the Russo-Chinese border. Her adolescent years were spent in Harbin, which offered a curious but stimulating mixture of Russian and Chinese language and customs. After several years in Harbin, the family left for the United States and settled permanently in New York City in 1928.

The following year Slobodkina enrolled at the National Academy of Design, where she studied for four years. She met and married Ilya Bolotowsky in 1933, and during the thirties the couple enjoyed a wide circle of acquaintance, being especially close to Alice T. Mason, Gertrude and Balcomb Greene, and Albert Swinden. Both Bolotowsky and Slobodkina worked for the WPA Federal Art Project, which she joined in 1936. She was also active in the Artists' Union as a member and organizer and joined the American Abstract Artists, participating in its first group exhibition at the Squibb Galleries in 1937.

During that same year, 1937, Slobodkina and Bolotowsky were separated, then divorced. She continued to develop her art along paths that were initially close to, then increasingly distinct from, the art of her former husband. Slobodkina's work began to mature about 1934 as she began to focus her attention on abstraction. A high-spirited, plain-speaking woman, she achieved a charming directness in her work. *Construction No. Three*, 1935 (cat. no. 130), is a typical early work, with plain and painted wooden shapes hinged to each other or attached to wires and floating in space. The loose spatial structure is a measure of her freedom from the Cubist grid; yet she was drawn to clear-cut shapes and definite contrasts of color, which place her work in the realm of geometry. Compared to other constructions of the period—for example, those of Gertrude Greene or Charles Shaw—Slobodkina's are more involved with found objects and contrasting textures, less firmly integrated, looser and freer in their structure.

By the forties, her work had deepened and matured. *Ancient Sea Song*, 1943 (cat. no. 131), nearly repeats several of the shapes present in her earlier constructions, but the entire work is now fluid and graceful. Especially fine is her palette of grays, red-browns, and tans, with cloudy tonal ranges in harmony with the theme of this painting.

Slobodkina has been an active member and officer of the American Abstract Artists for several decades; she is also a

founding member of the Federation of Modern Painters and Sculptors. While continuing her work as a painter, she pursued an active and successful career as an author and illustrator of children's books, many of which are considered classics. Since the late seventies, one-artist exhibitions of her work have been held at the Sid Deutsch Gallery in New York City. Slobodkina lives and works in Hallandale, Florida.

Susan C. Larsen

CAT. NO. 130. ESPHYR SLOBODKINA
Construction No. 3, 1935
Painted wood
12½ × 23½ in. (31.8 × 59.7 cm.)
Ertegun Collection Group

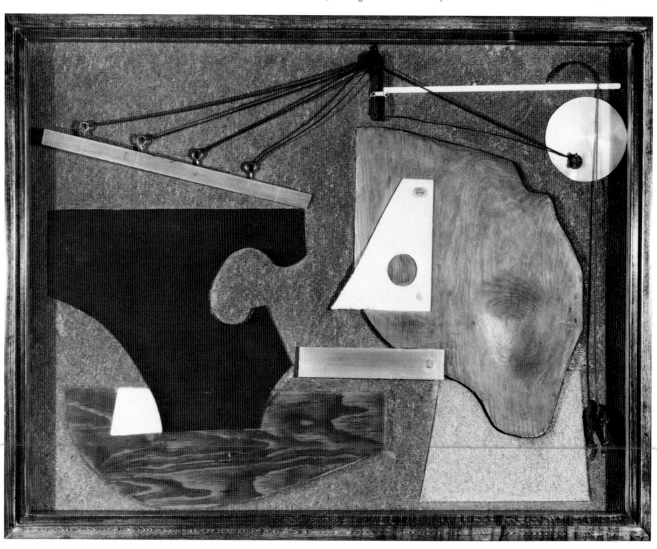

DAVID SMITH

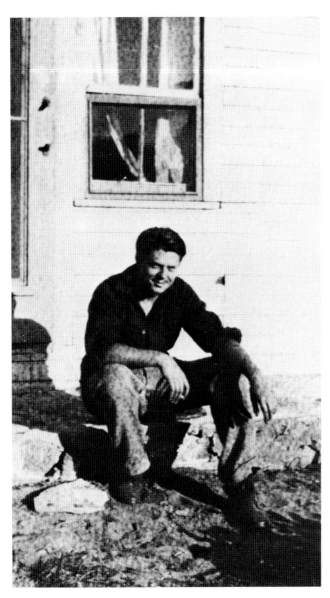

Born 1906 in Decatur, Indiana; died 1965 near Bennington, Vermont. Studied at Ohio University, 1924; briefly at Notre Dame University, 1925, and George Washington University, 1926; Art Students League, New York, 1927–32; privately with Jan Matulka, 1928–29.

David Roland Smith's formative art training and his first exposure to advanced modernist art began in 1926 when he arrived in New York and enrolled at the Art Students League on the advice of his future wife, Dorothy Dehner. His early friendships with artists, including Adolph Gottlieb, Milton Avery, and Jean Xceron, were reinforced by later participation in WPA art projects, and were sustained even after the Smiths moved to Bolton Landing, New York, in 1940. Probably the most significant friendship was with John Graham, who provided information about the newest European art, introduced the Smiths to African sculpture, and later guided them through Paris. It was also Graham who introduced them to Stuart Davis, Arshile Gorky, and Willem de Kooning.

Virtually untrained as a sculptor, with little direct experience of advanced sculpture, Smith liked to say he belonged with painters.[1] However, while a student of Jan Matulka's at the League, he began to turn his paintings into reliefs and eventually into three-dimensional constructions. When Graham showed him reproductions of welded metal sculptures by Picasso and Julio González in *Cahiers d'Art*, Smith realized that the skills he had acquired in an Indiana Studebaker factory could be used to make art, and in 1933 he made his first welded sculptures. Throughout his life he continued to paint and especially to draw as a way of generating and working out ideas, but by the mid-thirties he was devoting himself more and more exclusively to sculpture, working at Terminal Iron Works in Brooklyn, alongside commercial welders who sometimes offered technical advice and materials.

Smith's early work ranges restlessly from relief plaques to cast bronze and aluminum pieces, to steel and iron constructions often incorporating found objects. A single sculpture may include several materials differentiated not only by their inherent properties but by varied patinas and polychromy. The works are uniformly small and explore a wide spectrum of formal concerns, from figurative expressionist images and swelling organic forms cast in bronze or iron to attenuated constructions in sheet and rod.

Like most of his contemporaries, Smith sought direction from the European avant-garde rather than from pioneer American modernists. He claimed that his technical liberation came from González, and his aesthetics from Kandinsky, Mondrian, and Cubism,[2] and he was clearly indebted to Picasso, Giacometti, Gargallo, and Miró, but his notebooks testify to unlikely sources ranging from *Life* magazine photographs to fossil fish, African carvings to Egyptian tomb fur-

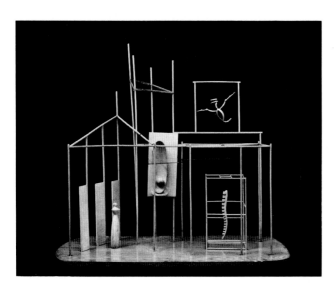

FIG. 22. ALBERTO GIACOMETTI
The Palace at 4 A.M., 1932–33
Construction in wood, glass, wire, and string
25 × 28¼ × 15¾ in. (63.5 × 71.8 × 40 cm.)
The Museum of Modern Art, New York

Smith's notion of collage substitutes assembly of perceptions for the traditional assembly of disparate parts. It is not the multiple views of a single object typical of Cubist painting, but a conflation of a wealth of pictorial elements into a single structure. The drawings (fig. 23) for *Billiard Player Construction*, 1937 (cat. no. 134), forced a great many forms from the billiard hall into a new relationship that owed little to their original scale or disposition in space.[4] This amalgamating vision is a painter's habit, a way of organizing the random visible world onto the two-dimensional canvas. Smith's sculptures bring discontinuous things into unexpected proximity by dispersing them in apparently illogical ways or by compressing them into a single plane.

Smith's imagery, too, is similarly compressed; suggestive, nonspecific forms reverberate with layers of allusions, like the portmanteau words of James Joyce's novels.[5] The phallusgun and a bird-fish-fetus form recur often, in various guises. Dorothy Dehner has suggested that this kind of allusive abstraction allowed Smith to make use of intimate emotions without revealing himself fully.[6]

Smith's sculpture became increasingly inventive and ambitious during the forties. It also became decreasingly specific, without losing the sense of highly charged persona that had characterized even his earliest work. By about 1950, it shifted dramatically in scale and, at the same time, appeared far

FIG. 23. DAVID SMITH
Study for Billiard Player, ca. 1935
Pencil and black ink on handmade rice paper
17⅛ × 22¼ in. (43.5 × 56.5 cm.)
Courtesy of Estate of David Smith

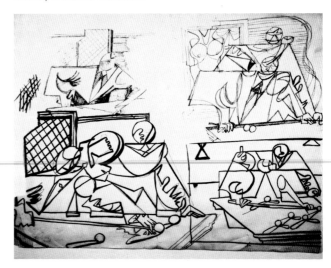

nishings. Yet whatever his relationship to his sources, Smith's work of the thirties and forties bears the mark of his unique inventiveness more than the traces of his chosen ancestors.

Smith's individuality is obvious in a comparison of one of his many "hermetic enclosure" pieces, *Interior for Exterior*, 1939 (cat. no. 135), with the work from which it is derived: Giacometti's *The Palace at 4 A.M.*, 1932–33 (fig. 22). Smith saw the actual Giacometti, so the differences between the two works must be acknowledged as deliberate choices.[3]

The Giacometti is a fragile, precariously constructed skeletal building, populated by mysterious forms utterly different from their surroundings, suggestive of impermanence and imminent collapse. Smith appropriated Giacometti's conception, but translated it into his own robust vocabulary, replacing European refinement with ad hoc transformations: witness the "flying pliers," which parodies Giacometti's frail bird. The magic toy building becomes a rigid metal cage; light, swung forms become cast and forged masses.

Even Smith's first welded sculptures are surprisingly independent of their Cubist ancestors. His use of found objects in *Sawhead*, 1933 (cat. no. 132), differs radically from Cubist prototypes. The "real" elements of Picasso's constructions and collages were evidence of alien actuality in the invented world of Cubist planes. Smith's shears and saw blade are subsumed by the hieratic personage they suggest.

more abstract than what had come before. Because of this, Smith's sculpture after 1951 can be seen as belonging to another phase of his evolution, yet there are characteristic images and formal concerns that can be traced throughout his career. His early work, in addition to its high quality, provides extraordinary insight into his preoccupations.

Karen Wilkin

[1]David Smith, interview with David Sylvester of the British Broadcasting Corporation, 16 June 1961. Published in *Living Arts*, April 1964. Reprinted in Garnett McCoy, ed., *David Smith* (New York and Washington: Praeger, 1973), p. 174.
[2]"The New Sculpture." Speech given by David Smith at a symposium of that title at The Museum of Modern Art, New York, 21 February 1952. Reprinted, McCoy, p. 82.
[3]*The Palace at 4 A.M.* was reproduced by Christian Zervos, "Quelques notes sur les sculptures de Giacometti," *Cahiers d'Art* 7 (1932): 337–42. It was included in the 1936 Museum of Modern Art exhibition "Fantastic Art, Dada and Surrealism."
[4]The odd pierced shape in the lower part of the sculpture, rather like the stylized f-hole on a Cubist violin, resolves itself with the help of the drawings as billiard balls and/or a player's hand, disembodied, flattened, and turned into a negative arabesque. Similarly, the pierced "heads" of the upright plane cannot be assigned any particular place in space, but from the other side of the sculpture a peculiar arrangement of horizontal bands seems to delineate two figures—an impression reinforced by an astonishing painted passage that continues, on a flat plane, the open shapes above, implying even greater spatial ambiguity between near and far forms than is apparent from the "front."
[5]Smith admired Joyce's work and, in several interviews, spoke of his identification with Joyce and Joycean characters. See McCoy, *Smith*, p. 180.
[6]Dorothy Dehner, conversation with Karen Wilkin, spring 1978.

CAT. NO. 133. DAVID SMITH
Aerial Construction, 1936
Painted and welded iron
10 × 30⅞ × 11½ in. (25.4 × 78.4 × 29.2 cm.)
Hirshhorn Museum and Sculpture Garden,
 Smithsonian Institution, Washington

CAT. NO. 132. DAVID SMITH
Sawhead, 1933
Painted iron
18½ × 12 × 8¼ in. (47 × 30.5 × 21 cm.)
Estate of David Smith. Courtesy of M. Knoedler and Co., Inc., New York

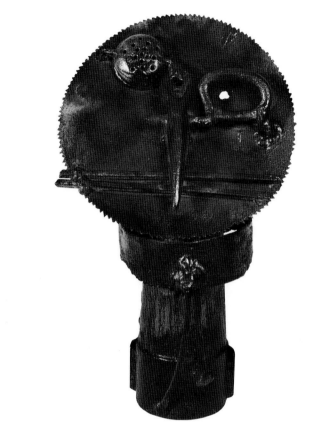

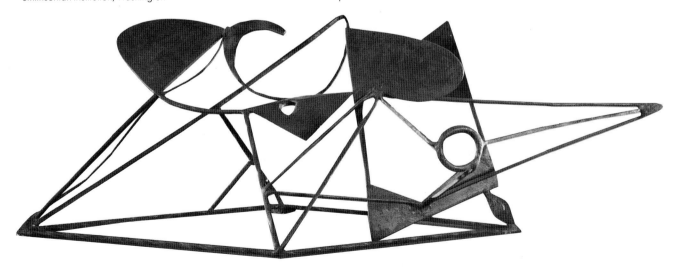

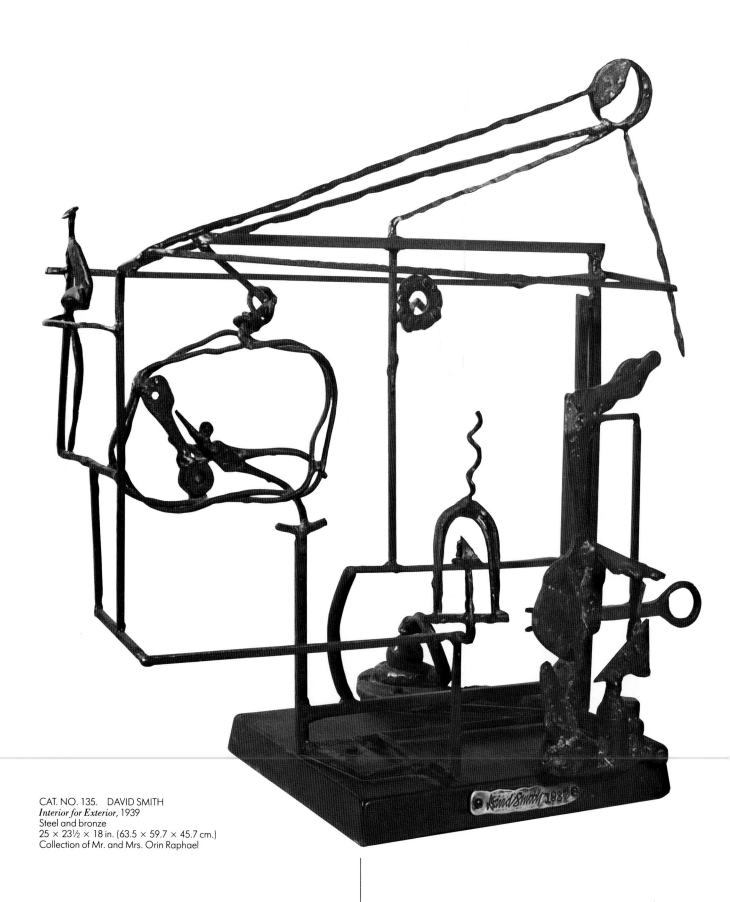

CAT. NO. 135. DAVID SMITH
Interior for Exterior, 1939
Steel and bronze
25 × 23½ × 18 in. (63.5 × 59.7 × 45.7 cm.)
Collection of Mr. and Mrs. Orin Raphael

JOHN STORRS

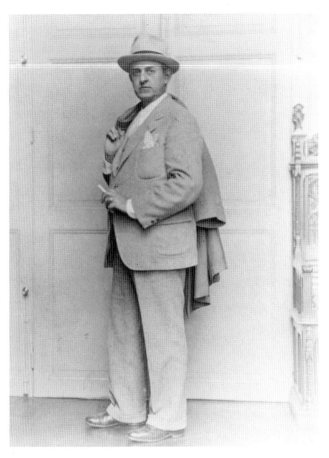

Born 1885 in Chicago; died 1956 in Mer, France. Studied with Arthur Bock, Germany, and Académie Julian, Paris, 1906; Académie Franklin, 1907; Chicago Academy of Fine Arts and School of The Art Institute of Chicago, 1908–9; School of the Museum of Fine Arts, Boston, with Bela Pratt, 1909–10; Pennsylvania Academy of the Fine Arts, with Thomas Anshutz and Charles Grafly, 1910–11; Académie Colarossi, Paris, with Paul Bartlett and Jean-Antoine Injalbert, and Académie de la Grande Chaumière, Paris, 1911–12; with Auguste Rodin, 1912 or 1913–14; Académie Julian, Paris, 1919.

A member of an old and prominent New England family, John Henry Bradley Storrs was born in Chicago, where his architect father, David W. Storrs, was a successful real estate developer. Always musical, Storrs went to Berlin in 1905 to study voice, but by the following year had become the pupil of the sculptor Arthur Bock in Hamburg. Bock immediately recognized Storrs's talent and wanted him to study at the Berlin Academy, but the young man opted instead to study in Paris, and by 1911 he had settled in the French capital. His studies with Rodin led to exhibitions of his sculpture in the 1913 Salon d'Automne, the 1914 Salon des Beaux-Arts, and the 1915 Panama-Pacific International Exposition in San Francisco. In 1914 he married Marguerite Deville Chabrol, a French author, and subsequently purchased the Château de Chantecaille in Mer, near Orléans.

Stimulated by Cubism, Futurism, and Vorticism, Storrs had his first one-artist exhibition of sculpture and wood engravings at the Folsom Galleries in New York in 1920. By then, he had already created advanced abstract sculpture. His work was exhibited by the Société Anonyme in 1923 and was included in the Société Anonyme's "International Exhibition of Modern Art" at The Brooklyn Museum in 1926.

Beginning in the late twenties, it became necessary for Storrs to commute between France and America. By the terms of his father's will, which he unsuccessfully contested, he could not establish permanent residence outside the United States and was required to spend at least six months of each year in America. Back in Chicago in 1931, Storrs began to paint seriously while simultaneously creating figurative and abstract sculpture.

The works for which Storrs is perhaps best known are his simple, pure columnar forms in stone and metal. Created during the twenties, these architectonic works were intimately connected with the development of the Art Deco movement and sometimes resemble skyscrapers or clusters of buildings.

In the late twenties and early thirties Storrs was involved in commissioned works, including a monumental stone figure of Christ for the facade of Christ King Church in Cork, Ireland; reliefs for the monument to the U.S. Navy at Brest, France; and a thirty-foot-high chromed aluminum statue of Ceres, goddess of grain, for the Board of Trade building in Chicago. By 1931, Storrs had been approached to create sculpture for the Chicago World's Fair of 1933. While waiting for fair plans to be finalized by the committee of A Century of Progress, he began to paint seriously. It is not surprising, given his extensive background in sculpture, that his paintings of the early thirties are sculptural in feeling, abstract yet with references to the human figure.

From 1928 to 1932, Storrs was in close contact with Marsden Hartley. Although their friendship dated from earlier years, Storrs and Hartley dined and traveled together during this period and visited galleries in Paris, New York, and Chicago. Storrs and Léger were also friends during the years from 1928 to 1936; Storrs's diary entries for 1930 indicate meetings and an exchange of information concerning their work.[1] Such friendships undoubtedly encouraged Storrs to approach painting with dedication, and certain formal connections can be made between the paintings of Storrs and Léger during the thirties.

Storrs had his first exhibition of paintings at the Chester Johnson Galleries in Chicago in 1931—the year of Léger's first visit to the United States, at which time he visited New York and Chicago. Among the paintings shown at that exhibition was the humorous *Portrait of an Aristocrat*, ca. 1931 (cat. no. 137), in which it is possible to see profile faces, both snobbish and totemic, deployed like sculptural relief forms. *Double Entry*, 1931 (cat. no. 136), utilizes abstract relief forms, but these images can also be seen as male and female profile faces or figures. Storrs, a published poet, enjoyed visual and verbal puns. Since a double entry in a horse race refers to two horses that come from the same stable or owner, it may not be amiss to view these male and female forms as the double entry in the human race.

As the thirties progressed, Storrs's paintings became increasingly surreal and painterly. His most advanced sculpture of that decade made use of organic and primitive forms, often combined with machine images. In viewing Storrs's sculpture and painting—so striking in its purity and simplicity—there is always more by way of symbolic content and profound meaning than immediately meets the eye.

During World War II, Storrs was arrested as an enemy alien in France by the Occupation Forces and twice interned in concentration camps. Physically weakened by these experiences, upon his release he nevertheless continued to work in his studio in Mer until his death.

Noel Frackman

CAT. NO. 137. JOHN STORRS
Portrait of an Aristocrat, ca. 1931
Oil on canvas
44 × 30 in. (111.8 × 76.2 cm.)
Collection of Edward R. Downe, Jr.

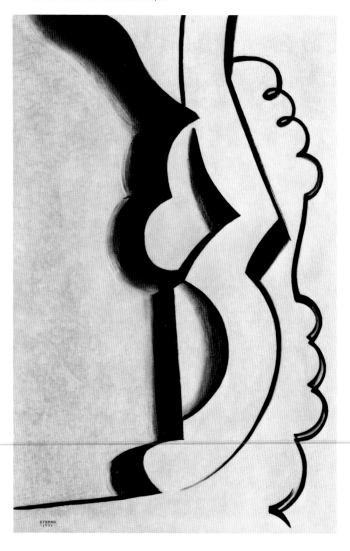

[1]Information concerning John Storrs has been derived from the John Storrs Papers, Archives of American Art, Smithsonian Institution, Washington, the gift of the artist's daughter, Monique Storrs Booz.

ALBERT SWINDEN

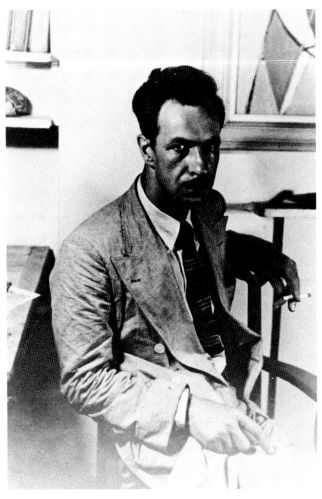

Born 1901 in Birmingham, England; died 1961 in New York City. Arrived in the United States in 1919; became U.S. citizen ca. 1923. Studied at National Academy of Design, ca. 1927–30; Art Students League, New York, 1930–34.

Although he could generally be found at the center of activity, Albert Swinden was a reticent, soft-spoken man, a painter's painter much admired by his contemporaries in New York during the thirties. He immigrated to the United States from Windsor, Ontario, Canada, in 1919, settling in Chicago for eighteen months and then moving to New York. After studying briefly at the National Academy of Design, Swinden attended the Art Students League from 1930 to 1934; he was a student of Hans Hofmann's when he came to teach at the League in 1932. Swinden was friendly with Burgoyne Diller and Harry Holtzman during the early thirties and participated in the League's first exhibition of abstract painting in 1932.

Swinden took an active role in the WPA Mural Division in New York City, producing large works for the Williamsburg Housing Project in 1938–39 and the Chilean Pavilion at the New York World's Fair of 1939–40. He was also instrumental in the founding of the American Abstract Artists, and many of the group's organizational meetings in 1936 were held in his studio on Seventeenth Street. In a rare public statement, Swinden contributed an essay, "On Simplification," to the American Abstract Artists 1938 Yearbook and participated in the group's annual exhibitions for several decades.

Swinden came to an understanding of abstract form very early and in 1928 began to paint abstract canvases in his own firmly controlled and quite personal variant of Synthetic Cubism. His work was highly esteemed by his contemporaries and closest friends, such as Ilya Bolotowsky and Balcomb Greene, because of its cleanly articulated form and complex tonal range of color.

Swinden's *Abstraction*, 1939 (cat. no. 138), is a rare example of his work of the late thirties, most of which was destroyed by fire in a studio he was sharing with Greene in 1940. The few surviving early works, such as *Abstraction*, confirm the high opinion held by many of his peers about his painting of this period. It is a beautifully organized work, with complex interpenetrating planes, subtle but forceful shifts in perspective, and dramatic color contrasts.

Introspection of Space, ca. 1944–48 (cat. no. 140), is perhaps the finest of his extant works, revealing his mastery of tonal color and his unusual practice of confining certain colors to separate areas of the canvas. Although Swinden produced many of his most refined and ambitious paintings during the forties, while working much of the time as an engineer's draftsman, his total output as a painter was relatively small. During the fifties he introduced the human figure into his otherwise abstract paintings and tended to work on paper rather than on canvas.

Swinden's is a calmly classical vision, an art based on subtle and refined geometry, carefully modulated color, and internal complexity. It is a rare instance when our image of a man and his work coincide so effortlessly and completely.

Susan C. Larsen

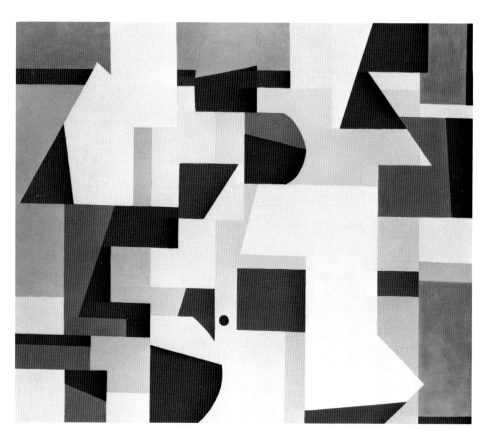

CAT. NO. 138. ALBERT SWINDEN
Abstraction, 1939
Oil on canvas
30¼ × 35⅞ in. (76.8 × 91.2 cm.)
Ertegun Collection Group

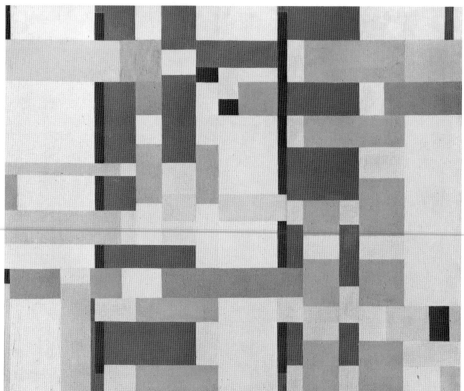

CAT. NO. 139. ALBERT SWINDEN
Abstraction, 1940
Oil on canvas
30 × 36 in. (76.2 × 91.4 cm.)
Sheldon Memorial Art Gallery,
 University of Nebraska, Lincoln;
 F. M. Hall Collection

VACLAV VYTLACIL

Born 1892 in New York City. Studied at Art Students League, New York, 1912–16; with Hans Hofmann, Munich, 1922–26.

Born in New York City in 1892 of Czechoslovakian parents, Vaclav Vytlacil grew up with a strong awareness of his European cultural heritage. When he was a child, his family moved to Chicago, where he attended young people's classes at The Art Institute of Chicago. At the age of twenty, he went to New York City on a scholarship to the Art Students League, the institution that was to be the focus of his activities as student and teacher for many decades to come. From 1913 to 1916, he studied with a variety of instructors at the League, but principally with John C. Johansen, known for his expressive and stylish portraits. Vytlacil taught at the Minneapolis School of Art from 1916 to 1921 and saved his money until he could afford a year's sojourn in Paris to study the art of Cézanne.

In 1921 Vytlacil set out for Paris, found lodging and a studio, then made a trip to Prague to see relatives. Stopping in Germany on the way back to Paris, he was impressed by the museums and the intellectual environment. Vytlacil altered his original plan and moved to Munich, where fellow Americans Worth Ryder and Ernst Thurn introduced him to the atelier and school of Hans Hofmann. This was to be a fateful meeting for Vytlacil, who became one of the most active members of the Hofmann class as both student and friend. His work, which had been a type of figurative expressionism, changed as Vytlacil undertook a serious and systematic study of Cézanne. Hofmann also pointed out the logical relationships between the art of Cézanne and that of the Cubists, urging him to consider the structural character of his work. By 1933, Vytlacil had become an abstract painter.

Vytlacil's own teaching career prospered as he returned from Europe to accept a summer post at the University of California, Berkeley, in 1928 and 1929. He also began a long tenure at the Art Students League as a popular and controversial instructor who brought the lessons of European art to his students in New York. Early on, he encountered opposition from fellow faculty members Kenneth Hayes Miller and Reginald Marsh when he demonstrated abstract principles underlying the art of Cézanne and the Cubists. In each institution, Vytlacil paved the way for his own mentor, Hofmann, who came to teach at Berkeley during the summers of 1930 and 1931 and at the Art Students League in 1932. Among the students Vytlacil taught during his long and successful career at the League were Louise Bourgeois, Robert Rauschenberg, Cy Twombly, James Rosenquist, and Tony Smith.

Vytlacil was instrumental in the formation of the American Abstract Artists in 1937 and participated in many of the

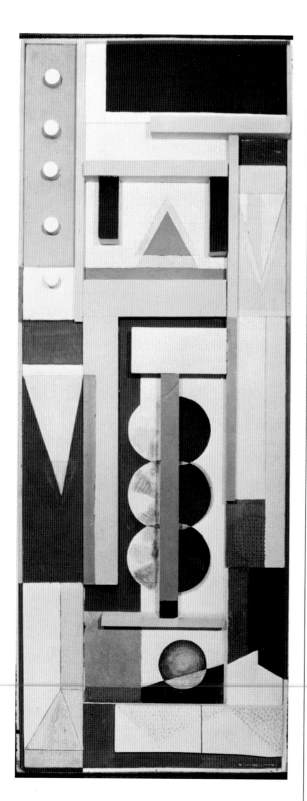

group's exhibitions during the late thirties and early forties. He exhibited his most abstract work with the AAA and pursued other avenues, including expressionist figuration, in his own studio. By the early forties, his expressionist emphasis was no longer compatible with the nonobjective styles of most AAA members, and Vytlacil quietly disengaged from the group.

During the thirties, Vytlacil exhibited a number of constructions remarkable for their verve and direct approach to the integration of two- and three-dimensional forms (cat. nos. 141 and 142). Tall, frequently thin, and composed of layers of painted wood, these constructions incorporate found objects such as tin plates, exposed nails, and pieces of lumber that have been well integrated into the abstract portions of the composition. Contrasting linear projections are added at a ninety-degree angle to the picture plane. These works are unique among the many constructions of the period, having the roughness of a sketch in three dimensions. Other artists who used spare pieces of wood and precut forms painted and disguised them more completely than did Vytlacil. Many were striving for the polished look of industrial fabrication rather than the looser, more informal spirit of the Cubist collage and assemblage or of the *Merz* constructions of Schwitters. Vytlacil is typical of his generation in his desire for a dominant geometric composition, but he did not aspire to a high degree of finish in his work—a characteristic that expresses something of the raw-boned dynamism of its creator.

A retrospective exhibition of Vytlacil's work was staged by the Montclair Art Museum in Montclair, New Jersey, in 1975. More recently, annual exhibitions of his work of the thirties and forties have been presented at Martin Diamond Fine Arts in New York.

Susan C. Larsen

CAT. NO. 142. VACLAV VYTLACIL
Untitled, 1939
Painted wood and mixed media
80 × 30 in. (203.2 × 76.2 cm.)
Estate of Joseph Hirshhorn

JEAN XCERON

Born 1890 in Isari Likosouros, Greece; died 1967 in New York City. Arrived in the United States in 1904; subsequently became U.S. citizen. Studied at Corcoran School of Art, Washington, 1910–17.

Jean Xceron was born in 1890 at Isari Likosouros, an isolated mountain village deep in the Peloponnesos. From earliest youth, he made decorations that were received enthusiastically by the villagers—sculpture fashioned from scraps in his father's blacksmith shop, devotional images, and wall paintings about the history of the Greek revolution.

At the age of fourteen, in 1904, Xceron was sent to America to earn his fortune. For six years he lived with relatives and friends in New York, Indianapolis, and Pittsburgh, making a living working in hat-cleaning, shoeshine, ice cream, and candy shops. Only when he settled in Washington, in 1910, did Xceron decide to pursue what he liked to do best —art. He enrolled in classes at the Corcoran School of Art, attending them intermittently until 1917. These were important years for Xceron, as he encountered not only fellow students Abraham Rattner, George Lohr, and Charles Logasa (the latter two responsible for the creation of Washington's "Armory Show" in 1916) but also the tradition of classical antiquity as revealed through an academic course of study that required copying museum casts. Thus, at the same moment in his education, Xceron was introduced to the great Western tradition and to modernism. While his teachers regarded him as a revolutionary for his free and flat interpretations of the model, in 1918 the Greek community in Washington chose him to paint an enormous temporary mural for the pediment of the U.S. Treasury building to celebrate Greek Independence Day and Greek-American solidarity: a classical decoration in which scenes of Greek gods and heroes were balanced against modern American World War I soldiers. Reconciling the different approaches to art and its function that were implied in such disparate, if not contradictory, activity was to become one of Xceron's aims.

Moving to New York in 1920, Xceron became friendly with Torres-García, who—in an evolution even more eccentric than Xceron's—had just come to New York from Europe. Xceron also associated with Max Weber, Abraham Walkowitz, and Joseph Stella. He exhibited in the New York Independents in 1921 and 1922 and began to travel, venturing up the New England coast as far as Ogunquit, Maine. By 1923, as a result of these expanding contacts, Xceron was producing more sophisticated if less personal work, in which the influence of Cézanne's landscape painting becomes dominant in his carefully composed, harmonious canvases.

By 1927, having painted independently for ten years, Xceron had saved enough money to go to Paris. As one already conversant with the new art, he was welcomed by the Paris editor of the *Chicago Tribune* and invited to write art criticism.

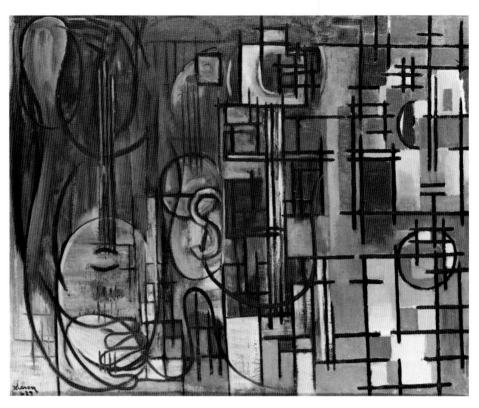

CAT. NO. 143. JEAN XCERON
Violin No. 6E, 1932
Oil on canvas
25⅛ × 31½ in. (63.8 × 80 cm.)
Ertegun Collection Group

CAT. NO. 145. JEAN XCERON
Composition No. 250, 1940
Oil on paperboard
27¾ × 19⅝ in. (70.5 × 50 cm.)
Hirshhorn Museum and Sculpture Garden,
 Smithsonian Institution, Washington

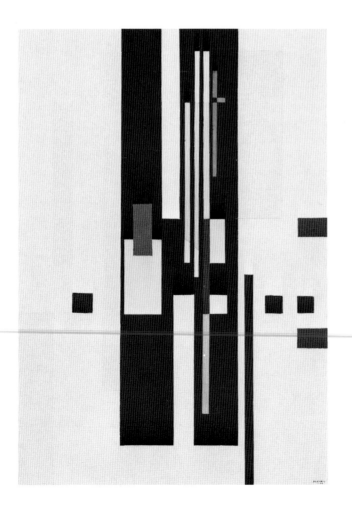

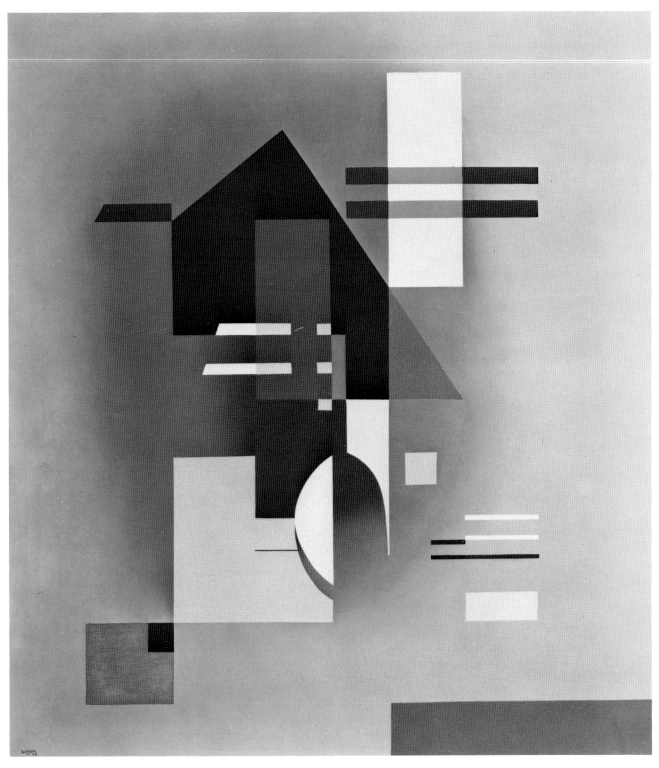

CAT. NO. 147. JEAN XCERON
Composition No. 269, 1944
Oil on canvas
51 × 45 in. (129.5 × 114.3 cm.)
The Solomon R. Guggenheim Museum, New York

He was greeted by his old friend and mentor, Torres-García, who introduced him to van Doesburg, Mondrian, Hélion, Léger, and Arp. He visited studios, discussed painting, wrote articles, and was on the periphery of the groups that founded Cercle et Carré and then Art Concret and Abstraction-Création. Sensitive to the doctrinal differences in both painting and politics that distinguished these rallying movements for abstract art, Xceron gave his allegiance to none. Instead, he painted quietly and steadily, evolving a deeply personal idiom in which reminiscences of reality were not absolutely banished, but were raised by formal interplay to the level of generalizations. Thus, paintings of the early thirties that depart from the motifs of musical instruments—such as *Violin No. 6E*, 1932 (cat. no. 143)—are about sound, while other themes concern people, shelter, and light. By 1936–37, Xceron had developed his mature style, producing beautifully modulated and transparent harmonies from which the last traces of figuration had disappeared, leaving only the poetic quality of the representational world distilled into quiet geometric shapes. Among these works is *Composition No. 239A*, 1937 (cat. no. 144).

Xceron's first one-artist exhibition opened at the Galerie de France in Paris in 1931 and attracted the interest of many young painters as well as the respect of major abstract artists, including Léger, Mondrian, Arp, Gleizes, and Herbin. In exhibitions at the Galerie Percier in 1933 and 1934, he continued to be identified with pure design, pure painting—and with the most radical and intransigent abstraction. This critical reaction amused Xceron, a gentle and noncombative person who was accustomed to being misunderstood. Abstraction was the most profound means he knew to communicate personal feeling.

In 1935 he returned to the United States for an exhibition of his work at the Garland Gallery in New York and was sought out by American artists interested in abstraction. He developed friendships with David Smith, whom he counseled to concentrate on sculpture, and with James Johnson Sweeney, who arranged for Xceron's next New York show, early in 1938, at the Nierendorf Gallery. On this occasion, after a ten-year stay in Europe, Xceron returned to the United States for good. Hilla Rebay saw his work and acquired examples for the Solomon R. Guggenheim Foundation, inaugurating a long association that ended only when Xceron died in 1967. The American Abstract Artists group welcomed him with enthusiasm, for in those days before the arrival in New York of the great wave of exiled Europeans, he was one of the very few abstract artists who had acquired an international reputation, and the only one who was an American citizen.

For about a dozen years he enjoyed a modest fame, until about 1950, when the kind of painting he had perfected began to be regarded as old-fashioned. For five years after his 1950 show at the Sidney Janis Gallery, he did not exhibit, but continued to paint with tranquillity. In 1955, when his one-artist exhibitions resumed, at the Rose Fried Gallery, Xceron discovered that he had been relegated to the category of old master. Throughout the last dozen years of his life, he continued to develop and grow as a painter, reaching back to absorb into his art the poetry and strength of classical civilization. The Greece he had experienced as a boy was combined with the classical heritage he had learned about during the course of his adult life. The fusion of the traditions of the Western past with the vocabulary of geometric abstraction is one of the improbable and major accomplishments of Jean Xceron.

Daniel Robbins

CATALOGUE

*Dimensions are given in the following order: height, width, depth. Works marked * are shown only in Pittsburgh and New York; those marked † are shown only in New York; those marked ‡ are shown only in San Francisco; and those marked § are shown only in Pittsburgh.*

CAT. NO. 1. JOSEF ALBERS
b and p, 1937
Oil on Masonite
23⅞ × 23¾ in. (60.6 × 60.3 cm.)
The Solomon R. Guggenheim Museum, New York

CAT. NO. 2. JOSEF ALBERS
Penetrating (B), 1943
Oil, casein, and tempera on Masonite
21½ × 24⅞ in. (54.6 × 63.2 cm.)
The Solomon R. Guggenheim Museum, New York

CAT. NO. 3. CHARLES BIEDERMAN
New York, July 1936, 1936
Oil on canvas
42½ × 29⅝ in. (108 × 75.3 cm.)
Private Collection. Courtesy of Grace Borgenicht Gallery, New York

CAT. NO. 4. CHARLES BIEDERMAN
Work No. 16, New York, 1938–39, 1938–39
Painted wood
29 × 22½ × 2½ in. (73.7 × 57.2 × 6.4 cm.)
Collection of Mrs. Raymond F. Hedin

CAT. NO. 5. CHARLES BIEDERMAN
Work No. 3, New York, 1939, 1939
Painted wood, glass, and metal rods
32⁷⁄₁₆ × 26¹¹⁄₁₆ × 3¼ in. (82.4 × 67.8 × 8.3 cm.)
Collection of Mr. and Mrs. John P. Anderson

CAT. NO. 6. CHARLES BIEDERMAN
No. 11, New York, 1939–40, 1939–40
Painted wood and glass
29 × 21½ × 1⅞ in. (73.6 × 54.6 × 4.7 cm.)
Museum of Art, Carnegie Institute, Pittsburgh; Edith H. Fisher Fund, 1982

CAT. NO. 7. CHARLES BIEDERMAN
No. 2, New York, February 1940, 1940
Painted wood and metal
62½ × 48¾ × 10¾ in. (158.8 × 123.8 × 27.3 cm.)
The Minneapolis Institute of Arts; Gift of Mr. and Mrs. John P. Anderson

CAT. NO. 8. CHARLES BIEDERMAN
No. 9, New York, July 1940, 1940
Painted wood, glass, and fluorescent tubes
54½ × 51⅞ × 17¾ in. (138.4 × 132.1 × 31.8 cm.)
Collection of Mrs. Raymond F. Hedin

CAT. NO. 9. ILYA BOLOTOWSKY
White Abstraction, 1934–35
Oil on canvas
37 × 19 in. (88.5 × 48.2 cm.)
Robert Hull Fleming Museum, University of Vermont, Burlington

CAT. NO. 10. ILYA BOLOTOWSKY
Painting, ca. 1936
Oil on canvas
25½ × 36¼ in. (64.8 × 92.1 cm.)
Private Collection. Courtesy of Washburn Gallery, New York

CAT. NO. 11. ILYA BOLOTOWSKY
Abstraction (No. 3), 1936–37
Oil on canvas
27¹⁵⁄₁₆ × 36 in. (71 × 91.4 cm.)
Museum of Art, Carnegie Institute, Pittsburgh; Gift of Kaufmann's and the Women's Committee of the Museum of Art, 1981

CAT. NO. 12. ILYA BOLOTOWSKY
Untitled, ca. 1936–37
Oil on canvas
30 × 40 in. (76.2 × 101.6 cm.)
Collection of Edward R. Downe, Jr.

CAT. NO. 13. ILYA BOLOTOWSKY
Study for "Mural for Health Building, Hall of Medical Science, New York World's Fair," 1938–39
Oil on canvas
30 × 48 in. (76.2 × 121.9 cm.)
The Art Institute of Chicago; Wilson L. Mead Fund Income, 77.1

CAT. NO. 14. ILYA BOLOTOWSKY
Construction in a Square, 1940
Oil on canvas
30⅛ × 30⅛ in. (76.5 × 76.5 cm.)
The Museum of Fine Arts, Houston; Museum purchase with funds provided by the National Endowment for the Arts and Joan Fleming

CAT. NO. 15. ILYA BOLOTOWSKY
Blue Diamond, 1940–41
Oil on canvas
21 × 21 in. (53.3 × 53.3 cm.)
Washburn Gallery, New York

CAT. NO. 16. BYRON BROWNE
Still Life with Apples, 1935
Oil on Masonite
30 × 38 in. (76.2 × 96.5 cm.)
Collection of Mr. and Mrs. Harvey W. Rambach

CAT. NO. 17. BYRON BROWNE
Non-Objective Composition, 1935–36
Oil on canvas
35½ × 29 in. (90.2 × 73.7 cm.)
Collection of Cornelia and Meredith Long

CAT. NO. 18. BYRON BROWNE
Classical Still Life, 1936
Oil on canvas
47 × 36 in. (119.4 × 91.4 cm.)
Collection of Barney A. Ebsworth

CAT. NO. 19. BYRON BROWNE
Arrangement, 1938
Oil on canvas
38 × 30 in. (96.5 × 76.2 cm.)
New Jersey State Museum, Trenton; Museum Purchase

CAT. NO. 20. ALEXANDER CALDER
The Pistil, 1931
Brass and wire on wooden base
40 × 12¾ × 12¾ in. (101.6 × 32.4 × 32.4 cm.)
Whitney Museum of American Art, New York; Gift of the Howard and Jean Lipman Foundation, Inc., and purchase, 1970

*CAT. NO. 21. ALEXANDER CALDER
Construction, 1932
Painted wood and metal
35 × 30¼ × 26½ in. (88.9 × 76.8 × 67.3 cm.)
Philadelphia Museum of Art; A. E. Gallatin Collection

CAT. NO. 22. ALEXANDER CALDER
Dancers and Sphere, 1936
Wood and metal
17¾ in. (45 cm.)
Private Collection

CAT. NO. 23. ALEXANDER CALDER
Untitled (Hanging Mobile for Hotel Avila Ballroom, Caracas, Venezuela),
1941
Painted metal
6 × 8 × 8 ft. (1.8 ×·2.4 × 2.4 m.)
Aluminum Company of America, Pittsburgh

CAT. NO. 24. ALEXANDER CALDER
Constellation, 1943
Wood and metal rods
22 × 44½ × 11¾ in. (55.9 × 113 × 30 cm.)
The Solomon R. Guggenheim Museum, New York; Collection of Mary
 Reynolds: Gift of her brother

CAT. NO. 25. ALEXANDER CALDER
Constellation with Quadrilateral, 1943
Wood and wire
15 × 18 × 7¾ in. (38.1 × 45.7 × 19.7 cm.)
Whitney Museum of American Art, New York; 50th Anniversary Gift of the
 Howard and Jean Lipman Foundation, Inc.

CAT. NO. 26. STUART DAVIS
Eggbeater No. 1, 1927–28
Oil on canvas
27 × 38¼ in. (68.6 × 97.2 cm.)
The Phillips Collection, Washington

CAT. NO. 27. STUART DAVIS
House and Street, 1931
Oil on canvas
26 × 42¼ in. (66 × 107.3 cm.)
Whitney Museum of American Art, New York

CAT. NO. 28. STUART DAVIS
Landscape, 1932–35
Oil on canvas
32½ × 29¼ in. (82.5 × 74.2 cm.)
The Brooklyn Museum, New York; Gift of Mr. and Mrs. Milton Lowenthal

CAT. NO. 29. STUART DAVIS
Sail Loft, 1933
Oil on canvas
15 × 18½ in. (38.1 × 47 cm.)
Collection of Dr. and Mrs. Milton Shiffman

CAT. NO. 30. STUART DAVIS
Terminal, 1937
Oil on canvas
30⅛ × 40⅛ in. (76.5 × 101.9 cm.) ·
Hirshhorn Museum and Sculpture Garden, Smithsonian Institution, Washington

CAT. NO. 31. STUART DAVIS
Hot Still-scape for 6 Colors—7th Ave. Style, 1940
Oil on canvas
36 × 45 in. (91.4 × 114.2 cm.)
Museum of Fine Arts, Boston, and William H. Lane Foundation
(Not in exhibition)

CAT. NO. 32. STUART DAVIS
Report from Rockport, 1940
Oil on canvas
24 × 30 in. (61 × 76.2 cm.)
Collection of Edith and Milton Lowenthal

CAT. NO. 33. STUART DAVIS
Ultramarine, 1943
Oil on canvas
20 × 40 in. (50.8 × 101.6 cm.)
Pennsylvania Academy of the Fine Arts, Philadelphia; Temple Fund Purchase

CAT. NO. 34. WILLEM DE KOONING
Untitled, ca. 1942
Oil on canvas
24 × 31½ in. (61 × 80 cm.)
Allan Stone Gallery, New York

CAT. NO. 35. WILLEM DE KOONING
The Wave, ca. 1942–44
Oil on Masonite
48 × 48 in. (121.9 × 121.9 cm.)
National Museum of American Art, Smithsonian Institution, Washington; Gift
 of Vincent Melzac Collection

CAT. NO. 36. BURGOYNE DILLER
Untitled, ca. 1933
Tempera on board
15½ × 9½ in. (39.4 × 24.1 cm.)
Meredith Long & Co., Houston

CAT. NO. 37. BURGOYNE DILLER
Construction, 1934
Painted wood and fiberboard
24 × 24 × 2 in. (61 × 61 × 5.1 cm.)
Hirshhorn Museum and Sculpture Garden, Smithsonian Institution, Washington

†CAT. NO. 38. BURGOYNE DILLER
Second Theme, 1937–38
Oil on canvas
30⅛ × 30 in. (76.5 × 76.2 cm.)
The Metropolitan Museum of Art, New York; George A. Hearn Fund, 1963

*CAT. NO. 39. BURGOYNE DILLER`
Construction No. 16, 1938
Painted wood
31⅞ × 27¾ × 5⅛ in. (81 × 70.5 × 13 cm.)
The Newark Museum; Celeste and Armand Bartos Foundation Fund Purchase,
 1959

CAT. NO. 40. BURGOYNE DILLER
Construction, 1938
Painted wood
14⅝ × 12½ × 2⅝ in. (37.2 × 31.8 × 6.7 cm.)
The Museum of Modern Art, New York; Gift of Mr. and Mrs. Armand
 P. Bartos, 1958

CAT. NO. 41. BURGOYNE DILLER
First Theme, 1943
Oil on panel
34 × 34 in. (86.4 × 86.4 cm.)
Collection of Mr. and Mrs. Fayez Sarofim

CAT. NO. 42. BURGOYNE DILLER
Untitled No. 21 (Second Theme), 1943–45
Oil on canvas
42⅛ × 42 1/16 in. (107 × 106.8 cm.)
Museum of Art, Carnegie Institute, Pittsburgh; Edith H. Fisher Fund, 1981

CAT. NO. 43. WERNER DREWES
City (Third Avenue El), 1938
Oil on canvas
33¾ × 42 in. (85.7 × 106.7 cm.)
Collection of Mr. and Mrs. Milton Rose

CAT. NO. 44. WERNER DREWES
Escape, 1941
Oil on canvas
34 × 36 in. (87.4 × 91.4 cm.)
The Solomon R. Guggenheim Museum, New York

CAT. NO. 45. JOHN FERREN
Composition, 1935
Oil on canvas
38½ × 57½ in. (97.8 × 146.1 cm.)
Collection of Edward R. Downe, Jr.

CAT. NO. 46. JOHN FERREN
Untitled (JF 7), 1937
Oil on canvas
44¾ × 57½ in. (113.7 × 146.1 cm.)
The Solomon R. Guggenheim Museum, New York

CAT. NO. 47. JOHN FERREN
Untitled, ca. 1937
Painted plaster
11¾ × 9½ in. (29.9 × 24.1 cm.)
Collection of Edward R. Downe, Jr.

CAT. NO. 48. SUZY FRELINGHUYSEN
Composition, 1943
Mixed media and oil on panel
40 × 30 in. (101.6 × 76.2 cm.)
Collection of Barney A. Ebsworth

CAT. NO. 49. SUZY FRELINGHUYSEN
Still Life, 1944
Painted collage
29⅝ × 39½ in. (75.3 × 100.3 cm.)
Ertegun Collection Group

CAT. NO. 50. A. E. GALLATIN
Untitled, 1938
Oil on canvas
30 × 20 in. (76.2 × 50.8 cm.)
Collection of Edward Albee

CAT. NO. 51. A. E. GALLATIN
Composition No. 70, 1944–49
Oil on canvas
25 × 30 in. (63.5 × 76.2 cm.)
Collection of Edward R. Downe, Jr.

CAT. NO. 52. FRITZ GLARNER
Painting, 1937
Oil on canvas
45 × 55⅞ in. (114.5 × 142 cm.)
Kunsthaus Zürich; Bequest of Mrs. Lucie Glarner

CAT. NO. 53. FRITZ GLARNER
Composition, 1942
Oil on canvas
21 × 19½ in. (53.3 × 49.5 cm.)
Collection of Mrs. Robert C. Graham, Sr.

CAT. NO. 54. FRITZ GLARNER
Relational Painting, Tondo No. 1, 1944
Oil on Masonite
52⅜ in. diameter (133 cm. diameter)
Kunsthaus Zürich; Bequest of Mrs. Lucie Glarner

CAT. NO. 55. ARSHILE GORKY
Still Life, ca. 1930–31
Oil on canvas
38½ × 50⅜ in. (97.8 × 128 cm.)
The Chrysler Museum, Norfolk; On loan from the collection of Walter P.
 Chrysler, Jr.

CAT. NO. 56. ARSHILE GORKY
Organization (Nighttime, Enigma and Nostalgia), ca. 1933–34
Oil on board
13½ × 21⅝ in. (34.3 × 55 cm.)
University of Arizona Museum of Art, Tucson; Gift of Edward J. Gallagher, Jr.

CAT. NO. 57. ARSHILE GORKY
Untitled (detail from "Aviation: Evolution of Forms under Aerodynamic
 Limitations"), ca. 1935–36
Oil on canvas
30 × 35½ in. (76.5 × 90.3 cm.)
The Grey Art Gallery and Study Center, New York University, New York; Gift
 of May Walter, 1965

‡CAT. NO. 58. ARSHILE GORKY
Composition (Still Life), ca. 1936–38
Oil on canvas
34⅛ × 26⅛ in. (86.7 × 66.4 cm.)
Collection of Thomas Weisel

CAT. NO. 59. ARSHILE GORKY
Enigmatic Combat, ca. 1936–38
Oil on canvas
35¾ × 48 in. (90.8 × 121.9 cm.)
San Francisco Museum of Modern Art; Gift of Jeanne Reynal

CAT. NO. 60. ARSHILE GORKY
Mojave, 1941–42
Oil on canvas
28⅞ × 40⅝ in. (73.4 × 103.2 cm.)
Los Angeles County Museum of Art; Gift of Burt Kleiner

CAT. NO. 61. JOHN GRAHAM
Still Life with Pipe, 1929
Oil on canvas
13¼ × 23 in. (33.7 × 58.4 cm.)
The Museum of Fine Arts, Houston; Purchased with funds provided by Mr.
 and Mrs. George R. Brown and George S. Heyer, Sr.

CAT. NO. 62. JOHN GRAHAM
Lunchroom Coffee Cup, 1930
Oil on canvas
11 × 18 in. (27.9 × 45.7 cm.)
Allan Stone Gallery, New York

CAT. NO. 63. JOHN GRAHAM
Crucifiction, 1931
Oil on canvas
40 × 32 in. (101.6 × 81.3 cm.)
Allan Stone Gallery, New York

CAT. NO. 64. JOHN GRAHAM
Blue Abstraction (Still Life), 1931
Oil on canvas
26 × 36 in. (66 × 91.4 cm.)
The Phillips Collection, Washington

CAT. NO. 65. BALCOMB GREENE
Angular, 1937
Oil on panel
15½ × 24 in. (39.4 × 61 cm.)
Collection of the artist. Courtesy of ACA Galleries, New York

CAT. NO. 66. BALCOMB GREENE
Composition, 1940
Oil on canvas
20 × 30 in. (50.8 × 76.2 cm.)
The Solomon R. Guggenheim Museum, New York

CAT. NO. 67. GERTRUDE GREENE
La palombe (The Dove), 1935–36
Wood and metal
10 × 18⅝ × 1½ in. (25.4 × 47.3 × 3.8 cm.)
Ertegun Collection Group

CAT. NO. 68. GERTRUDE GREENE
Composition, 1937
Wood
20 × 40 in. (50.8 × 101.6 cm.)
The Berkshire Museum, Pittsfield, Massachusetts; Gift of A. E. Gallatin

CAT. NO. 69. GERTRUDE GREENE
Construction in Blue, 1937
Wood
48 × 32 in. (121.9 × 81.3 cm.)
Private Collection

CAT. NO. 70. GERTRUDE GREENE
Space Construction, 1943
Wood and Masonite
36 × 27 in. (91.4 × 68.6 cm.)
Ertegun Collection Group

CAT. NO. 71. GERTRUDE GREENE
White Anxiety, 1943–44
Painted wood relief construction on composition board
41¾ × 32⅞ in. (106.1 × 83.5 cm.)
The Museum of Modern Art, New York; Gift of Balcomb Greene

CAT. NO. 72. JEAN HÉLION
Equilibre, 1933
Oil on canvas
32½ × 39½ in. (82.6 × 100.3 cm.)
Collection of Louis Hélion Blair

CAT. NO. 73. JEAN HÉLION
Figure d'Espace, 1937
Oil on canvas
52 × 38 in. (132.1 × 96.5 cm.)
San Francisco Museum of Modern Art; Albert M. Bender Collection, Albert
 M. Bender Bequest Fund Purchase

CAT. NO. 74. HANS HOFMANN
Atelier Still Life—Table with White Vase, 1938
Oil on panel
60 × 48 in. (152.4 × 121.9 cm.)
Collection of Mr. and Mrs. James A. Fisher

CAT. NO. 75. HANS HOFMANN
Abstract Figure, 1938
Oil on panel
67½ × 43¾ in. (171 × 109 cm.)
Estate of Hans Hofmann. Courtesy of André Emmerich Gallery

CAT. NO. 76. CARL HOLTY
Circus Forms, 1938
Oil on Masonite
59¾ × 39¾ in. (151.8 × 101 cm.)
The Archer M. Huntington Art Gallery, University of Texas, Austin; The James
 and Mari Michener Collection

CAT. NO. 77. CARL HOLTY
Table, 1940
Oil on Masonite
60½ × 40⅝ in. (153.7 × 103.2 cm.)
The Archer M. Huntington Art Gallery, University of Texas, Austin; The James
 and Mari Michener Collection

CAT. NO. 78. CARL HOLTY
Of War, 1942
Original painting destroyed. Repainted by the artist from a photograph in
 tempera in 1942; this second version was overpainted by the artist in oils
 in 1960.
Oil and tempera on Masonite
54 × 36 in. (137.2 × 91.4 cm.)
Museum of Art, Carnegie Institute, Pittsburgh; Museum purchase: Gift of the
 Robert S. Waters Charitable Trust, 1980

CAT. NO. 79. CARL HOLTY
City, 1942
Oil on Masonite
36 × 48 in. (91.4 × 121.9 cm.)
The Museum of Fine Arts, Houston; Museum purchase: George R. Brown
 Funds in honor of his wife, Alice Pratt Brown

CAT. NO. 80. HARRY HOLTZMAN
Square Volume with Green, 1936
Recreated by the artist from the original in 1982
Acrylic on gessoed Masonite
23¾ × 23¾ in. (60.3 × 60.3 cm.)
Collection of the artist

CAT. NO. 81. HARRY HOLTZMAN
Horizontal Volume, 1938–46
Oil on gessoed linen
12 × 33 in. (30.5 × 83.8 cm.)
Collection of the artist

CAT. NO. 82. HARRY HOLTZMAN
Vertical Volume No. 1, 1939–40
Acrylic and oil on gessoed Masonite
60 × 12 in. (152.4 × 30.5 cm.)
Collection of the artist

CAT. NO. 83. HARRY HOLTZMAN
Sculpture (I), 1940
Oil and acrylic on gessoed Masonite
78 × 12 × 12 in. (198.1 × 30.5 × 30.5 cm.)
Museum of Art, Carnegie Institute, Pittsburgh; Edith H. Fisher Fund, 1983

CAT. NO. 84. RAYMOND JONSON
Variations on a Rhythm—H, 1931
Oil on canvas
32½ × 28½ in. (82.6 × 72.4 cm.)
Collection of Dr. and Mrs. Phillip Frost

CAT. NO. 85. RAYMOND JONSON
Oil No. 2, 1940
Oil on canvas
29 × 38 in. (73.7 × 96.5 cm.)
Collection of Joseph Erdelac

CAT. NO. 86. PAUL KELPE
Machine Elements, 1934
Oil on canvas
24 × 24 in. (61 × 61 cm.)
The Newark Museum; Purchase 1978 Charles W. Engelhard Bequest Fund

CAT. NO. 87. PAUL KELPE
Weightless Balance II, 1937
Oil on canvas
33 × 23 in. (83.8 × 58.4 cm.)
Collection of Louise and Joe Wissert

CAT. NO. 88. IBRAM LASSAW
Sculpture in Steel, 1938
Steel
18½ × 24 × 15 in. (47 × 61 × 38.1 cm.)
Collection of the artist

CAT. NO. 89. IBRAM LASSAW
Intersecting Rectangles, 1940
Steel and Lucite
27½ × 19 × 19 in. (69.9 × 48.3 × 48.3 cm.)
Collection of the artist

CAT. NO. 90. FERNAND LÉGER
Plongeurs (Divers), 1942
Oil on canvas
49½ × 35½ in. (125.7 × 90.2 cm.)
Sidney Janis Gallery, New York

§CAT. NO. 91. FERNAND LÉGER
La forêt (The Forest), 1942
Oil on canvas
72¹/₁₆ × 49⅝ in. (183 × 126 cm.)
Musée National d'Art Moderne, Paris

CAT. NO. 92. ALICE TRUMBULL MASON
Untitled, ca. 1940
Oil on Masonite
22 × 28 in. (55.9 × 71.1 cm.)
Washburn Gallery, New York

CAT. NO. 93. ALICE TRUMBULL MASON
Brown Shapes White, 1941
Oil on board
21 × 31¾ in. (53.3 × 80.7 cm.)
Philadelphia Museum of Art; A.E. Gallatin Collection

CAT. NO. 94. JAN MATULKA
Arrangement with Phonograph, 1929
Oil on canvas
30 × 40 in. (76.2 × 101.6 cm.)
Whitney Museum of American Art, New York

CAT. NO. 95. JAN MATULKA
Still Life with Lamp, Pitcher, Pipe, and Shells, 1929–30
Oil on canvas
30 × 36 in. (76.2 × 91.4 cm.)
The Museum of Fine Arts, Houston; Museum Purchase

CAT. NO. 96. JAN MATULKA
View from Ship, ca. 1932
Oil on canvas
36 × 30 in. (91.4 × 76.2 cm.)
Collection of Mr. and Mrs. Raymond Learsy

CAT. NO. 97. LÁSZLÓ MOHOLY-NAGY
Space Modulator, 1938–40
Oil on canvas
47 × 47 in. (119.4 × 119.4 cm.)
Whitney Museum of American Art, New York; Gift of Mrs. Sibyl Moholy-Nagy

CAT. NO. 98. LÁSZLÓ MOHOLY-NAGY
Mills No. 1, 1940
Oil on Plexiglas
34¾ × 25¾ in. (87.4 × 65.4 cm.)
The Solomon R. Guggenheim Museum, New York

CAT. NO. 99. PIET MONDRIAN
New York, New York City, ca. 1942
Originally pencil, charcoal, oil, and tape on canvas. Restored by Harry Holtzman with the help of Bill Steeves in 1977, at which time the colored tapes were replaced by paper strips painted with acrylic paints. Of the tapes, only the black ones are original.
Oil, pencil, charcoal, and painted tape on canvas
46 × 43½ in. (116.8 × 110.5 cm.)
Sidney Janis Gallery, New York

†CAT. NO. 100. PIET MONDRIAN
Victory Boogie Woogie, 1943–44
Oil on canvas with colored tape and paper
49⅝ × 49⅝ in. (126.1 × 126.1 cm.)
Collection of Mr. and Mrs. Burton Tremaine

CAT. NO. 101. GEORGE L. K. MORRIS
Pocahontas, 1932
Oil on canvas
25 × 19 in. (63.5 × 48.3 cm.)
Collection of Robert L. B. Tobin

CAT. NO. 102. GEORGE L. K. MORRIS
Stockbridge Church, 1935
Oil on canvas
54⅛ × 45¹/₁₆ in. (137.4 × 114.4 cm.)
Museum of Art, Carnegie Institute, Pittsburgh; The A. W. Mellon Acquisition Endowment Fund, 1980

CAT. NO. 103. GEORGE L. K. MORRIS
Configuration, 1936
Bronze
25½ × 11 × 6 in. (64.8 × 27.9 × 15.2 cm.)
Private Collection

CAT. NO. 104. GEORGE L. K. MORRIS
Nautical Composition, 1937–42
Oil on canvas
51 × 35 in. (129.5 × 88.9 cm.)
Whitney Museum of American Art, New York

CAT. NO. 105. GEORGE L. K. MORRIS
Mural Composition, 1940
Oil on canvas
52 × 62½ in. (132.1 × 158.8 cm.)
Collection of Mr. and Mrs. John T. Whatley

CAT. NO. 106. GEORGE L. K. MORRIS
Posthumous Portrait, 1944
Oil on board and plaster relief
21 × 19½ in. (53.3 × 49.5 cm.)
Collection of Dr. and Mrs. Phillip Frost

CAT. NO. 107. ISAMU NOGUCHI
Leda, 1928
Brass with marble base
24½ × 14½ × 11 in. (62.2 × 36.8 × 27.9 cm.)
The Isamu Noguchi Foundation, Inc.

CAT. NO. 108. ISAMU NOGUCHI
Play Mountain, 1933
Bronze
29¼ × 25¾ × 4½ in. (74.3 × 65.4 × 11.4 cm.)
The Isamu Noguchi Foundation, Inc.

CAT. NO. 109. ISAMU NOGUCHI
Noodle, 1943–44
Marble
26¼ × 19½ × 12¼ in. (66.7 × 49.5 × 31.1 cm.)
Collection of the artist; in trust for Jody Spinden

CAT. NO. 110. IRENE RICE PEREIRA
Ascending Scale, 1937
Oil on canvas
27 × 22 in. (68.6 × 55.9 cm.)
The Lowe Art Museum, The University of Miami, Coral Gables; Gift of
 John V. Christie

CAT. NO. 111. IRENE RICE PEREIRA
Abstraction, 1940
Oil on canvas
30 × 38 in. (76.2 × 96.5 cm.)
Honolulu Academy of Arts; Gift of Philip E. Spalding, 1949

†CAT. NO. 112. IRENE RICE PEREIRA
Green Depth, 1944
Oil on canvas
31 × 42 in. (78.7 × 106.7 cm.)
The Metropolitan Museum of Art, New York; George A. Hearn Fund, 1944

CAT. NO. 113. AD REINHARDT
Number 30, 1938
Oil on canvas
40½ × 42½ in. (102.9 × 108 cm.)
Promised gift of Mrs. Ad Reinhardt to the Whitney Museum of American Art,
 New York

CAT. NO. 114. AD REINHARDT
Red and Blue Composition, 1939–41
Oil on Celotex
23½ × 29¼ in. (59.7 × 74.3 cm.)
Collection of Dr. and Mrs. Phillip Frost

CAT. NO. 115. AD REINHARDT
Untitled, 1940
Oil on canvas
16 × 20 in. (40.6 × 50.8 cm.)
Collection of Edward R. Downe, Jr.

CAT. NO. 116. AD REINHARDT
Untitled, 1940
Oil on Masonite
47 × 25 in. (119.4 × 61 cm.)
Collection of Dr. and Mrs. Phillip Frost

*CAT. NO. 117. THEODORE ROSZAK
Airport Structure, 1932
Copper, aluminum, steel, and brass
23 in. (58.4 cm.)
The Newark Museum; The Members Fund Purchase 1977

CAT. NO. 118. THEODORE ROSZAK
Large Rectilinear Space Construction, 1932
Bronze, copper, and plastic
23 × 10¼ × 10 in. (58.4 × 26 × 25.4 cm.)
Private Collection

CAT. NO. 119. THEODORE ROSZAK
Trajectories, 1938
Metal, plastic, and wood
18¾ × 30 × 4 in. (47.6 × 76.2 × 10.2 cm.)
Private Collection

CAT. NO. 120. THEODORE ROSZAK
Ascension, 1939
Wood, steel, and bronze
32¼ in. (81.9 cm.)
Collection of Suzanne Vanderwoude

CAT. NO. 121. THEODORE ROSZAK
Watchtower, ca. 1939–40
Wood, plastic, metal, and paint
23¹⁄₁₆ × 10⅜ × 5¼ in. (58.6 × 26.3 × 13.3 cm.)
Museum of Art, Carnegie Institute, Pittsburgh; Fine Arts Discretionary
 Fund, 1982

CAT. NO. 122. ROLPH SCARLETT
Composition, 1938–39
Oil on canvas
31 × 53 in. (78.7 × 134.6 cm.)
The Solomon R. Guggenheim Museum, New York

CAT. NO. 123. ROLPH SCARLETT
Untitled, ca. 1940–44
Oil on canvas
38 × 32 in. (96.5 × 81.3 cm.)
Zabriskie Gallery, New York

CAT. NO. 124. JOHN SENNHAUSER
Lyrical No. 7, 1942
Oil on parchment
22 × 25 in. (55.9 × 63.5 cm.)
Collection of Dr. Peter B. Fischer

CAT. NO. 125. JOHN SENNHAUSER
Lines and Planes No. 1, 1944
Oil on canvas
35¾ × 45¾ in. (90.8 × 116.2 cm.)
Museum of Art, Carnegie Institute, Pittsburgh; Mary Oliver Robinson
 Memorial Fund, 1982

CAT. NO. 126. CHARLES SHAW
Plastic Polygon, 1937
Oil on wood
45 × 30 in. (114.3 × 76.2 cm.)
Collection of Mr. and Mrs. Rolf Weinberg

CAT. NO. 127. CHARLES SHAW
Polygon, 1938
Painted wood relief
19½ × 22 × 3 in. (49.5 × 55.9 × 7.6 cm.)
Washburn Gallery, New York

CAT. NO. 128. CHARLES SHAW
Plastic Polygon, 1939
Painted wood
26½ × 17½ in. (67.3 × 44.5 cm.)
Collection of Dr. Peter B. Fischer

CAT. NO. 129. CHARLES SHAW
Top Flight #1, 1944
Oil on panel
50¼ × 32¾ in. (127.6 × 83.2 cm.)
Washburn Gallery, New York

CAT. NO. 130. ESPHYR SLOBODKINA
Construction No. 3, 1935
Painted wood
12½ × 23½ in. (31.8 × 59.7 cm.)
Ertegun Collection Group

CAT. NO. 131. ESPHYR SLOBODKINA
Ancient Sea Song, 1943
Oil on board
35 × 44 in. (88.9 × 111.8 cm.)
Collection of Barney A. Ebsworth

CAT. NO. 132. DAVID SMITH
Sawhead, 1933
Painted iron
18½ × 12 × 8¼ in. (47 × 30.5 × 21 cm.)
Estate of David Smith. Courtesy of M. Knoedler and Co., Inc., New York

CAT. NO. 133. DAVID SMITH
Aerial Construction, 1936
Painted and welded iron
10 × 30⅞ × 11½ in. (25.4 × 78.4 × 29.2 cm.)
Hirshhorn Museum and Sculpture Garden, Smithsonian Institution, Washington

CAT. NO. 134. DAVID SMITH
Billiard Player Construction, 1937
Iron and encaustic
20½ × 23½ × 17¼ in. (43.8 × 52.1 × 16.2 cm.)
Collection of Dr. and Mrs. Arthur E. Kahn

CAT. NO. 135. DAVID SMITH
Interior for Exterior, 1939
Steel and bronze
25 × 23½ × 18 in. (63.5 × 59.7 × 45.7 cm.)
Collection of Mr. and Mrs. Orin Raphael

CAT. NO. 136. JOHN STORRS
Double Entry, 1931
Oil on canvas
45¼ × 30¼ in. (114.9 × 76.8 cm.)
Collection of Barney A. Ebsworth

CAT. NO. 137. JOHN STORRS
Portrait of an Aristocrat, ca. 1931
Oil on canvas
44 × 30 in. (111.8 × 76.2 cm.)
Collection of Edward R. Downe, Jr.

CAT. NO. 138. ALBERT SWINDEN
Abstraction, 1939
Oil on canvas
30¼ × 35⅞ in. (76.8 × 91.2 cm.)
Ertegun Collection Group

CAT. NO. 139. ALBERT SWINDEN
Abstraction, 1940
Oil on canvas
30 × 36 in. (76.2 × 91.4 cm.)
Sheldon Memorial Art Gallery, University of Nebraska, Lincoln; F. M. Hall
 Collection

CAT. NO. 140. ALBERT SWINDEN
Introspection of Space, ca. 1944–48
Oil on canvas
30 × 40 in. (76.2 × 101.6 cm.)
Whitney Museum of American Art, New York; Gift of the Herbert and
 Nannette Rothschild Fund

CAT. NO. 141. VACLAV VYTLACIL
Untitled, 1937
Painted wood and mixed media
52 × 24 in. (132.1 × 61 cm.)
Collection of Olga Hirshhorn

CAT. NO. 142. VACLAV VYTLACIL
Untitled, 1939
Painted wood and mixed media
80 × 30 in. (203.2 × 76.2 cm.)
Estate of Joseph Hirshhorn

CAT. NO. 143. JEAN XCERON
Violin No. 6E, 1932
Oil on canvas
25⅛ × 31½ in. (63.8 × 80 cm.)
Ertegun Collection Group

CAT. NO. 144. JEAN XCERON
Composition No. 239A, 1937
Oil on canvas
51 × 35 in. (129.5 × 89 cm.)
Collection of Barney A. Ebsworth

CAT. NO. 145. JEAN XCERON
Composition No. 250, 1940
Oil on paperboard
27¾ × 19⅝ in. (70.5 × 50 cm.)
Hirshhorn Museum and Sculpture Garden, Smithsonian Institution,
 Washington

CAT. NO 146. JEAN XCERON
Composition No. 263, 1943
Oil on canvas
50⅛ × 40⅛ in. (127.3 × 101.9 cm.)
The Solomon R. Guggenheim Museum, New York

CAT. NO. 147. JEAN XCERON
Composition No. 269, 1944
Oil on canvas
51 × 45 in. (129.5 × 114.3 cm.)
The Solomon R. Guggenheim Museum, New York

SELECTED BIBLIOGRAPHY

GENERAL

American Abstract Artists. *American Abstract Artists 1936–1966*. Introduction by Ruth Gurin. New York: Ram Press, 1966.
————. *American Abstract Artists, Three Yearbooks (1938, 1939, 1946)*. New York: Arno Press, 1969.
————. "The Art Critics—! How Do They Serve the Public? What Do They Say? How Much Do They Know? Let's Look at the Record!" Twelve-page pamphlet written by members of the group with typography by Ad Reinhardt. New York: privately printed, June 1940.
————. "How Modern Is The Museum of Modern Art?" One-page broadside with typography by Ad Reinhardt. New York: privately printed, April 15, 1940.
————. *Prospectus*. New York: privately printed, January 1937.
Ashton, Dore. *The New York School: A Cultural Reckoning*. New York: Viking Press, 1972.
Barr, Alfred H., Jr. *Cubism and Abstract Art*. New York: Museum of Modern Art, 1936.
Baur, John I. H. *Revolution and Tradition in Modern American Art*. Cambridge, Mass.: Harvard University Press, 1951.
Berman, Greta. "Abstractions for Public Spaces, 1935–1943." *Arts* 56 (June 1982): 81–86.
————. *The Lost Years: Mural Painting in New York City Under the W.P.A. Federal Art Project 1935–43*. New York: Garland, 1978.
Bohan, Ruth L. *The Société Anonyme's Brooklyn Exhibition: Katherine Dreier and Modernism in America*. Ann Arbor, Mich.: UMI Research Press, 1982.
Dallas: Dallas Museum of Fine Arts. *Geometric Abstraction 1926–1972*. 1972. Essay by John Elderfield.
Dreier, Katherine, and Duchamp, Marcel. *The Collection of the Société Anonyme: Museum of Modern Art 1920*. New Haven: Yale University Press, 1950.
Elderfield, John. "American Geometric Abstraction in the Late Thirties." *Artforum* 11 (December 1972): 35–42.
————. "Geometric Abstract Painting and Paris in the Thirties." Part I, *Artforum* 8 (May 1970): 54–58. Part II, *Artforum* (June 1970): 70–75.
Greenberg, Clement. *Art and Culture*. Boston: Beacon Press, 1961.
————. "New York Painting Only Yesterday." *Art News* 56 (Summer 1957): 58–59, 84–85.
Hobbs, Robert Carleton, and Levin, Gail. *Abstract Expressionism: The Formative Years*. New York and Ithaca: Whitney Museum of American Art and Herbert F. Johnson Museum of Art, 1978.
Houston: Museum of Fine Arts, Houston. *Modern American Painting 1910–1940: Toward a New Perspective*. 1977. Essay by William C. Agee.
Janis, Sidney. *Abstract & Surrealist Art in America*. New York: Reynal & Hitchcock, 1944.
Kootz, Samuel. *New Frontiers in American Painting*. New York: Hastings, 1943.
Larsen, Susan C. "The American Abstract Artists: A Documentary History 1936–41." *Archives of American Art Journal* 14 (1974): 2, 6.

————. "The American Abstract Artists Group: A History and Evaluation of Its Impact upon American Art." Ph.D. dissertation, Northwestern University, 1975.
Lukach, Joan M. *Hilla Rebay: In Search of the Spirit in Art*. New York: George Braziller, forthcoming 1983.
McCoy, Garnett. "Poverty, Politics and Artists 1930–1945." *Art in America* 53 (August-September 1965): 88–130.
McKinzie, Richard D. *The New Deal for Artists*. Princeton: Princeton University Press, 1973.
McNeil, George. "American Abstract Artists Venerable at Twenty." *Art News* 55 (May 1956): 34–35, 65–66.
Monte, James. *The Transcendental Painting Group, New Mexico 1938–41*. Albuquerque: Albuquerque Museum, 1982.
Munich: Haus der Kunst. *Amerikanische Malerei 1930–1980*. 1981. Introduction by Tom Armstrong.
New Brunswick: Rutgers University Art Gallery. *Vanguard American Sculpture 1913–1939*. 1979.
New York: Whitney Museum of American Art. *Abstract Painting in America*. 1935.
————. *American Art of the 1930s: Selections from the Collection of The Whitney Museum of American Art*. 1981. Essay by Patterson Sims.
————. *The 1930's: Painting and Sculpture in America*. 1968. Essay by William C. Agee.
————. *200 Years of American Sculpture*. 1976.
O'Connor, Francis V. *Federal Support for the Visual Arts: The New Deal and Now*. Greenwich, Conn.: New York Graphic Society, 1969.
————, ed. *Art for the Millions: Essays from the 1930s by Artists and Administrators of the WPA Federal Art Project*. Greenwich, Conn.: New York Graphic Society, 1973.
————. *The New Deal Art Projects: An Anthology of Memoirs*. Washington: Smithsonian Institution Press, 1972.
Park, Marlene, and Markowitz, Gerald E. *New Deal for Art*. Hamilton, N.Y.: Gallery Association of New York State, 1976.
Pincus-Witten, Robert. *Post-Mondrian Abstraction in America*. Chicago: Museum of Contemporary Art, 1973.
Plastique. Number 3. Paris–New York (Spring 1938). Articles by Charles Shaw, Balcomb Greene, A. E. Gallatin, and George L. K. Morris.
Rebay, Hilla. "Value of Non-Objectivity." In *History of the Museum of Non-Objective Painting*. New York: privately printed, 1948.
Rembert, Virginia Pitts. "Mondrian, America and American Painting." Ph.D. dissertation, Columbia University, 1970.
Ritchie, Andrew Carnduff. *Abstract Painting and Sculpture in America*. New York: Museum of Modern Art, 1951.
Rose, Barbara. *American Abstract Artists: The Early Years*. New York: Sid Deutsch Gallery, 1980.
————. *American Art Since 1900*. New York: Praeger, 1967.
————. *Miró in America*. Houston: Museum of Fine Arts, Houston, 1982.
————, ed. *Readings in American Art Since 1900*. New York: Praeger, 1968.
Sandler, Irving. *The Triumph of American Painting: A History of Abstract Expressionism*. New York: Praeger, 1970.
Société Anonyme: The First Museum of Modern Art 1920–44. 3 vols. New York: Arno Press, 1972.

Tritschler, Thomas Candor. *American Abstract Artists*. Albuquerque: Art Museum, University of New Mexico, 1977.

———. "The American Abstract Artists 1937–41." Ph.D. dissertation, University of Pennsylvania, 1974.

Troy, Nancy J. *Mondrian and Neo-Plasticism in America*. New Haven: Yale University Art Gallery, 1979.

Van Wagner, Judith K. *Geometric Abstraction*. Lincoln, Neb.: Sheldon Art Gallery, University of Nebraska, 1974.

Washington: Archives of American Art, Smithsonian Institution. American Abstract Artists Papers.

INDIVIDUAL ARTISTS

Albers

Albers, Josef. *Interaction of Color*. New Haven: Yale University Press, 1963.

———. *Poems and Drawings*. New York: George Wittenborn, 1956.

Bucher, Francois. *Josef Albers: Despite Straight Lines*. Cambridge, Mass., and London: The MIT Press, 1977.

Finkelstein, Irving. "The Life and Art of Josef Albers." Ph.D. dissertation, New York University, 1968.

Gomringer, Eugen. *Josef Albers*. New York: George Wittenborn, 1968.

Hamilton, George Heard. *Josef Albers—Paintings, Prints, Projects*. New Haven: Yale University Art Gallery, 1956.

Josef Albers, Formulation: Articulation. New York: Harry N. Abrams, and New Haven: Ives-Sillman, 1972.

Nordland, Gerald. *Josef Albers: The American Years*. Washington: Washington Gallery of American Art, 1965.

Spies, Werner. *Albers*. New York: Harry N. Abrams, 1970.

Biederman

Bann, Stephen. "The Centrality of Charles Biederman." *Studio International* 178 (1969): 71–74.

Biederman, Charles. *Art as the Evolution of Visual Knowledge*. Red Wing, Minn.: Art History Publishers, 1948.

———. "Art in Crisis." *Studies in the Twentieth Century*, Russell Sage College, Troy, New York (Spring 1968): 39–59.

———. *Letters on the New Art*. Red Wing, Minn.: Art History Publishers, 1951.

———. *The New Cézanne*. Red Wing, Minn.: Art History Publishers, 1958.

———. *Search for New Arts*. Red Wing, Minn.: Art History Publishers, 1979.

Kuspit, Donald B. "Charles Biederman's Abstract Analogues for Nature." *Art in America* 65 (May/June 1977): 80–83.

London: Arts Council of Great Britain. *Charles Biederman*. 1969. Foreword by Robyn Denny and essay by Jan van der Marck.

Minneapolis: Minneapolis Institute of Arts. *Charles Biederman: A Retrospective*. 1976. Introduction by Gregory Hedberg and essays by Leif Sjöberg and Jan van der Marck.

Bolotowsky

Bolotowsky, Ilya. "Adventures with Bolotowsky." *Archives of American Art Journal* 22 (1982): 8–31.

———. "On Neoplasticism and My Own Work." *Leonardo* II (1969): 221–30.

Larsen, Susan C. "The American Abstract Artists Group: A History and Evaluation of Its Impact on American Art." Ph.D. dissertation, Northwestern University, 1974.

———. "Going Abstract in the Thirties: An Interview with Ilya Bolotowsky." *Art in America* 64 (September-October 1976): 70–79.

New York: The Solomon R. Guggenheim Museum. *Ilya Bolotowsky*. 1974.

Rickey, George. *Constructivism: Origin and Evolution*. New York: George Braziller, 1967.

Rosenthal, Deborah. "Ilya Bolotowsky." *Arts* 52 (March 1978): 2.

———. *Ilya Bolotowsky*. New York: Harry N. Abrams, forthcoming.

Browne

Berman, Greta. "Byron Browne: Builder of American Art." *Arts* 53 (December 1978): 98–102.

Browne, Byron. Archives of American Art, Smithsonian Institution, Washington, NBB1, NBB2, NDA18, NSM1, D308, D313, P72, 79, 1021, 1022, 1162, 1318, 1319, 1320, 97.

Paul, April J. "Byron Browne: A Study of His Art and Life to 1940." M.A. thesis, University of California, Davis, 1980.

———. "Byron Browne in the Thirties: The Battle for Abstract Art." *Archives of American Art Journal*, Smithsonian Institution, Vol. 19, no. 4, 1979, pp. 9–24.

Calder

Arnason, H. H., and Guerrero, Pedro. *Calder*. New York: Van Nostrand, 1966.

Calder, Alexander. *An Autobiography with Pictures*. New York: Pantheon, 1966.

Chicago: Museum of Contemporary Art. *Alexander Calder/A Retrospective Exhibition*. 1974. Essay by Albert Elsen.

Lipman, Jean. *Calder's Universe*. New York: Viking Press, 1976.

Marter, Joan; Tarbell, Roberta; and Wechsler, Jeffrey. *Vanguard American Sculpture 1913–1939*. New Brunswick: Rutgers University Art Gallery, 1979.

Sweeney, James Johnson. *Alexander Calder*. New York: Museum of Modern Art, 1943.

Davis

Baigell, Matthew. *The American Scene: American Painting of the 1930s*. New York: Praeger, 1974.

Blesh, Rudi. *Stuart Davis*. New York: Grove Press, 1960.

Cambridge, Mass.: Fogg Art Museum, Harvard University. Stuart Davis Papers.

Goossen, E. C. *Stuart Davis*. New York: George Braziller, 1959.

Kelder, Diane, ed. *Stuart Davis: A Documentary Monograph*. New York: Praeger, 1971.

Lane, John R. *Stuart Davis: Art and Art Theory*. New York: Brooklyn Museum, 1978.

Minneapolis: Walker Art Center. *Stuart Davis*. 1957. Essay by H. H. Arnason.

O'Doherty, Brian. *American Masters: The Voice and the Myth*. New York: Random House, 1973.

Sweeney, James Johnson. *Stuart Davis*. New York: Museum of Modern Art, 1945.

Washington: National Collection of Fine Arts. *Stuart Davis Memorial Exhibition*. 1965. Essay by H. H. Arnason.

De Kooning

Berlin: Akademie der Kunst. *Willem de Kooning*. Forthcoming 1983.

Hess, Thomas B. *Willem de Kooning*. New York: George Braziller, 1959.

———. *Willem de Kooning*. New York: Museum of Modern Art, 1968.

Rosenberg, Harold. *De Kooning*. New York: Harry N. Abrams, 1974.

Diller

Campbell, Lawrence. "Diller: The Ruling Passion." *Art News* 67 (October 1968): 36–37, 59–61.

———. "The Rule that Measures Emotion." *Art News* 60 (May 1961): 34–35, 56–58.

de Kooning, Elaine. "Diller Paints a Picture." *Art News* 51 (January 1953): 26–29, 55–56.

Diller, Burgoyne. Interview with Ruth Gurin, 21 March 1964. Typescript, Archives of American Art, Smithsonian Institution, Washington.

Johnson, David Hoyt. "The Early Career of Burgoyne Diller: 1925–1945." M.A. thesis, University of Arizona, 1978.

Minneapolis: Walker Art Center. *Burgoyne Diller: Paintings, Sculpture, Drawings*. 1971. Essay by Philip Larson.

Troy, Nancy J. *Mondrian and Neo-Plasticism in America*. New Haven: Yale University Art Gallery, 1979.

Drewes

Dreyfuss, Caril. *Werner Drewes Woodcuts*. Washington: National Collection of Fine Arts, 1969.

Ferren

Bailey, Craig. *Ferren: A Retrospective*. New York: The Graduate Center of the City University of New York, 1979.

"Les Expositions: Bidermann [*sic*], Ferren, Gallatin, Morris, Shaw." *Cahiers d'Art* 8–10 (1936): 278–79.

Ferren, John. Interview, 4 May 1966, in Karlen Mooradian, *The Many Worlds of Arshile Gorky*, pp. 14–42. Chicago: Gilgamesh Press Limited, 1980.

———. [Statement] in *Art of This Century*, pp. 98, 149. Edited by Peggy Guggenheim. New York: Art of This Century, 1942.

———. [Statement] in *The 30's: Painting in New York*, n.p. New York: Poindexter Gallery, [ca. 1956].

K., L. "Die Entwicklung der Abstrakten Kunst in Amerika." *Plastique* 3 (Spring 1938): 16–20.

Frelinghuysen

There is no in-depth biographical or critical writing on this artist.

Gallatin

"Albert Gallatin's Great-Grandson Sponsors a Museum of Abstract Art." *Life*, May 2, 1938, p. 45.

Frost, Rosamund. "Living Art Walks and Talks." *Art News* 42 (February 15, 1943): 14, 27.

Gallatin, Albert E. "Abstract Painting and the Museum of Living Art." *Plastique* III (Spring 1938).

———. "Museum-Piece." *American Abstract Artists 1946*. New York: Ram Press, 1946.

———, ed. *Museum of Living Art Catalogue 1933*. Articles by A. E. Gallatin, Jean Hélion, James Johnson Sweeney. New York: privately printed, 1933.

———. *The Museum of Living Art 1936*. New York: George Grady Press, 1936.

Gallery of Living Art Catalogue 1927. New York: privately printed, 1927.

Gallery of Living Art Catalogue 1929. New York: privately printed, 1929.

Gallery of Living Art Catalogue 1930. New York: privately printed, 1930. Entries compiled by A.E. Gallatin, Henry McBride, Philip L. Goodwin, and Mrs. Charles Russell, Jr.

Hellman, Geoffrey. "Gallatin Revisited." *New Yorker*, January 18, 1927, pp. 30–32.

———. "The Medici on Washington Square." *New Yorker*, January 18, 1941, pp. 25–32.

Larsen, Susan C. "Albert Gallatin: The 'Park Avenue Cubist' Who Went Downtown." *ARTnews* 77 (December 1978): 80–84.

New York: New-York Historical Society. A. E. Gallatin Correspondence.

Paintings by Gallatin. New York: Wittenborn, Schultz, 1948.

Philadelphia: Philadelphia Museum of Art. *A. E. Gallatin Collection*. 1954. Essays by A. E. Gallatin, Jean Hélion, James Johnson Sweeney.

Glarner

Ashton, Dore. "Fritz Glarner." *Art International* 7 (January 25, 1963): 48–54.

Bern: Kunsthalle. *Fritz Glarner*. 1972.

Hnikova, Dagmar. *Fritz Glarner im Kunsthaus Zürich*. Kunsthaus Zürich Sammlungsheft 8. Zürich: Kunsthaus, 1982.

Rembert, Virginia Pitts. "Mondrian, America, and American Painting." Ph.D. dissertation, Columbia University, 1970.

Staber, Margit. *Fritz Glarner*. Zürich: ABC Verlag, 1976.
Troy, Nancy J. *Mondrian and Neo-Plasticism in America*. New Haven: Yale University Art Gallery, 1979.

Gorky

Austin: University Art Museum, University of Texas at Austin. *Arshile Gorky: Drawings to Paintings*. 1975.
Bowman, Ruth. *Murals Without Walls: Arshile Gorky's Aviation Murals Rediscovered*. Newark: Newark Museum, 1978.
Jordan, Jim M. *Arshile Gorky: A Critical Catalogue*. New York: New York University Press, 1982.
Levy, Julien. *Arshile Gorky*. New York: Harry N. Abrams, 1966.
Rand, Harry. *Arshile Gorky: The Implications of Symbols*. Montclair: Allan Held and Schram, 1980.
Rosenberg, Harold. *Arshile Gorky: The Man, the Time, the Idea*. New York: Grove Press, 1962.
Schwabacher, Ethel K. *Arshile Gorky*. New York: Macmillan, 1957.
Waldman, Diane. *Arshile Gorky 1904–1948: A Retrospective*. The Solomon R. Guggenheim Museum. New York: Harry N. Abrams, 1981.

Graham

Graham, John. "Excerpts from an Unfinished Manuscript." *Art News* (September 1961).
———. "Primitive Art and Picasso." *Magazine of Art* (April 1937).
———. *System and Dialectics of Art*. Paris and New York: 1937; reprinted as *John D. Graham's System and Dialectics of Art*, with introduction by Marcia Epstein Allentuck, Baltimore: Johns Hopkins Press, 1971.
Herrera, Hayden. "John Graham: Modernist Turns Magus." *Arts Magazine* (October 1976).
Kokkinen, Eila. "Ionnus Magus Servus Domini St. Georgii Equitus." *Art News* (September 1968).

Balcomb Greene

Baur, John I. H. *Balcomb Greene*. New York: American Federation of Arts, 1961.
Greene, Balcomb. "Differences over Léger." *Art Front* 2 (January 1936).
———. "Expression as Production." *American Abstract Artists Annual 1938*; reprinted in *American Abstract Artists, Three Yearbooks (1938, 1939, 1946)*. New York: Arno Press, 1969.
———. "Society and the Modern Artist." In *Art for the Millions*. Edited by Francis V. O'Connor. Greenwich, Conn.: New York Graphic Society, 1973.
Hale, Robert Beverly, and Hale, Niké. *The Art of Balcomb Greene*. New York: Horizon Press, 1977.

Gertrude Greene

American Abstract Artists. Letters, minutes, lists. Microfilm Roll NY 59–11. New York: Archives of American Art, 1936–44.

American Abstract Artists, Three Yearbooks (1938, 1939, 1946). Reprint ed., New York: Arno Press, 1969.
Hale, Robert Beverly, and Hale, Niké. *The Art of Balcomb Greene*. New York: Horizon Press, 1977.
Hyman, Linda. *Gertrude Greene: Constructions, Collages, Paintings*. New York: ACA Galleries, 1981.
Larsen, Susan C. "Going Abstract in the '30s." *Art in America* 64 (September-October 1976): 70–79.
Moss, Jacqueline. "The Constructions of Gertrude Greene, the 1930s and 1940s." M.A. thesis, Queens College, City University of New York, 1980.
———. "Gertrude Greene: Constructions of the 1930s and 1940s." *Arts* 55 (April 1981): 120–27.

Hélion

Abadie, Daniel. *Hélion ou la force des choses*. Brussels: La Connaissance s.a., 1975.
Bruguière, Pierre G. *Jean Hélion*. Paris: S.P.E.I., 1970.
Burton, Scott. "Cool and Concrete from the Thirties." *Art News* 66 (April 1967): 34, 69–71.
Frigério, Simone. "Hélion: Peintures 1929–1939." *Aujourd'hui* 6 (June 1962): 20–23.
Hélion, Jean. "Art Concret, 1930: Four Painters and a Magazine." *Art and Literature* 12 (Winter 1967): 128–240.
———. "Poussin, Seurat, and Double Rhythm." *Axis* 6 (Summer 1936): 9–17. Reprinted in Evans, Myfanwy, ed. *The Painter's Object*. London: G. Howe, 1937, and New York: Arno Press, 1971, pp. 31–37.
———. "Seurat as a Predecessor." *Burlington Magazine* 69 (July 1936): 4–14.
Micha, René. *Hélion*. Paris: Flammarion, 1979.
Schipper, Merle. "Jean Hélion: The Abstract Decade." *Art in America* 64 (September-October 1976): 85-92.
———. "Jean Hélion: The Abstract Years, 1929–1939." Ph.D. dissertation, University of California, Los Angeles, 1974.

Hofmann

Bannard, Walter Darby. *Hans Hofmann*. Houston: Museum of Fine Arts, 1976.
Goodman, Cynthia. *Hans Hofmann*. New York: André Emmerich Gallery, 1981.
Greenberg, Clement. *Hans Hofmann*. Paris: Editions Georges Fall, 1961.
Hayes, Bartlett H., and Weeks, Sara T., eds. *Search for the Real and Other Essays*. Andover: Addison Gallery of American Art, 1948.
Hunter, Sam. *Hans Hofmann*. New York: Harry N. Abrams, 1964.
Rose, Barbara. *Hans Hofmann: Drawings*. New York: André Emmerich Gallery, 1977.
Seitz, William. *Hans Hofmann*. New York: Museum of Modern Art, 1963.
Wight, Frederick S. *Hans Hofmann*. New York: Whitney Museum of American Art, 1957.

Holty

Holty, Carl. "The Mechanics of Creativity of a Painter: A Memoir." *Leonardo* I (1968).

————. "Mondrian in New York: A Memoir." *Arts* 31 (September 1957): 17–21.

Milwaukee: Milwaukee Art Museum. *Carl Holty: The World Seen and Sensed.* 1980. Essay by I. Michael Danoff.

New York: City University of New York. *Carl Holty/Fifty Years.* 1972. Essay by Patricia Kaplan.

Rembert, Virginia Pitts. "Carl Holty." *Arts* 55 (December 1980): 11.

————. "Mondrian, America, and American Painting." Ph.D. dissertation, Columbia University, 1970, pp. 234–41.

Washington: Archives of American Art, Smithsonian Institution. Carl Holty Papers, ND68: 93.

————. Hilaire Hiler Papers, D302.

Holtzman

Rembert, Virginia Pitts. "Mondrian, America, and American Painting." Ph.D. dissertation, Columbia University, 1970.

Troy, Nancy J. *Mondrian and Neo-Plasticism in America.* New Haven: Yale University Art Gallery, 1979.

Jonson

Albuquerque: University of New Mexico, Jonson Gallery. *Raymond Jonson: A Retrospective Exhibition.* 1964.

Garman, Ed. *The Art of Raymond Jonson, Painter.* Albuquerque: University of New Mexico Press, 1976.

Monte, James. *The Transcendental Painting Group, New Mexico 1938–41.* Albuquerque: Albuquerque Museum, 1982.

Kelpe

Long Beach, Calif.: Long Beach Museum of Art. *Paul Kelpe: American Abstract Artist.* 1980. Essays by Susan C. Larsen and Kent Smith.

Springfield: Illinois State Museum. *The Emergence of Modernism in Illinois 1914–1940.* 1976. Essay by Robert Evans.

Lassaw

Heller, Nancy Gale. "The Sculpture of Ibram Lassaw." Ph.D. dissertation, Rutgers University, 1982.

Lassaw, Ibram. "On Inventing Our Own Art." *American Abstract Artists Yearbook*, section VIII. New York, 1938.

————. "Perspectives and Reflections of a Sculptor: A Memoir." *Leonardo* I (1968): 351–61.

Marter, Joan; Tarbell, Roberta; and Wechsler, Jeffrey. *Vanguard American Sculpture 1913–1939.* New Brunswick: Rutgers University Art Gallery, 1979.

Sandler, Irving. "Ibram Lassaw." In *Three American Sculptors*, pp. 45–57. New York: Grove Press, 1959.

Sawin, Martica. "Ibram Lassaw." *Arts* 30 (December 1955): 22–26.

Strickler, Susan Elizabeth. "The Sculpture of Ibram Lassaw: Its Relationship to Abstract Expressionism." M.A. thesis, University of Delaware, 1977.

Léger

Giedion, Siegfried. "Léger in America." *Magazine of Art* 38 (December 1945): 295–99.

Janis, Sidney. "School of Paris Comes to U.S." *Decision*, Vol. II, no. 5–6 (November-December 1941): 85–95.

Kotik, Charlotta. "Léger and America." In *Fernand Léger*, pp. 41–59. New York: Abbeville Press, 1982.

Kuh, Katharine. *Léger.* Urbana: University of Illinois Press, 1953.

Leger, Fernand. *Functions of Painting.* Edited by Edward F. Fry. New York: Viking Press, 1973.

[Léger, Fernand.] "Chicago." *Plans* (Paris) 2, no. 11 (January 1932): 63–68.

[Léger, Fernand.] "New York vu par Fernand Léger." *Cahiers d'Art*, 6e année, no. 9–10 (1931): 437–39. Reprinted in English in *Artforum* 7 (May 1969): 52–55.

Morris, George L. K. "Fernand Léger Versus Cubism." *The Museum of Modern Art Bulletin*, Vol. III, no. 1 (1935).

Sweeney, James Johnson. "Eleven Europeans in America: Fernand Léger." *The Museum of Modern Art Bulletin*, Vol. XIII, no. 4–5 (1946): 13–15, 38.

Mason

Brown, Marilyn R. *Two Generations of Abstract Painting: Alice Trumbull Mason–Emily Mason.* New Orleans: Tulane University Gallery, 1982.

Mason, Alice Trumbull. "Concerning Plastic Significance." *American Abstract Artists 1938.* New York, 1938, pp. VI–VIa.

Pincus-Witten, Robert. *Alice Trumbull Mason (1904–1971).* New York: Whitney Museum of American Art, 1973.

Washington: Archives of American Art, Smithsonian Institution. Alice Trumbull Mason Papers.

Matulka

Foresta, Merry A., and Sims, Patterson. *Jan Matulka 1890–1972.* Washington: Smithsonian Institution Press, 1980.

Moholy-Nagy

Engelbrecht, Lloyd C. "László Moholy-Nagy: Perfecting the Eye by Means of Photography," *Photography by Moholy-Nagy from the Collection of William Larson.* Claremont, California: The Galleries of the Claremont Colleges, 1975.

Kostelanetz, Richard. *Moholy-Nagy.* New York: Praeger Publishers, 1970.

Lukach, Joan M. *Hilla Rebay: In Search of the Spirit in Art.* New York: George Braziller, forthcoming 1983.

Moholy-Nagy, László. *The New Vision*. New York: Brewer, Warren and Putnam, 1930; 4th revised ed., New York: Wittenborn, 1947.
———. *Vision in Motion*. Chicago: Paul Theobald, 1947.
Moholy-Nagy, Sibyl. *Moholy-Nagy: Experiment in Totality*. New York: Harper & Brothers, 1950.
Russell, John. *The Meanings of Modern Art*. New York: Harper & Row, 1981.

Mondrian

Holty, Carl. "Mondrian in New York: A Memoir." *Arts* 31 (September 1957): 17–21.
Mondrian, Piet. *Plastic Art and Pure Plastic Art, 1937, and Other Essays, 1941–1943*. New York: Wittenborn, 1945.
New York: Solomon R. Guggenheim Museum. *Piet Mondrian 1872–1944 Centennial Exhibition*. 1971.
Rembert, Virginia Pitts. "Mondrian, America, and American Painting." Ph.D. dissertation, Columbia University, 1970.
Seuphor, Michel. *Piet Mondrian: Life and Work*. New York: Harry N. Abrams, 1956.
Stuttgart: Staatsgalerie. *Mondrian: Zeichnung, Aquarelle, New Yorker Bilder*. 1981.
Toronto: Art Gallery of Ontario. *Piet Mondrian 1872–1944*. 1966.
Troy, Nancy J. *Mondrian and Neo-Plasticism in America*. New Haven: Yale University Art Gallery, 1979.
Welsh, Robert. "Landscape into Music: Mondrian's New York Period." *Arts* 40 (February 1966): 33–39.
Wiegand, Charmion von. "Mondrian: A Memoir of His New York Period." *Arts Yearbook* 4 (1961): 57–65.

Morris

American Abstract Artists, Three Yearbooks (1938, 1939, 1946), reprint ed., New York: Arno Press, 1969.
Hoopes, Donelson. "The Art of George L. K. Morris." *George L. K. Morris Retrospective Exhibition of Painting and Sculpture 1930–1964*. Washington: Corcoran Gallery of Art, 1965.
Jackson, Ward. "George L. K. Morris: Forty Years of Abstract Art." *Art Journal* 32 (Winter 1972–73): 150–56.
Larsen, Susan C. "The American Abstract Artists Group: A History and Evaluation of Its Impact Upon American Art." Ph.D. dissertation, Northwestern University, 1975.
Lorenz, Melinda A. *George L. K. Morris, Artist and Critic*. Ann Arbor, Mich.: UMI Research Press, 1982.
Morris, George L. K. "What Abstract Art Means to Me." *Museum of Modern Art Bulletin* 18 (Spring 1951).
Petruck, Peninah R. Y. "American Art Criticism 1910–1939." Ph.D. dissertation, New York University, 1979.
Stross, Dorian H. "George L. K. Morris: Artist and Advocate of Abstract Art, or How a Millionaire Found Meaning Through Modern Art." M.A. thesis, Wayne State University, 1976.

Noguchi

Friedman, Martin. *Noguchi's Imaginary Landscapes*. Minneapolis: Walker Art Center, 1978.

Grove, Nancy, and Botnick, Diane. *The Sculpture of Noguchi 1924–79*. New York: Garland Press, 1982.
Hunter, Sam. *Isamu Noguchi*. New York: Abbeville Press, 1978.
New York: Whitney Museum of American Art. *Isamu Noguchi, the Sculpture of Spaces*. 1980. Essay by Isamu Noguchi.
Noguchi, Isamu. *A Sculptor's World*. New York: Harper & Row, 1968.

Pereira

Baur, John I. H. *Loren MacIver—I. Rice Pereira*. New York: Whitney Museum of American Art, 1953.
McCausland, Elizabeth. "Alchemy and the Artist: I. Rice Pereira." *Art in America* 35 (July 1947): 177–86.
Pereira, Irene Rice. *The Lapis*. New York: By the Author, 1957.
———. *The Nature of Space: A Metaphysical Inquiry*. By the Author, 1956; reprint ed., Washington: Corcoran Gallery of Art, 1968.
Washington: Archives of American Art, Smithsonian Institution. Irene Rice Pereira Papers, Roll 223.

Reinhardt

Düsseldorf: Stadtische Kunsthalle. *Ad Reinhardt*. 1972.
Lippard, Lucy R. *Ad Reinhardt*. New York: Harry N. Abrams, 1981.
Reinhardt, Ad. *Art-as-Art: The Selected Writings of Ad Reinhardt*, ed. Barbara Rose. New York: Viking Press, 1975.
Rowell, Margit. *Ad Reinhardt and Color*. New York: The Solomon R. Guggenheim Museum, 1980.
Sims, Patterson. *Ad Reinhardt: A Concentration of Works from the Permanent Collection of the Whitney Museum of American Art*. New York: Whitney Museum of American Art, 1981.

Roszak

Arnason, H. H. *Theodore Roszak*. Minneapolis: Walker Art Center, 1956.
Marter, Joan. "Theodore Roszak's Early Constructions: The Machine as Creator of Fantastic and Ideal Forms." *Arts* 54 (November 1979): 110–13.
Marter, Joan; Tarbell, Roberta; and Wechsler, Jeffrey. *Vanguard American Sculpture 1913–1939*. New Brunswick: Rutgers University Art Gallery, 1979.
Roszak, Theodore. "In Pursuit of an Image." *Quadrum* 2 (November 1956): 49–60.
———. "Some Problems of Modern Sculpture." *Magazine of Art* 42 (February 1949): 53–56.
———. [Untitled statement]. In Dorothy Miller, ed. *Fourteen Americans*, pp. 58–59. New York: Museum of Modern Art, 1946.
Sawin, Martica. "Theodore Roszak: Craftsman and Visionary." *Arts* 31 (November 1956): 18–19.

Scarlett

Guelph, Ontario. Catalogue of the University of Guelph Art Collection, 1979, p. 317.

Jellinek, Roger. "Rolph Scarlett—Twentieth Century Painter." *Canadian Art* 22 (May 1965): 23–25.

Lukach, Joan M. *Hilla Rebay: In Search of the Spirit in Art*. New York: George Braziller, forthcoming 1983.

New York: The Solomon R. Guggenheim Museum. The Hilla von Rebay Archive.

———. Washburn Gallery. *Rolph Scarlett: Works from c. 1940*. 1982.

Sennhauser

There is no in-depth biographical or critical writing on this artist.

Shaw

Larsen, Susan C. "Through the Looking Glass with Charles Shaw." *Arts* 51 (December 1976): 80–82.

Morris, George L. K. "Charles Green Shaw." *The Century Yearbook 1975*. New York: The Century Association, 1975.

Pennington, Buck. "The 'Floating World' in the Twenties: The Jazz Age and Charles Green Shaw." *Archives of American Art Journal*, Vol. 20, No. 4 (1980): 17–24.

Shaw, Charles G. "The Plastic Polygon." *Plastique: Paris–New York* 3 (Spring 1938): 28–29.

———. "A Word to the Objector." *American Abstract Artists 1938*. New York: privately printed, 1938, pp. 9–11.

Slobodkina

Slobodkina, Esphyr. *American Abstract Artists*. Great Neck, N.Y.: privately printed, 1979.

———. *Notes for a Biographer*. Great Neck, N.Y.: privately printed, 1978.

Smith

Carmean, E. A., Jr. *David Smith*. Washington: National Gallery of Art, 1982.

Cone, Jane Harrison. *David Smith 1906–1965: A Retrospective Exhibition*. Cambridge: Fogg Art Museum, Harvard University, 1966.

Cummings, Paul. *David Smith, The Drawings*. New York: Whitney Museum of American Art, 1979.

Fry, Edward F. *David Smith*. New York: Solomon R. Guggenheim Foundation, 1969.

———, and McClintic, Miranda. *David Smith, Painter, Sculptor, Draftsman*. New York: George Braziller, in association with Hirshhorn Museum and Sculpture Garden, Smithsonian Institution, Washington, 1982.

Gray, Cleve, ed. *David Smith by David Smith*. New York: Holt, Rinehart and Winston, 1968.

Greenberg, Clement. *Art and Culture*. Boston: Beacon Press, 1961.

Krauss, Rosalind F. *Terminal Iron Works, The Sculpture of David Smith*. Cambridge, Mass., and London: The MIT Press, 1971.

McClintic, Miranda. *David Smith, The Hirshhorn Museum and Sculpture Garden Collection*. Washington: Smithsonian Institution Press, 1979.

McCoy, Garnett, ed. *David Smith*. New York and Washington: Praeger Publishers, 1973.

Wilkin, Karen. *David Smith: The Formative Years*. Edmonton, Canada: Edmonton Art Gallery, 1981.

Storrs

Bryant, Edward. "Rediscovery: John Storrs." *Art in America* 57 (May–June 1969): 66–71.

Davidson, Abraham A. "John Storrs, Early Sculptor of the Machine Age." *Artforum* 13 (November 1974): 41–45.

Frackman, Noel. "John Storrs and the Origins of Art Deco." M.A. thesis, Institute of Fine Arts, New York University, 1975.

Kirshner, Judith Russi. *John Storrs: A Retrospective Exhibition of Sculpture*. Chicago: Museum of Contemporary Art, 1977.

Kramer, Hilton. *The Age of the Avant-Garde*. New York: Farrar, Straus & Giroux, 1973.

Marter, Joan; Tarbell, Roberta; and Wechsler, Jeffrey. *Vanguard American Sculpture 1913–1939*. New Brunswick: Rutgers University Art Gallery, 1979.

Tarbell, Roberta K. "John Storrs and Max Weber: Early Life and Work." M.A. thesis, University of Delaware, 1968.

Washington: Archives of American Art, Smithsonian Institution, John Storrs Papers. Gift of Monique Storrs Booz.

Williamstown, Mass.: Sterling and Francine Clark Art Institute. *John Storrs & John Flannagan: Sculpture & Works on Paper*. 1980. Essays by Jennifer Gordon, Laurie McGavin, Sally Mills, and Ann Rosenthal.

Swinden

Swinden, Albert. "On Simplification." In *American Abstract Artists 1938 Yearbook*. New York: privately printed, 1938.

Vytlacil

Campbell, Lawrence. *Vaclav Vytlacil: Paintings and Constructions from 1930*. Montclair: Montclair Art Museum, 1975.

Larsen, Susan C. "The American Abstract Artists Group: A History and Analysis of Its Impact Upon American Art." Ph.D. dissertation, Northwestern University, 1975. Interview with Vaclav Vytlacil, pp. 573–86.

Xceron

Ashton, Dore. "Jean Xceron." *XXᵉ Siècle* 23, no. 16 (May 1961), n.p.

"Radar: A Non-Objective Painter Tries to Marry Science and Art on Canvas." *Life*, February 2, 1948, p. 69.

Robbins, Daniel. *Jean Xceron*. New York: Solomon R. Guggenheim Museum, 1965.

[Xceron, Jean.] Statement, *Cercle et Carré*, No. 2, Paris (April 15, 1930).

INDEX

Page numbers are in roman type. Pages on which works of art appear are indicated in *italic* type. All works of art are listed under the artist's name.

A

Abstract Expressionism, 13, 14, 32, 39, 43, 66, 78, 171, 198, 209
"Abstraction and Empathy" (Worringer), 34
Abstraction-Création Non-Figuratif, 20, 35; exhibitions of, 16, 167; founding of, 16, 167; influence of, 78, 161, 164, 174, 176, 236; members of, 16, 27, 59, 147, 167, 172, 194
Abstraction-Création Non-Figuratif, journal, 16, 17, 167
"Abstract Painting in America," exhibition, Whitney Museum of American Art, 11, 20–21, 65
Académie de l'Art Contemporain, Paris, 184
Académie Moderne, Paris, 17, 184
A.C.A. Gallery, New York City, 191
"Action Painting," 69
Adoian, Vosdanig Manoog, see Gorky, Arshile
African art, 30, 31, 43, 223
Albers, Anni, 46
Albers, Josef, 43, 49, 51, 162; AAA and, 36, 39, 46; *b and p*, 46–47, *81*; critical essay on, 46–47; exhibitions, 37, 39, 46, 47; "Homage to the Square" series, 39, 46; *Penetrating (B)*, 47, *47*; photograph of, *46*; as teacher, 39, 46, 47, 51; as writer, 46
Albright-Knox Art Gallery, Buffalo, New York, 147
Allerton Gallery, Chicago, 211
Allianz group, 147
American Abstract Artists (AAA), 36–39, 40, 43, 48, 52, 60, 78, 150, 166; exhibitions, 36, 37–38, 40, 42, 46, 51, 72, 79, 146, 147, 172, 176, 183, 190, 193, 198, 200, 216, 219, 221, 229, 232; founding members of, 46, 51, 58, 74, 164, 172, 180, 183, 187, 200, 231; founding of, 35–36, 79, 161, 168, 176, 229; lithographs produced by, 71; members of, 72, 79, 171, 190, 196, 198, 208, 216, 219, 220, 221, 236; objectives of, 36, 162; protests by, 39, 58; viewpoint of, 11; Yearbook of, 162, 166, 200, 229, cover for (Greene, B.), 162, *162*
American Artists' Congress, 12, 31, 58, 65, 79, 176, 208
American Artists' School, 208
American Art Today Building, New York World's Fair, 176
American Fine Arts Society, New York City, 37–38
"American Geometric Abstraction in the 1930s," exhibition, Zabriskie Gallery, 181
American Indian art, 30, 198, 199
American Scene painting, 21, 26, 27, 34, 64, 65, 196
Analytic Cubism, 70, 194
Anderson, Karl, 208
Animal Sketching (Calder), 59
Anshutz, Thomas, 227
Anuskiewicz, Richard, 47
Archipenko, Alexander, 182
Armory Show, 15, 17, 20, 63, 178
Arp, Jean, 15, 26, 147, 192, 213, 236; exhibitions, 18, 25, 42; influence of, 16, 17, 26, 34, 35, 51, 54, 59, 60, 78, 182, 199, 202, 218; *Vase Buste*, 165; as writer, 200
Art and the Great War (Gallatin), 144
Art as Experience (Dewey), 22
Art as the Evolution of Visual Knowledge (Biederman), 50
Art Center, New York City, 190
"Art Chronicle" column (Morris), *Partisan Review*, 26, 38
Art Concret, Paris, 167, 236

"Art Critics—! How Do They Serve the Public? What Do They Say? How Much Do They Know? Let's Look at the Record!," AAA pamphlet, 39
Art Deco movement, 227
Art Front, journal, 10, 12, 22, 24, 31, 34, 58, 65, 190
"Art in Our Time," exhibition, Museum of Modern Art, 38, 39
Art Institute of Chicago, 70, 186; School of, 48, 172, 178, 211, 227
Artists Equity, 200
Artists Gallery, New York City, 190, 209
"Artists in Exile," exhibition, Pierre Matisse Gallery, 42
Artists' Union, 22, 24, 31, 58, 64–65, 164, 176, 190, 208, 221
Art News, 161
Art of This Century Gallery, New York City, 42, 168, 171
Art of Tomorrow, the Museum of Non-objective Painting, New York City, see Museum of Non-objective Painting, New York City
Arts Club, Chicago, 50
Art Students League, New York City, 21; exhibitions at, 28, 70, 189, 229; students at, 21, 23, 27, 28, 52, 59, 70, 71, 157, 172, 175, 189, 190, 198, 205, 218, 223, 229, 231; teachers at, 21, 23, 27, 28, 52, 58, 170, 172, 175, 189, 190, 205, 218, 223, 229, 231
Aubrey Beardsley's Drawings (Gallatin), 144
Avery, Milton, 223
Axis, publication, 167

B

Balla, Giacomo: *Dog on a Leash*, 25
Ballet mécanique, film, 184
Ballet Suédois, 184
Barr, Alfred H., Jr., 48, 193; Cubism and, 31; Museum of Modern Art and, 12, 19, 26, 37, 41, 42, 164; views on art, 12, 21, 26
Bartlett, Paul, 227
Bauer, Rudolf, 40, 41, 193, 214, 215; *Great Fugue*, 214, *215*
Bauhaus, Germany, 23, 39, 46, 74, 211, 213; influence of, 16, 34, 49, 205, 211, 213; teachers at, 10, 15, 39, 46, 192
Baur, John I. H., 35
Baziotes, William, 42, 171
Becker, John, Gallery, New York City, 168, 186
Bel Geddes, Norman, 213
Bengelsdorf, Rosalind, 22, 35, 52, 166, 190
Benton, Thomas Hart, 15, 20, 21, 24, 27, 151, 218
Berenson, Bernard, 31
Berlin Secession, 170
Bichier, see Hélion, Jean
Biddle, George, 22
Biederman, Charles, 16, 18, 42, 43; artistic goal of, 218–19; critical essay on, 48–50; exhibitions, 25, 26, 48, 50; influences on, 26, 48–49; *New York, July 1936*, 26, 49; *No. 2, New York, February 1940*, 49, *49*; *No. 9, New York, July 1940*, 49–50, *50*; *No. 11, New York, 1939–40*, 49, *84*; in Paris, 26, 48; photograph of, *48*; as student, 48; *Work No. 3, New York, 1939*, 49, *83*; *Work No. 16, New York, 1938–39*, 43; as writer, 50
Bigelow, Barbara, 36
Bisttram, Emil, 179
Black Mountain College, North Carolina, 39, 46, 47, 51, 69
Blair, Jean, 168

Blaue Reiter, 42
Bliss, Lillie B., 19
Bluemner, Oscar, 20
Bock, Arthur, 227
Bolotowsky, Ilya, 17, 18, 33–34, 39, 42; AAA and, 36, 38, 39, 51, 52; *Abstraction (No. 3)*, 34, 54, *85*; artistic theories of, 34, 43; *Blue Diamond*, 34, 54, *87*; *Construction in a Square*, 34, 54, *55*; critical essay on, 51–52, 54; exhibitions, 33, 41, 51; friendships, 33, 35, 52, 54, 79, 166, 187, 229; influences on, 32, 34, 40, 51, 52, 54, 196; marriage of, 221; Mural for Medicine and Public Health Building, New York World's Fair, 23, 33–34, 54, study for, 34, *86*; *Painting*, 33, *53*, 54; photograph of, *51*; *Untitled*, *53*; *White Abstraction*, 33, *52*, 54; WPA and, 22, 23, 33, 51, 72, 221
Borgenicht, Grace, Gallery, New York City, 51
Bouchard, Thomas, 186
Bourgeois, Louise, 231
Bowden, Harry, 23
Brancusi, Constantin, 15, 16, 18, 48; *Fish*, 202; friendships, 17, *192*; influence of, 16, 78, 164, 165, 182, 202
Braque, Georges, 17, 39, 79, 170; Cubism and, 15, 52; exhibition, 38; influence of, 31, 51, 52, 56, 63, 184
Breton, André, 14, 39, 42, 186
Bronx School of Arts and Sciences, 162
Brooklyn College, Brooklyn, New York, 72, 74, 174, 177, 209
Brooklyn Museum, 35, 78; exhibitions at, 18, 63, 175, 182, 196, 227
Browne, Byron, 18, 21, 32–33; AAA and, 35, 58, 190; *Arrangement*, 56, *57*; *Classical Still Life*, 56, *58*; critical essay on, 56, 58; exhibitions, 20, 37, 58; friendships, 33, 58, 166; influences on, 33, 56, 58; *Non-Objective Composition*, 33, 56, *57*; photograph of, *56*; *Still Life with Apples* (1935), 56, *57*; *Still Life with Apples* (1944), 56, 58, *58*; as teacher, 58; WPA and, 22, 23, 58, 72, 186; as writer, 58
Bruce, Patrick Henry, 16, 20, 189
Burchfield, Charles, 20

C

Cahiers d'Art, journal, 16, 18, 48, 56, 71, 182, 186, 223
Cahill, Holger, 22, 23, 24, 176
Calder, Alexander, 26, 27, 37, 70, 186, 202, 213; *Animal Sketching*, 59; artistic goal of, 218, 219; *Circus*, 59; *Constellation*, 42, 60, *90*; "Constellations" series, 60; *Constellation with Quadrilateral*, 60, *62*; *Construction*, 26, *61*; critical essay on, 59–60, 62; *Dancers and Sphere*, 60, 89; exhibitions, 16, 19, 25, 26, 41, 42, 59, 60, 182; *Grande Vitesse, La*, Grand Rapids, Michigan, 62; influence of, 71, 182; influences on, 16, 26, 40, 42, 59, 60, 168; International Arrivals Building, Kennedy International Airport, mobile for, 62; *Man*, World's Fair, Montreal, 62; *Mercury Fountain*, Spanish Pavilion, Paris Exposition, 62; New York World's Fair, fountain for, 62; in Paris, 16, 26, 59; *Pistil, The*, 59–60, *60*; photograph of, *59*; as set designer, 60, 62; *Sol Rojo, El*, Aztec Stadium, Mexico City, 62; *Teodelapio*, stabile, 62; UNESCO Building, Paris, mobile for, 62; *Untitled*, hanging mobile for ballroom, Hotel Avila, Caracas, Venezuela, 60, *62*
Carles, Arthur, 36
Carles, Mercedes, 36
Carnegie Institute, Pittsburgh, 191
Cassirer, Paul, 170

Cavallon, Giorgio, 22, 36, 58
Cendrars, Blaise, 184
Cercle et Carré, Paris, 16, 194, 236
Cézanne, Paul, 18, 21, 26, 146; Cubism and, 231; influence of, 23, 29, 48, 50, 70, 144, 150, 184, 187, 194, 231, 233
Chabrol, Marguerite Deville, 227
Chagall, Marc, 186
Chai Pai Shi, 202
Chicago Tribune, Paris edition, 233
Chirico, Giorgio de, 30, 69, 156, 160, 211; *Fatal Temple, The*, 152
Christie, A. N., 36
Civic Club, New York City, 147
Clausewitz, Karl von, 174
Club, The, 78
Coates, Robert, 38
Columbia University, New York City, 37
Concerning the Spiritual in Art (Kandinsky), 178
Constructivism, 59, 146, 200, 219; Czech, 211; exhibitions, 18, 28; influence on American art, 16, 23, 26, 28, 35, 40, 41, 42, 56, 60, 71, 78, 164, 165, 182, 192, 193, 211, 213; in Paris, 15, 16; Russian, 15, 16, 19, 28, 180, 192; Swiss, 147; writings about, 19, 34
Cooper Union, New York City, 78
Cor Ardens, artists' organization, 178
Corbett, Harvey Wiley, 186
Cornell, Joseph, 42
Craig, Martin, 22, 23, 36
Craven, Thomas, 21, 25
Criss, Francis, 22, 23, 190, 208
Crowninshield, Frank, 157
Cubism, 11, 13, 21, 146, 167, 188, 196; American forms of, 10, 17, 20, 21, 27, 33, 41; Braque and, 15, 52; Cézanne, relation to, 231; Davis and, 10, 17, 31, 63, 64, 66, 174; evolution of, 19; exhibitions of, 15, 18, 25 (see also "Cubism and Abstract Art," exhibition, Museum of Modern Art); founders of, 15; influence on American art, 28, 29, 31, 32, 33, 41, 48, 52, 56, 64, 66, 78, 79, 80, 150, 162, 170, 172, 174, 184, 189, 198, 223, 227; influence on European art, 15; Picasso and, 15, 52, 65, 174, 187, 224; post-Cubist trends, 13, 161; reactions against, 20, 28, 33, 40, 42, 194, 224; subject matter and, 10; Surrealism vs., 14, 40, 42; writings about, 16, 19, 25, 26, 34; see also Analytic Cubism; Synthetic Cubism
"Cubism and Abstract Art," exhibition, Museum of Modern Art, 12, 19–20, 25, 26, 37, 39, 48, 59, 164, 166
Curry, John Steuart, 15, 20, 24

D

Dabrovsky, Ivan Gratianovitch, see Graham, John
Dada, 15, 17, 18, 42, 200
Dali, Salvador, 42
Dasburg, Andrew, 20
Daugherty, James, 189
Davies, Arthur B., 18
Davis, Stuart, 31–32, 37, 70, 150, 152, 186, 202; abstractions from nature, 11, 14; artistic philosophy of, 11, 12, 21, 24, 31–32, 63, 65, 66, 80; artistic purpose of, 10, 63, 66; Brooklyn College Faculty Lounge, mural for, 65; critical essay on, 63–66; Cubism and, 10, 17, 31, 63, 64, 66, 174; *Eggbeater No. 1*, 32, 63, *91*; "Eggbeaters" series, 21, 32, 63; exhibitions, 20, 63, 65, 189; friendships, 31, 33, 64, 68, 160, 172, 189, 223; *Hot Still-scape for 6 Colors—7th Ave. Style*, 32, *67*; *House and Street*, 32, 66; influence of, 23, 30, 31, 32, 33, 38, 64, 65, 199, 208; influences on, 40, 63, 64, 65, 160;

Landscape, 64, 67; in Paris, 16–17, 64, 189; photograph of, *63*; Radio Station WNYC, mural for, 23, 65; *Report from Rockport*, 32, 65, *93*; *Sail Loft*, 32, 64, 67; social and political beliefs of, 12, 13, 24, 31, 65; as student, 63; *Super Table*, 63; *Swing Landscape*, mural for Williamsburg Housing Project, 64, 65; as teacher, 65, 189; *Terminal*, 65, *92*; *Ultramarine*, 11, 66, *94*; WPA and, 22, 23, 65, 72; as writer, 10, 11, 13, 21, 22, 24, 63, 64–65
Davis, Wyatt, 152, 190
Dehner, Dorothy, 21, 190, 223, 224
de Kooning, Willem, 18–19, 32, 39, 171; AAA and, 36; critical essay on, 68–69; exhibitions, 69; friendships, 30, 31, 32, 33, 64, 68, 150, 160, 177, 223; immigration to New York, 17, 30, 68; influence of, 33, 69; influences on, 30, 32, 33, 42, 168; photograph of, *68*; as student, 68; as teacher, 69; *Untitled*, 32, 68–69, *95*; *Wave, The*, 32, 69, *69*; WPA and, 22, 23, 68, 186
Delaunay, Robert, 78, 147, 170, 172, 192, 199
Delaunay, Sonia, 147
Dělnik Kalendar, journal, 189
Delphic Studios, New York City, 46
Demuth, Charles, 15, 20, 144, 146
Denby, Edwin, 68
Denslow, Dorothea, 182
Depression, 21–22, 24, 196
Design Laboratory, New York City, 213
De Stijl, 15, 17, 18, 71, 194
Deutsch, Sid, Gallery, New York City, 222
Dewey, John, 22, 193
Diamond, Martin, Fine Arts, New York City, 74, 216, 232
Diebenkorn, Richard, 168
Diller, Burgoyne, 18, 29, 34, 43, 162; AAA and, 35, 36, 38; artistic goals of, 30; *Construction* (1934), 71, *73*; *Construction* (1938), 71–72, *97*; *Construction No. 16*, 28, 71–72, *96*; critical essay on, 70–72; exhibitions, 28, 70, 72; *First Theme*, *98*; friendships, 28, 52, 54, 70, 71, 175, 229; influences on, 16, 23, 28, 40, 42, 70, 71, 72, 196; photograph of, *70*; *Second Theme*, 28, 71, *73*; as student, 21, 23, 28, 52, 70, 71, 171, 190; as teacher, 72; *Third Theme*, 71, 72; *Untitled*, 28, 71, 72; *Untitled No. 21 (Second Theme)*, *99*; WPA and, 22, 23, 29, 33, 34, 72, 164, 176, 180, 186, 190, 208
"Dissertation on Modern Painting" (Hartley), 15
Doesburg, Theo van, 17, 28, 71, 147, 167, 194, 236
Dombrowski, Ivan Gratianovitch, *see* Graham, John
Domela, César, *see* Niewenhuis-Domela, César
Dos Passos, John, 186
Dove, Arthur, 20, 187
Downtown Gallery, New York City, 65
Dreier, Katherine, 17–18, 19, 21, 28, 46, 70, 147, 189, 190, 196
Drewes, Werner, 20, 22, 36, 41, 46, 70; *City (Third Avenue El)*, 74, *100*; critical essay on, 74; *Escape*, 74, *75*; "Manhattan" woodcuts, 74; photograph of, *74*
Duchamp, Marcel, 17, 42, 59, 148, 196
Dudensing Gallery, New York City, 157
Dufy, Raoul, 170
"Dymaxion House" drawings (Fuller), 182

E

Eakins, Thomas, 39
Egan, Charles, Gallery, New York City, 69
Eight, The, 20, 63

Emanuel, Herzl, 190
Emerson, Ralph Waldo, 179
Ernst, Max, 18, 39, 42, 78, 186
Everen, Jay Van, 189
"Evolution of Abstract Art, The" (Hélion), 168
Exposition Internationale des Arts Décoratifs, Paris (1925), decorations for French Ambassador's Pavilion (Léger), 184
"Expression as Production" (Greene, B.), in AAA Yearbook, 162
Expressionism, 26; *see also* Abstract Expressionism; German Expressionism

F

"Fantastic Art, Dada and Surrealism," exhibition, Museum of Modern Art, 42
Fauvism, 15, 26, 170
Federation of Modern Painters and Sculptors, 79, 200, 216, 222
Feininger, Lyonel, 37
Ferber, Herbert, 183
Ferren, John Millard, 17, 25, 26–27, 39, 41, 176, 218; *Composition*, 77, 78, 168; critical essay on, 76, 78; photograph of, *76*; *Untitled*, 27, 78, 101; *Untitled (JF 7)*, 76, 77, 78
Ferrier, Gabriel, 184
"First Biennial of Contemporary American Painting," exhibition, Whitney Museum of American Art, 65
"First Papers of Surrealism," exhibition, Reid Mansion, 42, 60
"Five Contemporary American Concretionists: Biederman, Calder, Ferren, Morris, and Shaw," exhibition, Reinhardt Galleries, 25–27, 48, 59, 219
Folsom Galleries, New York City, 227
Force, Juliana, 63–64
Foujita, Tsugouharu, 202
Fourth Dimension, The (Hinton), 205
Frankenthaler, Helen, 171
Frelinghuysen, Suzy, 37, 146, 166, 200, 220; *Composition*, 79–80, *102*; *Composition—Toreador Drinking*, 79; critical essay on, 79–80; photograph of, *79*; *Still Life*, 80, *80*
Freud, Sigmund, 161
Fried, Rose, 51
Fried, Rose, Gallery, New York City, 236
Frontier, ballet, 203
Fuller, Buckminster, 182
Futurism, 18, 227

G

Gabo, Naum, 16, 148, 176; exhibitions, 18, 42; influence of, 26, 35, 49, 164, 182
Galerie Cahiers d'Art, Paris, 167
Galerie de France, Paris, 236
Galerie Percier, Paris, 59, 236
Galerie Pierre, Paris, 48, 167
Gallatin, Albert Eugene (A. E.), 21, 29, 48; AAA and, 146, 200, 220; as artist, 17, 19, 27, 36, 39, 78, 79, 80, 144, 146; as collector, 17, 18, 19, 25, 27, 35, 41, 43, 56, 79, 144, 146, 164, 165, 175, 187, 196; *Composition No. 70*, *103*; critical essay on, 144, 146; as curator, 25, 26, 31, 59, 187, 219; friendships, 17, 19, 27, 146, 168, 199, 200, 218, 220; photograph of, *144*; *Untitled*, *145*; as writer, 144, 146; *see also* Gallery of Living Art, New York University; Museum of Living Art, New York University, New York City
Gallery of Living Art, New York University, New York City, 18–19, 20, 27, 48, 56, 79, 146, 152, 168, 196; installation views of, *146*; *see also* Museum of Living Art, New York University, New York City

Gallery 291, New York City, 15
Gargallo, Pablo, 223
Garland Gallery, New York City, 236
Gauguin, Paul, 26
Genauer, Emily, 25
German Expressionism, 18, 70, 192
Gérôme, Jean-Léon, 184
Gestalt psychology, 65, 66
Giacometti, Alberto, 19, 43, 54, 183; *Palace at 4 A.M., The*, 54, 224, *224*
Gidding, Jaap, 68
Gidding, Jan, 68
Gilmour, Leonie, 202
Glarner, Fritz, 37, 196; *Composition*, 148; critical essay on, 147–49; *Painting*, *104*, 147; *Peinture Relative*, 148, 149, *149*; photograph of, *147*; *Relational Painting*, 149, *149*; *Relational Painting, Tondo No. 1*, *105*, 148–49
Gleizes, Albert, 16, 236
Gogh, Vincent van, 19
Golden Gate International Exposition, San Francisco, 179
González, Julio, 43, 160, 182, 223
Gorky, Arshile, 11, 14, 18, 19, 29–30, 34, 70, 80, 171, 186, 213; AAA and, 36, 150; *Activities on the Field*, 152, *152*, *153*; *Aviation: Evolution of Forms under Aerodynamic Limitations*, Newark Airport mural, 13, 23, 150, 152, *152*, *153*, 168; *Composition (Still Life)*, 152, *154*; critical essay on, 150–52, 156; *Enigmatic Combat*, 30, *107*, 152, 156; exhibitions, 20, 42, 189; friendships, 29, 30, 31, 32, 64, 68, 150, 160, 189, 223; *Garden in Sochi*, 30, 156, *156*; "Garden in Sochi" series, 30, 156; immigration to New York, 17; influence of, 33, 39, 58, 66, 151; influences on, 23, 29, 30, 31, 32, 33, 40, 42, 150, 151, 152, 156, 160, 168, 187; *Liver Is the Cock's Comb, The*, 68, 156, *156*; *Mojave*, 156, *156*; *Nighttime, Enigma and Nostalgia*, 33, 151, 151–52; "Nighttime, Enigma and Nostalgia" series, 30, 69, 151, 151–52, *153*; *Organization*, 30, 152, frontispiece; *Organization (Nighttime, Enigma and Nostalgia)*, 152, *153*; photograph of, *150*; *Still Life*, *106*, 151, 152; *Still Life (Composition with Vegetables)*, 150–51, *151*; as teacher, 150, 187; technique of, 151; *Untitled*, 152, *153*; WPA and, 22, 23, 72, 150; as writer, 64
Gorky, Maxim, 150
Gottlieb, Adolph, 43, 58, 68, 223
Grafly, Charles, 227
Graham, John, 11, 18, 70, 150; as art dealer, 31, 157; artistic philosophy of, 31, 157–58; *Blue Abstraction (Still Life)*, *109*, 160; critical essay on, 157–58, 160; *Crucifixion*, *159*, 160; as curator, 69, 157, 160; exhibitions, 20, 157, 189; friendships, 30, 31, 32, 33, 58, 64, 68, 160, 172, 189, 223; immigration to New York, 17, 30, 157; influence of, 33, 157, 160; influences on, 30, 31, 32, 33, 151, 158, 160; *Lunchroom Coffee Cup*, 31, 158, *158*, 160; photograph of, *157*; social beliefs of, 12; *Still Life with Pipe*, 31, *108*, 158, 160; as student, 157; as writer, 30–31, 58, 157, 160, 189
Graham, Martha, 60, 203
Grand Central School of Art, New York City, 150
Greenberg, Clement, 13, 171, 200
Greene, Balcomb, 18, 34–35, 42, 164, 196, 221; AAA and, 35, 38, 39, 161–62, *162*; *Angular*, 162, *163*; artistic theories of, 24, 34, 162; *Composition*, 35, *110*, 163; critical essay on, 161–63; exhibitions, 21, 41; friendships, 32, 33, 35, 187, 229; influences on, 32, 35, 161, 162, 166; in Paris, 34, 161, 164;

photograph of, *161*; social and political beliefs of, 13, 24; as teacher, 161, 164; in Vienna, 161; WPA and, 22, 23, 24, 72, 162; as writer, 24, 34, 39, 161, 162
Greene, Gertrude, 18, 34, 35, 37, 161, 162, 187, 221; *Composition*, 35, 164, *165*, 166; *Construction in Blue*, 165, 166; critical essay on, 164–66; *palombe, La* (The Dove), 35, 165, *165*; photograph of, *164*; *Space Construction*, 166, *166*; *White Anxiety*, 35, *111*, 166
Greene, John Wesley, *see* Greene, Balcomb
Gribbroek, Robert, 179
Gris, Juan, 146, 170; influence of, 48, 56, 63, 79, 161, 172, 174, 198, 199
Gropius, Walter, 34, 39, 192, 193
Grosz, George, 70, 175
Guggenheim, Irene, 214
Guggenheim, Peggy, 42, 168, 171
Guggenheim, Solomon R., 10, 40, 41, 193, 214, 215
Guggenheim, Solomon R., Collection, 10, 39, 41, 193
Guggenheim, Solomon R., Foundation, 190, 214, 236
Guggenheim, Solomon R., Museum, New York City, 35, 51, 179, 193; *see also* Museum of Non-objective Painting, New York City
Guston, Philip, 18, 168

H

Halpert, Edith Gregor, 65
Harari, Hananiah, 190
Hare, David, 42, 168
Harnett, William, 38, 39
Harriman, Marie, Gallery, New York City, 203
Harris, Lawren, 179
Harrison, Wallace K., 60, 186
Hartley, Marsden, 15, 17, 20, 146, 228
Hawthorne, Charles W., 187, 211
Hayes, Roland, 76
Hayter, Stanley W., 78, 176
Heisenberg, Werner, 213
Hélion, Jean, 19, 27, 147, 236; AAA and, 37, 168; critical essay on, 167–68; *Equilibre*, 167, 168, *169*; "Equilibres" series, 167; exhibitions, 18, 167, 168; *Figure d'Espace*, *112*, 167; "Figures" series, 167; friendships, 17, 19, 168, 176, 199–200; as idealist, 10; influence of, 52, 54, 78, 168, 199; influences on, 17, 167; "Orthogonale" series, 167; in Paris, 15, 16, 17, 78; photograph of, *167*; social and political beliefs of, 13, 168; as writer and editor, 13, 17, 19, 167, 168
Henri, Robert, 20, 63
Henry, Charles Trumbo, 28, 70
Hepworth, Barbara, 192
Herbin, Auguste, 236
Hesse, Eva, 47
Hiler, Hilaire, 172
Hinton, C. Howard, 205
Hofmann, Hans, 35, 69, 76, 171; AAA and, 171; *Abstract Figure*, 171, *171*; artistic philosophy of, 28, 29, 43; *Atelier Still Life—Table with White Vase*, *113*, 170; critical essay on, 170–71; exhibitions, 42, 170, 171; influence of, 171, 172; influences on, 170, 171, 175; in Munich, 16, 21, 170, 172, 231; in New York, 18, 21, 23, 28, 42, 170, 231; in Paris, 17, 170; photograph of, *170*; in Provincetown, 58, 170; *Spring*, 171; as student, 170; as teacher, 16, 18, 21, 23, 28, 29, 31, 34, 38, 52, 70, 71, 170, 171, 172, 175, 229, 231; as writer, 28
Holty, Carl Robert, 18, 78; AAA and, 36, 37, 168, 172; artistic views of, 174; *Circus*

Forms, *114*, 174; *City*, *173*, 174; critical essay on, 172, 174; exhibitions, 172; friendships, 172, 174, 196, *197*; influences on, 32, 172, 174, 196; in Munich, 16, 172; *Of War*, *115*, 174; in Paris, 16, 172; photograph of, *172*; political views of, 172; as student, 171, 172; *Table*, *173*, 174; as teacher, 33, 172, 174, 208
Holtzman, Harry, 18, 28–29, 30, 42, 70, 195; AAA and, 168, 176; critical essay on, 175–77; exhibitions, 28, 176; friendships, 29, 40, 70, 71, 175, 176, 177, 196, 229; *Horizontal Volume*, *176*; influences on, 16, 29, 40, 168, 175–76, 196; in Paris, 29, 176; photograph of, *175*; political views of, 176; *Square Volume with Green*, 29, *116*, 176; *Sculpture (I)*, 29, *117*, 176; as student, 21, 28, 29, 171, 175; as teacher, 36, 175; *Vertical Volume*, 176, *177*; WPA and, 22, 29, 176, 177; as writer, 176, 177
Homer, Winslow, 38, 39
Hopper, Edward, 20
"How Modern Is The Museum of Modern Art?," AAA broadside, 39, 58
Huxley, Julian, 193

I

I Ching, 76
Impressionism, 10, 70, 144, 150
Ingres, Jean-Auguste-Dominique, 30, 33, 156
Injalbert, Jean-Antoine, 227
Institute for General Semantics, 48, 177
Institute of Design, Chicago, 39, 74, 193
Interaction of Color (Albers), 46
"International Exhibition of Modern Art," Brooklyn Museum, 18, 63, 175, 182, 196, 227
"International Surrealist Exhibition," Paris, 42
Intransigeant, L', 186
"Italian Masters," exhibition, Museum of Modern Art, 38
Itten, Johannes, 74

J

Janis, Sidney, 197
Janis, Sidney, Gallery, New York City, 236
Jawlensky, Alexej von, 170
Jewell, Edward Alden, 24, 25, 37, 38
Jinmatsu, Uno, 202
Johansen, John C., 231
Johnson, Chester, Galleries, Chicago, 228
Jonson, Raymond, 41; critical essay on, 178–79; *Oil No. 2*, *179*; photograph of, *178*; *Variations on a Rhythm—H*, *118*, 178–79; "Variations on a Rhythm" series, 178
Joyce, James, 224
Jung, Carl, 30, 182

K

Kahnweiler, Daniel-Henri, 184
Kainen, Jacob, 22
Kaiser, Ray, 36
Kandinsky, Wassily, 175, 180, 214; artistic theories of, 41; Blaue Reiter period, 42; exhibitions, 18, 19, 193; influence of, 13, 34, 40, 41, 42, 46, 70, 78, 156, 170, 174, 178, 187, 216, 223; as teacher, 15, 74; as writer, 178
Kelly, Ellsworth, 220
Kelly, J. Wallace, 213
Kelpe, Paul, 17, 22, 23, 36, 46, 70, 72; critical essay on, 180–81; *Machine Elements*, 180, *181*; photograph of, *180*; *Weightless Balance II*, *119*, 180
Kennedy, Marie, 36

Kiesler, Frederick, 40, 177, 186, 190, 196
Kiesler, Lillian, *see* O'Linsey, Lillian
Klee, Paul, 15, 18, 41, 46, 51, 74, 78, 214
Klein, Jerome, 38
Kline, Franz, 43, 68
Knaths, Karl, 58
Kootz, Samuel, Gallery, New York City, 58
Korda, Alexander, 193
Korzybski, Alfred, 48, 177
Krasner, Lee, 22, 58, 160, 171
Kuh, Katharine, Gallery, Chicago, 50, 179, 193

L

La Farge, John, 38, 39
Lances, Leo, 36, 190
Lapis, The (Pereira), 206
Lassaw, Ibram, 39, 42; AAA and, 35, 36, 183; critical essay on, 182–83; exhibitions, 37, 41, 42, 183; friendships, 166, 187; immigration to New York, 17, 182; influences on, 42, 182, 183; *Intersecting Rectangles*, 42, *120*, 183; photograph of, *182*; *Sculpture*, 182, 183; *Sculpture in Steel*, 42, 183, *183*; *Sing Baby Sing*, 182; as student, 182; as teacher, 183; WPA and, 22, 183
League for Cultural Freedom and Socialism, 200
Le Corbusier (Charles-Edouard Jeanneret), 15, 176, 184
Léger, Joseph Fernand Henri, 26, 39, 41, 146, 147, 176, 236; AAA and, 37; *Adieu New York*, 186; in America, 184, 186, 228; as costume and set designer, 184; critical essay on, 184, 186; Cubism and, 174, 184; exhibitions, 27, 38, 39, 40, 42, 184, 186; as filmmaker, 184; *forêt, La* (The Forest), 40, 184, *185*; friendships, 17, 184, 186, 192, 228; influence of, 17, 23, 26, 27, 30, 40, 48, 59, 63, 65, 78, 79, 152, 158, 167, 198, 199; influences on, 184; lecture by, 10; in New York, 39, 40, 186, 189; in Paris, 15, 16, 17; photograph of, *184*; *Plongeurs* (Divers), *121*, 184; social and political philosophy of, 12–13, 186; as student, 184; as teacher, 17, 40, 184, 186; *Three Musicians*, 186; *ville, La* (The City), 18, 27, 65, *65*, 146; as writer, 186
Lescaze, William, 23
Levy, Julien, Gallery, New York City, 42, 59
Lichtenstein, Roy, 168
Light Play: Black White Gray, film, 193
Lipchitz, Jacques, 182
Lipton, Seymour, 183
Lissitzky, El, 18, 35, 71, 164, 166
Little Gallery, Chicago, 180
Loew, Michael, 23, 190
Logasa, Charles, 233
Lohr, George, 233
Long Beach Museum of Art, Long Beach, California, 181
Lozowick, Louis, 17, 22
Luks, George, 20, 211, 218
Lumpkins, Bill, 179

M

MA (Today), magazine, 192
Macbeth Gallery, New York City, 20
MacDonald-Wright, Stanton, 15, 20
McMahon, Audrey, 23, 72
McNeil, George, 21, 22, 23, 35, 36, 187, 190
Malevich, Kazimir, 18, 35, 43, 54, 71, 164, 166, 192; *White on White*, 25, 35
Manet, Edouard, 30
Man Ray, 17
Marc, Franz, 18
Marin, John, 15, 20, 144, 146

Marsh, Reginald, 15, 20, 21, 231
Martin, John, 208
Mason, Alice Trumbull, 18, 36, 221; *Brown Shapes White*, 187–88, *188*; critical essay on, 187–88; photograph of, *187*; *Untitled*, *122*, 188
Mason, Warwick, 187
Masson, André, 19, 39, 42, 166
Matisse, Henri, influence of, 32, 65, 76, 78, 156, 161, 170, 175, 199
Matisse, Pierre, 48
Matisse, Pierre, Gallery, New York City, 42, 48, 59, 182, 186
Matta (Roberto Sebastian Antonio Matta Echaurren), 14, 39, 42, 156, 186
Matter, Herbert, 186
Matulka, Jan: AAA and, 190; *Arrangement with Phonograph*, *123*, 190; critical essay on, 189–91; exhibitions, 21, 189, 190, 191; friendships, 64, 189; influence of, 38; influences on, 160, 189; in Paris, 16, 189; photograph of, *189*; political views of, 189; *Still Life with Lamp, Pitcher, Pipe, and Shells*, 190; as student, 189; as teacher, 21, 23, 70, 190, 191, 205, 223; *View from Ship*, *191*; WPA and, 22, 23, 72, 190
Maurer, Alfred, 20
Mayor Gallery, London, 48
Miller, Florence, 179
Miller, Kenneth Hayes, 21, 231
Minimalism, 43
Miró, Juan, 172, 211, 213; "Constellations" series, 60; *Dog Barking at the Moon*, 18, 19, 146; exhibitions, 18, 19, 42; influence of, 13, 16, 26, 30, 32, 33, 34, 48, 49, 54, 59, 60, 65, 78, 156, 166, 174, 182, 187, 199, 202, 223
"Modern Masters," exhibition, Museum of Modern Art, 38, 39
Moholy-Nagy, László, 39–40, 41, 43, 49, 74, 214; AAA and, 37, 193; artistic goal of, 192; in Chicago, 39, 192; Constructivism and, 192, 193; critical essay on, 192–93; exhibitions, 18, 25, 192, 193; as filmmaker, 192, 193; friendships, 148, 192; influence of, 182, 183, 192, 206, 211, 213; *Mills No. 1*, *124*, 193; in New York, 39; in Paris, 17; photograph of, *192*; *Space Modulator*, 40, 193, *193*; as teacher, 192, 193, 213; *T1*, 193; as writer, 10, 40, 182, 192, 211
Mondrian, Pieter Cornelis (Piet), 26, 39, 40, 42, 54, 147, 172, 236; AAA and, 37, 40, 166, 168, 196; *Broadway Boogie Woogie*, 197, *197*; *Composition with Blue and Yellow*, 18, 19; critical essay on, 194, 196–97; death of, 43, 194; exhibitions, 18, 25, 29, 39, 42, 196; friendships, 17, 29, 40, 148, 174, 176, 177, 192, 196, 197; influence of, 16, 17, 19, 26, 28, 29, 35, 40, 41, 43, 48–49, 52, 54, 59, 65, 71, 72, 78, 148, 149, 161, 164, 166, 167, 174, 175–76, 183, 187, 188, 196, 197, 198, 199, 223; influences on, 194; lecture by, 10; Neo-Plasticism of, 15, 16, 18, 19, 28, 40, 148, 166, 174, 187, 194, 196; in New York, 13, 39, 40, 166, 168, 174, 177, 183, 186, 196; *New York City I*, 196, *197*; *New York, New York City*, 40, 195, *195*, 197; in Paris, 15, 16, 17, 26, 29, 36, 194; photograph of, *194*; spiritual values of, 10, 14, 174, 194; technique, 40, 197; *Victory Boogie Woogie*, 40, 72, *125*, 148, 149, 197; as writer, 194, 196
Monet, Claude, 50
Montclair Art Museum, Montclair, New Jersey, 232
Montross Gallery, New York City, 33
Moore, Mary Katherine, 50
Morley, Eugene, 23
Morris, George Lovett Kingsland, 11, 18,

26, 48, 78, 186, 190; AAA and, 36, 38, 39, 146, 168, 183, 198, 200, 220; artistic theories of, 80, 198–99, 218, 219; *Concretion*, 199, *199*; *Configuration*, *201*; critical essay on, 198–200; exhibitions, 25, 26, 183, 198; friendships, 17, 27, 146, 166, 199–200, 218, 220; influence of, 198; influences on, 17, 27, 32, 40, 79, 168, 198, 199; marriage of, 79, 200; *Mural Composition*, 127, 168, 199; *Nautical Composition*, 27, 199, *201*; in Paris, 198, 199; *Personnage*, 199, *199*; photograph of, *198*; *Pocahontas*, 27, 199, *200*; *Posthumous Portrait*, 199, *201*; social beliefs of, 12, 13; *Stockbridge Church*, 27, *126*, 199; as student, 27, 186, 198; as writer, 26, 27, 38, 198, 200
Mose, Eric, 23
Moss, Marlow, 16
Motherwell, Robert, 42, 168, 171
Municipal Art Gallery, New York City, 35, 79
Münter, Gabriele, 18
"Murals by American Painters and Photographers," exhibition, Museum of Modern Art, 65
Murphy, Gerald, 186
Museum of Living Art, New York University, New York City, 18, 25, 26, 28, 29, 30, 35, 43, 146, 164, 165, 175, 187, 219; *see also* Gallery of Living Art, New York University, New York City
Museum of Living Art, Philadelphia Museum of Art, 43, 146
Museum of Modern Art, New York City, 10, 20, 30, 39, 41, 79, 177; exhibitions at, 12, 19–20, 25, 31, 37, 38, 39, 40, 42, 46, 48, 59, 65, 164, 166, 186, 206; policy of, 19, 37
Museum of Modern Art Bulletin, The, 27
Museum of Non-objective Painting, New York City, 10, 35, 39, 40–41, 42, 179, 193, 215, 216; *see also* Solomon R. Guggenheim Museum, New York City

N

National Academy of Design, New York City, 38, 51, 52, 56, 172, 187, 189, 208, 211, 221, 229
National Collection of Fine Arts, Washington, D.C.
Nature of Space, The (Pereira), 206
Neo-Impressionism, 194
Neo-Plasticism, 18, 29, 35, 49, 146, 166, 188; in Holland, 15; influence on American art, 13, 16, 23, 26, 28, 29, 33, 40, 42, 43, 51, 54, 71, 148, 162, 164, 167, 176, 183, 187; influence on European art, 15, 16; Mondrian and, 15, 16, 18, 19, 28, 40, 148, 174, 187, 194, 196
Neumann, J. B., 51, 172
Neumann, J. B., Gallery, New York City, 46
Neutra, Richard, 34
Nevelson, Louise, 171
New Art Circle Gallery, New York City, 51, 172
New Bauhaus, Chicago, 39, 192, 193, 206
New Masses, The, 37, 189
"New Realism, A" (Mondrian), 196
"New Realism, The" (Léger), lecture, 10
New School for Social Research, New York City, 65, 78
New Vision, The (Moholy-Nagy), 40, 182, 192, 211
New York American, 25
New Yorker, magazine, 38, 218
New York Post, 38
New York School, 68, 171, 209; *see also* Abstract Expressionism
New York Times, 24, 25, 37, 38, 58

New York World's Fair (1939–40), New
York City, 72, 213; American Abstract
Artists exhibition at, 176, 183; fountain
for, 62; murals for, 23, 33–34, 54, *86*,
162, 229
New York World-Telegram, 25
Nicholson, Ben, 16, 192, 199
Nierendorf Gallery, New York City, 46,
172, 196, 236
Niewenhuis-Domela, César, 16, 26, 48,
166, 176, 200
Noguchi, Isamu, 16, 59, 183; critical essay
on, 202–203; *Leda, 128*, 202; *Noodle,
203, 204*; photograph of, *202*; *Play
Mountain*, 203, *203*
Noguchi, Yonejiro, 202
Noland, Kenneth, 47, 220

O

Oceanic art, 30
O'Keeffe, Georgia, 15, 20
O'Linsey, Lillian, 190
"On Simplification" (Swinden), 229
On War (Clausewitz), 174
Opper, John, 36
Orozco, José, 24
Ozenfant, Amédée, 17, 42, 184, 186

P

Pach, Walter, 17
Panama-Pacific International Exposition,
San Francisco, 227
Parsons, Betty, Gallery, New York City,
209
Partisan Review, 13, 26, 38, 200
Pascin, Jules, 202
Passedoit, Georgette, Gallery, New York
City, 168
Pavillon de l'Esprit Nouveau, 184
Peale, Charles Willson, 144
Peech, Sibyl, 192
Pelton, Agnes, 179
Pennsylvania Academy of the Fine Arts,
Philadelphia, 191, 227
Pereira, Irene Rice, 21, 22, 41, 190;
Abstraction, 207; *Ascending Scale*,
205–206, *206*; critical essay on, 205–206;
Green Depth, 129; photograph of, *205*
Pereira, Umberto, 205
Pevsner, Antoine, 16, 18, 26, 48, 49, 164,
176, 182, 192
Philadelphia Museum of Art, Gallatin
collection at, 43, 146
Philadelphia Press, 63
Phillips, Duncan, 31, 157
Phillips Collection, Washington, 31, 157
Phillips Memorial Gallery, Washington, 157
Picasso, Pablo, 11, 39, 146, 161, 170, 175,
211; Cubism and, 15, 31, 52, 65, 174,
187, 224; exhibitions, 18, 25, 31, 38, 42;
friendships, 17, 78; *Guernica*, 31, 78;
Harlequin, 171; influence of, 29, 30, 31,
43, 48, 52, 56, 63, 64, 79, 151, 152, 156,
160, 171, 182, 184, 187, 198, 223; *Studio,
The*, 64, *64*; Surrealism and, 31, 160;
Synthetic Cubism and, 171; *Three
Musicians*, 18, 25, 146, 160; tribal art
and, 30–31
Pierce, H. Towner, 179
Piero della Francesca, 52
Piper, John, 192
Plans, publication, 186
Plastique, magazine, 200
"Plenty of Duds Found in Abstract Show:
More Fizzles than Explosions in Display
at Fine Arts Building" (Klein), 38
PM, newspaper, 38, 39, 209
Pollock, Jackson, 14, 32, 43, 151, 183;
exhibitions, 42, 160; friendships, 68, 171;
influence of, 66, 69; influences on, 21,

42; as student, 21
Post-Impressionism, 70, 150, 160
Powell, Louise, 147
Pratt, Bela, 227
Precisionism, 15, 18, 20
"Primitive Art and Picasso" (Graham),
30–31
Provincetown, Massachusetts, 58
Public Works of Art Project (PWAP), 21–22,
51
Puni, Ivan, 16
Putzel, Howard, Gallery, Hollywood,
California, 179

Q

Queens College, New York City, 78
Quinn, John, 18

R

Radio Station WNYC, Municipal Building,
New York City, murals for, 23, 65; wall
relief for, 164
Rattner, Abraham, 233
Ratton, Charles, 48
Rauschenberg, Robert, 47, 231
Rebay, Hilla, 10–11, 35, 40–41, 192, 193,
214, 215, 216, 236
Regionalism, 19, 20, 21, 24, 38, 39
Rehn, Frank K. M., Gallery, New York City,
190, 191
Reid Mansion, New York City, 42, 60
Reinhardt, Adolph Frederick (Ad), 18, 22,
31, 33, 39, 43, 168, 172; critical essay
on, 208–209; *Number 30*, 33, *130*, 209;
photograph of, *208*; *Red and Blue
Composition*, 33, 168, *209*; *Untitled*
(1940, 16×20"), *131*; *Untitled* (1940,
47×25"), 33, *210*
Reinhardt, Paul, Galleries, New York City,
26, 59, 219
Rivera, Diego, 24
Rivera, Jose de, 23, 213
Rivers, Larry, 171
Riverside Museum, New York City, 38
Rockefeller, Abby Aldrich, 19
Rockefeller, Nelson, 186
Rockefeller Center, New York City, 186;
mural for, 24
Rodchenko, Alexander, 164
Rodin, Auguste, 76, 227
Roerich, Nicholas, 178
Romein, Bernard, 68
Roosevelt, Franklin D., 21, 22, 176
Rosenberg, Harold, 69, 171
Rosenborg, Ralph, 36
Rosenquist, James, 231
Roszak, Theodore, 16, 21, 182; *Airport
Structure*, *212*, 212–13; *Ascension*, *133*,
213; critical essay on, 211–13; *Large
Rectilinear Space Construction*, 211, *212*;
photograph of, *211*; *Trajectories*, *132*,
213; *Watchtower*, 213, *213*
Rothko, Mark, 14, 43, 68, 171
Russell, Morgan, 20
Ryder, Albert Pinkham, 39
Ryder, Worth, 231

S

Salon d'Automne, Paris, 227
Salon des Beaux-Arts, Paris, 227
Sargent, John Singer, 38, 39
Scarlett, Rolph, 41; *Composition*, 41, *134*,
214–15; critical essay on, 214–15;
photograph of, *214*; *Untitled*, 215
Schanker, Louis, 21, 22, 23
Schapiro, Meyer, 12, 13, 168, 208
Schlemmer, Oscar, 213
Schoen, Eugene, Gallery, New York City,
202

School of Design, Chicago, *see* Institute of
Design, Chicago
Schwarz, Willi, 170
Schwitters, Kurt, 180, 192, 232
Section d'Or, 184
Sennhauser, John, 41; critical essay on,
216; *Lines and Planes No. 1*, 216, *217*;
Lyrical No. 7, 41, *135*, 216; photograph
of, *216*
Seurat, Georges: *Sunday Afternoon on the
Island of La Grande Jatte*, 70
Shahn, Ben, 22
Shaw, Charles Green, 18, 27, 78, 221;
AAA and, 146, 183, 200, 219–20; artistic
goals of, 80, 219; critical essay on,
218–20; exhibitions, 25, 37, 41, 183,
219, 220; friendships, 27, 79, 146, 200,
218, 220; photograph of, *218*; *Plastic
Polygon* (1937), *136*, 218; *Plastic
Polygon* (1939), 219, *220*; "Plastic
Polygon" series, 27, 37, 218, 219;
Polygon, 219, *219*; as student, 27, 218;
Top Flight # 1, *220*; as writer, 218
Sheeler, Charles, 15, 20, 144, 146
Shelter, magazine, 182
Siqueiros, David Alfaro, 24
Sloan, John, 20, 21, 27, 63, 157
Slobodkina, Esphyr, 17, 36, 41, 79; *Ancient
Sea Song*, *137*, 221; *Construction No.
Three*, 221, *222*; critical essay on,
221–22; photograph of, *221*
Smart Set, The, magazine, 218
Smith, David Roland, 18, 43, 70; AAA and,
37; *Aerial Construction*, *225*; artistic
theories of, 43; *Billiard Player
Construction*, *138*, 224, drawing for,
224, *224*; critical essay on, 223–25;
friendships, 31, 64, 160, 223, 236;
influences on, 43, 160, 223, 224; *Interior
for Exterior*, 224, *226*; in Paris, 223;
photograph of, *223*; *Sawhead*, 43, 224,
225; as student, 21, 190, 223; WPA
and, 22, 223
Smith, Tony, 231
Social Realism, 13, 24, 41, 56, 196, 208
Société Anonyme: Museum of Modern
Art, New York City, 17–18, 19, 20, 28,
63, 70, 175, 182, 189, 227
"Society and the Modern Artist" (Greene,
B.), 23–24
Society of Independent Artists, New York
City, 20, 180
Soyer, Raphael, 15
Spanish Civil War, 31, 147
Squibb Galleries, New York City, 36, 37,
38, 221
Stea, Césare, 164
Stedelijk Museum, Amsterdam, 192
Steeves, Bill, 195
Stein, Gertrude, 17, 25, 76, 78
Stella, Joseph, 15, 17, 20, 233
Stieglitz, Alfred, 15
Still, Clyfford, 42, 171
Storrs, David W., 227
Storrs, John Henry Bradley: critical essay
on, 227–28; *Double Entry*, *139*, 228;
photograph of, *227*; *Portrait of an
Aristocrat*, 228, *228*
Structuralism, 50
Stuart, Gilbert, 144
Suprematism, 15, 18, 19, 28, 33, 34, 35, 54,
71, 164, 165
Surrealism, 15, 31, 42, 183; exhibitions, 18,
19, 42, 60; influence on Abstract
Expressionism, 13–14; influence on
American art, 23, 26, 29, 30, 32, 33, 34,
38, 39, 40, 42, 43, 54, 68, 156, 164, 171,
183, 203; Picasso and, 31, 160; reaction
against, 200
Sweeney, James Johnson, 48, 186, 236
Swinden, Albert, 22, 29, 34, 221; AAA
and, 35, 36, 229; *Abstraction* (1939), 29,

229, 230; *Abstraction* (1940), *230*; critical
essay on, 229; exhibitions, 37, 41;
friendships, 35, 54, 229; influences on,
40, 196; *Introspection of Space, 140*,
229; photograph of, *229*; as student, 21,
28, 229; WPA and, 23, 72, 229; as
writer, 229
Symbolism, 194
Synchromy, 20, 78
Synthetic Cubism, 28, 32, 65, 80, 171;
influence on American art, 23, 26, 27,
31, 63, 70, 79, 150, 160, 174, 187, 199,
206, 229
System and Dialectics of Art (Graham),
160, 189

T

Taeuber-Arp, Sophie, 147, 200
Tanguy, Yves, 39, 42, 186
Taoism, 76
Tatlin, Vladimir, 18, 35, 164
Taylor, Richard, 36
"Ten, The," 33
They Shall Not Have Me (Hélion), 168
Things to Come, film, 193
Thoreau, Henry David, 179
Thurn, Ernst, 175, 231
Tillim, Sidney, 71
Torres-García, Joaquín, 78, 167, 233, 236
*Transcendental Formal Logic of the
Infinite, The* (Pereira), 206
Transcendental Painting Group, 178, 179
*trans/formation: arts, communication,
environment*, journal, 177
Transition, publication, 182
Treasury Section of Painting and Sculpture,
22
Trotsky, Leon, 13, 65, 200
Trumbull, John, 187
Trumbull, R. D., 36
Twombly, Cy, 231

U

Uccello, Paolo, 30
Unemployed Artists' Group, *see* Artists'
Union

V

Valentin, Curt, Gallery, New York City, 219
Valentine Gallery, New York City, 31, 168
Vanity Fair, magazine, 218
Vantongerloo, Georges, 16, 26, 48, 192
Veen, Stuyvesant Van, 23
Villon, Jacques, 16
Vordemberge-Gildewart, Fritz, 180
Vorticism, 227
Vytlacil, Vaclav, 16, 21, 29–30, 36; critical
essay on, 231–32; photograph of, *231*;
Untitled (1937), *141*, 232; *Untitled*
(1939), 232, *232*

W

Walker, Stuart, 179
Walkowitz, Abraham, 233
Ward, Ralph, 36
Washburn Gallery, New York City, 188,
215, 220
Weber, Max, 15, 20, 21, 233
Weinstock, Clarence, 22
Weisenborn, Rudolf, 36
Welliver, Neil, 47
Werkbund, Germany, 34
Weyhe's Bookshop, New York City, 71
Whistler, James A. McNeill, 39
Whistler: Notes and Footnotes (Gallatin),
144
Whistler's Art Dicta (Gallatin), 144
Whistler's Pastels and Other Modern

Profiles (Gallatin), 144
Whitehead, Alfred North, 182
Whiteman, Frederick, 190
Whitman, Walt, 179
Whitney, Gertrude Vanderbilt, 20
Whitney Museum of American Art, New
 York City, 11, 20, 64, 65, 188, 191, 206,
 211
Whitney Studio Club, New York City, 20,
 64, 190
Wicht, John von, 22, 23
Wiegand, Charmion von, 22, 37, 196, 197
Wilkenson, Albert S., 21, 28, 70
Williamsburg Housing Project, Brooklyn,
 New York, murals for, 13, 23, 33, *64*, 65,
 162, 190, 229
Wood, Grant, 15, 20
Works Progress Administration (WPA),
 Federal Art Project of, 22–24, 28, 34, 39,
 44, 51, 60, 74, 177, 183, 203, 221, 223;
 Design Laboratory, 205, 206; Easel
 Division, 208; gallery operated by, 35;
 Graphic Art Project, 74; Mural Division,
 23, 29, 33, 58, 65, 72, 150, 164, 176,
 180, 186, 190, 229; requirements of, 68;
 War Service Section, 72
Worringer, Wilhelm, 34
WPA, *see* Works Progress Administration

(WPA), Federal Art Project of
Wright, Frank Lloyd, 34, 49
Wright, Russel, 209

X

Xceron, Jean, 41, 168, 177, 216, 223;
 Composition No. 239A, 142, 236;
 *Composition No. 250, 41, 234;
 Composition No. 263, 143; Composition
 No. 269, 235;* critical essay on, 233,
 236; photograph of, *233; Violin No. 6E,
 234,* 236

Y

Yale University, New Haven, Connecticut,
 39, 46, 47, 198, 218
Yun Gee, 76, 78

Z

Zabriskie Gallery, New York City, 181
Zarate, Laure Ortiz de, 78
Zarre, André, Gallery, New York City, 206
Zen Buddhism, 76
Zervos, Christian, 48
Zogbaum, Wilfrid, 36

PHOTOGRAPH CREDITS

The authors and publishers wish to thank all those who have supplied photographs for use herein. Photographs have generally been provided by owners or custodians, as cited in captions. Additional acknowledgment is due to the following (all numbers refer to pages):

Courtesy of ACA Galleries: 163, 165 (below left), 166 The Josef Albers Foundation, Inc.: 46 *Art & Artists Today:* 157 Adam Avila: 135, 220 (left) Ben Blackwell: 112 Courtesy of the Brooklyn Museum of Art: 29 (above right and below) © Stephen B. Browne: 57 Courtesy of Stephen B. Browne: 56, 58 Kevin Brunelle: 62 (above), 113 © Rudy Burckhardt: 68 Alice Swinden Carter: 229 Chisholm, Rich & Associates: 57 Geoffrey Clements: 53 (above and below), 57, 60, 66, 71, 122, 128, 130, 140, 150, 151 (below), 193, 201 (above right), 219, 220 (right) Ken Cohen: 148, 225 (top) Collection One—Photos of Artists, Archives of American Art, Smithsonian Institution: 51 (Mepans); 205 (WPA Federal Art Project) Dorothy Dehner: 223 Martin Diamond Fine Arts, Inc.: 179, 231 (Peter A. Juley and Son) Werner Drewes: 74 (Aaron Siskind), 100 Jerome Drown: 199 (below) Rick Echelmeyer: 94 Robert D. Edwards/Courtesy of The Edmonton Art Gallery: 224 (below) Roy M. Elkind: 80, 191, 230 (above), 234 (above) Courtesy of Rae Ferren: 76 Suzy Frelinghuysen: 79 (Eric Pollitzer), 198 Philip Galgiani: 107 Courtesy of the Fritz Glarner Papers, Kunsthaus Zürich: 147, 194 (Fritz Glarner) Cynthia Goodman: 170 (Herbert Matter) Balcomb Greene: 161 Carmelo Guadagno: 110, 124, 134 Carmelo Guadagno and David Heald: 90 David Heald: 80 Laszlo Hege: 132 Helga Photo Studio: 200, 201 (above left) Bartlett Hendricks: 165 (above) Ted Hendrickson: 116 Harry Holtzman: 167, 175 (Fritz Glarner) Courtesy of Sidney Janis Gallery: 196 Jonson Gallery, Albuquerque: 178 (F. von James) Courtesy of the Peter A. Juley and Son Collection, National Museum of American Art, Smithsonian Institution: 63 Paul Kelpe: 180 Ibram Lassaw: 182 Susan Larsen: 216 Joan Marter: 59 (Herbert Matter) Courtesy Emily Mason: 187 Robert E. Mates: 47, 75, 77 (below), 235 Allen Mewbourn: 55, 190 The Milwaukee Art Museum: 172 (E. T. Howell) Jacqueline Moss: 164 (Balcomb Green) Otto E. Nelson (for Sidney Janis Gallery): 121, 195 Courtesy of The Newark Museum: 152 Courtesy of New York University Archives: 144 Isamu Noguchi: 202 (André Kertész) Eric Pollitzer: 95 Courtesy Kenneth W. Prescott: 70 (© Estate of Burgoyne Diller) Courtesy of the Hilla von Rebay Foundation: 192, 215 (left), 233 (Nellys Studio) Anna Reinhardt: 208 (H. Bowden) T. K. Rose: 77 (above), 101, 103, 125, 131, 145, 212 (right), 228 Sara Roszak: 211 (Dordick and Dordick) Kevin Ryan (for André Emmerich Gallery): 171 Sandak, Inc.: 123 Rolph Scarlett: 214 Charles Green Shaw Papers, Archives of American Art, Smithsonian Institution: 218 (Pinchot Studio) Patterson Simms: 189 Aaron Siskind: 176, 177 Esphyr Slobodkina Papers, Archives of American Art, Smithsonian Institution: 221 (Fritz Glarner) Lee Stalsworth: 92 The John Storrs Papers, Archives of American Art, Smithsonian Institution: 227 (J. Roseman) Bill J. Strehorn: 127 Ken Strothman and Harvey Osterhoudt: 64 (below) Joseph Szaszfai: 149 (below) Jerry L. Thompson: 62 (below) Roland I. Unruh: 206 Jan van der Marck: 48 (Joan Sangrain) *Vanity Fair:* 184 (Reiss) © Sarah Wells: 153 (below)